THE OWL AND THE ROSSETTIS

THE OWL
AND THE
ROSSETTIS

Letters of Charles A. Howell
and Dante Gabriel,
Christina, and
William Michael Rossetti

Edited, with an Introduction,
by C. L. Cline

The Pennsylvania State University Press
University Park and London

Letters of the Rossetti family are printed or quoted by permission of the late Mrs. Helen Rossetti Angeli and her daughter, Mrs. Imogen Dennis, and the Humanities Research Center, The University of Texas. Letters from Burne-Jones to Howell are quoted by permission of the Rossetti Collection of Janet Camp Troxell in Princeton University Library. Manuscripts from the Violet Hunt collection are quoted by permission of Cornell University Library. A letter from Charles A. Howell to D. G. Rossetti, 15 December 1875, is reprinted by permission of the Beinecke Rare Book and Manuscript Library, Yale University Library. Correspondence between Howell and George Howard and Frederick Sandys is quoted by permission of The John Rylands University Library of Manchester. Letters of John Ruskin are quoted by permission of George Allen & Unwin Ltd.

Library of Congress Cataloging in Publication Data
Main entry under title:
The Owl and the Rossettis.
 Includes bibliography and indexes.
 1. Rossetti, Dante Gabriel, 1828–1882. 2. Painters—England—Correspondence. 3. Howell, Charles Augustus, d. 1890? 4. Art dealers—England—Correspondence. 5. Preraphaelitism—Holland. 6. Poets, English—19th century—Correspondence. I. Cline, Clarence Lee. ND497.88A34 700′.92′2 [B] 77-88468 ISBN 0-271-00530-0

Introduction and Notes Copyright © 1978 The Pennsylvania State University
Printed in the United States of America

Contents

Preface

The relationship between artist and agent—during the Victorian period, when such a relationship was still rare—is vividly depicted in the 438 letters herein between Charles Augustus Howell (or his wife) and Dante Gabriel Rossetti. Since the artist was also a major poet, the Howell correspondence enhances our understanding of a figure prominent in both literature and art. Christina Rossetti, herself a major poet, is represented by six letters in this volume. Their brother, William Michael, art and literary critic, represents both metiers. He wrote or received nineteen letters herein. Beyond the Rossetti family, most of the leading artists and literary figures—especially the Pre-Raphaelites—are illuminated, if not exposed, by the epistolary candor of "the Owl" and his three friends.

James McNeill Whistler called Howell "the wonderful man, the genius, the superb liar, the Gil-Blas, Robinson-Crusoe hero out of his proper time, the creature of top-boots and plumes—splendidly flamboyant." To the artist Burne-Jones, who first dubbed him "Owl," he was "My pretty owl," "My sweet little owl"; Burne-Jones was "desolate" when Howell was away, yearned for him, and hated everybody who didn't love Howell. To Ruskin, for whom Howell acted as secretary and general factotum from about 1866 to late 1870, he was sometimes "dearest sweet owl," "dearest owl," or simply "dear Howell." Dante Gabriel Rossetti, in his letters, occasionally addressed him as "Dear Owl" but more usually "My dear Howell" or "Dear Howell."

Such was the young man, half English, half Portuguese, who first came to London in 1857 but was soon forced to flee because of innocent involvement in the Orsini conspiracy. He returned to London late in 1864 and about a year later became Ruskin's secretary. Concurrently he carried on a sideline activity as art salesman and interior decorator, which he continued after parting company with Ruskin in 1870. Meanwhile he had become friend or business associate of the principal artists of the day—G. F. Watts, Whistler, Rossetti, Burne-Jones, Sandys, and others. By 1873 he had sold no less than 68 drawings and paintings by Rossetti despite the fact that Rossetti never exhibited after his initial Pre-Raphaelite exhibition of 1849 and would not permit any prospective purchaser to visit his studio unless he were a certain buyer. As a salesman, says William Rossetti, "Howell was unsurpassable; and he achieved for Rossetti, with ease and also with much ingenious planning, many a stroke of most excellent business, such as other men . . . would have found arduous or impossible."

The relationship between Howell and Rossetti, an informal business arrangement based upon mutual interest, lasted until early 1876, when Rossetti had less need of an agent and had become increasingly impatient with Howell's complaints about the artist's failure over a period of years to deliver drawings that had constituted Howell's only commission on art works sold. In reading the correspondence between the two, one can be sympathetic with each of the principals. The end came in early 1876, but when Rossetti lay dying at Birchington-on-Sea

in 1882, Howell paid him a friendly visit and kept him laughing all day by the amusing stories he told his former client.

All of Howell's friendships with artists and with the poet Swinburne came to an end, often under mysterious circumstances as with Ruskin and Burne-Jones. Toward the end of the relationship between Howell and Rossetti, the latter accused Howell of having "wantonly sacrificed many of the friends and advantages which accrued on my connexion." Defending himself, Howell replied that he wished he had never known any of these former friends, "and the very best proof I can have of their being worthless is that you a much older friend of theirs, never see one, and for all use, enjoyment or pleasure they afford you, you might be in the same position I am in." The riposte should have struck home: Rossetti, now a recluse, saw none of his old friends, except occasionally Ford Madox Brown. In his last days the artist-poet was attended almost solely by his new follower, the young T. Hall Caine.

Much has been written about Howell, notably by the late Mrs. Helen Rossetti Angeli, niece of Dante Gabriel and almost Howell's only defender. The Introduction to this book corrects some of Mrs. Angeli's minor errors and adds a great deal of new information about Howell; in the course of doing so, it attempts to be fair and objective in all respects. The principal purpose of the correspondence collected here is to document the relationship between an important artist and his agent—possibly the most complete record of any such relationship in the history of art—and to provide much new information about a major Victorian poet and artist.

Acknowledgments

I recall with pleasure the cordial reception which my wife and I received many years ago when Lady Mander escorted us to tea with the late Mrs. Angeli and her daughter, Mrs. Dennis, at the house of the latter in Woodstock. The talk was all of the Pre-Raphaelites, and we were permitted to examine Mrs. Angeli's papers and art works, which had not then been dispersed. My indebtedness to Mrs. Angeli for her pioneering work on Charles Augustus Howell will be apparent throughout this book, and I am happy to record that indebtedness. More recently Lady Mander introduced us to Mrs. Marsden-Smedley, who kindly invited us to be her guests at the Chelsea Arts Club. There we visited the Whistler Room, where we saw the Satanic portrait of Whistler, done by A. L. Thomson from a reversed etching (with the monocle therefore on the wrong eye), and the putative cabinet which inspired Whistler's *The Owl and the Cabinet*. One would be glad to believe the cabinet genuine, as it well may be. I would like especially to thank Lady Mander for her friendship and many kindnesses.

To Professors William E. Fredeman and Stanley Weintraub, both of whom read the manuscript, I owe more than I can express. Both, masters of the subject, contributed valuable advice and assistance which constitute a deep obligation. Professor Fredeman also kindly put at my disposal certain of the Angeli Papers pertinent to my subject.

I wish to thank the officials of the Princeton, Cornell, John Rylands, and University of Glasgow libraries for their warm reception of me and for permission to make use of the materials recorded in the Introduction or the text of the letters.

My thanks are also due to Mrs. Troxell for her encouragement and her assistance at several points in the editing. I am of course greatly indebted to Mrs. Virginia Surtees, whose two-volume catalogue of Rossetti's paintings and drawings was indispensable in identifying works of art referred to in the letters; in addition she personally assisted in the identification of works of art not listed in her catalogue. I am also grateful to Simon Nowell-Smith, Esq., for his encouragement and moral support and for a memorable visit to Kelmscott Manor.

I wish to thank the Faculty Library Committee and the various officials of the Humanities Research Center in the Harry Ransom Center for reserving for my use the letters which form the corpus of this book and for permission to publish them. The courtesy of the attendants in the HRC made working there a pleasure.

During much of the work on this project I had the efficient and faithful service of Mrs. Barbara Barlow, to whom I wish to express my warm thanks.

Finally I wish to acknowledge the generous support of the John Simon Guggenheim Memorial Foundation and the University Research Institute of The University of Texas for grants which enabled me to complete the major portion of this work. Without their support the project might never have been undertaken.

Introduction: Agent to the Pre-Raphaelites

The association of Charles Augustus Howell with members of the Pre-Raphaelite circle and their friends has been recounted many times by his contemporaries in their diaries and journals, by subsequent biographers—notably Mrs. Angeli, daughter of William Michael Rossetti—and by various scholars, memorialists, and dissectors of the corpses of the great dead whose art and letters remain to titillate our curiosity. Whatever else Howell may have been—and he was an exceedingly complex figure—our interest in him lies primarily in his friendship with the Pre-Raphaelites and his activities as agent for the works of half a dozen artists, including G. F. Watts, Ford Madox Brown, Edward Burne-Jones, Frederick Sandys, and, most of all, Dante Gabriel Rossetti, for whose paintings and drawings, at first privately and later officially, he created an unrivaled market. The letters printed in this volume document the history of Howell's friendship with the Rossettis and his role as a Pre-Raphaelite picture agent in a day before such associations became general. In a letter of 19 August 1873 Howell informed Rossetti that in six years he had sold "no less than sixty eight pictures and drawings" of Rossetti's, a feat that only a superb salesman could have done for an artist who refused to exhibit his works or even allow them to be seen unless the viewer was a certain buyer.

When Mrs. Angeli wrote her very personal little book on Howell, *Pre-Raphaelite Twilight*—indispensable to anyone interested in Howell—she printed many of Howell's letters to Rossetti, in part or *in toto*, but the reciprocal letters and postcards of Rossetti to Howell, numbering 501 in The University of Texas collection, were unavailable to her. They had been sold by Howell's executors, following Howell's death in 1890, to Charles Fairfax Murray, onetime assistant to Rossetti and later a noted collector, whose son sold them at Sotheby's in 1962. They were subsequently acquired by The University of Texas at Austin. Not long thereafter Texas acquired Howell's letters to Rossetti, some ninety in number, from Mrs. Angeli. The correspondence between the two, omitting many of Rossetti's trivial notes and invitations, forms the corpus of this book.

William Rossetti states that Howell was first introduced to the Rossettis by "a man of some twenty-five years of age, of gentlemanly address, who had once been in the army" (*FL*, I.257).[1] The year was 1857, not 1856, as he remembered it, and he designates the man only "by his initials, J.F.H. (the name is not Howell)." Letters in the Texas collection, however, identify him as J. Fanell Hogg. Through William, Hogg "became known to various members of [the Pre-Raphaelite Brotherhood] circle, including my brother, who, being kind-heartedly anxious to help him out of circumstances of great money embarrassment promoted his interests to the best of his power." Howell at the time of the introduction seemed "a very well-grown, pleasant-spoken, sprightly youth" of about seventeen, although he looked several years older. Subsequently, William continued,

1. See Note on the Text for abbreviations of works and collections cited. Short references are used in footnotes for books listed in Select Bibliography.

"but not until some mischief had been done in attempts to serve him, J.F.H. was found by Howell to be a very disgraceful character. Howell gave us notice of this, and J.F.H. was abandoned to his fate—which proved to be an equally dismal and well-deserved one," apparently prison.

Who was this young "well-grown, pleasant-spoken, sprightly youth" of about seventeen who thus appeared for the first time in the Pre-Raphaelite circle? Mrs. Angeli, from an obituary notice in *The Royalist* (a Jacobite organ) and from information obtained in Portugal, states that he was born in Oporto on 10 March, probably in 1840, that his father was Alfred William Howell, an Englishman who combined the profession of artist and drawing-master with the selling of wine, and that his mother was Dona Enriqueta Amelia de Souza de Rosa Coelho, member of a distinguished Portuguese family. Of Howell's first sixteen years almost nothing is known beyond the fact that, according to the Institudo do Vino Porto (*PRT*, p. 28), he assisted his father in the wine trade. At about age sixteen, however, he was sent to England, presumably to be placed in some suitable occupation by his uncle, Alexander James Howell, vicar of Darlington.

According to *The Royalist*, Howell was apprenticed to "the great engineer Stephenson," but this cannot be true since the famous railway engineer had been dead for eight years. A letter in the Cornell Library from the Secretary of the Stockton and Darlington Railway, however, makes clear that he was employed in some capacity by the railway. The position could hardly have been menial, for according to a letter written by Mrs. Elizabeth J. Melland to Sir Henry Lucy in 1913 Howell associated with upper-class persons on an equal footing: "We young people found him a very interesting and stimulating friend, well read even then, and he gave us ideas on books and art, and his influence was all for the good. He went to Manchester to the Fine Arts Exhibition in 1857 and told a friend he had seen every picture in the Exhibition, the friend said describe them and he sat down and made sketches of several."[2] Thus at an early age the young Howell manifested an interest in art that was to become the consuming interest of his life. More about him in Darlington is learned from Violet Hunt's uncompleted life of Howell, *The Foulest Soul That Lived* (a title borrowed from Swinburne), the manuscript of which is in the Cornell Library. On 12 November 1856 Howell was elected to the Darlington Library and Philosophical Society, and in June 1857 he was instrumental in inviting Orsini to give a lecture in Central Hall, presided over by the Lord Mayor, Mr. Comyn. Already he was in touch with Ruskin, who addressed a letter to him on 24 December 1856.

The reasons that prompted Howell to leave Darlington for London are unknown, but he carried with him a testimonial, dated 26 September 1857, written by John Edward MacNay, Secretary to the Stockton and Darlington Railway. In it MacNay stated that "during the two years you have been employed by this company, your employers have had every reason to congratulate themselves on having as a servant one who performed his duties with such conscientious honesty and care for their interests." MacNay added that he might indeed say more on Howell's behalf but for fear of violating good taste or being thought a flatterer. He concluded with the hope that "you will ever pursue the honourable course you have hitherto pursued and [that] your life may be a prosperous and happy

2. Sir Henry Lucy, *Sixty Years in the Wilderness* (London, 1904), quoted in *PRT*, pp. 37–38.

one" (Cornell). It is worth noting that Violet Hunt later found in a visit to Darlington that the MacNay clan never abandoned Howell: he took several of them to the Goodwood races in 1881, and some of them were his guests at Selsey the year before he died.

Just what Howell did, during his short time in London, other than make acquaintances, is unknown. As we have seen, however, he was already acquainted with Orsini, and in his first known letter to one of the Rossettis (William, 17 November 1857), he wrote requesting a promised autograph of Ruskin and one of Dante Gabriel. He added that he had that day written to Orsini asking when he could meet William and Howell for dinner.[3] Howell could not have remained in London long: both *The Royalist* and William inform us that he became innocently involved with the Orsini conspiracy and was forced to flee England. As Mrs. Angeli heard the story from her father, Howell "had at one time innocently harboured what may have been some rather compromising properties of Orsini's" but had left the country before the explosion of the bomb which killed eight persons and injured many others (*PRT*, p. 41). According to Violet Hunt, Howell left England in January 1858 and did not return until 1864.

Here legend takes over. As Ford Madox Hueffer heard the story from Ford Madox Brown, his grandfather, who would have heard it from Howell: "At an early age Howell and a brother supported his mother and sisters by diving for the treasures of a sunken galleon that he had purchased. This proving not altogether a lucrative pursuit, he emigrated to Morocco, became the sheik of an Arab tribe, passed day and night in the saddle, and after having rendered various services to the Portuguese Government, returned to England and became—Mr. Ruskin's secretary."[4] The story strains credulity even though Howell seems to have had slight knowledge of the Arabic language, and indeed *The Royalist* account makes no mention of a sojourn in Morocco. It does contribute the information, however, that the reward for his services to the government was an appointment as "attaché to the Embassy at Rome" and that at some unspecified time "he was employed to construct the Porto and Badajos Railway." Somehow Howell had indeed acquired a knowledge of the Italian language that passed muster with the Rossettis, who would have detected any pretense, and if one reads the word "attaché" loosely, the attachment to the Embassy at Rome is at least plausible. So too with the employment "to construct the Porto and Badajos Railway" if one reads "to work on" the railway, for, as Mrs. Angeli says, "he referred not infrequently to his prowess as an engineer and displayed on occasion considerable knowledge" of the profession (*PRT*, p. 39).

The year or two following Howell's return to England are blank. He appears to have been living at 3 York Villas, Brixton, with his aunt, the mother of his future wife, Frances Catherine Howell, mentioned in an unprinted letter of 16 July 1867 to William Rossetti in connection with insuring his life for £400. A relative, one John Florence Maitland, who had sat to both Rossetti and Millais, according to Violet Hunt, introduced him to various artists, and as each new acquaintance found him engaging and presentable, he was introduced to still others—the Ros-

3. This letter, in the Texas collection, is not printed here but appears, with slight inaccuracies and initials only for a mention of Hogg, in *PRT*, pp. 49–50.
4. Hueffer, *Life of Ford Madox Brown*, p. 287; the author's later pen name was Ford Madox Ford.

settis, Martineau, Hunt, Boyce, Scott, Swinburne, Burne-Jones (who, according to Violet Hunt, was the first to call him "Owl"), William Morris, never one of his intimates, and so on. These contacts undoubtedly reinforced what was to become his exclusive interest in artists and the art world.

During Howell's absence from England, the original Pre-Raphaelite Brotherhood had virtually disintegrated. Gabriel, following his solitary exhibition in 1849, continued painting but never exhibited again. In 1861 he published his *Early Italian Poets, together with Dante's Vita Nuova*, helped the Gilchrists with their work on Blake, with whose poetry his own is "much more akin than to any of his own contemporaries," says Lady Mander (p. 81), sporadically wrote sonnets and such poems as "Jenny," engaged himself to Lizzie Siddal, and finally married her in 1860. Then followed the tragedy of her death and the burial of Gabriel's poems with her (17 February 1862).

In 1862 Gabriel established himself at 16 Cheyne Walk, Chelsea, which was to be his home, off and on, for the remainder of his life. Originally he and Swinburne were to occupy it jointly, with William Rossetti and George Meredith as tenants, but the arrangement broke down, with William seldom there, Meredith departing within a few months, and Swinburne leaving shortly later. Fanny Cornforth was established as housekeeper and mistress, thus formalizing a relationship that had begun as early as 1852 and was to continue almost to the end of Gabriel's life.

It was at 16 Cheyne Walk that Howell was to renew his acquaintance with Gabriel and by May 1865 was on friendly terms with him. Probably toward the end of 1865 Howell was installed in his post as secretary, almoner, and factotum to Ruskin, with whom, it will be remembered, he had been in correspondence while still in Darlington. At any rate on 25 January 1866 he was receiving instructions from Ruskin to answer a letter from a young lady who wished to quote from his published works. On the letter Ruskin wrote, "Dearest Owl,/ I've told the young lady to write & call on you. She may do whatever she likes, as far as I am concerned—except bother me./ Ever your affectionate/ JR."[5] Both salutation and conclusion suggest a degree of intimacy already developed. By 28 February 1868 he was addressing Howell as "My dearest wee owl" and signing himself "Ever your loving JR." There were invitations to dinner and to tea, letters to write, commissions to be carried out. But by 27 June 1867 Ruskin had heard of Howell's intention to marry his cousin Catherine and wrote to him immediately. After a paragraph on improvident marriages in general, he declared that "my judgment and my most earnest words are & must be wholly adverse to it." Evidently he learned that his advice was without effect, for on the flyleaf of a letter of instructions, written from Keswick on 7 July, he expressed once more his great concern:

> I am still sadly anxious about your marriage. I don't see the slightest real motive or need for it (as your cousin is *with* you—), and all marriages are improvident in comparative poverty—unless the peasant-ones in which the wife is a fellow worker and the children also as they get up. I beseech you not to *deceive* yourself and your cousin in this.

5. All quotations are from Ruskin's letters in the HRC, Texas. Most of them, and excerpts from others, have been published by Jay W. Claiborne in *Texas Studies in Literature and Language*, XV.3 (Fall 1973).

It _cannot_ be as you both think it will be. It _may_ be so very different. It seems to me that marriages of this kind are only justifiable when people cannot otherwise see or be near each other.

Perhaps only Ruskin could have written such a letter, and Howell, knowing Ruskin's own marital history as he surely did, could not have regarded him as an authority on marriage. Despite the warnings Charles Augustus Howell and Frances Catherine Howell were married on 21 August 1867 at St. Matthew's Church, Brixton, with one Bellenden Gyll, a family connection, as best man and Madox Brown's two daughters as bridesmaids. Also signing the register were the William Morrises, the Burne-Joneses, William and Christina Rossetti, and one Murray Howell, the black sheep of the family (a grandson of Sir John Murray, the Jacobite, who assumed the title upon the death of Sir John). Gabriel Rossetti ducked the occasion but sent a green dinner service, and of course Ruskin did not attend.

However much Ruskin may have disapproved of the marriage he at least accepted it gracefully. On 13 September he wrote to Howell, who was honeymooning at St. Leonards-on-Sea, "I am very thankful you are well and happy. Stay as long as you like, there's nothing for you to do here at present" and concluded with "love to you both from Joan and me." Two days later he was again urging Howell to stay longer, if he liked, and promised to send him £50 "for your wedding excursion." On the 20th he wrote thanking Howell for his "sweet letter" and enclosing the cheque. After the return of the newlyweds they were invited to dinner or to tea at various times. "I was really happy looking at you and Kate last night," he wrote on 1 November—"what a sweet, softly bright, face it is!"

The extent to which Ruskin had come to trust Howell is revealed by a letter of 31 March 1868 in which he enclosed an account from his legal agent, Rutter, "and have told him to call upon you instead of me and pay you the cheque tomorrow at _twelve_—Would you kindly if you cannot see him send a line to make an appointment as I have told him you are to have the entire superintendence of my affairs—" The cheque was less than he expected, and he instructed Howell to "go into the details of the matter with Rutter and ascertain clearly what I am to have and when?—" At the end he requested Howell to come to tea at half-past seven on the following day to "put my cheque book to rights & me. . . ."

By the middle of May, Ruskin was off in Dublin lecturing on "The Mystery of Life and Its Arts" and pursuing his love affair with Rose LaTouche. About the love affair he wrote to his "Dearest Owl" on 17 May, "I have a curious game to play. All is now at perfect peace between Rose and me,—but the mother came home a week ago and [is] in a rage which makes me almost fear for her sanity. . . ." Meanwhile he was cultivating "all the other branches of the family—cousins and aunts and the like, and I am winning them for friends as fast as can be. . . ." He was thinking of leasing a place about five miles away and, if successful, "the state of mind of mama will be in will be!!!—well—you know—there never _was_ such a game, since romance began!" So ecstatic was he that he forgot to sign the letter. But about two weeks later, though all was going well, he was returning home and was then going to spend a day or two with a friend in Kerry and work on Irish wild flowers.

In his diary for 10 November 1868 William Rossetti notes that Howell told

Gabriel that he had been sent over to Ireland by Ruskin "to try to get over the difficulties; and he says he disguised himself as a tramp or labourer to obtain an interview (with the young lady) whom he refrained from naming, but without effecting the desired change of sentiment." If this was not one of Howell's "tall tales," the mission is one that most certainly would have appealed to him. Mrs. Angeli (*PRT*, p. 212), disposed to believe the story, remarks that Howell "was in fact the first to mention the matter of Ruskin's love for Rosie LaTouche, and all that he said of it in private talk with Gabriel has since been confirmed and made public by Ruskin's biographers." But as with all poor Ruskin's love affairs the result was an unhappy one.

On 8 September Ruskin wrote to "Dearest Owl" from Abbeville, "You need never fear my being angry. I know, if anything ever goes wrong, it is not your fault, nor *has* anything gone wrong at all." Other letters from Abbeville dealt with his membership on the Committee for the Employment of the Destitute Poor and with his decision to "fit up" the Herne Hill house, the furnishing of which was to be turned over to Howell, Kate Howell, and Joanna, for his mineralogy collection. Other relatively unimportant letters followed till 28 February 1870 when he protested, "*I* angry with you! My dear—I was only utterly ashamed of myself!—because I have done nothing to help you in your sorrow."[6]

After two letters of March 1870, one with "best thanks for that lovely letter of nice flattery, it does one good," the other saying "How beautifully you have done my Greek vases for me—and Baccio Baldini—and everything," came the sudden and final letter terminating the connection. Ruskin was at Cowley, visiting the Rev. J. C. Hilliards from 29 September to 5 October, but he mistakenly dated his letter "4 September 1870."[7] It read:

> My dear Howell,
>
> Being absent from home, I was not able to answer by return of post.
>
> I have perhaps done you injustice. You will certainly do *me* injustice if you suppose that I wrote to Mr Howard with less pain than you feel in knowing that I so wrote. But I must decline giving you any reasons for writing to him; and you must think of me, or act, as, on that refusal, you see good.
>
> My letters last written to you, were—as all my letters are—and words, entirely true, with exception of such reserves as are necessary in order to keep faith with other persons. Their expression of confidence in you, and regard for you—was wholly sincere—though the confidence had been, even then, shaken by circumstances into which I will not now enter.
>
> That confidence has now been taken away; and it is assuredly as much my misfortune as yours that it has been so.
>
> —There is no need for your either showing me—or troubling yourself to write out, any accounts for my satisfaction—unless you have claims upon me of which I am not aware, beyond the amount of your salary up to this date.
>
> Will you kindly send me a note of that; and of the costs of the furnishing of the rooms at Herne Hill as far as these remain unpaid, and for what balance may be against me, I will immediately send you a cheque.

6. A reference to the death of Kate Howell's mother the preceding November.
7. The postmark is "Uxbridge Oc 4 70."

With respect to my conduct towards Mr Howard—you must accept this as my final answer,—but I am, in very true sorrow for both of us.

Always faithfully yours,
J. Ruskin

I shall be at Denmark Hill now—but must beg you to conduct the business now between us by correspondence only.

What the circumstances were into which Ruskin would not enter but which took away his confidence in Howell have forever remained a mystery. So many charges have been leveled at Howell that one hardly knows where to begin. Dr. Williamson, admittedly no friend of Howell, writes in his biography of Murray Marks: "Howell . . . was always ready to present his own relatives (his cousins) as fitting recipients for Ruskin's generosity, and was shy of giving detailed statements to Ruskin concerning the sums of money which from time to time passed through his hands."[8] If the inference is that Howell appropriated the money supposedly collected for the cousins to his own use, Violet Hunt at least discovered on a visit to Darlington years later that two cousins had lived there, one of whom died in a workhouse and the other "going on the streets."[9] As for Howell's being shy of giving Ruskin "detailed statements," we have seen that as late as November 1868 all the accounts were "highly satisfactory." Moreover, if the Ruskin accounts were in question, we should expect him to instruct Howell to take the accounts to his legal agents, Messrs. Rutter, for certification, but he seems to manifest indifference toward his own accounts.

If peculation indeed had anything to do with the dismissal, the important clue may lie in the name "Mr. Howard." To his dabbling in art and art objects, Howell had added the activity of house decoration, and on 1 January 1869 George Howard (later 9th Earl of Carlisle) wrote to Howell thanking him for his services in finding furniture for a new house and saying that it was an "immense advantage for us to have the help of your taste and wonderful skill in the discovery of pretty things" (John Rylands Library). Other transactions between the two related to Howell's acting as art adviser to Howard. As we know, Howell was indefatigable in his assistance to friends and acquaintances, whether he received a commission or not. These relationships often ended in a painful pattern—requests for repayment of money lent or pictures in Howell's possession that remained unsold. So with Howard as letters in the John Rylands Library reveal, but whether he complained to Ruskin and convinced him that Howell was less than honest in various transactions is matter for speculation only; nevertheless this is a possibility inasmuch as Howell's accounts with Ruskin do not appear to be in question. Howell never lacked for enemies, and it is possible that someone, whether Howard or not, had cast suspicion upon the existence of the impoverished cousins or upon other of Howell's financial affairs. All that can be said is that, inasmuch as Ruskin did not demand a strict accounting of the Herne Hill accounts, the loss of confidence does not *appear* to have been the result of Howell's handling of Ruskin's money,

8. Williamson, *Murray Marks and His Friends—A Tribute of Regard*, p. 116.
9. Letter from Mrs. Emma Summers-Gill, 25 April 1923, to Violet Hunt, repeating what Violet had written to her (Cornell). All references to Violet Hunt are from the papers in the Cornell Library.

and certainly as late as 16 March 1870 he had written to Howell in the friendliest possible manner to inquire how he was.

There is another side of the story—Howell's. The Pennells heard it from a Mrs. Jenner, a friend of Miss Alice Chambers (executrix of Howell's estate), and both of the Jenners had known Howell well and believed in him. According to Mrs. Jenner:

> He was the soul of honour, generosity itself, the most amusing of men. Because of some entanglement with a woman—he swore never to tell the story—he got into all his troubles. It was the reason of his misunderstanding with Ruskin. Honour forbade him to tell the story and he left Ruskin with his honesty in question. . . . Though he wouldn't give the facts of his entanglement to Ruskin to clear himself, he confided them to Mr. and Mrs. Jenner, who cannot break confidence. (*Whistler Journal*, ed. E. R. & J. Pennell, p. 68)

Howell, says Whistler (p. 59), "was like a great Portuguese cock of the poultry yard: hens were always clucking about him—his wife 'Kitty,' and Miss Alice Chambers, and Rosa Corder." Though apparently a devoted husband and father, Howell was, like many of his artist associates, a less than faithful husband. Several women besides Kitty figure in his life, and in addition to those mentioned by Whistler, the elusive Clara Vaughan was at the time of his break with Ruskin reputed to be his mistress. Had knowledge of this liaison reached Ruskin, it may have been in his mind when he wrote that "the confidence had been, even then, shaken by circumstances into which I will not now enter." But Mrs. Jenner speaks of Howell's leaving Ruskin "with his honesty in question." Were the liaison solely the issue, it would seem to have been more a question of morality than of honesty. And there, in the absence of further evidence, the matter must rest.

All while in the service of Ruskin, as we have seen, Howell was carrying on a sideline as dealer in art, art objects, and house decoration. For a time he and Kitty lived with Kitty's mother in Brixton before moving to Northend Grove, Northend, Fulham, in May 1868 (letter in HRC, Texas). Thereafter it was Howell's custom in houses that he leased to decorate rooms to show to potential customers, who might engage him to duplicate his "blue" room, his "gold" room, his "white" room, or whatever. Pictures and art objects in the rooms might also be for sale, although some would not be. It was from his own house, then, that Howell carried on such activities. We hear from William Rossetti (*RP*, 1862–70, p. 339) that in December 1868 Howell was "projecting" an Arts Company, with Murray Marks as business man, but the plan fell through, presumably because Marks refused to put up all of the capital. Later, as the letters printed here reveal, he was associated with W. Hutton Brayshay and John Aldam Heaton, based in Bradford, but mostly he operated alone. He sold works of Rossetti, of course, Madox Brown, Sandys, Burne-Jones, Whistler (later), and according to his own statement established the market for G. F. Watts's pictures.

Burne-Jones—the name gives pause. If one had only Lady Burne-Jones's *Memorials* to depend upon, one would conclude that the association was brief, casual, and alien in nature. The opposite is true, although certainly it ended, as did so many of Howell's relationships, in bitter enmity. Writing of a dinner party

at the Madox Browns's which included the French artist Legros, Swinburne, the two Morrises, Christina and Dante Gabriel Rossetti, with others, Lady Burne-Jones concluded, "And on this day of union and reunion of friends there was one who had come amongst us in friend's clothing, but inwardly he was a stranger to all that our life meant. This was Mr. Howell" (I.294).

So Howell is polished off in two sentences. Yet in the Janet Camp Troxell Collection in Princeton University Library there are more than fifty endearing letters of Burne-Jones, mostly undated but covering the years 1865–71, which reveal that until the end the greatest possible intimacy existed between the two men. Throughout, until the last letter, Howell is "Dear Owl," "Little Owl," "Pretty Little (wl) ," "My pretty owl," "My sweet little owl," "Pretty soft little (wl) ," etc. He wants "dreadfully" to see Howell; he needs some cheap turkey carpets and asks Howell to find them and some roses to paint; he sends a list of his engagements and promises to do so each week so that Howell will not come to visit and find him gone; he is "desolate" because Howell is away; he yearns for Howell; he hates "everybody who doesn't love" Howell; and so on. Then abruptly the friendship came to an end. On 8 February 1871 he wrote to Howell that he wants their "money affairs settled now." If Howell cannot come up with the £200 due him, at least they might come to some arrangement about work that Howell has of his unsold, and he signs himself "Yours truly, E.B.J."

Understandably Gabriel Rossetti found himself caught in the middle between two friends. As he wrote to William in answer to a question about his relations with Howell: "They are in a rather awkward phase, between you and me. I have no cause to complain of him myself, but I have lately found that Ned Jones is so extremely hurt and even irritated at my keeping up any acquaintance with him, as he (Jones) conceives himself, and perhaps justly, greatly injured by him, that I don't know how to act and wish to keep as clear of H. as may be, J. being so much the older and more valued friend of the two. The predicament is an awkward one" (D-W, III.1011). "Greatly injured" does not seem to be a phrase applicable to financial transactions or even unpaid debts, and indeed Mrs. Angeli (p. 166) says that "Jones himself declared emphatically in a letter to Gabriel that his detestation of Howell was not dependent upon 'shiftiness in money matters or looseness of tongue'. . . ."

Whistler offers another explanation, which no doubt derived from Howell: "Burne-Jones was painting and drawing one of the Greek colony and there were dreadful times. But Howell managed to bring her and Mrs. Burne-Jones together, and they were friendly, and all was pleasant. But the first time 'Ned' saw the two together, he fainted, and in falling struck his head against the mantel. 'And,' said Howell, with his last convincing touch—the touch of realism only he could have invented—'whenever it's damp, he feels it here,' pointing to his temples" (*Journal*, p. 63).

Mrs. Angeli concedes that "there was some talk going on connecting the name of Burne-Jones with that of a certain Greek lady, and, considering Jones's blameless character and the great mutual devotion of himself and his wife, the matter was hushed up—though in fact there seems to have been little to hush!" Though Burne-Jones's friends knew something of "this passing attachment," Mrs. Angeli thought that "most of the gossip was among the Greek colony," from which she

first heard the story, and "that Howell served as a useful scapegoat for both the gossipers and their victims, and that Burne-Jones and his wife came to believe that he had played a mischievous and treacherous part." The lady, unnamed by Mrs. Angeli, was a Mrs. Mary Zambaco ("M.Z.").[10]

Born Mary Cassavetti in Athens in 1843, a granddaughter of Constantine Ionides, Mary had married Dr. Demetrius Zambaco in Paris and had borne him two children in 1864 and 1865. But in 1866 she abandoned him and came with her two children to live with her mother in London. "Warmth and sexual generosity were the note of Mary's beauty," says Mrs. Fitzgerald, with ". . . her glorious red hair and almost phosphorescent white skin" (p. 113). Soon Burne-Jones was painting her and making innumerable drawings of her. He was deeply involved with her as early as 1866–67 and in an undated letter of 1869 said of the affair to Gabriel, "I believed it to be all my future life." Twenty years or more after the affair had ended he could write to Olive Maxse, "I have been a bad man and am sorry for it, but not sorry enough to try to be a good one." Either Mrs. Angeli did not know or chose to ignore what was going on when she speaks of Burne-Jones's "blameless character," for it is clear that it was a passionate love affair on both sides. Matters came to a climax early in January 1869, and in a private note to Madox Brown (D-W., II.685) Rossetti described what had happened:

> She [M.Z.] provided herself with laudanum for two at least, and insisted on their winding up matters in Lord Holland's Lane. Ned didn't see it, when she tried to drown herself in the water in front of Browning's house &c—bobbies collaring Ned who was rolling with her on the stones to prevent it, and God knows what else.

Apparently Burne-Jones was attempting to break off the affair, and he and William Morris set off for Rome, "leaving the Greek damsel beating up the quarters of all his friends for him and howling like Cassandra," according to Gabriel. Significantly the year 1869 is blank in Lady Burne-Jones's *Memorials*, but at one time, possibly following the "climax" in Lord Holland's Lane, she took the children to Oxford and lived there in lodgings for an unknown time. Details are lacking, but the affair between Burne-Jones and Mary Zambaco apparently continued, as Mrs. Fitzgerald states that "1872 was the year of what were almost his last studies of M.Z." (p. 146).

It is difficult to assess Howell's blame, if any, in all this. It is conceivable but hardly likely, in view of the numerous pictures and drawings in which M.Z. served as a model for Burne-Jones, that he was instrumental in Burne-Jones's seeing his wife and M.Z. together for the first time, but considering what happened over a period of years Howell's part would seem to have been minor indeed. Moreover, to Howell, the Portuguese cock with his flock of hens, nothing could have been more natural and innocuous than to bring the two women together. Years later (17 November 1875) he wrote to Rossetti, "And as to Ned Jones I wish to God I had never known him at all. He was my friend and worshipper as long as I rowed in with him, and a most cowardly enemy the moment I struck, trying night and day to ruin me, and doing all that whores do" (Letter

10. In much of what follows I am indebted to Fitzgerald's *Edward Burne-Jones*, the fullest account of the B.-J. – M.Z. affair, though it does not tell as much as one would like to know.

438). The word *struck* suggests something more than innocent blundering; if more is meant, just how he "struck"—unless deliberately bringing the two women together with the intention of injuring Jones—and what his motive was must remain another of the numerous mysteries attached to Howell.

Although it is known that by 1868 Mrs. Morris ("Janey") had become Gabriel Rossetti's favorite model, the letters printed here reveal that as early as August 1868 he was sending letters to Howell to be secretly delivered to her, and in 1872 he wrote of her as "the one indispensable" person in his life. By 1868 he was forty, was troubled by insomnia and the hydrocele that required surgical treatment from time to time, and, even worse for an artist, began to fear loss of his eyesight. Rest being prescribed by oculists, he and Howell went in August to visit his patron Frederick Leyland at Speke Hall, where Howell claimed to have nursed him back to health (Letter 135). Still unable to work, however, Gabriel accepted the invitation of William Bell Scott's friend Alice Boyd to spend some weeks at Penkill Castle, Ayrshire. Howell's "cure" must have been temporary, for Rossetti's health continued to be bad, he was drinking whiskey excessively, and he talked of suicide. Yet it was at Penkill that his interest in his poetry revived, and upon his return to London William reported that he was busy "looking up his poems of old days" and even writing some new ones (Doughty, p. 367). His memory was inadequate to the task of reproducing all of the buried poems, however, and earlier drafts of many of them were non-existent, as he told Scott of the poem "Jenny." Lady Mander (p. 128) thinks that it was "the Penkill household" that first put the idea of recovering the buried poems into Gabriel's head; but writing to Howell on the eve of a second visit to Penkill, Gabriel said, "I feel disposed, if practicable, by your friendly aid, to go in for the recovery of my poems if possible, as you proposed some time ago. Only I should have to beg *absolute* secrecy to *everyone*, as the matter ought really not to be talked about." In return he promised Howell "the swellest drawing conceivable, or if you like paint the portrait of Kitty" (D-W, II.712).

The story of the exhumation of the poems has been told many times, notably by Mrs. Troxell in *Three Rossettis*, and need not be repeated here. Suffice it to say that the deed was done, that Howell stage-managed it, and that it constituted a sizable debt in Howell's favor. Small wonder, then, that Gabriel, though uncomfortable, could not make up his mind to cast off Howell entirely despite the disfavor of Burne-Jones. As we have seen, however, he did hold somewhat aloof from Howell, though it should be added that Howell was ill, in London and in the country, throughout most of 1871 and that his illness may have accounted for a part of the infrequency of relationship between the two and the paucity of letters during that time.

Howell must have met Whistler at 16 Cheyne Walk some time in the mid sixties, and perhaps none of the Pre-Raphaelite circle and their friends were so congenial to Howell, or in some respects so like him, as Whistler. No one else had such quick wit, so little regard for strict truth, or such great ingenuity in inventing tall tales that were so delightful in the telling and the hearing. Of no one did Whistler talk so much to the Pennells as of Howell—"the wonderful man, the genius, the superb liar, the Gil-Blas, Robinson-Crusoe hero out of his proper time, the creature of top-boots and plumes—splendidly flamboyant" (*Journal*, p. 58). In the early days of the friendship, after the Greaves brothers had taught

11

Whistler to row, they would pull up the Thames to Brixton and breakfast with Howell (*Journal*, p. 117). The *Whistler Journal* is never more interesting than when Whistler was talking of the wonderful Portuguese. "Howell," say the Pennells, "was of most use to Whistler during the difficulties that ended in bankruptcy, taking debts upon his own shoulders, signing notes, accepting responsibilities." With access to the bankruptcy papers, they add, "It is only fair to say that they show Howell in a more favourable light than that in which he is usually seen" (*Journal*, p. 65). Since Howell's acceptances of two bills in the sum of £450 for the benefit of Whistler are in the Glasgow collection, this story may be accepted as true.

It was Howell who set Whistler to etching again. The artist was living in Lindsey Row, looking out the window one day, when he saw Howell and Rosa Corder passing by. He hailed them, they came in, and in the course of conversation—quite possibly about how hard up Whistler was—Howell said, "Why you have etched many plates, haven't you? You must get them out, you must print them, you must let me see them—there's gold waiting. And you have the press." Protests that the press was rusty were unavailing. "And the next morning," Whistler concluded, "there we all were, Rosa Corder too, and Howell pulling at the wheels, and there were basins of water and paper being damped, and prints being dried, and then Howell was grinding more ink, and with the plates under my fingers, I felt all the old love of it come back" (*Journal*, p. 59). Then comes the characteristic postscript when Whistler adds: "Howell profited, of course. But he was so superb. One evening we left a pile of eleven prints, just pulled, and the next morning only five were there. 'It's very strange,' Howell said, 'we must have a search. No one could have taken them but me, and that you know is impossible.'"

It is hard to determine how much to accept of one legendary storyteller's tales of another legendary storyteller. The story of the missing prints sounds very much like a variation of a story told by the engraver T. R. Way half a dozen years later. "Howell used to come to Wellington Street with Whistler almost always for a while and, watching the proofs come off the press, would say, 'This is for me, Whistler, and this, and this—' and Whistler never objected. And Way seemed to think it was not much in return for all Howell did for Whistler" (*Whistler Journal*, p. 66). In the University of Glasgow Whistler Collection there is a list of etchings without date, in Howell's hand, headed "In my collection belonging to Whistler." Another list with various dates in October and November 1877 is headed "Due to J. A. McNeill Whistler." As the date for the Whistler vs. Ruskin trial approached, a letter of 12 November 1878 from Whistler in the Glasgow Collection asks Howell to help Rose, Whistler's attorney, map out the plan of battle. The story is well-known that after the verdict, with its farthing in damages, Howell lamented that he had not been called as a witness and so have won the case. "Yes," retorted Whistler, "had you been a witness you would have won and we would all have been in Newgate" (*Journal*, p. 63).

Another record in the Glasgow Collection consists of an agreement in Howell's hand, except for Whistler's signature, assigning to Howell the copyright and all his interest in the engraving of the portrait of his mother and that of Rosa Corder in return for twenty-five artist's proofs of each. Just before Whistler's leaving for Venice, in September 1878, Howell found his friend concerned about a Japanese cabinet which Sydney Morse had agreed to purchase. Howell, typically, offered

12

to attend to the matter and had the cabinet removed to his apartment, then in Southampton Row. Subsequently he pawned the cabinet, gave the pawnbroker the top of it as a pledge and the lower part to Mr. Morse, and promised each the missing part as soon as it was returned from being repaired. So, according to the story as recounted by Whistler in *The Owl and the Cabinet* (1882), Howell played off pawnbroker and purchaser against one another with various excuses for three years. Whistler, unaware of this—at least in the beginning—in a letter from Venice (23 December 1878, Glasgow Collection) was calling Howell "my only true friend." But he changed his mind upon returning to London when he found the headpiece of the cabinet in the pawn shop, redeemed it, and subsequently advertised Howell's duplicity to the world.

I think that Mrs. Angeli's belief that the Whistler-Howell friendship survived the incident of the cabinet is mistaken. Whistler in Venice could not have known the whole story and did not learn of Howell's tergiversations until his return, and then apparently by accident. Afterward by his own account he had "the fiendish pleasure of making Howell lie about it over and over again for the past six months —bringing with me others to listen—carrying with me all the while signed papers [by the pawnbroker] to expose the whole—until even Oscar [Wilde] said it was 'really too brutal'" (*PRT*, p. 186). Even before *The Owl and the Cabinet* Whistler had printed *The Paddon Papers*, the sole purpose of which was to convict Howell of telling a lie about visiting Lord Beaconsfield at Hughenden. Howell's ingenious explanation hardly holds water, but Whistler was at pains to prove that Howell had never talked to Disraeli in his life. One trouble with liars is that nobody believes them when they are telling any part of the truth. In a letter of 2 May 1873 (HRC; printed *PRT*, p. 125) Howell wrote to Madox Brown apropos of a project to do something for the family of an artist who had died destitute: "Dizzy would I am sure give me something on the Civil List. . . . It was he who gave me the 95 yearly for Cruikshank and it was all done in five minutes in his little room and he said 'hang it of course, but there is no more than £95 to give, just now, and it should be more.'" Though this has the ring of authenticity it has only Howell's word to support it. But the Glasgow Collection contains a list of Whistler's etchings sold by Howell, more than 100 in all, one of which was to Disraeli. As the list was not made by Howell for the benefit of future biographers, it is at least presumptive evidence that Howell encountered Disraeli at the time of the sale.

Was Whistler tired of Howell or did he feel that Howell had compromised him or played him false with a friend? "Whistler never broke off with him really," say the Pennells, "though he did not let Howell attend to things in the end—but went with him and stayed at Paddon's, laughing at him and his adventures to his face, much to his discomfiture" (*Journal*, p. 62). It was Howell's habit, as a collector of autographs, to paste many of the letters he received from artists and men of letters in letter-books. When he became hard up, as so frequently happened, and he had nothing better to pawn, he would pawn some of these letter-books, no doubt with the intention of redeeming them in better days. So with the Whistler letter-books in the Glasgow Collection. In a note signed by Miss E. Birnie Philip, Whistler's sister-in-law, she says that the letter-books were pawned by Howell at a shop in King's Road, Chelsea, and that the pawnbroker subsequently communicated with Whistler, who redeemed them and destroyed such letters as

he did not wish to keep. (Alice Chambers tells the same story about the letter-books in general, but names the pawnbroker as one Coalford, whose shop was in the Strand.)

It would have been also through Rossetti at 16 Cheyne Walk that Howell first encountered Swinburne. Mrs. Angeli (*PRT*, pp. 167–82) chronicles at length the relationship between the two which developed into an intimacy that Swinburne lived to regret. During the friendship, however, numerous letters passed between them, and eighteen of Howell's letters to Swinburne—intimate, indiscreet missives written to a kindred spirit, with naughty references to flagellation and to the works of Marquis de Sade—have been preserved and are published in Cecil Lang's *Swinburne Letters*. That Howell was a sincere, if sometimes loose-tongued, friend to Swinburne cannot, I think, be doubted. Such records as exist, for example, show that he played the part of friend to Swinburne in the tangled relations between the poet and the publishers Hotten and Moxon and contradict a scurrilous story in Dr. Williamson (pp. 147–49).

According to Dr. Williamson, Howell "committed Swinburne to the 'oral contract' with Hotten" which "bound Swinburne to put everything he wrote into Hotten's hands and to accept such arrangements as he chose to make. The discovery of this contract, by which Howell was to have been the gainer, caused the rupture between Howell and Swinburne and led the latter to request Theodore Watts to act for him." This is in part inaccurate. There was no possible way in which Howell could have been gainer; moreover this account is not only contradicted by Howell's letter to Hotten, which is printed by Mrs. Angeli (*PRT*, p. 169), but also by a letter which Howell wrote to Swinburne on 2 October 1877 (British Library). Written in the friendliest possible terms, it thanks Swinburne for "this kind little note from you," indulges in some of the old bawdry that characterized the relationship between the two, and alludes to "the birth of my most bright and respectable daughter, who now keeps me from any thing that might bring a blush on that young cheek." Rosalind Howell was born earlier, on 20 March 1877, and was about to be christened. "Kitty and I both join in an earnest request that you will let me stand for you as her godfather unless you would like to come yourself," the letter continues. ". . . Say 'yes'—but only on condition that you give her nothing beyond a copy of your first book written when you were a kid, and let me bring her to see you." He signed himself "Your most affectionate /Charles A. Howell."

So much for Dr. Williamson. Swinburne declined the invitation, saying that he would "be delighted to make the acquaintance of the young lady you mention; but as for the godfatherhood, you must remember that sponsorship is hardly in my line. . . . None the less I am honoured and flattered by the invitation" (*PRT*, pp. 178–79). Apparently Whistler agreed to stand as godfather, however, for on 20 March 1878 he wrote a letter to Rosalind, whom he addressed as "My dear Godchild," wishing her "very many happy returns on [her] first birthday" and excusing himself for not sending "gold forks and spoons because of an impecuniosity attaching to your Godfather which he fervently hopes you may never experience" (Glasgow).

Already Howell and Swinburne had drifted apart, although as has been seen, on terms of friendship. But on 15 October 1879 Swinburne wrote to Edmund Gosse that Howell, "who was once my friend and is yet my debtor habitually

[amuses] mixed company of total strangers by obscene false anecdotes about my private eccentricities of indecent indulgence as exhibited in real or imaginary lupanaria" (*PRT*, p. 179). The date is significant: in the previous month Swinburne had become an inmate of The Pines, and the inference is irresistible that it was Watts who had poisoned Swinburne's mind against his old friend by relaying the story to Swinburne. That is not to say that there may not be at least a kernel of truth in the story, however exaggerated and slanted against Howell. "Sigma" (Julian Osgood Field) reports in *Personalia* (p. 203) that years earlier Howell had entertained the male guests at a dinner party (after the ladies had withdrawn) with "various erotic passages from Swinburne," and we know Howell to have been an irrepressible teller of tales.

Worse followed. At some unknown time Howell, hard pressed for money, pawned the letters which Swinburne had written to him and which were certainly intended for no other eyes. No doubt he expected to redeem them at some later time and meant no harm to Swinburne, but that does not excuse him. In December 1885 an antiquarian bookseller named George Redway came into possession of the letters and "wrote to the poet to advise him that some of these were of such a character as to make it probable that their writer would welcome an opportunity of regaining possession of them" and placed "himself at Swinburne's disposal in this respect. . . ."[11] In exchange for the letters Swinburne made over to Redway *A Word for the Navy*. One would expect Swinburne to have destroyed the letters immediately, but in point of fact Watts, who acted as Swinburne's agent, retained possession of them himself. As T. J. Wise assured Mrs. Angeli (*PRT*, p. 181), Swinburne "was not yet cold in his grave" before Watts (now Watts-Dunton) rushed over to Wise and sold them with other Swinburne papers to him. That is how they came to repose in the British Library. Without exculpating Howell, Mrs. Angeli's judgment was that "the person most deserving lapidation" was not Howell, Redway, nor even Wise, but the "hero of friendship. . . . What Mr. Redway was accused of selling to the rightful owner for a Song, Theodore Watts sold for full thirty pieces of gold" (p. 182). Swinburne, understandably wrathful at the time of the Redway transaction, then penned that venomous couplet:

> The foulest soul that lived stinks here no more.
> The stench of Hell is fouler than before.

The final artist for whom there is evidence that Howell was actively engaged in trying to market his wares was Frederick Sandys. Originally *Sands*, he was born at Norwich, the son of a dyer. Less is perhaps known of him than of any artist of comparable stature, although he is frequently mentioned in connection with the Pre-Raphaelites and their friends, possibly because of his amusing satire of them in *Sir Isambras at the Ford*, showing Rossetti, Millais, and Hunt crossing the ford, as the Immortals wait to welcome them, mounted on a donkey branded *J.R. Oxon* [Ruskin]. Largely self-taught, Sandys is yet frequently praised as a consummate draftsman. Apart from this facility, which is apparent in his works, he seems to be remembered chiefly for his impecuniosity and for "his matrimonial arrangements," which Dr. Williamson (p. 105) says "were difficult to

11. John Carter and Graham Pollard, *The Firm of Charles Ottley, Landon & Co.* (London, 1948), p. 32.

explain." Insofar as the present letters show, however, he was living with a Miss (Mary) Clive, an actress of sorts who was sometimes addressed by Rossetti as "Mrs. Sandys." Sandys himself usually referred to her as "the little girl."

The John Rylands Library possesses a large number of letters from Sandys to Howell which concern Howell's efforts to sell Sandys's pictures, presumably on commission, and from time to time appeals by Sandys for loans or advances. So hard up had Sandys been in 1866–67 that he resided with Rossetti at 16 Cheyne Walk for almost a year and a quarter, according to William Rossetti (FL, I.256). At some time he had been in debtor's prison, and in 1877 he was bankrupt. The letters to Howell, dating from at least 1869 to 1887, are for the most part a litany of requests for money. Sometimes Sandys was too depressed to work, at other times he was stuck in hotels that he could not leave because he was unable to pay his bill, once he was grateful to Howell for getting £85 "for the little girl," and so on.

From time to time he was in his native Norwich, where he had a sister and parents and where sometimes "the little girl" came. At Christmas he would occasionally send Norwich turkeys to such friends as Howell and George Meredith, but not infrequently he was stuck in Norwich, as elsewhere, and unable to return to London for lack of funds. There were importunate pleas to Howell to sell this or that picture—"What do the rascals mean by not buying pictures? They are created for no other purpose"—or for money due him or for loans that he needed desperately. The Rylands correspondence reveals that in 1882 Sandys was debtor to Howell to the extent of £106/18/0, which was mostly repaid by credit of £105 on 2 July 1882 for the portrait of Rosalind Blanche Howell, then five years of age. He had earlier made a drawing of Kate Howell (1873–74). Nothing in the correspondence confirms Howell's statement to Rossetti (Letter 443) that he had sold three of Sandys's pictures for £1000 each, but C. E. Fry's correspondence with Rossetti (PRT, p. 111) reveals that he had at least obtained for Sandys an advance of £1000 from Fry on a picture to be painted by Sandys.

So much for Howell's early relations with Gabriel Rossetti and his relations with other artists and with Swinburne. Were it not for an event that had its beginning in 1871 and was to be of great importance to both Howell and Rossetti, especially in 1872–74, the correspondence between Howell and Rossetti would be of slight interest: this event was the joint tenancy of Kelmscott Manor by Rossetti and William Morris. As William Rossetti says (FL, I.323), Kelmscott had the advantage of being "an out-of-the-way place of great seclusion . . . necessary for [Rossetti's] health and comfort, and for the avoidance of some of the worry and harass" of London. But Jack Lindsay believes "that a strong part of the motive in quest for a country house was the desire to find somewhere where Janey and Rossetti could live together without having the eyes of London upon them. How far this was admitted openly among the three of them we cannot say, but at some point Janey or Rossetti must have made the suggestion."[12] This last is speculation, but it is a matter of record that Janey moved to Kelmscott early in July 1871, that Morris left London on 6 July for Iceland, and that Rossetti moved to Kelmscott on 12 July. "By August," says Lindsay (p. 175), "[Rossetti] had thirty more sonnets for his House of Life, expressing his daily contact with Janey in their

12. William Morris/His Life and Work, p. 174.

love-idyll." This "love-idyll" continued until September, when Morris returned from Iceland, with Rossetti painting Janey and writing sonnets inspired by her.[13] Gabriel himself lingered on at Kelmscott until early October.

Rossetti's *Poems* had appeared earlier in April 1870 and had gone through six editions before the end of the year. He had assured himself in advance of favorable notices of the book by various friends and supporters, including the reluctant William Morris; and though their reviews were followed by some less enthusiastic ones by the professional critics, Rossetti might now, with reason, regard himself as an eminent poet as well as painter. He returned from Kelmscott in October 1871, however, to be greeted by Robert Buchanan's virulent attack upon him in "The Fleshly School of Poetry—D. G. Rossetti," an article in the October issue of the *Contemporary Review*. What followed has been amply related by Rossetti's biographers, and all that need be said here is that, aside from his natural anger at what was at first an anonymous attack, Rossetti seems to have feared that critics might read into the poems his relationship with Janey Morris.

The Buchanan attack, anger, worry, insomnia, and the increased use of chloral produced in Rossetti a complete breakdown. William Rossetti calls 2 June 1872 "One of the most miserable days of my life. . ." (*FL*, I.307). He spent the entire day with his brother at 16 Cheyne Walk, and "from his wild way of talking— about conspiracies and what not—I was astounded to perceive that he was, past question, not entirely sane."[14] Following an unsuccessful suicide attempt a few days later, he was packed off to Urrard House, Perthshire (lent by William Graham), in the company of Madox Brown and George Hake, son of Rossetti's friend Dr. Thomas Gordon Hake. By late September, however, he was sufficiently recovered to return to Kelmscott.

What William Rossetti does not say, in speaking of the advantages of Kelmscott, is that it offered, from time to time, the presence of the one person indispensable to him—Janey Morris. With her there, as William does not mention, he "had resumed painting with all zest and energy—equal at least to what had marked him in any earlier years." But isolated as he was, an agent was almost necessary to him to find new buyers and to relieve him of the burden of negotiations with old patrons such as Leyland and Graham. Howell, the obvious choice, as these letters show, readily agreed to be that agent. The letters printed here document that relationship as fully as between any other artist and his agent. As a salesman, says William Rossetti (*FL*, I.324), "Howell was unsurpassable; and he achieved for Rossetti, with ease and also with much ingenious planning, many a stroke of most excellent business, such as other men . . . would have found arduous or impossible."

Lindsay is responsible for further speculation concerning Rossetti during the Kelmscott years. He quotes Hall Caine (p. 205) as informing G. B. Shaw that Rossetti, toward the end of his life, had confessed that "he had (as the result of a horrible accident) been impotent for many years." (Lindsay's authority is Paul Meier, p. 741, n.4, citing a British Library letter of 24 September 1928 from Caine

13. For an account of Rossetti and Janey at Kelmscott at this time, see Doughty, *A Victorian Romantic/Dante Gabriel Rossetti*, pp. 469–85.

14. For answers to the questions "What happened to DGR at this juncture, why it happened, and what were the consequences?" consult Fredeman, *Prelude to the Last Decade: Dante Gabriel Rossetti in the Summer of 1872*.

to Shaw in which Rossetti is also quoted as saying that Fanny Cornforth had formerly been his mistress but had long since ceased to be so.) Lindsay accepts the statement about the impotence, with the exception of the "horrible accident," for which there is no evidence, and assigns the year 1872 as "the most likely time" for it. This, however, conflicts with his statement about the motive for leasing Kelmscott, and I must doubt 1872 as the time of the impotence, if indeed Caine's statement is to be believed at all. I find it impossible to picture Rossetti as a Platonic lover during the Kelmscott period, and both the Sonnets and Rossetti's letters to Janey strengthen my view.[15]

But to return to Howell as agent for Rossetti. It is surprising, I think, that an ill-defined business arrangement based upon friendship and certain talents that each possessed of great use to the other should have lasted as long as it did—almost two years after Rossetti's return to London in July 1874. It is possible to have great sympathy for the vexations that each caused the other. On the one hand Rossetti expected Howell to be at his beck and call to run countless errands —to procure watches or jewelry to be given Janey or ornaments to be painted or furniture for Kelmscott or to see to the sale and framing and delivery of pictures, or . . . or . . . or. While at Kelmscott, Rossetti wrote several hundred letters and postcards to Howell, to each of which he expected a prompt reply, though Howell may have been on a business trip to Manchester or Bradford or had other business of his own to attend to when Rossetti's instructions arrived. Most galling of all, however, was Rossetti's arrogant expectation that Howell should obtain commissions for pictures unpainted and from purchasers who could not be shown any of his work unless they were certain buyers, with Howell's commission often to be paid in drawings that were undelivered.

It is impossible to unravel completely the tangled skein of the business transactions between the artist and the agent, but it is clear that Howell could not subsist on receipts from the sale of Rossetti's pictures alone. Whether because of self-distrust, the expenditure of great care on his paintings as he himself said, illness combined with periods of indolence whiled away with Janey Morris, or whatever, Rossetti certainly did not turn out pictures expeditiously. And on his side Howell made promises that he could not fulfill, aroused expectations that ended in disappointment, sometimes neglected to attend to requests that were really demands from Rossetti, and was at least once culpable in failing to meet a bill that Rossetti had accepted. The end came early in 1876 when Rossetti, who had abandoned Kelmscott in July, 1874, had less need of Howell and could afford to be less tolerant of his deficiencies. Yet, concludes William Rossetti (*FL*, I.324), "I will here say with emphasis that my brother, long after he and Howell had parted company, assured me more than once that he had materially benefited in purse from Howell's exertions, had at no other time experienced equal facilities in disposing of his works, and had never been conscious of the least unfairness toward himself in the dealings of the highly resourceful Anglo-Portuguese." This is a little more than Rossetti himself was saying at the time of the break, but per-

15. See Bryson (ed.) in association with Troxell, *Dante Gabriel Rossetti and Jane Morris/Their Correspondence*, especially Rossetti's letters of 30 July 1869, [4 February 1870], and [18 (?) February 1870]. There is a break of five years in the correspondence from [7 March 1870] to [10 March 1875]. For me, at least, the later letters have the tone of a former lover who has remained a devoted friend.

haps William balances accounts properly by adding, "As my brother (though in some ways extremely heedless and lax in spending money) was always keenly alive to his own interests in acquiring it, and not at all the man to be long hoodwinked by anybody, and was in his later years more duly suspicious of various persons, this testimony to the fair dealing of Mr. Howell—considerably decried in life and after death—should in justice not be lost sight of."

It is pleasant to be able to record that as Rossetti was near death at Birchington-on-Sea in 1882, Howell—never lacking in effrontery or in affection for Rossetti—dropped in on him and was received with the utmost cordiality.

"And what are you doing now, Charles?" said Rossetti.

"Buying horses for the King of Portugal," said the soldier of fortune, and then Rossetti laughed until he nearly rolled out of his seat.[16]

Howell "stayed all day, telling stories, veracious and apocryphal, of nearly everybody known to us in the world. . . ." Despite Rossetti's feebleness, Caine continued, "the visit of this unaccountable being did him good, and he laughed all evening after the man had gone, talking of his adventures of various kinds, as well as telling his familiar stories over again." Yet "all this, however, was but the flickering of the lamp that was slowly dying out" (p. 240).

Howell and Kate sent William a telegram of condolence, and writing to him on 25 April from Woodlands, Red Hill (the home of Wreford Paddon), Howell said, "I would have written before but for the considerations of your sadness, and the heaviness of my own heart. I have just returned from my little place [Selsey], and the sea there was as sad to me as I found it at Birchington." He offered to place at William's disposal "any sum I may be able to afford towards lightening what I hear may be a heavy burden on your shoulders with but a small estate to ease it," mentioned books and a chest of drawers given Gabriel by Kate that he would like to buy, and offered his own buyers for the various sketches and drawings—all without profit to himself. If it was true that William had a cast of Gabriel's head and hand, he asked to be allowed to buy five copies—one for himself, one for Leyland, one for the Academy at Lisbon, one for Sandys, and "one for a very dear friend of mine," undoubtedly Rosa Corder.

In the end Howell made private purchases of various items—seven watercolours by Lizzy, two drawings by Fuseli, some silks, and some books. On 12 May he informed William that the Italian colony in London proposed some memorial to Gabriel and had asked him to head the movement. Subsequently at the Tudor House sale he made other purchases: after the sale he wrote to William on other minor business matters and ended with a "Private P.S.: Don't say anything about Gabriel's four poster. The feeling friend [Watts] knows all about it, and left it with the men to sell for a sop. I gave them £3 for it and am most thankful to have it."[17]

William, though confessing that he liked Howell, in later years always kept him at a distance, and in his reply to Howell's letter, turning to the subject of a visit proposed by the Howells, wrote: "Thank you, Lucy and I are well—also the children more or less. As you 'want to come and see them,' I will—however awkward for myself and perhaps not kindly taken by you—say that I had rather not renew any visiting or family intimacy between your house and mine. Our intimacy was

16. Caine, *Recollections of Dante Gabriel Rossetti*, p. 239.
17. This information is derived from a letter in the Texas collection. It also appears in *PRT*, p. 77.

severed some years ago by circumstances in which I was not personally concerned, and I think we had better leave it on that footing. Mutual helpfulness in any business relations which may be advantageous to both of us, without renewal of familiar visiting, etc. [sic]" (*PRT*, p. 78). What the circumstances were, whether the matter of the tie-pin, the Levy affair (see Letters 433 to 463, *passim*), or whatever, are unspecified.

The years of Howell's intimacy with Rossetti are the most fully documented of his life. Afterward the trail is often lost, although it apparently led mostly downhill. The Pennells had access to a journal which Howell kept in 1878 and part of 1879, but public advertisement has failed to discover it. Regrettably the birth of Rosalind Blanche Catherine Howell, as the birth certificate denominates her, occurred on 20 March 1877, almost ten years after the Howells' marriage. Had it occurred during the time of Howell's association with Rossetti, Howell would surely have given Rossetti desirable information about it. Whistler, remembering Howell at his house in Fulham, speaks of Howell's "hens all there clucking, and a child—no one knew who was the mother..." (*Journal*, p. 61). The earliest reference by Howell to the existence of the child that I have found occurs in the letter to Swinburne asking him to be its godfather (*supra*). Dr. Williamson, writing to Violet Hunt in 1923, said, "I hesitate to put in writing, or even viva voce, all the material that I possess. Such questions require handling with the greatest possible discretion. At the same time, I think you may take it as correct that there was no legitimate child at all, and that the daughter to whom you refer ... was the child of the lady whom you say you think died three years ago" (Cornell). Opposite this statement Violet wrote the name [Alice] *Chambers*.

When, however, Violet got in touch with Mrs. Emma Summers-Gill, daughter of Admiral Howell, commander of the Coast Guard station at Selsey Bill, Mrs. Summers-Gill, who as a young girl of thirteen in 1880 knew the Charles Howell family well in Selsey, contested the statement vigorously. (Kate Howell once said that there was surely some relationship between the two Howell families, and Violet Hunt attached a note saying that the Selsey Howells derived from an illegitimate son, but whether she meant that Admiral Howell and Charles were half-brothers is unclear.) "There is not a shadow of doubt that Rosalind was Mrs. Howell's child—I never heard any doubt cast on it before," wrote Mrs. Summers-Gill. "The notion is preposterous—Mrs. Colnagi—who lived at 7 Munster Terrace, Fulham—was with her at the child's birth and told me various little intimate details."[18] Beyond this, all that can be said is that Kate Howell always treated Rosalind as her own child and that Mrs. Summers-Gill thought there was a striking likeness between the two.

Howell meanwhile had been supporting his family by his dealings in art, art objects, and interior decoration. When in 1878 extension of the railway forced him to relinquish Chaldon House—the second such move caused by extension of the railway lines—he and his family moved to 91 Southampton Row. Shortly later he also acquired "Old Danner" at Selsey Bill, Sussex. The forced eviction was subsequently the occasion of an amusing suit which Howell brought against

18. All information attributed to Mrs. Summers-Gill is derived from her letters to Violet Hunt and notes that VH made of interviews with her (Cornell Library).

the Metropolitan District Railway for damages. As he was leasing the house, the suit was brought for damages to the business he carried on there, for the cost of removing valuable pictures and art objects, and for the increased cost of leasing another house.

On the witness stand Howell described himself as a Civil Engineer, member of a large number of scientific bodies, and a dealer in works of art and the decoration of houses. He testified that he had been obliged to expend £1000 on Chaldon House to make it livable and another £1000 in embellishments. The house thus became "a show specimen of domestic decoration. Men of wealth and position would see the house and wish to have rooms fitted up accordingly."[19] He had, he said, fitted up 43 such rooms—blue rooms, green and gold rooms, white rooms, etc. to "suit the taste of my friends"—and had earned an income of not less than £3000 a year for the past ten years in this fashion. He placed a value of £10,000 on the contents of the house and dwelt upon the great loss if anything was damaged.

Cross-examined, Howell said, "If people are in a collecting humour, they will buy, and if they are not in that humour, I soon put them in it." At that moment Whistler entered the courtroom, and Howell continued, "We must be very careful now. Here is an 'arrangement in black and white;' the key note of all true symphonies is in the court (Roar of Laughter)." A string of witnesses followed Howell to the stand, all of whom testified to losses that he would incur in an enforced move. The railway presented no witnesses, and in conclusion the counsel for the railway "felt bound to compliment Mr. Howell on the frank manner in which he had given his evidence. Mr. Howell, though modestly calling himself a dealer had proved himself to be not only a most accomplished gentleman but a man of the highest genius." The Under-Sheriff, presiding, summed up by stating that the plaintiff was entitled to compensation for the difference between the rent paid and its actual value, for the cost of fitting out a new house in a manner comparable to the old, for cost of removal of the furnishings, and for loss of business before he was established in a new house. After brief deliberation, the jury awarded Howell £3650. Howell's creditors intervened, however, and in February 1880 the railway was ordered to pay into court the sum of £1152 *ex parte* Howell and the balance, plus interest, to some two dozen creditors. So £1152 was what Howell received.[20]

Throughout the years following the break with Rossetti, Howell maintained a liaison with Rosa Corder, the sixth child of the fifth Micah Corder (1808–88), described as a lighterman on her birth certificate. She was born on 18 May 1853 and died on 28 November 1893, not in 1904 as stated by Mrs. Angeli. Rosa received part of her education at Boulogne and is credited by the British Library Catalogue with a translation of H. Didon's *La Science sans Dieu* as *Science Without God* (1882). A brother, Frederick (1852–1932), became Professor of Composition and Curator of the Royal Academy of Music, and with his wife translated and popularized the works of Wagner. Rosa's sister Charlotte was also educated

19. All information about the trial is taken from a manuscript court record in the Troxell Collection, Princeton Library.
20. Information from the Secretary of the London Transport Executive.

in part at Boulogne and was twelve years on the stage (as Charlotte Steel), playing the part of Mrs. Snagsby in *Bleak House* until she wearied of the role and retired.[21]

Rosa became interested in art and had two years' instructions from Felix Moscheles, son of the composer, attended evening classes at University College, and, as the Howell-Rossetti letters reveal, had a few lessons from Sandys. Clayton says that her first picture exhibited at the Royal Academy was "a most successful portrait of her mother [1879], but her great forte was in painting horses and dogs, and she did a good deal of work for the late Duke of Portland." So far as I can ascertain, the portrait of her mother was the only picture by her to hang in the Academy. Mrs. Angeli (*PRT*, p. 234) says that "several etchings after her drawings are preserved in the Print Room of the British Museum, comprising a portrait of Howell's daughter, Rosalind, at the age of eight months." Lady Mander has seen only one of her pictures, that of a jockey, and the present whereabouts of all of them are unknown to me and those whom I have questioned. Dr. Williamson (p. 133) says that she was "Whistler's favourite model and lived for a time on very intimate terms with him." However that may be, she certainly posed for one of Whistler's finest portraits, now in the Frick Museum in New York, which Howell commissioned and agreed to pay £100 for.

Rossetti first heard of Howell's liaison with Rosa in 1873. Presumably she was the successor of the mysterious Clara Vaughan, who was probably the woman who figured in Howell's own account of the cause of the breach with Ruskin. Mrs. Angeli (pp. 234–38) prints some highly interesting letters from Rosa to Rossetti at about the time of his final break with Howell. Writing on 23 March 1876, as in confidence, she calls Howell "the best friend you have got in the world: queer, eccentric, extremely proud, but a true man in every sense of the word, and one who would go to the devil for you or for anyone he liked half as much as he does you." The history of his affair with Clara Vaughan, toward whom he behaved like a Portuguese gentleman of the time of Vasco da Gama, she continued, was well known to her—not from Howell but from outside information. "Again," she went on, "with all his vagaries, his splendid conduct to his wife, of which I am, I might say, a daily witness, his tenderness and care for her, would alone stamp him as a man of rare gifts and large heart—and unable to bring sorrow on anything of his own however he might be suffering himself." In a letter of the following day, she continued: "Whatever may have happened between us (and in saying this I do not know if ever as an old friend he may have admitted to you what *did* happen) one thing I can tell you that for months past his conduct has been that of a good father and brother more careful and zealous than even those at home. Striving to aid me in name work reputation, and personal comfort no matter how much he has been hampered and worried, as I know he has been."

What *did* happen, we may well ask. Mrs. Angeli (*PRT*, p. 237) speculated that the reference was to a recent event, probably the birth of a child, and that the child was the "niece," Beatrice Ellen Howell, appointed in Howell's will as next heir after Rosalind. Neither Mrs. Angeli nor I was able to find a birth certificate

21. See Francis Corder Clayton, *A Few Memoranda concerning Micah Corder (1680– 1766) . . . and his Descendants* (printed for private circulation, 1885, and with Additions, 1914).

for Beatrice Ellen, but as Mrs. Summers-Gill says that she was about six years younger than Rosalind, she must have been born about 1883. That leaves Rosa's reference to what happened between her and Howell ten years earlier a mystery unless, indeed, Rosa was the mother and Howell the father of the dead baby whose mother Howell sent a picture of to Rossetti in 1873 (Letter 295). Of this, however, there is no proof.

Letters to Violet Hunt from Mrs. Summers-Gill give a good deal of information about the Howells, Rosa Corder, and Beatrice Ellen from about 1880. Both Kate and Rosalind were unwell in 1879, and the family went to live at Old Danner about 1880 for the sea air. Violet Hunt, who claimed to have seen the lease for Old Danner, says that Rosa Corder paid £150 for it. Howell retained 91 Southampton Row, however, from which to carry on his business and went down to Selsey for weekends or as circumstances permitted. Once a year Kate and Rosalind would come up to London for a holiday. After the birth of Beatrice Ellen, unquestionably the daughter of Howell and Rosa Corder, Mrs. Summers-Gill says that Rosa went to live at Newmarket, only coming up to Southampton Row for visits. One of Violet Hunt's sourceless notes states that Howell kept a house at Newmarket for her, "beautifully furnished," as of course it would be if the first part of the statement is true. Mrs. Summers-Gill, who knew Beatrice Ellen later in Selsey, says that she was the image of Rosa and that she was introduced as the child of Howell's brother. She called Howell "Uncle Charles" and Rosa "Losa."

If, as it appears, Howell was supporting three establishments, no wonder he was "hampered and worried," as Rosa Corder in 1876 [*supra*] knew him to be. Such a state was doubtless the norm with him. After the break with Rossetti, he was for a time selling Whistler's etchings and the pictures of Sandys and had at least two patrons, S. Wreford Paddon, "a diamond merchant who entrusted [Howell] with his cheque book and orders generally to furnish and decorate" his house (*Whistler Journal*, p. 61), and Henry Doetsch, who had made a fortune in the Rio Tinto mine and was engaged in banking. This was also the period when Howell was alleged, either alone or with the assistance of Rosa Corder, to have fabricated and marketed spurious Rossetti art works. Mrs. Angeli (pp. 241–44) treats the subject at length, repeating Dr. Williamson's charge (quoting Dunn) that Howell added Rossetti's monogram to copies made by Dunn and quoting Knewstub's daughter as saying that Howell initialed Knewstub's paintings and sold them as Rossetti's. "The same thing," Mrs. Angeli states, "has been alleged of specimens of Rosa Corder's paintings in 'Rossetti's style.' "

In August 1878 it came to Rossetti's attention that a spurious drawing attributed to him had been purchased in the shop of a London pawnbroker and art dealer (Attenburgh), whereupon he wrote a letter of protest to the *Athenaeum* (copied by *The Times*). Mrs. Angeli (p. 242) believed that "Gabriel does not appear to have suspected Howell" in connection with it, and Mr. Bryson (p. xix) remarked that "when protesting about forgeries of these drawings . . . Rossetti names no names. . . ." Finally, William Rossetti, in writing about forgeries, repeated the allegations against Howell but left the verdict open.[22] Quite recently,

22. Perhaps Max Beerbohm's *Rossetti and His Circle*, in which Howell and Rosa Corder are depicted as "perpetuating the touch of a vanished hand," is more responsible than anything else for convicting the two in the eyes of the public.

however, a letter from Rossetti to William Bell Scott has come to light which bears on the subject.[23] Writing on 11 August 1878, Rossetti says in part: "Howell's Baronet [Murray Howell] is dead and he [Howell] is taking up the title." Rossetti then alludes to his letter to the *Athenaeum* and adds, "since when the nuisance is dead. The name of the originator is to be found on the first page of this letter [i.e. Howell]." So Rossetti did suspect Howell of being at least the purveyor of the drawing. Howell was also doing a brisk business in "Old Masters," which Violet Hunt, never one to depend upon evidence, believed to be the handiwork of Howell's father, the drawing master.

When in *The Paddon Papers* (1882) Whistler charged his old friend with dishonesty, Paddon stood by Howell and informed Whistler that he wished to hear no more against Howell. It was Paddon, however, according to Whistler (*Journal*, p. 61), upon whom Howell palmed off some common black pots as Chinese rarities. Subsequently Paddon "discovered rows of the same pots in an Oxford Street shop—more fakes. And that was the end of Howell." Whistler gives no details about "the end of Howell," but on 12 March 1885 Paddon filed suit against Howell in the High Court of Justice, Queen's Court Division, seeking recovery of £1672/1/3 received by the Defendant as agent for the Plaintiff under false pretenses. Involved were some "fine Satsuma and fine Nagasaki" pottery, the genuineness of which was questioned; a "Gainsborough" picture, the history of which was requested; some black chinaware—the famous black pots?—represented falsely by the Defendant as from the Roydon Hall Collection purchased by one Jewell from Lady Twisden for £1000; and some pictures acquired from Alice Chambers. The Defendant was also requested to answer whether or not certain of the pictures and chinaware were not actually his own property at the time of the sale to the Plaintiff. Of minimal concern were some vases, brackets, and wall furniture of the value of £21/3/0.

As for the allegedly spurious pictures, the Defendant denied that he "fraudulently represented or at all that any pictures works of art or other things were genuine or that he thereby induced the Plaintiff to make any payments to the Defendant." Such pictures as he represented to be genuine were either genuine or were believed by the Defendant to be genuine and as represented by him. Five pictures had been purchased by the Plaintiff from one Vacani, among them three supposedly by Van Huysen, Van Dyck, and Terburg, all of which the Defendant denied having any property interest in or having made false representations about. Some chinaware—it is not clear what this was—was purchased by the Plaintiff from Vacani for £325, an alleged exorbitant price, but the Defendant declared that he [Vacani?] had originally paid £700 or thereabouts for it.

Even so, the defense must have been weak, for the Defendant's solicitors, on behalf of their client, accepted on 10 June 1886 the proposal of the Plaintiff's solicitors to settle the claim for £1299/8/2, in addition to the sum of £21/3/0 paid into the court, and "to entirely forget [the matter] and never refer to it again. . . ." In the settlement the sum of £500 was to be paid down, £250 "on Tuesday next," and the balance, with costs, to be paid in three equal payments at three, six, and

23. In the Janet Camp Troxell Collection in Princeton University Library. The finding of this letter after I had furnished the librarians with the false clue that such a letter had been written to Watts rather than Scott merits highest praise and gratitude.

nine months. These installments were to be secured by promissory notes of the Defendant, Alice Chambers, and Rosa Corder.[24] Whoever else might desert Howell, Alice Chambers and Rosa Corder always remained his staunch friends. As I find no further record of the suit, I can only assume that the immediate payments and the promissory notes were—somehow—met.

Henry Doetsch, for whom Howell was assembling a collection of "Old Masters," is named in Howell's will as his "best friend," who was not appointed one of Howell's executors only because of the great claims upon his time by business affairs. Howell's friendship with Doetsch lasted throughout the remainder of Howell's life, and Doetsch, who lived another five years, never learned that that friendship too had apparently been abused. According to Dr. Williamson (p. 154) the sale of Doetsch's pictures, "largely bought under Howell's advice," was announced by Christie's for 22, 24, and 25 June 1895, but "almost all the paintings . . . were suspect, and the prices for works bearing great names were so absurd that the catalogue, a costly compilation, was withdrawn" and "the sale never went beyond the first day." Sir Henry Lucy confirms the story. Once, he says, George Du Maurier, dining at Doetsch's, questioned the authenticity of the masterpieces and was never again invited to sit at Doetsch's table. "But he lived long enough to learn the result of the sale at Christie's of the treasured collection. Picture after picture was knocked down at prices little exceeding the cost of the frame."[25] Sir Henry also reports that "in moments of confidence, [Howell] spoke to me, with tears in his eyes, of his 'little daughter' who lived with a governess somewhere in the country. When I lost a dog he presented me with a valuable terrier which he said he had himself bred 'down in the country.'"[26]

Mrs. Summers-Gill, as a child in her teens, saw a good deal of the Charles Howells at Selsey Bill. Of Howell, she says that Rosalind's "father was a god to her—she adored him," and added, "I loved him also as a young girl idealizes a brilliant and clever man. He was as kind to me as if I had been his own child. I cannot think a man with his loving generous nature was 'merely a clever adventurer.'" She remembered vividly Boxing Day in 1881—she was then fourteen—when the Howells and friends who were spending Christmas with them came over during the course of the evening and distributed toys and other presents. The Paddons and Leyland were among the visitors, and Emma was so impressed with Leyland's frilled shirt and diamond stud that she thought him "a very grand person" indeed and "told all the girls about him when I went back to school."

It was to Emma that Howell turned when Kate Howell was dying in 1888. On 6 June he wrote to Emma's mother, from Southampton Row: "I write in great distress, and I know that you and dear old Howell will be with me in my great trouble. Poor Kitty is sinking fast, the change in the last four days is frightful. The cancer has spread fast and now she has lost the use of her legs and left arm. I and poor little Rosalind—she like a little woman—nurse day and night, and dear little soul she is so frail and worn I am quite frightened." He begged Mrs. Howell to send Emma to him "till the end," saying, "Today poor little Rosalind began to cry in a corner with me 'O dada if I only had little Emmy to help me.' It

24. From records of the suit in the University of Glasgow Library.
25. *Sixty Years in the Wilderness* (London, 1909), pp. 335–36.
26. *Sixty Years in the Wilderness: More Passages by the Way* (New York, 1912), p. 214.

is heartbreaking." Emma did go and was alone in the bedroom with Kate when death came, and she immediately ran and called Alice Chambers, who was also in the house. Burial took place on 18 June in the Brompton Cemetery.

Only after the death of Kate did Beatrice Ellen put in an appearance at Selsey. Emma Howell, a very observant girl, commented aloud on her resemblance to Rosa Corder and was gently reproved by her mother. She also observed that Rosalind was intensely jealous of Howell's attentions to Beatrice. "She could not bear to see C.A.H. cuddling Beatrice and calling her his dear, [his] darling little Beatrice." Moreover Rosalind asked inconvenient questions, such as "When did Beatrice come to England and why to live in a convent?" as she had probably been told when Beatrice was in Newmarket.

I last hear of Howell during his lifetime in a letter of 29 May 1887 which he wrote to C. Fairfax Murray. He thanked Murray for a cheque in the sum of £100 on account of some drawings and asked for the remaining £50 at earliest convenience. He was, he said, building in Newmarket and in Sussex and the workmen kept him so poor that he would almost willingly exchange places with them (HRC, Texas). No other word on how he was earning a living, though the inference is that he was continuing his activities as art salesman and interior decorator. He did not long survive Kate; he died on 24 April 1890.

The account of Howell's death, as disseminated by T. J. Wise, is so lurid and befitting the soldier of fortune, adventurer, and blackguard as he has so often been depicted that one almost regrets that the story cannot be true. Here is Wise's account, for which he gives no authority:

> Howell's death ended in sordid tragedy. He was found early one morning lying in the gutter outside a public-house in Chelsea. His throat was badly cut, and a ten-shilling piece was tightly wedged between his clenched teeth. He was removed to the Home Hospital, Fitzroy Square. Here he lingered a few days, sufficient to render it possible for the cause of death to be mercifully certified as pneumonia phthisis, from which disease he was suffering at the time. This prevented the scandal which an inquest would have involved. (*Swinburne Bibliography*, I.220)

If this story of a Mafia-style execution is untrue, as there is much evidence to support, how did it originate? A sourceless note in the Violet Hunt papers says that "the news of Howell's death and the manner of it was told to Watts by Oscar Wilde as he was sitting in the stalls at a Lyceum first night. Oscar came in and said, 'What about your friend H. now? He's been found in the street outside a public house dying, with his throat cut and a ten shilling piece between his clenched teeth.'" This at any rate would explain Wise's account, for no doubt Watts would have passed the story on to Wise. "How had Oscar heard?" asks Violet. "It points to a Sadistic revenge. . . . Isn't there a Charlie Howell in the evidence of [the] Wilde case?" If so, the two may have been confused, but I have found no mention of another Charlie Howell in newspaper accounts of the Wilde trial. The official death certificate, signed by T. Robinson, M.D., certified the cause of Howell's death as "Pneumonia Phthisis Asthenia," and Mrs. Angeli quite properly asks "in whose interest police or hospital authorities were anxious 'to avoid a scandal'" (*PRT*, p. 24). And one may also ask how it is possible for a man whose throat has been badly cut to linger even a few days.

Violet Hunt certainly heard a different story from Emma Summers-Gill, as told her by Rosa Corder and Beatrice Ellen. According to this report Howell was supervising the arrangements for removing the furniture at Selsey Bill, got wet, and returned ill to Southampton Row. His housekeeper Priscilla became frightened as he grew worse and "had him removed to a private hospital [Fitzroy House] in an ambulance." Rosa was living at Newmarket with Beatrice Ellen at the time, but she came daily to see him. "In the hospital Rosa said that he constantly talked of plans for going with her to Brittany and the two children but the Doctor told her there was no hope." Rosalind was apparently staying at Newmarket also during her father's confinement in hospital, but once Rosa brought her to see him. Though she had a "lovely dinner of chicken and bread sauce at his bedside," she reported to Beatrice on her return to Newmarket, "Daddy was so weak he could not have knocked down a puppy!" Rosa saw Howell die, according to this account, and came back wearing his watch and chain, so that Rosalind knew that he was dead.

The evidence of Alice Chambers, a woman of impeccable character as far as is known, supports the presumption that Howell's illness was more prolonged than "a few days." That inveterate collector, Fairfax Murray, was soon in touch with Miss Chambers about purchasing Howell's letters, which he eventually acquired. Miss Chambers was in no hurry to dispose of them, however, and the correspondence between the two dragged out over a period of years. In a letter of 27 July 1893, appointing a time for a visit by Murray, she wrote: "You may like to know at once about Fitzroy House. Owing to Mr. Howell's having been much too ill to attempt to make any bargain beforehand, I think he was charged more than *need* have been; but the whole place was excellently managed and the nurses were charming, refined, women." The charge per week, she said, was six guineas, but there were extras, "of which medical attendance was a heavy one,—amounting, I think, to something like 5 guineas per week" (John Rylands Library). I do not know the occasion which prompted Murray's interest, but it seems unlikely that Miss Chambers would have written in terms of the charge per week and of heavy medical costs had Howell been there only a few days. Finally *The Times* on 28 April reported among deaths: "On the 24th inst., after a long illness, Charles Augustus Howell, of 91 Southampton-row, W. C. and old Danner, Selsey, Sussex, aged 51."

Howell's will, signed on 20 September 1888, a few months after the death of Kate, appointed Frederick John Bonham, auctioneer, and Alice Mary Chambers, spinster, to be Executor and Executrix and Trustees of his will. All of his real and personal estate "except such articles and effects as my daughter may select for her own use or may wish to retain" was bequeathed to the Trustees to be converted into money. After payment of his debts and funeral expenses (not to exceed £12), the Trustees were directed to invest the residue and pay the income from it to Rosalind during her life. If she died childless, the Trustees were directed to pay the income "to my niece Beatrice Ellen Howell during her life. . . ." In case of the death of Beatrice Ellen without issue the Trustees were directed to pay the income to Rosa Frances Corder of Hamilton Cottage, Newmarket, during her life, and after her death to divide it among such nephews, nieces, or their issue as should be living at the time of her decease. Miss Chambers and Rosa

Corder were named joint guardians of Rosalind until she reached the age of twenty-one.

Such a will does not read like the instrument of a man who expects his creditors to devour everything, and indeed the personal estate was sworn on 11 June 1890 as of £1586/16/11 and resworn in May 1891 at £3072/6/11. Howell's collection of pictures, objects of art, and decorative furniture, comprising 547 lots, was sold at Christie's on 13–15 November and fetched a total of £4348/17/4. Among the objects of art was, to quote Dr. Williamson, "an important collection of Stuart relics which really belonged to Miss Rosalind B.B.C. de M. Howell, his only daughter, and to which she had succeeded from her mother. . . ." This rather sounds as if Howell had stolen the Stuart relics from his daughter, as indeed a note from Violet asserts, but we have seen that Rosalind was entitled to make selections from the relics, and the Trustees were certainly empowered to offer the remainder for sale. Dr. Williamson also says (p. 154) that Howell's "daughter did not succeed to any of his property. It was all divided between his creditors." As, however, Rosalind was later made a Ward in Chancery and sent to be educated and reared by a clergyman's widow in Harrow (*infra*), it seems likely that there was a residue.[27]

As might have been expected, joint-guardianship of Rosalind by the two women did not work out. She and Beatrice visited the Howells (Emma's family) for about six weeks after Howell's death; then Rosa Corder called for them and took them to Newmarket. Admiral Howell retired from his post in the summer of 1890 and moved to Hertford, where Rosalind was brought by Rosa in the summer of 1892 for a fortnight's visit. Thereafter Miss Chambers, according to Emma, took Rosalind to Normandy for an unstated period of time—but long enough for Rosa to apply to her lawyer to have the child returned to her. Beatrice told Emma that a lawyer's clerk was sent over for Rosalind. Alice-Chambers returned with them, for Beatrice reported that Rosa met them at the station and that "the two furious women fought and scratched over the whimpering Rosalind." Then followed a lawsuit in which Alice's solicitor argued "that Miss Corder's claim was inadmissable since she had had an illegitimate child by the father of the child she was claiming," and Rosa's solicitor retorted that Miss Chambers was apt to take the child to improper places—"to low inns in Normandy where she danced in the village bar or estaminets with wild Bohemian artists."

The upshot was that Rosalind was made a Ward in Chancery and was sent to Harrow to be educated and reared by a clergyman's widow and remained there for several years during which Emma Summers-Gill lost sight of her. When she turned twenty-one, however, she was reported to be lodging with a family named Edwards in London. From Beatrice, Emma learned that Rosalind had a friend named Eve, whom she helped to run away and marry a coachman. The coach-

27. Several months after the auction Fairfax Murray raised with Miss Chambers (as Executrix) the question of the authenticity of the portrait of Kate Howell, which had been offered as by Rossetti. Miss Chambers replied indignantly that it was genuine, "as it is past all doubt that Mrs. Howell gave Rossetti several sittings for that particular drawing, which is therefore more his work than many pictures which went out of his studio as his,—which were little more than copies from his work by persons employed by him to make them." She could produce a letter of Rossetti's, she said, to confirm her statement. (From a letter in the John Rylands Library.)

man then took a public-house, "Rosalind threw in her lot with them and served in the bar and married one of their friends," whose name Violet Hunt wrote first as Albert Hart and then Caylard Hart. Hart, whatever his given name, became first a ship's steward and later a steward in the dining car of a railway train. Miss Chambers, who never seems to have got on with Rosalind and who spent a good deal of time in France and Spain, told Emma of going to see Rosalind, finding her living "in very poor surroundings," servantless, and with the incubus of her father-in-law—"an old man in a linen smock." Once Rosalind brought her little daughter Edna, who had the same exquisitely small hands and feet as Kate Howell, to see Emma. She learned much later that Hart had been sent to the front during World War I and had returned safely. When the air raids became serious, Rosalind and her children were sent down to Selsey at Alice Chambers's expense, and there Emma Summers-Gill's knowledge of her ended.

Rosa Corder died on 28 November 1893 at Vale Lodge, Fordham, Cambridgeshire. Out of an estate of £679/2/7 she left £50 to her servant and the remainder to her sister Charlotte for her life and after her death to Beatrice Ellen Howell. Charlotte Corder then adopted Beatrice. In 1923 Violet Hunt, attempting to locate Rosalind, wrote to Rosa's brother Frederick, who replied, "I never knew Rosalind Howell. All I know about her (from her half-sister, who was brought up with her) is that she grew up and married, after which all traces of her were lost. The half-sister, I may mention, knows nothing of her own parentage."

So ends the history of Charles Augustus Howell and his family. Of his last years almost nothing is known beyond what Emma Summers-Gill wrote to Violet Hunt or told her and what the legal suit of S. Wreford Paddon and the sale of Henry Doetsch's pictures enable us to infer. In the end perhaps nothing said or written about him can improve upon William Rossetti's epitaph:

"I could have spared a better man."

Select Bibliography

Unless otherwise noted, the place of publication is London.

Angeli, Helen Rossetti. *Dante Gabriel Rossetti: His Friends and Enemies* (1949).

Angeli, Helen Rossetti. *Pre-Raphaelite Twilight: The Story of Charles Augustus Howell* (1954).

Baum, Paull Franklin. *Dante Gabriel Rossetti's Letters to Fanny Cornforth* (Baltimore, 1940).

B-J, G. [Lady Burne-Jones]. *Memorials of Edward Burne-Jones* (1904).

Bryson, John (ed.) in association with Janet Camp Troxell. *Dante Gabriel Rossetti and Jane Morris: Their Correspondence* (Oxford, 1976).

Caine, T. Hall. *Recollections of Dante Gabriel Rossetti* (Boston, 1883; revised, London, 1928).

Doughty, Oswald. *A Victorian Romantic: Dante Gabriel Rossetti* (1960).

Doughty, Oswald and John Robert Wahl. *Letters of Dante Gabriel Rossetti* (Oxford, 1965–67).

Dunn, H. Treffry. *Recollections of Dante Gabriel Rossetti and His Circle* (ed. Gale Pedrick, 1904).

Fitzgerald, Penelope. *Edward Burne-Jones: A Biography* (1975).

Ford [Hueffer], Ford Madox. *Ford Madox Brown: A Record of His Life and Work* (1896).

Fredeman, William E. *Pre-Raphaelitism: A Bibliocritical Study* (Cambridge, Mass., 1965).

Fredeman, William E. *Prelude to the Last Decade: Dante Gabriel Rossetti in the Summer of 1872* ("Bulletin of the John Rylands Library," Manchester, 1971).

Fuller, Jean Overton. *Swinburne: A Critical Biography* (1968).

Grylls, Rosalie Glynn [Lady Mander], *Portrait of Rossetti* (1964).

Hake, T. Gordon. *Memoirs of Eighty Years* (1892).

Henderson, Philip. *The Letters of William Morris* (1960).

Henderson, Philip. *William Morris: His Life, Works and Friends* (1967).

Hunt, Violet. *The Wife of Rossetti: Her Life and Death* (1932).

Hunt, W. Holman. *Pre-Raphaelitism and the Pre-Raphaelite Brotherhood* (1905–6).

Lindsay, Jack. *William Morris/His Life and Work* (1975).

Mackail, John William. *The Life of William Morris* (1927).

Mander, Lady. See Rosalie Glynn Grylls.

Marillier, H. C. *Dante Gabriel Rossetti: An Illustrated Memorial of His Art and Life* (1899).

Meier, Paul. *La Pensée utopique de William Morris* (Paris, 1972).

Packer, Lona M. *Christina Rossetti* (Berkeley and Los Angeles, 1963).

Pedrick, Gale. *Life with Rossetti or No Peacocks Allowed* (1964).

Pennell, E. R. and J. *The Life of James McNeill Whistler* (Philadelphia, 1911).

Pennell, E. R. and J. *The Whistler Journal* (Philadelphia, 1921).

Rossetti, William M. *Dante Gabriel Rossetti as Designer and Writer* (New York, 1970).

Rossetti, William M. *Some Reminiscences* (1906).

Rossetti, William M. (ed.). *D. G. Rossetti: His Family Letters, with a Memoir* (Boston, 1895).

Rossetti, William M. (ed.). *Pre-Raphaelite Diaries and Letters* (1900).

Rossetti, William M. (ed.). *Rossetti Papers, 1862–70* (New York, 1903).

Scott, William Bell. *Autobiographical Notes of the Life of William Bell Scott* (ed. W. Minto, New York, 1892).

"Sigma" [Julian Osgood Field]. *Personalia* (New York, 1904).

Surtees, Virginia. *The Paintings and Drawings of Dante Gabriel Rossetti, 1828–1882: A Catalogue Raisonné* (Oxford, 1971).

Swinburne, Algernon Charles. *Letters of Algernon Charles Swinburne* (ed. Cecil Lang, New Haven, 1959–62).

Troxell, Janet Camp. *Three Rossettis* (Cambridge, Mass., 1937).

Watts-Dunton, Theodore. *Old Familiar Faces* (1916).

Waugh, Evelyn. *Rossetti: His Life and Works* (1931).

Weintraub, Stanley. *Whistler* (New York, 1974).

Williamson, G. C. *Murray Marks and His Friends: A Tribute of Regard* (1919).

Note on the Text

All letters unless otherwise designated are from the Humanities Research Center of the Harry Ransom Center of The University of Texas.

Except for abbreviations, the ampersand, occasional inconsistencies in the use of the apostrophe, and carelessly omitted end punctuation, Rossetti's letters are printed as written. Letters of William Michael Rossetti, usually written in haste, abound in abbreviations, which have been written out in full for the sake of reading ease. No attempt has been made to correct the "lame" English of Howell's letters, as he expressed it, or his punctuation, but some misspellings have been corrected.

Dates and explanations in square brackets are those of the editor.

The following symbols appear frequently:

* indicates printed or embossed stationery.
+ indicates dates supplied by Charles Augustus Howell.
indicates dates supplied by Charles Fairfax Murray.

Mrs. Angeli's *Pre-Raphaelite Twilight* is abbreviated *PRT*.
Doughty and Wahl's *Letters of Dante Gabriel Rossetti* is abbreviated D-W.
Doughty's life of Rossetti is shortened to Doughty.
William Michael Rossetti's *Family Letters* is abbreviated *FL*.
William Michael Rossetti's *Dante Gabriel Rossetti as Designer and Writer* is abbreviated *DGRDW*.
William Michael Rossetti's *Rossetti Papers, 1862–70*, is abbreviated *RP*.
Virginia Surtees' *Dante Gabriel Rossetti, 1828–1882: A Catalogue Raisonné* is shortened to Surtees.
The Humanities Research Center at The University of Texas is abbreviated HRC.

Addressees and senders of letters are shown by the following abbreviations:

CAH Charles A. Howell
KH Catherine ("Kate") Howell
CGR Christina G. Rossetti
DGR Dante Gabriel Rossetti
WMR William M. Rossetti

Letters which have been published elsewhere—or which are not central to the purpose of this book—have been summarized by the editor. All letters, whether printed in full or summarized, are numbered serially. A Table of Letters, showing addressees and senders, appears in the Indexes.

I. Family Friend and Factotum

22 March 1865 to 26 September 1872 (Letters 1 to 145)

1. CAH to WMR. 3 York Villas, Brixton, 22 March 1865. (Partly printed, partly summarized PRT, pp. 52-53, misdated 22 May 1865.) CAH apologizes for allowing 115 days to pass without paying courtesy call on the Rossetti family, repays 2/- borrowed for cigar on 26 November 1864, encloses Orsini's autograph, and thanks WMR for copies of WMR's Dante and for the Germ given him eight years previously. Two pages of discussion of WMR's translation of Dante follow. Inquires whether CGR's Goblin Market is published, wishes to purchase a copy of it and of DGR's Early Italian Poets and have both autographed. Is hopeful of getting a £400 post, meanwhile is writing history of the Inquisition in Portugal, hopes WMR will help with spelling and "lame English."

2. DGR to CAH. 16 Cheyne Walk, 10 April 1865. (Printed D-W, p. 550.) Thanks for a Corregio head and discussion of whether genuine or not, thanks for choice Madeira. Hopes to see CAH soon.

3. DGR to CAH. *16 Cheyne Walk, 18 April 1865. Rejoicing to hear of improvement in health of Kate (or "Kitty" Howell, CAH's cousin, whom he married in 1867).

4. DGR to CAH. Tuesday, [?May 1865]. CAH a beast not to join Jones, Prinsep, Webb, and Leyland at dinner yesterday. DGR has been rubbing at portrait of Kate (Surtees 338, dated "31 July 1865"), wants her and CAH to come on Thursday, "sit and stay dinner."

5. DGR to CAH Sunday, [28 May 1865][1]

Dear Howell,
Can you, who are "townier" in your habits than I, do me the good turn of getting an opera box as heretofore for Friday? Will you thank Kitty for letting me know that Don Giovanni is played that night. The best box available of course, as before. If at the same time you would post to Janey, 26 Queen Square, a book of the opera, you would still further oblige her and me.
 Your affectionate
 D.G.R.

The box had also better be posted to her. Kitty's portrait is done now, and improved since you saw it.[2] It has no back board to the frame, but only a strainer which is not needed.

[1]June 2 was the only Friday on which Don Giovanni was offered at Covent Garden by the Royal Italian Opera Co. in the 1865 season.
[2]See preceding letter.

6. DGR to CAH. *16 Cheyne Walk, Wednesday, [7 June 1865]. Enclosure from Ned Jones. Today got a photograph of the Beloved (Surtees 182, dated "1865-66") and several of Mrs. Morris.

7. DGR to CAH *16 Cheyne Walk, Chelsea
 Thursday night, 15 June [1865+]
My dear Howell,
Wednesday evening of last week I wrote to you enclosing note from Ned Jones[1] which I was told was of moment. I hope it reached you safely. Not having heard from you in reply makes me ask the question. I trust all is well with you and yours, but should like a line to tell me, and to let me know when you are likely to be here again. Not that there was any need of replying to my former hurried note, only I am anxious to know that your silence is not owing to any painful preoccupation.
 News is scarce here. I have been scraping and altering at my picture[2] and am no further with it than when I last saw you. Nor has anyone done any good I know of this hot weather. My people seem to be enjoying themselves vastly in Italy, and Christina is reported as decidedly improved in health.

I have not seen Ned Jones lately, so do not know if he heard from you in answer to his, or saw you. No one turns up at all. Whether Swinburne be still among the undamned I do not even know. Whistler has been in Paris but is back again. Brown has closed his gallery. Ruskin probably still has his minerals. Hogg[3] may be presumed to be still a convict, if not a bogie. With which general news of friends

<div align="right">
I am yours,

D.G. Rossetti
</div>

P.S. I need hardly say kindest remembrances to Miss Howell, of whom I hope good tidings.

P.P.S. The Lumpses[4] has been to Brighton and Shoreham, but "never seed no Owl."

[1]Edward Jones, later Sir Edward Burne-Jones; see Introduction.

[2]The Blue Bower (Surtees 178). WMR (DGRDW, p. 53) says that it was bought by Gambart for £210 and that a story was told that he sold it to a Mr. Mendel for £1680. This Gambart denied, and WMR says that some years later "it was alleged that in fact Gambart had sold the picture to the Agnews for £500" and that they had resold it for a much larger sum (presumably to Mr. Mendel, in whose possession it was at one time). See DGRDW, pp. 53-54.

[3]J. Fanell Hogg; see Introduction.

[4]One of DGR's pet names for Fanny Cornforth, inspired no doubt by her ample charms. "Owl" was of course Howell; the nickname was bestowed upon him by Burne-Jones.

8. DGR to KH *16 Cheyne Walk, Chelsea
 Sunday, 18 June [1865]

My dear Miss Howell,

I have an idea of painting some hawthorn in my picture of The Blue Bower,[1] and Charles tells me that if I write to you, you, of your goodness, will pack me up some in a hamper and send it. Will you? How good of you it will be if you do! I am not quite sure of using it, but am casting about for what kind of foliage to paint in my picture, and think your cousin is right in his suggestion that hawthorn would be best, but cannot tell till I try. He slept here last night, under a changed régime, as my servants are all gone and new ones not come yet. Being a citizen of the world, he got up prepared to black his own boots, but the usual fairy tale reward accrued to his humility, and an old woman appeared and did it.

I do not know how to thank you for the provision I hear you have been making for my known rapacity in Chinese and Japanese products; nor how to tell you how glad I shall be to see you again soon, so much better as I hear you are.

<div align="right">
Most sincerely yours,

D.G. Rossetti
</div>

[1]DGR to F.M. Brown, 18 Apr. 1865: "I've begun an oil-picture all blue, for Gambart, to be called The Blue Bower" (D-W, p. 552).

9. DGR to KH *16 Cheyne Walk, Chelsea
 22 June 1865

My dear Miss Howell,

I feel quite guilty of all your trouble with the hawthorn so kindly and promptly sent. Unfortunately, owing to my own stupid fault, it is all kindness lost, as I should have said that without blossom it would not serve my turn. It was very tantalizing to look on the leaves held against my picture, as had the blossom only been there, it would have been the very thing. As it is, I shall have to find something else for the purpose near at hand. At present however I am up to my ears in other work, and, such as it is, would like of all things to show it you soon, not because it is worth showing but because I want to see how well you have got.

So trusting from Charles's report that this will now be very soon indeed

<div align="right">
I am ever yours most sincerely,

D.G. Rossetti
</div>

P.S. I would send Charles's love only for the monstrous number of postage stamps it would take.

10. DGR to CAH. *16 Cheyne Walk, 3 August [?1865 or 1866]. Request for CAH's service in cashing crossed cheque.

11. DGR to CAH *16 Cheyne Walk, Chelsea
 Friday evening,[?August 1865][1]
My dear Howell,
I have got now to the point in my water colour at which the next thing ought decidedly to be the working out your figure. But one ought to try and get that coat. If you're passing Nathan's in Tichborne Street, Haymarket, it might be well to look in. Ruffles also are needed, and a waistcoat.
 However if you could come Sunday I could get a day's work even without the coat, only <u>tolerably early</u> if you love me. As near 12 as may be. Or could you look in tomorrow (Saturday)?
 With kindest remembrances to the discoverer of the Blue Pin Mines,[2] I am
 Yours affectionately,
 D.G.R.

P.S. Ward (U.S. Brit. illus.) will be here on Sunday afternoon. I'd come up tonight to Brixton but am doubtful of finding you.

[1]The contents of this letter concern the water-color <u>Washing Hands</u> (Surtees 179), in which CAH sat for the woman's lover. The picture is dated "Aug. 1865," and on 15 Aug. DGR wrote to J. Anderson Rose that he had just finished a water-color (D-W. p. 565).
[2]Humorous reference to Ruskin, for whom CAH acted as nominal secretary and general factotum.

12. DGR to CAH. *16 Cheyne Walk, Wednesday, [?August 1865]. "The moment has arrived at which I ought to finish your head" [in <u>Washing Hands</u>].

13. DGR to CAH. *16 Cheyne Walk, Monday, [September 1865#]. Invitation to join Chapman and Parsons at dinner on Wednesday. "The Lumpses says she has no one to bully now, and feels the want of you sorely." [George W. Chapman was a portrait painter, J. R. Parsons an art-agent with whom CAH entered into partnership.]

14. DGR to CAH. *16 Cheyne Walk, 3 December [1865#]. Expressing concern over health of Kate, inviting CAH to join Smetham at dinner on Wednesday. [James Smetham was one of the many artists aided by DGR.]

15. DGR to CAH. *16 Cheyne Walk, Tuesday,[1865#]. Request for CAH to take "an action with Augusta Jones" [a model].

16. DGR to CAH. *16 Cheyne Walk, Saturday night [?late 1865]. Injunction against mentioning "<u>to a soul</u> what [he] told [CAH] this evening about the bargain with Gambart about those 2 pictures and the prices paid. Great annoyance accrued to [DGR] by exaggeration and repetition on a former occasion..." [presumed reference to <u>The Blue Bower</u>; see n. 2, Letter 7].

17. DGR to CAH *16 Cheyne Walk, Chelsea
 Thursday,[?1865 or 1866]
My dear Howell,
Is your garden still full of those white roses? If so, I think they would suit me capitally to paint in the <u>Lady Lilith</u>[1]--i.e. branches growing out behind her head as if from a pot. [sketch] You see I should have branches in the right direction as in sketch, and I want a good clustre of roses right up in the corner above the head. But of course I could combine much, only the

direction of the branches is desirable, and plenty of the leaves and red buds.
If you have them, Loader[2] will call early tomorrow or Saturday morning for
them--quite early. Probably tomorrow.

<div align="center">Your
Gabriel</div>

[1]Marillier, p. 134: "Lilith, though dated 1864, was not finished completely
until 1866 or 1867." Commissioned by Leyland "who, unwisely as the event turned
out, let Rossetti have it back in 1873, after one of his illnesses, when he
became seized with a sort of mania for altering his work." Face originally
Fanny; Miss Wilding substituted "with anything but satisfactory results, although
he himself was not displeased with the work done upon it." Water color replica
1867, another same year.
[2]DGR's servant.

18. DGR to CAH *16 Cheyne Walk, Chelsea
 23 February 1866
My dear Howell,
With reference to the conversation which we had some days ago, it would give me
sincere pleasure to make one on any committee of artists and others which had
for its object to do honour to George Cruikshank.[1]
 Such a duty is far from devolving on artists alone; since who is there in our
time who has not enjoyed the works of Cruikshank's genius, and does not feel
grateful to him? Artists however know, with more certainty than others can, that
there is a quality of consummate art in much of Cruikshank's work which no
contemporary productions in the same class possess in an equal degree. And for
this reason artists have a special right to initiate some due mark of respect
to one whose name, whatever names may pass away, is certainly among those which
will represent to the future our still early days of English Art.

<div align="center">I am, my dear Howell,
ever yours sincerely,
D.G. Rossetti</div>

C.A. Howell Esq.

[1]CAH was a prime-mover in the planned subscription for George Cruikshank (1792-
1878), artist and caricaturist, who had fallen on hard times. A little later a
Civil List pension of £95, which CAH was to claim that he personally obtained
from Disraeli, was granted Cruikshank.

19. DGR to CAH *16 Cheyne Walk, Chelsea
 Saturday, [?24 March 1866][1]
My dear Howell,
Tuesday be it, and I will meet you at the bank door at 2 o'clock. It is in
Chancery Lane, is it not? I will meet you there, as I may be going elsewhere on
my way in the morning. If not in Chancery Lane, I know it is in Fleet St., near
there, and will find it easily. If 3 suits you better, let me know, but on these
Devil's days at Easter, it struck me they shut everything at mad hours. Could
we get the tin from Ellis[2] by then, and bank it at the same time, think you?

<div align="center">Your affectionate
Gabriel</div>

[1]Easter Sunday fell on 1 Apr. in 1866.
[2]For the crayon drawing of Lady Lilith (Surtees 205B), bought by the publisher
F.S. Ellis, dated "c. 1866" by Mrs. Surtees.

20. DGR to CAH *16 Cheyne Walk, Chelsea
 Saturday, [March 1866+]
My dear Howell,
I have favorable answers from Leighton Watts and Halliday--also through Rose
from Anthony[1]--which I keep till I see you.
 I suppose tin's not afloat. I have to pay a bill of £100 on Monday and have
only 50 as yet assured. If there were any floating tin, I could with certainty
repay it in a day or two as soon as I get the money from the purchaser of my
Hamlet,[2] to whom I have written and who is sure to pay on the nail. But if you've

none by you, <u>don't on any account</u> bother yourself--least of all ask Ruskin. I shall be all <u>right</u> somehow--this is only written <u>in case</u> of possibility.

<div align="right">
Your affectionate

D.G.R.
</div>

P.S. Your dinner was splendid in itself and a great success socially--I hope Kate did not get fagged--I was delighted to see her looking so much better.
P.P.S. I have heard from Whistler all right.

[1]Responses to subscribe to the Cruikshank Testimonial from Frederick Leighton (1830-96), G.F. Watts (1817-1904), Michael Frederick Halliday (d. 1869), and H. Mark Anthony (1817-86), all artist friends of DGR. James Anderson Rose was a solicitor-patron of DGR.
[2]A water-color dated 1866 illustrating Ophelia's return of letters and presents to Hamlet (Surtees 189). The purchaser was A.T. Squarey.

21. DGR to CAH. *16 Cheyne Walk, Tuesday night,[?]14 August 1866]. Is expecting crossed cheque for £105, needs assistance of CAH in cashing, wonders if CAH can do so if he goes [to Boulogne on errand for Ruskin], warns him not to go because of cholera scare.

22. DGR to CAH *16 Cheyne Walk, Chelsea
 21 August [1866]
My dear Howell,
Many thanks from me to Kate for the flowers which are serving my turn splendidly.
 I wanted to speak to you about 2 matters. The first is that poor devil W.S. Burton.[1] Do you think (confidentially) that you could mention his case to Ruskin? You know he painted once a picture of <u>The Wounded Cavalier</u> which I believe R. noticed with praise in his Notes of that year. Burton is in the most pitiably destitute state, constantly coming on me in one form or another. I have done all I can in various ways, and am <u>à bout de ressources</u>.
 The other matter is that I am expecting probably to receive another blessed crossed cheque. Could you transact its passage through the bank from your present distance? I know not. But if so, how?
 I hope you and Kate are flourishing at Dover. Send me your exact address and believe me (with love to her)

<div align="right">
Your affectionate

Gabriel
</div>

P.S. Did you see "Swinburne's Folly"[2] reviewed in <u>Pall Mall</u> last night 20th.

[1]William Shakespeare Burton (b. 1830), exhibited at the Royal Academy and the British Museum (1846-76). On 3 April DGR wrote to F.M. Brown that "that poor devil W.S. Burton keeps writing to me and I have just sent him £10 by subscription with two other artists" (D-W, p. 595).
[2]<u>Poems and Ballads</u> was greeted with "unequivocally expressed disgust, by the press, generally," said the <u>Athenaeum</u> (18 August, p. 211), and the book was withdrawn. On 4 August the <u>Saturday Review</u> had called Swinburne "the libidinous laureate of a pack of satyres." DGR, though on Swinburne's side, thought him unwise to publish some of the poems.

23. DGR to CAH *16 Cheyne Walk, Chelsea
 25 August 1866
My dear Howell,
Many thanks for your note. I sent in the cheque to your bankers and telegraphed to you at the same time this morning, so I dare say I shall get your cheque on Monday. The cheque is from Cowper--half the price of the <u>Beatrice</u>,[1] he having proposed himself such payment on account.
 I am delighted to hear how you are all enjoying yourselves. Pray give my love to Kate and kindest regards to all. Tell Kate her roses are half the picture now, which they have quite transfigured. That idea of suffocated croppers is really too frightful. In Cholera time such a pressure on the constitution is hardly safe. You should tell Kate to let you have a good lie or two now and then, even if only on Sundays.

I saw the bard[2] last night at Brown's, having run up from Knebworth[3] but going back again. He seemed in high feather, delighted with Lytton who really appears to give him a friend's advice--which I needn't say he doesn't take. He has of course settled with Hotten.[4]

Your advice about Burton is much the best plan, and something of the sort had passed through my own head. I fear it will be only too easy to get him to write to Ruskin. I only think it possible he may have used R. up long ago. However it is a desperate case and something he <u>must</u> do. After R. has heard from him, when you speak about the matter, I have no objection to have my name mentioned in corroboration of the facts.

<div align="right">

Your affectionate
Gabriel
</div>

P.S. I have had a letter, and now a call, from Chance[5] wanting that Turner. Please write him word when he can get it.

<div align="center">

Mr. Chance
28 London Street
Tottenham Court Road
</div>

[1]<u>Beata Beatrix</u> (Surtees 168), which Mrs. Surtees says was begun at an unknown date and completed for the Honble. William Cowper-Temple in 1870. It was CAH who saved the picture from destruction: he found "it in a very dirty condition and without saying a word to Rossetti took it away and had it relined, bringing it back to him in a most inviteable state to work upon and with Howell's persuasion and entreaties he took fresh heart of grace and completed it" (Surtees quoting unpublished Dunn papers). There are no roses in the picture; they were probably for <u>Monna Vanna</u> (Surtees 191, 1866), which DGR wrote to his mother that he had been working on (D-W, p. 602).
[2]Swinburne.
[3]Lord Lytton had invited Swinburne to visit him at Knebworth and "talk things over." It was while there that he received a letter from John Camden Hotten, offering to take over <u>Poems and Ballads</u> from Moxon, the original publisher (Jean Overton Fuller, <u>Swinburne: A Critical Biography</u>, London, 1968, p. 154).
[4]A reference to the complicated dispute between Hotten and Swinburne over publication of ACS's works. It was far from settled and dragged on for years. Contrary to an ugly story in Dr. Williamson's <u>Murray Marks and his Friends</u> (pp. 147-49), such evidence as exists shows that CAH acted as ACS's friend in the matter.
[5]James Henry Chance, a carver and gilder.

24. DGR to KH. *16 Cheyne Walk, Monday,[?27 August 1866]. Thanking KH for roses, requesting more [presumably for <u>Monna Vanna</u>].

25. DGR to CAH

<div align="right">

[16 Cheyne Walk]
Thursday, [September 1866#]
</div>

Dear Owl,
J.A. Whistler/14 Walham Grove/Walham Green.
 I thought you told me Ned Jones was giving the boy[1] £60 for the <u>St. Dorothy</u> besides weekly wages. If so, I should have to do the same sort of thing according to the amount of work in the picture on which I employed him. I will write to Ned or see him about it.

<div align="right">

Ever yours,
D.G. Rossetti
</div>

P.S. If writing again, let me know where those <u>Ainsworth's Magazines</u> are.

[1]C. Fairfax Murray. See n. 1, Letter 27.

26. DGR to CAH. 21 November 1866. Wants to borrow drawing of Sandys's sycamore tree, doesn't know otherwise how to get tree "in my little picture done in winter."

27. DGR to CAH *16 Cheyne Walk, Chelsea
 15 December [1866]
My dear Howell,
We were talking of Murray,[1] but did not settle anything. However, the first
day he can spare, from Ned's, I should like him to come down, as he could begin
a copy of the Beatrice[2] at once. But before naming it to him would you write me
a line to say what pay I ought to be giving him. I think you said Ned gave
25/- a week, and you told me he was to give him £60 for a copy of St. Dorothy.[3]
Now these terms would suit me very well if the payment of the picture were only
to be when I received payment for it.
 Yours affectionately,
 D.G.R.

[1]C. Fairfax Murray (1849-1919), one-time assistant to DGR and later a noted
collector. Writing to Samuel Bancroft in 1893 (HRC), Murray said that when DGR
saw some of his work in the studio of Burne-Jones, DGR asked him to make a copy
of one of the Dante pictures. He continued: "I am nearly certain that my first
attempt in Jan. 1867 was made on a canvass that had been spoilt by Dunn, but it
may have been Knewstub's work....I failed like my predecessor, at the time, and
altho' I was a constant visitor did not undertake any work again for him till
1869-70. I then copied the hand of the Sibylla Palmifera and also made two
copies, both of which were completed by DGR of Lucrezia Borgia washing her hands.
In 1871, I went to Italy and that stopped my work definitely, but it was not
very satisfactory to him though he praised the Palmifera copy highly...."
[2]See n.1, Letter 23.
[3]A water-color of this time painted by Burne-Jones and exhibited at the Old
Water-Colour Society in 1867.

28. DGR to CAH 16 Cheyne Walk, Chelsea
 Thursday, [1866]
My dear Howell,
Though very reluctant to worry you, I must say I am beginning to be anxious as
to the prospects of the Cruikshank Testimonial unless the List of Committee is
now immediately issued. Committeemen are constantly impressing on me the
absolute necessity of this, and I entirely concur. Many can do much if the papers
were to be had, and nothing without. If the London Season goes by (being now far
advanced), it will be almost impracticable to produce any effect when everyone
is scattered far and wide.
 I almost judge that you must consider delay beneficial for some reason, but I
cannot conceive any which at all counterbalances such evils, amounting indeed to
the almost complete failure of any further efforts, unless the List is now
in a day or two in every committee-man's hands. I do not think the question of
getting the R.A.'s to join the 1st List, if that is the cause of delay, is of
nearly such vital importance as other questions. Surely the printer cannot be
the cause of delay. If so, and if you have not time to be always at him, let me
know at once, and Loader shall become an inhabitant of St. Martin's Lane till
the lists are produced. But pray, my dear Howell, do let us get it done.
 Your
 Gabriel

29. DGR to CAH. *16 Cheyne Walk, Friday, [1866]. Urgent request for Cruikshank
papers, hopes doctor has seen KH's mother.

30. DGR to CAH [16 Cheyne Walk]
 2 January 1867
Dear Owl,
Many thanks for your very kind letter and information. I'll certainly send
Loader as soon as possible, but today we're all snowbound here, including my
mother and Christina who slept here last night and can't get home. The garden is
like the North Pole--really a most splendid sight.

All my drawings shall be at your service to choose from. I'll send the
Wainwrights[1] if I send, but if practicable shall come myself on Friday evening--
supposing that suits you. I am excessively sorry to hear how seedy you have
been and should propose coming tomorrow, were it not that Scott[2] has asked me.
 Ever your
 D.G.R.

[1]Drawings by Thomas Griffith Wainwright, who exhibited at the R.A. from 1821-25;
suspected of murdering his sister-in-law and afterwards transported for forgery
(Bryan).
[2]William Bell Scott (1811-90), minor poet and painter; a friend of DGR's who
afterwards in his Autobiographical Notes (1892) made some ill-natured remarks
about DGR.

31. DGR to CAH Monday, [11 February 1867][1]

My dear Howell,
I am going to see Boyce[2] this evening, and I judge from a letter in which he
sends you his love (he had done so also once before) that he is a little hurt
at not having seen or heard from you in his illness. If you could dine here
today at 6, we would go round together afterwards. He is leaving town on Thursday
His address is 5 Park Place Villas Maiden Hill West which is his mother's house.
Infection it seems there has never been--
 As regards tin, I am only answerable for £100 of the £500 outlay, and the only
thing which has prevented the Carol[3] reaching you yet is the degree to which I
have worked on your Venus drawing.[4] This and 3 others--that is 4 out of the 5--
are now ready for delivery, though I may possibly do more to the Triple Rose
drawing,[5] which nevertheless is finished as it is. I know, my dear Howell, that
you did not for a moment mean to complain of my proceedings, and that being so--
let me say frankly that I really think we had better be off the bargain for the
5 drawings and this wholly and solely for your sake--they are not marketable
commodities--at least only so by a fluke sometimes, and if you are bent on
keeping any of them they are all the worse as an investment. I shall be all
right as I will raise funds elsewhere--My reason for sending to you is wholly
the Boyce question.
 Your affectionate
 Gabriel

The Carol shall reach you in a very few days--I would say tomorrow or next day,
but may be forced to work first at the Dragon drawing[6] on certain accounts.
Valpy asking one for Tuesday--tomorrow week!

P.S. If you could not get here by 6 to dinner, 7 would probably be early enough
for going to Boyce's.

[1]I derive the date from WMR's diary for 16 Feb. 1867 (RP, p. 224) stating that
The Christmas Carol was now finished.
[2]George Price Boyce (1826-1897), water-color painter and friend and patron of DGR
[3]The oil of 1867 (Surtees 195), not related to an earlier water-color of the
same title.
[4]Probably Surtees 173A (Venus Verticordia), a chalk drawing which has initials
and date "AD 1867," though it went to Leyland, and I find no association with
CAH.
[5]Apparently Surtees 238A, which has a monogram and the date "1867"; possibly
Surtees 238B, dated "c. 1867."
[6]DGR had earlier done six designs of the Story of St. George and the Dragon,
five of which came into the possession of CAH. One (Surtees 146) was done in
water-color over India ink and bears the date "1868." It is uncertain exactly
which the one here referred to was.

32. DGR to CAH. Friday, [22 February 1867, established by WMR's diary]. The
Lumpses always asking why CAH doesn't come. DGR hasn't seen him for "whole age."

33. DGR to CAH. Friday, [22 March 1867, confirmed by WMR's diary]. Request for CAH to buy the Botticelli at sale next day if it goes very cheap.

34. DGR to KH *16 Cheyne Walk, Chelsea
 31 March 1867
My dear Kate,
Many and many thanks for the promised frame which will make the mediaeval lady's portrait a pleasanter thing still to me, as including memories of a modern one.[1] It is most kind of you. I shall trust to Charley's making an exact appointment for the visit you promise me at the time you name--i.e. in about a fortnight.
 I am afraid you have not escaped the effects of this trying weather. I thought I had, but have just now been pounced upon with my first sore throat this year.
 You know I expect Charley to dinner on Tuesday at 7, or as much earlier as he pleases.
 My mother has been very poorly, but is now much better again; indeed I trust in her usual health which is good. I hope you are less anxious now about Mrs. Howell,[2] and with kind remembrances to all at York Villas,
 am yours affectionately,
 D.G. Rossetti

[1]Presumably Monna Vanna (Surtees 191, dated "1866"), the title for which came from the Vita Nuova.
[2]Kate's mother.

35. DGR to CAH *16 Cheyne Walk, Chelsea
 20 April [1867]
My dear Howell,
Will you dine here tomorrow (Sunday) and come as early as you can. As to your P.S.--of course, when I see you.
 Howard's[1] letter shows what a good fellow he is, but I think law quite out of the question in such a case. It would only bring ridicule on Legros,[2] who at present escapes it in all opinions worth having. It is quite a mistake, according to the account I had from Luke Ionides[3] who was present, to say that Legros did not defend himself--he did, but Whistler knew how to use his fists, and L. didn't. I have already given my opinion to Whistler so strongly that I do not even know exactly how he may take it; so am at liberty to say now that I do not think the affair, if it stops here, quite amounts to a cause for cutting W., considering his other good points, however utterly in the wrong he has been in this matter, and though my own first impression was just yours. Of course it will introduce a painful limitation into one's intercourse with him. The truth is, this affair had been rankling so long on both sides that something had to come of it sooner or later, and at last it occurred in hot blood.
 You know Ionides asked me from Whistler to manage the money affair. I said yes to W. (if wished) at first, giving my opinion without reserve at the same time, but next day on further reflection wrote to W. again to say I could not do it. I find W. is at present in Paris. Of course show this note if you like. Love to Kate whose improvement I rejoice to hear of.
 Your
 D. Gabriel R.

[1]George Howard (1843-1911), later 9th Earl of Carlisle, who subsequently employed CAH in the decoration of his new house (information from a letter of 1 Jan. 1869 from Howard to CAH in the John Rylands Library).
[2]Alphonse Legros (1837-1911), born in Dijon but came to England in 1863; Slade Professor of Fine Art, University College, London (1876-93). Stanley Weintraub (Whistler, N.Y., 1974, p. 88) quotes DuMaurier as writing in Nov. 1863 that "Jimmy and Legros are going to part company, on account (I believe) of the exceeding hatred with which the latter has managed to inspire the fiery Joe [Joanna Heffernan]...." The break, says Weintraub, did not occur "till several years later, the subject supposedly money Whistler claimed was long owed him." WMR later told the Pennells that "the real cause was women." At any rate when the two met in the office of Luke Ionides, Legros provoked an attack by Whistler when he called him a liar, whereupon Whistler promptly knocked him down.

Member of a prominent family in the Greek colony of London who were friends and patrons of Whistler and other artists.

36. DGR to CAH. *16 Cheyne Walk, Monday, [April 1867#]. Asks CAH and KH not to shriek when they see Botticelli, as he has been restoring head-dress.

37. DGR to KH *16 Cheyne Walk, Chelsea
 2 May 1867
My dear Kate,
As it is good to know the precise nature of a slanderous insinuation, I have thought it better to give you the opportunity of learning exactly what it is that Charlie has had the coolness to call you for some time past. Here according come two Licka Dormeuses to remind you continually of his extreme freedom of speech.
 Your two namesakes require to be nourished on apple-slices, hazel-nuts, rusks, hemp-seed, and any delicacy of the season--I am told that they will be sure to get bigger, but that at present they are not to be met with on a larger scale till a later season of the year.
 I hope you'll come and see me one day with Charlie and that I shall then see you all right again as I hear you are.
 Affectionately yours,
 D.G. Rossetti

38. DGR to CAH. [9 May 1867]. Postponing Friday dinner, is unable to go to Dulwich on Monday.

39. DGR to KH *16 Cheyne Walk, Chelsea
 10 May 1867
My dear Kate,
Of course I shall come Monday with the greatest pleasure--infinitely rather than dining at home; and of course when I wrote I had not received a positive impression that there was any actual appointment otherwise than for going to Dulwich which my work prevents me from doing, much as I should like it in some ways. Certainly I now remember that we were coming to York Villas in the evening, but had no idea that there was a party of several invited.
 The ululations of a dejected Owl which reach me together with your letter excite my sympathy and remorse. Will you either scratch his poll or stir him up with a stick, whichever your knowledge of his instincts points out as most adapted to his present condition, and tell him I shall not bring my raven to bite his head off, and therefore hope he will leave mine on my shoulders when I see him, though indeed it is sometimes a very foggy oblivious and unserviceable head,--mine I mean.
 The appointment for today I had not forgotten however, for I never knew of it at the time. Will you assure the aforementioned Owl that here in the studio or the aviary--or shall I say more poetically--on the hearth and in the heart--his perch is ever reserved for him.
 Your affectionate
 D.G. Rossetti

P.S. I'll suppose dinner to be at 8, considering long days and distance, but if otherwise will you kindly let me know.
P.P.S. Moreover I wrote half asleep at William's last night, or rather this morning at 2 a.m.

40. DGR to CAH *16 Cheyne Walk, Chelsea
 28 June 1867

My dear Howell,
The recent tope tells on our friend's clearness of head, but let us trust when he turns up next week, he will not have been so lately turned off, and may be calmer. Any day will suit me.

Thanks for all your trouble in the money matter. I have made a note of.
I've been reflecting helplessly on my recreant relation to your wedding.[1]
But after all I __am__ a bogie and there's no help for it. So I must just tell you
to give Kate my love, and need say no more, for you both know all I would say,
and what I hope for you both. One thing is,--even she will find it hard to be
fonder of you than your friends are, nor can you yourself easily believe more
in her than those among us do who know her the best.

<div align="right">

Your affectionate
Gabriel

</div>

[1]Set for 21 Aug.

41. WMR to KH 56 Euston Sq. N.W.
 30 June [1867]
Dear Kate,
You are one of the persons whose wedding--and that to another person of like
kind--I shall attend with pleasure: only don't let Charles bespeak me, as he
has aforetime shown morbid symptoms of doing, for best man, as he will easily
find some one better adapted to those delicate and festive functions--less
middle-aged and less glum. You know how truly I wish both of you all happiness,
or I might need to dilate more in the expression of these aspirations. No doubt
I shall get good notice of the precise day: it is not unlikely that I may be in
Scotland the first few days of August (I expect to start thither somewhere
about the middle of July)--but my absence would under any circumstances, I
think, not last beyond those first few days. Give my best love and sincerest
congratulations, please to Charles.
 The packet to be stamped arrived duly on Thursday--Friday was a public holiday.
I have not the faintest idea as yet where to take it to--but shall find out, and
do what is needful in a day or two. It would have been done already, but that
I am especially busy at Somerset House:[1] however I did yesterday make a
beginning of finding out what requires to be done. You see we red-tapists are
sometimes as densely ignorant, even of these things, as other mortals.
 Will you remember me very kindly to your mother, and believe me and all of us
(moving going on very well)

<div align="right">

Your true friends,
W.M. Rossetti

</div>

I see that is wrong grammar but never mind.

[1]Where William was employed in the Excise Office.

42. CGR to KH 56 Euston Square, N.W.
 Tuesday, 2nd [July 1867]
My dear Kate,
(For I count on your kindness to pardon the friendly freedom.)
 I am truly pleased to receive from you and Mrs. Howell so very kind an
invitation to be with you on what will I hope be a happier day than you have
yet experienced, and my heart warms towards you and Mr. Howell and wishes you
both every possible blessing. Your and his wedding day has for me a dear and
special interest. Pray then believe that it is only because I am quite uncertain
about being in town on the 21st August that I do not accept what it would give
me such special pleasure to accept and be sure that I shall not be unmindful of
your happy change: indeed if I __am__ in town I may manage to get an unobtrusive
glimpse of you in Church after all.
 Please offer my compliments to Mrs. Howell with my grateful thanks to her for
her goodness, remember me to your Cousin till I may call him something more,
and believe me

<div align="right">

Affectionately yours,
Christina G. Rossetti

</div>

43. DGR to CAH. *16 Cheyne Walk, Wednesday, [?July 1867]. Invitation to join Leyland at dinner next day. Leyland has not yet seen letter of Murray Howell [see n.3, following letter] but DGR has spoken to him about matter.

44. DGR to CAH [16 Cheyne Walk]
 [?July 1867][1]
Dear Owl,
Your letter which is a Ballad of Burdens has arrived. It calls for congratulations and condolences both for yourself and others. Valpy's probable execution is melancholy but let us hope final.[2]
 I have just sent on Murray's[3] letter with explanation to Leyland. I thought it unnecessary to enclose the other which I return.
 I am sending your list to Shields. It seems to me you must have got details from Sandys, and that he therefore is willing to sell. I saw him once since-- told him about Hotten. He said he had called there twice but H. was out. Also that he had rather the sketches were not sold--also that he was daily expecting £300 etc.
 Shields to whom I spoke yesterday is going to see the sketches at Hotten's. McConnel[4] who is the buyer in prospect is away just now for several weeks.
 Ever yours,
 D.G. Rossetti

P.S. I've got the £9. Of course it would be better not to renew, but I don't see my way. Sacrificing a drawing to Gambart would be worse as more than £9 would be lost that way.
 Agnew is coming to see me but mayn't come before then and mayn't buy.
 Your
 D.G.R.

[1]The contents of this letter are akin to those of DGR's letter of Saturday, [July 1867] in D-W, p. 623; in both letters DGR was awaiting a visit from Agnew, there is mention of Valpy, and DGR has sent Murray Howell's letter to Leyland (though D-W misread the reference to Murray Howell and insert the verb says between the two names).
[2]Possibly a reference to Valpy's engagement and forthcoming marriage. He was a solicitor and patron of DGR.
[3]Murray Howell; see Introduction, p. 5.
[4]Shields saw DGR's water-color of Tristram and Yseult at T.H. McConnell's in Feb. 1868 (DGRDW, pp. 62-63).

45. CGR to KH 56 Euston Square, N.W.
 Monday, 5th [August 1867]
My dear Kate,
Maria tells me that your exceptional kindness will allow of my altering my mind now that I find I shall be in town on the 21st. May I then after all have the pleasure of seeing you married? My sister goes to Brighton tomorrow for a month with our Mother, so she cannot hope to be with you: but please as her substitute and as my precursor accept the cardcase which accompanies this. It refuses to hold ladies' cards; but perhaps you will like it as a pretty bit of carving, or perhaps Mr. Howell will use it as your proxy.
 Mamma and Maria join in affectionate congratulations. Pray offer my compliments to Mrs. Howell to whom I hope so soon to be introduced, remember me to Mr. Howell, and believe me truly
 Your affectionate friend,
 Christina G. Rossetti

46. DGR to KH *16 Cheyne Walk, Chelsea
 Tuesday evening, [?August 1867]
My dear Kate,
Will you give me the pleasure of accepting from me for yourself and Charles a dinner service of green and white china all over dragons.[1] I believe it will reach you tomorrow. I am sorry to say it has somebody's initials on each piece-- being T.M.H. The last letter however is appropriate enough; for the others,

nothing remains but to ransack the past for an ancestor and fix the traditional possession on him, or else indeed to trust to the future of the family for a fortunate coincidence of initials.

Hoping to see you soon, and with affectionate remembrances, I am

<div align="right">Most sincerely yours,

D.G. Rossetti</div>

[1]A wedding present.

47. DGR to KH　　　　　　　　　　　　*16 Cheyne Walk, Chelsea
<div align="right">Saturday, [?31 August 1867]</div>

My dear Kate,

I'm quite grieved to hear of poor Charlie's being "took bad" just now. I needn't tell you to take care of him. Still, however sure I am of your own anxiety to do this, I think if you had heard us talking about him at Webb's[1] last night, you would almost admit his friends to an equality with yourself in such anxiety. The fact is he is the darling of our circle and must be taken care of for all our sakes. Webb, Morris, Brown, Scott, myself, and even Leyland who was present all voted him a treasure and a joy of our lives. Indeed one has not a habit of saying these things strongly enough at most times, so let this appropriate moment of happiness in your life and his be chosen to tell you how dear he is to his friends.

I saw Murray Howell the day after the wedding[2] and gave him a letter to Rae (of Liverpool)[3] and some photos which he kindly undertook the charge of to deliver to that gentleman. He seemed to me in good spirits and much brightened by better prospects.

Dunn[4] sends his kindest regards to both of you. The degree to which he has improved in copying my things is extraordinary, and I now perceive that he will prove most valuable to me.

About the china, any time will do. If I find it convenient I will send soon, but if not, after your return. At any rate the things are not wanted in the least, so pray do not let your Mamma give them a second thought.

With love to both of you

<div align="right">I am your

D. Gabriel R.</div>

[1]At the house of Phillip Webb, architect and member of the firm of Morris, Marshall, Faulkner, & Co.
[2]Which occurred on 21 August at St. Matthew's Church, Brixton (see Introduction, p. 5).
[3]A Birkenhead banker and patron of DGR.
[4]H. Treffry Dunn (1838-99) now DGR's assistant. He was introduced by CAH, perhaps as great a favor as he ever did DGR, as DGR later thought.

48. DGR to CAH　　　　　　　　　　　　[16 Cheyne Walk]
<div align="right">[August 1867]</div>

My dear Howell,

I've heard such good news of Murray [Howell] that I must tell you. Leyland, whom I saw yesterday, says he "works like a nigger." Old Miller[1] writes me twice about him. First "Young Howell who is a very fine young fellow I will do everything I can for." And again:--"I am glad to hear that you take so much interest in my young friend Howell who is a fellow lodger with 2 of my sons who like him much and to me he seems a very fine lad."

So let us hope all will be well. I am going to send him the letter for Rae forthwith.

<div align="right">Your

Gabriel</div>

Love to Kate.

[1]John Miller, a picture collector of Liverpool.

49. DGR to CAH Lymington
 Sunday, 15 September [1867]
My dear Howell,
Here I am, you see. There's that affair of the deacon Harris (£24) on the 1st
October. Will the bill be presented at my place, or what? I've got the tin all
right. At any rate I don't want you to be troubled about it. What are we to do?
 I hope Kate is well, and yourself also. Love to her. I have only been here
2 or 3 days, with Allingham[1] who sends all sorts of things. I don't know
whether I shall be back by 1st October but I suppose most likely. I thought I'd
write at once lest you should be in doubt about the bill.
 How about coming as you hinted? Accommodations here being of the Noah's Ark
kind. Allingham and I would entertain you between us; but I dare say you'd
manage all right. Only I feel rather criminal towards Kate in referring to such
a possibility.
 Your affectionate
 Gabriel

[On side of p. 1:] My dear Howell--You shall be most welcome if you can come,
and walked off your legs, and then slept on them again. Name day and train--
yours always, W.A.

[1]William Allingham (1824-89), Irish poet and friend of the Pre-Raphaelites;
customs officer presently assigned to Lymington. DGR arrived for a visit on 11
September (D-W, p. 633n).

50. DGR to CAH. Sunday, [20 October 1867#]. Cancelling visit to CAH, as he
always spends Sunday with Fanny, will make another appointment when he has
anything to show.

51. DGR to CAH [16 Cheyne Walk]
 1 November [1867]
Dear Howell,
Red Lion Mary[1] of whom you have heard me speak married a man named Nicholson
who is a respectable man and a capable one I believe in a line fluctuating
between a barrister's clerk and an electioneering agent. He has now been
entirely without employment for a whole year and the family are literally
starving, though being decent people they try to hide it as well as they can.
I have assisted them to the best of my power, but the best thing would be to
try and find employment for the husband. I have now given him a letter for
Valpy but don't know what may come of it.
 As you are one of those exceptional fools who take an interest in people
according to their need of it, I write you a line to ask if it would be any use,
for poor Nicholson (whom I do not know personally but believe to be a good and
competent fellow) to call on you in case anything suggested itself through
conversation as to finding him work.
 Your
 Gabriel

[1]Mary Nicholson, the "plain, shrewd, good-tempered, resourceful little cockney,"
as Doughty (p. 208) described the maid-of-all work in the rooms occupied
formerly by DGR and Walter Deverell.

52. DGR to CAH *16 Cheyne Walk, Chelsea
 Monday, [January 1868]
Dear Howell,
Thanks for the cheque. I fear it's been a trouble to you--or rather would have
been to any less genial Owl.
 Valpy's affair is off, so I suppose there's no need to think about showing
him drawings just now.
 It seems after all Matthews' letter which I sent back was a humble apology,
and Halliday has just called on me with the critur's remorse and desire of
reconciliation.[1] I will tell you the circumstances when I see you. I'm going to
take old Brown's advice on the matter.

Love to Kate. Come soon. I want to see you. Look in tomorrow or next day.

 Your
 Gabriel

[1]See n. 3, following letter. Michael Frederick Halliday, amateur artist, was a
friend of both DGR and Matthews.

53. DGR to CAH *16 Cheyne Walk, Chelsea
 Friday, [January 1868]
My dear Howell,
Wednesday next will suit me well to dine with you.
 On looking again at that Loving Cup[1] I find something could be made of it if
necessary. The price in that case ought to be 100 guineas but I would take 80
from any friend of yours if the 100 could not be got. Or else there is the
larger drawing--Dragon business[2]--I merely mention these matters, but dare say
nothing is feasible.
 Matthews has written a very penitent letter and I am to see him shortly, so
probably all will be well[3]--Look up
 Your affectionate
 D.G.R.

P.S. The Christmas Carol[4] is getting toward completion.

[1]DGR had painted an oil of this title, dated "1867," for Leyland (Surtees 201).
On 10 February 1873 DGR wrote to F.M. Brown (D-W, p. 1135) that he had done
three water-color replicas of it but gave no date, which Mrs. Surtees surmises
to have been 1867. The reference here is doubtless to one of them.
[2]?St. George and the Princess Sabra (Surtees 146, dated 1868 by Mrs. Surtees).
[3]C.P. Matthews, a wealthy brewer, had commissioned Aspecta Medusa for 1500
guineas but later refused it because of the Medusa's severed head (Doughty,
p. 341). Matthews called on DGR on 31 January, however, and the breach was
healed (RP, p. 296).
[4]Surtees 195, initialed and dated "1867" but not finished till early 1868.

54. DGR to CAH [16 Cheyne Walk]
 Tuesday, [?11 February 1868]
Dear Owl,
Graham will have the 3 Roses[1] and take it with him when he calls before long.
I suppose he will then also pay.
 About our conversation yesterday. I certainly understood you to say that the
encouragement of the Lucrezia[2] to Ellis if I did my best with it (as I think I
did) would be such that he would be willing for the future always to go and do
likewise in case of need. Indeed I had a letter of yours which urged this view
while I was working on the Lucrezia, but I dare say it is lost. The difficulty
you raised yesterday "What is Ellis to do if he finds he can get it cheaper
than the sum named?" is of course nothing to the purpose as regards my
interests--the point in question being that it should be bought not below a
certain sum. Otherwise it would be much better for me not to direct the
attention of a well-disposed man like Ellis to the fact that it is possible for
my work to go in in sale-rooms, and instead to let the thing just take its
chance and be heard of as little as may be. I should be happy to give 50 myself
in the present case.
 Your affectionate
 Gabriel

[1]Rosa Triplex, a chalk drawing dated "1867" (Surtees 238A), bought by William
Graham, M.P. for Glasgow.
[2]Lucrezia Borgia, a water-color of 1860-61 (Surtees 124), acquired by B. W.
Windus. Gabriel's concern here is that Windus's pictures were being sold at
Christie's on 15 Feb. 1868, and he feared that the Lucrezia might go at such a
low price as to affect his market. WMR (RP, pp. 299-300) says that by pre-
arrangement with CAH it was run up to £70. As Mrs. Surtees says, the history of
the picture is confused. She does not mention F.S. Ellis in connection with it,

but CAH must have been acting for Ellis at the Windus sale, as in Letter 63 DGR speaks of CAH's handing Ellis £50 as his profit on the picture. The later history of the picture is still more confusing.

55. DGR to CAH [16 Cheyne Walk]
 Monday, [?2 March 1868][1]
Dear Howell,
I've not tackled the Borgia yet, and don't know whether I shall be able to show it to Leyland on his coming to town--you don't tell me when. However I will if in a showable state by then, but do not mean to show it till altered, and have much to do on all hands.
 I had better not keep you waiting about the parcel to Leyland's, but will write to F. and D.[2] when ready and send off my section by itself. If not to-day, then Wednesday, I hope to get the things ready to go, but there is a little to do to two of them.
 I should be really glad to talk to you on various points if you could look up tomorrow (Tuesday)(say) at 5, and we'd either dine out together or dine here. Do come.
 Your affectionate
 Gabriel

P.S. I'm afraid I can't afford the print, I gave the picture to Rose.

[1]Dated 9 Mar. (a Monday in 1868) in the hand of CFM. But the letter obviously precedes Letter 56, which can be dated 5 Mar. with certainty.
[2]Foord and Dickinson, picture framers.

56. DGR to CAH [16 Cheyne Walk]
 Thursday, [5 March 1868]
Dear Howell,
The brandy has just come, and I will pay for it when I see you, as there was nothing in the house but a big note.
 Do you think you can secure me £50 if not the 100 for the 5 drawings[1] by the 18th of this month, as I then have a bill for that amount coming due, and should thus be free to work when Janey Morris[2] comes to sit, without thinking of pot-boiling for the moment. She and Top are to be here next Wednesday to stay. Would you dine here that day with them. I want to see you, but that must be always the cry of your friends.
 What a triumph Ned's party was![3] Nothing like it ever known in the circle.
 I am getting the Lucrezia really good now I think, and shall finish it straight off, and it certainly ought not to sell for less than 120 guineas. Indeed I cannot doubt that may be got for it, and shall advise Leyland to buy it with a good conscience. I wish you'd keep me informed as to that infernal report of farther things of mine for sale. Anything done with Carol.[4]
 Your
 Gabriel
 On Saturday I'm going to Matthews[5] in the country. Could you look in to dinner tomorrow?

[1]One of the five was a drawing of Venus Verticordia from which DGR painted the water-color (Surtees 173 R.2) bought by George Hamilton. (See Letter 58 and RP, pp. 302-03.)
[2]From this time on, DGR's favorite model, with whom he was in love. She and "Top" or "Topsy," her husband, came to stay with DGR on 11 March "for some few days" (RP, p. 302) while Janey sat for La Pia, for which DGR made several studies.
[3]A note at the bottom of the page dates the party 4 March, confirmed by RP, p. 301.
[4]See n. 4, Letter 53.
[5]See n. 3, Letter 53.

57. DGR to CAH [16 Cheyne Walk]
 Wednesday, [11 March 1868]
My dear Howell,
Don't forget Friday dinner at 6:30--Top and wife coming.
 I wrote to Leyland offering Lucrezia at 120 guineas and expected an answer
this morning but it has not come yet. The drawing will I expect be finished by
Friday.
 I'm very unwilling to bother you, but do you think that £100 for the 5
drawings could be managed now--i.e. 50 now and 50 by the day I named before?
Funds are exhausted and I want to be doing Janey's picture which is not
potboiling. If the whole thing is a nuisance to you, say so, and I will try to
dispose of the drawings at once elsewhere.
 Tibullus[1] will soon I hope be in Marks's hands. I suppose B[irket] Foster did
not buy the Carol as I did not hear from you to that effect. I meant to have
talked of these things the other night, but 2 big Greeks[2] were in the way.
 Your affectionate
 Gabriel
P.S. Of course an answer on Friday when I see you will do as to the money
matter.

[1]The Return of Tibullus to Delia (Surtees 62 R.2). On 20 Feb. DGR wrote to
Marks that it "will be done in a month" and in an undated letter to Marks said
that it would be his "first job to follow" Mrs. Morris' sittings (Williamson,
p. 59). Marks had not commissioned the picture but was apparently being kept in
reserve by DGR to act as agent in case he himself failed to place it.
[2]Members of the Ionides family.

58. DGR to CAH [16 Cheyne Walk]
 Monday, [16 March 1868#]
Dear Good Owl,
Don't be in a rage. Just today turns up my necessity of one of those wretched
drawings you took away. Leyland writes that he is going to call tomorrow with
a bloke named Hamilton[1] who collects daubs and wants something of mine. So as
I'm going to do the Venus like the drawing and he might order it I ought to
have the drawing here. My messenger will take it now and bring it back to you
on Wednesday if that will do, as I believe you only want it for Thursday.
 Your affectionate
 Gabriel

[1]"Tuesday, 17 March.--Leyland brought round to Chelsea a Mr. [George] Hamilton,
partner of Graham, M.P. for Glasgow:...Hamilton bought for £300 a water-colour
copy, on a goodish scale of size, of the Venus picture" (RP, pp. 302-03). As
the picture was in the Graham sale at Christie's (3 Apr. 1886), he may have
been acting for Graham (Surtees 173 R.2). Boyce, calling on DGR on 27 Mar. says
that "he has altered and partly repainted his Venus picture, making it much
finer..." (Diary).

59. DGR to CAH *16 Cheyne Walk, Chelsea
 Tuesday, [?24 March 1868]
My dear Howell,
Valpy has asked me to meet you Friday next at 7:30 to dinner. As you are going
I accept, so take care you do go--
 Many and many thanks for yielding me the cabinet which looks splendid. It has
displaced an old foe of yours and Janey's--a black chest of drawers in the
first floor bedroom.
 It has arrived quite perfect except for one half of the ivory scutcheon on
the upper keyhole. Surely this was all right when I saw it at your place--was
it not? It has been looked for here in vain. Is there a chance that it might
be found knocked off on your staircase or elsewhere? If not I must have one
made.
 Love to Kate whom I must inveigle to fix a sitting soon.
 Your affectionate
 Gabriel

60. DGR to KH *16 Cheyne Walk, Chelsea
 26 March 1868
My dear Kate,
How shall I thank you for such a very delightful present as that lovely old
chest? It is even unreasonably treasured by me, if something which is your gift
as well as a beauty in itself can possibly be so. I had had, as I think I told
you, a pang for some years at not having secured it long ago, and here after all
you are the good fairy who enriches my house with it.
 Charley promised me that he and you would dine here next Wednesday to meet
the Morris's and Jones's. But since seeing him I have fatally remembered that
that day was already engaged with me, so I am writing to Ned to fix either
Thursday or Friday instead. I hope one of these days (whichever he may fix) may
suit you also, but if not must try and make a further change, as I want to
secure all.
 Affectionately yours,
 D. Gabriel R.

P.S. I shall be seeing Charley tomorrow evening and he can then tell me about it.

61. DGR to CAH [16 Cheyne Walk]
 Sunday, [?March 1868]
My dear Howell,
I made an appointment for yesterday with Graham to show him the Tibullus up to
3:30. He came later and I was gone out with Leyland, but Dunn showed it him and
tells me he appeared pleased. He is coming again,--perhaps it may be on Tuesday.[1]
 On seeing the drawing again I find it not disgraceful but so inferior to the
original (for which I only had 225 guineas) that I should hesitate to ask more
than 250 guineas for it. Do you like to take this price if Graham is willing?
Let me know at once without fail. You would thus have a profit of £62-10/-. I
would of course gladly ask the 300 to serve you, but am afraid of frightening
Graham.
 Your
 Gabriel

[1]Graham did not buy the picture.

62. DGR to CAH *16 Cheyne Walk, Chelsea
 Sunday, [?29 March 1868][1]
Dear Good Owl,
The Tibullus[2] goes to Marks tomorrow (Monday).
 I find there will be 14 at table on Thursday. Suppose you were to come early
and superintend arrangements! Of course I am engaging the man cook. I suppose it
would probably be wise to get another waiter besides Emma. What think you? If
you come I will confide to you the fruit and flower department (how kind of me!)
as with ladies I should like to get a nice little dessert. What do you say to a
special bottle of wine or two which you might let me have on tick for drawings?
 I hear by the way that little Swinburne is considering himself neglected, and
am almost inclined to ask him (making 15) but am rather afraid of results.
 Your affectionate
 D.G.R.

[1]Dated "Mar. 1868" in the hand of CFM; on the assumption that the dinner party
is the one given by DGR on 2 Apr., I assign a date of 29 Mar. to it.
[2]See n. 1, Letter 57.

63. DGR to CAH *16 Cheyne Walk, Chelsea
 Thursday, [?March 1868]
Dear Howell,
I'm infinitely sorry not to come tonight, and so is Topsy, but he is prevented
coming and I was so late last night that I can not face Brixton at 3 in the
morning, and really without humbug know that my own inclination would not let
me leave the owl-hutch earlier.

As to the £50 it strikes me it may really not be convenient to you not to hand it over to Ellis as his profit on the Lucrezia[1] in the first instance, after which you could perhaps get it for me again in the course of the week. Otherwise he might be disappointed and the brilliant coup of getting him this profit might fail of its effect. I must trouble you for a line again on this point as I shall get the tin tomorrow I expect from Leyland, so look in if you can.

All you say is like the brick you are.

Your affectionate
D. Gabriel R.

[1]See n. 2, Letter 54.

64. DGR to CAH Wednesday, [?March 1868]

Dear Howell,
I can't be bothered with that bad old drawing, but will finish you the full face one of Miss W.[1] if you like for 60£. In that case I'll let you have also the drawing of J.[2] which I cleaned while you were here on the terms you propose. Only I'm wanting the cash, and will when I get it finish the larger drawing at once.

Ever yours,
D.G.R.

[1]Alexa Wilding.
[2]Janey Morris.

65. DGR to CAH [16 Cheyne Walk]
 [?March 1868]
Dear Owl,
Let us gather up the ravelled threads of business. You see I mean to charge Leyland £10 for alteration to Borgia--that will be my sole profit. But I think also (as I have lost much time over it) that this would be the right moment for me to receive the other £50 for the 5 drawings--i.e. if the transaction for them is Ellis's as well as yours--What do you say? I shall be receiving immediately the tin from Leyland, and would be glad of a line from you on this point.

Ever yours,
D.G.R.

P.S. If not Ellis's transaction of course no more about it.

66. DGR to CAH [?March 1868][1]

Regiostissimo Gufo,
I find the Owl and not the Dog is the friend of man. I write with this to the best of Vampires.[2] I must treat the drawings in a foggy manner in my letter, as I do not understand if they are supposed to be all done or not. You will arrange all that.

See you on Saturday. Love to Kate.

Your
Gabriel

P.S. You said V.'s letter was left with yours in the table but I only found his envelope addressed to you.

[1]Dated on the assumption that the drawings are the ones referred to in Letters 56 and 57.
[2]Valpy.

67. DGR to CAH. [?March 1868]. Stunning news about money Morris says CAH received, will talk about it when the two meet at Valpy's. Morris enraged at DGR's possession of old chest given DGR by KH.

68. DGR to CAH. Friday, [?17 April 1868]. Postponing visit to CAH because Leyland expected. Has altered the Princess in Dragon picture. (See n. 2, Letter 53.)

69. DGR to CAH. Friday, [15 May 1868]. Hopes CAH can let him have £50 on Tuesday, is getting Venus drawing all right.

70. DGR to CAH Monday, [May 1868][1]

Dear Howell,
Here you see is another skeleton in the house.
 I suppose as Sandys appears too, that the things are probably some of Rose's again, and that mine is most likely the Bogie drawing.[2] In that case I should be very glad to give as much as 60 for it myself and think that you might safely run it up if so inclined on your own account even to 80. I would do something to it to give more richness to the colour and then it would be a thoroughly good thing. However if you bought it and I worked on it I should (when sold to advantage) have to charge a trifle for my labour, as the fortnight lost on the Lucrezia[3] will be no joke though all my own doing and well worth while for once.
 I find my banker's account running low, so when you can quite conveniently pay me for the 3 chalks (£80) you will earn the gratitude of
 Your own
 Gabriel

[1]I assign this date on the assumption that the auction to which this letter refers was that held by Messrs. Christie on 16 May. Advertisements had appeared offering "a valuable assemblage of modern pictures" (Times, 14 May 1868) by more than 30 artists, including DGR and Sandys.
[2]How They Met Themselves (Surtees 118R.1).
[3]On 11 Mar. (supra) DGR informed CAH that he was offering the Lucrezia to Leyland for £120.

71. DGR to CAH. Monday, [May 1868]. Authorizing CAH to bid £50 for Fiammetta (Surtees 192). [WMR (FL, I.285) states that it was acquired by Gambart at an unspecified time.]

72. DGR to CAH *16 Cheyne Walk, Chelsea
 16 May [1868]
My dear Howell,
I was telling you that I have a bill of £50 to pay on Thursday the 21st. Could you let me have that amount by then on account of the chalk drawings as my tether is almost run out at the bank? If impracticable please let me know at once.
 Can you tell me what happened about the Fiammetta? I have heard something from Dunn about the result of your enforced sleep walking the other night. I suppose you are beginning to settle.[1]
 That Venus has given me more botheration and kept me off your chalk drawings as yet but you shall have them in a day or two now I trust. I can not get the frame for Graham's 3 Roses out of Williams. Did you stir him up? If I had it I could send that in.
 I shall be painting the Medusa[2] after all if I don't die first as Leyland has commissioned it for 1500 guineas like a brick!
 Love to Kate and yourself from
 Your affectionate
 Gabriel

[1]The Howells had recently moved to Northend Grove, Fulham.
[2]The picture rejected by Matthews, but though DGR did a number of pencil, chalk, and crayon studies for it, the picture itself was never painted.

73. DGR to CAH *16 Cheyne Walk, Chelsea
 Tuesday, [19 May 1868]
My dear Howell,
Thanks for cheque £50--[1]
 As you say nothing of Fiammetta I suppose nothing was done. I am sorry for
this as in case you could not see about it I wish you would have said so as I
would then myself have attended to it. It is important at present that my things
should not go badly in sale rooms as it would discourage those from whom I have
commissions.
 Your note reaches me just as I have finished the Janey drawing (La Pia)[2] and
made it such that it certainly ought to be worth 40 or even 50 guineas. On
looking at the Andromeda[3] I really do not see my way to do any more to it as it
does not bear a background. If leaving this as it is leaves our bargain
incomplete I will include something else besides. As to the Venus I hardly know
what to do to that either on reconsidering it. It all seems in good tone. If
you keep this I suppose there can be no hurry about it, I being just now much
pressed.
 To put great things after small--poor Taylor[4] is dying. I saw him last night.
 Ever yours,
 D.G.R.

[1]CAH's canceled cheque, dated 19 May 1868, is in the HRC.
[2]One of the several studies for La Pia de' Tolomei (Surtees 207). The sitter was
Janey Morris, but the picture was not completed until 1880. Surtees 207F is now
in the HRC.
[3]Identical with Aspecta Medusa.
[4]Warington Taylor (1836-70), manager of the Morris & Co. firm. On 30 August
1868, however, DGR found him "comparatively speaking and for the time being,
well" (RP, p. 325).

74. DGR to CAH Thursday, [?July 1868]

My dear Howell,
How about the worthy Valpy? He'd really better have that largest drawing of
Miss W. at once while he can get it.[1] It's larger than yours, more finished,
and has 2 hands, and I'll sell it for £25. You'd do me a service by seeing about
it, as I'm pressed with small debts and don't want to sacrifice several water
colours to Gambart, which if kept a little longer would bring more than he will
give.
 Your affectionate
 D.G.R.

P.S. I suppose that bill to Harris can really be renewed when due, can it not?

[1]This may be Surtees 207C, a colored chalk, 25 x 31, of La Pia de' Tolomei,
with monogram and date "1868"; described by Mrs. Surtees as similar to 207B,
but with the head of Miss Wilding substituted for that of Janey Morris. The
provenance of 207C is ascribed "probably C.A. Howell." There is no known
connexion with Valpy, who, however, purchased 207D, smaller in size (18 x 4),
probably through C.A. Howell"; but 207D cannot be the drawing under consideration
here, as it is head and bust only. In DGRDW (p. 64) WMR mentions that in May
1868 Valpy wrote of possessing a "full bust" by DGR--almost certainly 207D.

75. DGR to CAH [16 Cheyne Walk]
 Sunday, [July 1868#][1]
Dear Old Boy,
The circular head[2] is finished and vastly improved. Is it really worth your
while to have it for 50 guineas, or shall I send it to Gambart on account of
the exchange pending between us? Either plan will suit me, so do not hesitate
to suit yourself. I am always in terror of your getting bad bargains.

As I did not see you, I managed the affair we spoke of yesterday. Do let me see you as soon as you can. I want you much, but do not know if there is any chance of ever finding you at home.

<div align="right">Your affectionate
Gabriel</div>

Love to Kate.

[1]The date is confirmed by the following letter.
[2]As appears in the account (infra), this was an oil, which I am unable to identify with any picture of this date. In DGR's account submitted to CAH (following letter) it is described as an oil, and in Letter 78 DGR says "You can call it a circular head of Christ as the True Vine." It may be an unrecorded variant of Surtees 109.

76. DGR to CAH. Wednesday, [July 1868]. Cover letter submitting bill for £52/10/0, dated by DGR "July 1868." [See preceding letter.] Has also executed drawing of La Pia.

77. DGR to CAH 16 Cheyne Walk
 Monday, [10 August 1868#]
My dear Howell,
I have seen Mr. Bader,[1] who has been here today, and write you word as you will be anxious.
 He assures me I need have no fear of losing my sight. He says the affection is cerebral, and he trusts to diminish it. I am to see him again on Friday, and he has given me one or two prescriptions. Of course I told him all about myself in every way. Of course also I am very much relieved in my mind, as I found it impracticable to work since coming to town.[2] I do not know how soon I may get to work again to any purpose, but will hope for the best, and at any rate need I trust have no great fear of the worst now.

<div align="right">Your affectionate
Gabriel</div>

I think I shall write also to Leyland, as I know he felt uncomfortable.

[1]An oculist, recommended by Howell (RP, p. 322).
[2]CAH and DGR had just returned from visiting DGR's patron, Frederick Leyland, at Speke Hall, near Liverpool.

78. DGR to CAH. Wednesday, [?12 August 1868]. Possibly Valpy good for circular head of Christ as the True Vine; has written thanks to Leyland [?for his hospitality earlier in August].

79. DGR to CAH [16 Cheyne Walk]
 Thursday, [?20 August 1868][1]
My dear Howell,
Thanks for your note. I am afraid I shall not be able to come before you leave where you are, but have to be seeing doctors just now. Very likely next week William and I may go away somewhere. I wish to God I could come to you just now, as I am horribly seedy; but don't tell any one I am so. I pass such dreadful nights that there is no getting better.
 Needing money, I have written to Leyland offering him the water colour Bocca Baciata[2] for 150 guineas. I have not his answer yet. You will not mind this.
 I have borrowed from Northend[3] the Venus and one of the La Pias to finish Leyland's 2 drawings from[,] that I may let him have them.
 By the bye, you have of mine a large roll of green stuff, and an old curtain. Do let me have them when you can. The green stuff I am needing. Also I think you must have a large white-paper-covered solid strainer which belongs to a frame which you returned to me.

Love to Kitty who I hope is benefiting, and to all friends. Will you tell Janey[4] that I hope she will be able to sit to me again very soon, as I want awfully to begin Graham's big picture[5] where she is to sit for Beatrice, and that is the part I want to begin with. I hope she won't think it too bad of me.

<div align="center">
Your affectionate

Gabriel
</div>

[1]Dated "Aug. 68" by CFM. By Friday, 21 Aug., WMR knew that it was impossible for him to accompany DGR out of town, a subject referred to in the third sentence below.
[2]Presumably Surtees 114 R.1, an enlarged water-color replica of the 1859 oil; with monogram and date "1868."
[3]Howell's London address. He was in Southwold at the moment.
[4]In a letter of 25 Aug. 1868 DGR wrote to Allingham that the Morrises, Howells, and others "have been lately" at Southwold, Suffolk (D-W, pp. 663-64).
[5]Dante's Dream at the Time of the Death of Beatrice (Surtees 81 R.1), a very large (85 x 125) oil replica of the water-color of 1856.

80. DGR to CAH [16 Cheyne Walk]
 Friday, [?21 August 1868][1]
My dear Howell,
I sent you Graham's address yesterday, and now return the letter. I have not yet heard from Leyland about the picture.
I should like extremely to have the dishes you mention and shall be most happy to pay the price.
I wish I could get to Yarmouth[2]--it is barely possible I may, with William, next week which he has at his disposal and will go anywhere with me. I wish you would write me your address as soon as you get there. But I rather incline to Southwold, as a very quiet place, in spite of what you say. It is provoking to get there just as every one is gone, but I have been seeing doctors till now. Yesterday a fearful night caused me to go to Dr. Gull[3] who is a very eminent man. Marshall[4] is away in Germany, or I should before this have seen him. Gull examined me thoroughly, tested my water etc., and declared there was no organic disease of any kind, that the brain was affected through overwork, and that he would set me right very soon. Of course he told me to get away and recommended Harrogate which however I don't seem to fancy. I have begun taking his prescriptions but had a bad night again last night. Whirling flickering and something like approaching apoplexy has become the order of my nights--much worse than when at Speke. I must hope for the best.
Will you let me know what is doing about everything when you write--what lodging would be best at Southwold, etc.,[5] and what is the least miserable way of getting there from Darsham.
Don't trouble about what I send unless it is convenient.[6] I couldn't think for a moment of giving you a long job over it. Now really don't as there is nothing of importance.

<div align="center">
Your affectionate

Gabriel
</div>

[1]This letter, dated "Sept. 1868" in the hand of CFM, must have been written before DGR learned--probably late on 21 Aug.--that WMR could not travel with him. Further, DGR saw Dr. Gull on 20 August. Also the contents of the letter tie in with those of Letter 81 following.
[2]CAH had gone from Southwold to Lowestoft, where he was at the time of this letter. Presumably he was going next to Yarmouth.
[3]Sir William Gull (1816-90), an eminent clinician, physician to Queen Victoria.
[4]John Marshall (1818-91), a surgeon who attended Lizzie at the time of her death; later qualified as M.D. and became President of the Royal College of Physicians. He was DGR's regular doctor.
[5]Line inserted at this point: "Didn't Topsy have a house to himself? Could this be got?"
[6]A letter for Janey Morris (an inference borne out by subsequent letters).

81. DGR to CAH [16 Cheyne Walk]
 Saturday, [?22 August 1868][1]
My dear Howell,
The address is
 George Hamilton Esq.
 W. & R. Graham and Co.
 Rumford St.
 Liverpool.
 I saw the oculist Bader again today; and though I had had some further
troublesome symptoms since last seeing him, he, on examining my eyes again,
assured me I must not fear for my sight in the least,--that the adjusting power
was the only thing at fault owing to a slight imperfection in the form of one
eye which he said he was surprised to find had never caused me inconvenience
before. He said that care with spectacles, about which he gave me directions,
and Gull's prescription for my head (which I am happy to find today seems
already beginning to benefit me decidedly) will set me right again.
 Last night Brown was advising me decidedly to go (as I am going somewhere)
to Bonn and Coblentz. John Marshall is at Bonn just now for a few weeks, and
at Coblentz is the famous oculist to whom every one goes. I may really perhaps
look you up at Yarmouth, next week, so send me your address there at once. I
couldn't go to Germany alone, but might possibly if you would come with me.
William now suddenly finds himself prevented from stirring by the absence of
some one else at his office.
 Today Leyland writes that he would "prefer waiting for larger work" to
buying the watercolour. Under these circumstances I am making up my mind,
though much against my will, to get an advance from him of £150 on the Medusa
commission and another thing he wants me to do.
 With love to Kitty
 Your affectionate
 Gabriel

P.S. I just see in your letter that you will be another week at Lowestoft. So
I suppose I may look you up there but am uncertain. I thought you would be at
Yarmouth all alone next week with Kitty.
P.P.S. I don't know if you like still to take the water colour.

[1]DGR saw Dr. Gull on Thursday, Aug. 20 (RP, p. 322), and WMR was unable to
accompany DGR on a trip during the following week because of the illness of a
colleague at Somerset House (RP, p. 323).

82. DGR to CAH. 16 Cheyne Walk, Monday, [?24 August 1868]. Wants CAH's address
at Lowestoft at once, as he wishes to send CAH something [evidently a letter to
JM].

83. DGR to CAH 16 Cheyne Walk, Chelsea
 31 August [1868]
My dear Howell,
I am going away with Dunn to walk about in Warwickshire for a few days, before
going elsewhere.
 If you write to me, do not allude to any private affairs in your letter, and
if you come to London before I am back, it will be better not to tackle the
chump-wump[1] who has got into a rage somehow, I didn't know what to do better
than this trip with Dunn at present. I'm very unsettled as to plans.
 I had a sitting the other day and finished Janey M's portrait.[2] Have done
little else.
 I am sending your two chalk drawings back to Northend, and also a large frame
of the same kind which has come and which I presume to be for you.
 Love to Kate.
 Your affectionate
 Gabriel

P.S. I don't know if convenient to pay me £12 or rather £7/16- allowing for the four dishes. You will remember the matter.
P.P.S. I got the £150 from Leyland on account of Medusa, but find much to do with it.

[1]Fanny.
[2]?The portrait of Mrs. Morris in a blue dress, commissioned by Graham (RP, p. 327).

84. DGR to CAH

Kenilworth
Saturday, [?5 September 1868][1]

Dear Howell,
I am likely to be back again in London tomorrow (Sunday) or Monday. Would you write a line to Cheyne Walk if you are back when this letter reaches Northend, and I will try and see you.
 The disturbance and weakness in my sight gets certainly rather worse than better, and I pass such dreadful nights that to benefit by air or walking is impossible. I am therefore returning to town to settle on what my next step should be. I may possibly go to see the oculist at Coblentz (in which case I would try and get your company) or else to Scott at Penkill.
 With love

Ever yours,
D. Gabriel R.

P.S. One thing I ought to say which I hope won't frighten and bore you. That bill for £50--21 October! I am happy to find on referring to notes that it is not 100 but 50, and not 1st October but 21st. Now I hope to be able to meet it, but if I were prevented by inability to work meanwhile, do you think it could be renewed? The other 3 later ones are renewable. I hope there may be no need, but if needed do you think it possible. Of course if I am better in time, nothing will be easier than to meet it.

[1]WMR says that DGR and Dunn left on 1 September. They were back at least by 12 September (RP, pp. 326-27).

85. DGR to CAH

Penkill Castle, Girvan, Ayrshire[1]
30 September [1868]

Dear Howell,
You will be a darling if you can manage the enclosed.[2]
 This is a truly heavenly place for beauty of scenery, and all private. Such a glen of running stream and lovely woods and such nooks for loving in if there were only the material. "Bits" too which I really should paint if I were all right. However I get comparatively excellent sleep now without--strange to say-- other benefit as yet.
 If you could come down, I've no doubt you'd be offered quarters here. Could you? I fancy that I am keeping Miss Boyd and Scott from London now, and perhaps if a friend offered to come and be with me here, they might consent to go and leave us to ourselves. Not that they are not the dearest and best of friends, for so they are both,--but Scott won't walk--by the bye I hear you say--no more wouldn't the Owl if he could fly or be carried instead. The weather seems to be setting in wet I fear just now, but still in these private grounds and this lovely sheltered glen there is much enjoyable in all weathers.
 By the bye, about that bill on the 21st Oct (£50) I begin to funk rather, as to getting to work before then, but I suppose if absolutely necessary I can get the tin out of Bowman.[3]
 I spent half a day at Leeds and saw the exhibition (glorious glorious glorious Botticelli and splendid Carpaccio!) and whom should I actually turn up at my hotel in the (let us hope ardent) flesh, but Valpy[4] spooning and honeymooning. I was introduced to Mrs. V. who seemed capable and I think contented enough, so we will not doubt that B. Carew has adhered to his principles and "done his best to make her so."
 Love to Kate and all friends. Do write me a line at once.

Your affectionate
Gabriel

[1] In the end DGR decided to accept the invitation of Alice Boyd and W.B. Scott to visit them at Miss Boyd's castle.
[2] A letter to Janey Morris.
[3] Sir William Bowman was one of the several medical men consulted by DGR. Under date of Tuesday, 22 Sept. 1868, WMR states that "Bowman called to-day...: he bought for 150 guineas a copy lately finished of the Bocca Baciata." But in a P.P.S. to a letter of 21 August 1869 (D-W, p. 717) DGR wrote to his mother, "I suppose I told you of my seeing Bowman before I left London, and that, instead of taking a guinea fee (which he refused), he proposes to pay me 150 for a little water-colour which is fortunately just upon finished...." The attempt in Surtees, p. 69, note 5, to reconcile these unreconcilable dates is unsatisfactory. Having by now seen dozens of DGR's P.S.'s and P.P.S.'s written on separate single sheets with the date on them pencilled in by CFM, I suspect that the P.P.S. belongs to a letter of 1868--quite possibly that of 6 October--to his mother. The P.P.S. obviously refers to the same transaction as the one in this letter.
[4] WMR says that Valpy "was something of a sentimentalist, of a nervous and flurried turn....The rumour also ran--I suppose erroneously--that he was the original of the effusive and tearful solicitor Baines Carew, in the Bab Ballads of Mr. W.S. Gilbert" (RP, pp. 267-68).

86. DGR to CAH Penkill
 9 October 1868
Dear Howell,
Thanks for your letter and postal delivery the results of which have just appeared in a reply, which however says nothing of the impediment you so happily overcame.[1] In writing again, give me a history of its nature. It was enough to frighten one certainly.
 It shall be all right about the £50 bill for 21st. I have had occasion to write a line to Ellis today (on Smetham's account, who wants a Topsy book sent him to review) and have assured him to that effect. If it happens I am unable to get the picture to Bowman before that date, Scott will lend me the tin till I do so.
 It is splendid weather out here, and all well except the standing ailment.[2] I do not know how long I may stay. I fear it would be of no practical use my returning to London at present.
 Are you still available as a pillar post (surmounted by a monumental group of Love and Friendship) or is a permanent statue of Prudence to keep the lid fast shut for the future?[3]
 Miss Boyd and Scott send best remembrances and I am your and Kate's affectionate
 D. Gabriel R.

P.S. Write some general news for this wild solitude.
P.P.S. As to the Botticelli, it belongs to one Fuller-Maitland[4] and is of course I suppose not for sale.
P.P.P.S.--No doubt (whether you come or not on Friday or earlier) you will let me hear from you in reply to this by Friday morning. I need to know, because of arrangements with Dunn.

[1] In the delivery of a letter to Janey Morris, to which DGR had received a reply.
[2] The hydrocele, which required surgery at intervals.
[3] I.e. as an intermediary for conveying letters to Janey Morris.
[4] William Fuller-Maitland (1813-76) of Trinity College, Cambridge, a noted picture collector.

87. DGR to CAH [Penkill Castle]
 Thursday, [?22 October 1868]
Dear Owl,
Not having heard from you yet, I can't resist sending another enclosure, which you will manage I know if possible, though not if impossible.[1]
 Scott and I have just settled to return to town together on Monday 27th.[2] So you see the enclosed ought to reach at once if it is to secure a result which is my only solace out here.

When in London I shall try if work is at all possible and shape my plans accordingly. The weather here, which has been splendid hitherto, seems just today to threaten breaking up a little.

Old Brown has been asked down. If you were to find he intends coming, I would of course be only too glad to put off my return, and should probably benefit by doing so. But as Scott has to be going back, I shall do so too unless Brown is coming.

I needn't say you are a dear old thing for all you do on my behalf. You know what the service is to me and what my gratitude must be to you.

<div style="text-align:right">Your
Gabriel</div>

[1]Another letter to Janey Morris.
[2]Monday was the 26th of Oct. in 1868; actually DGR returned to London on 3 Nov. (RP, p. 332).

88. DGR to CAH [16 Cheyne Walk]
 15th [December 1868][1]

My dear Howell,

I most unaccountably forgot last night (for one appointment was made with Brown at your party itself) that he, Scott and Nettleship are to dine with me on Friday. This precludes for me the Christie-Evans scheme.[2] Would you kindly let Constantine Ionides[3] know at once, as he asked me and I don't know his address.

The date of today reminds me that the bill business is drawing near. To pay would be only not quite impossible to me, so extremely inconvenient should I find it. Could I not renew for one month when I hope a more settled state of work would make it as easy as it is ever likely to be. I'm sorry to trouble you in the matter.

<div style="text-align:right">Ever yours,
D.G. Rossetti</div>

P.S. I suppose the Empress has left the Empire Room desolate ere now.

If you can get the bill for renewal, name a day to dine here and bring Ellis[4] if you think it advisable, but not if you think it would look like giving a sop to Cerberus. But do dine here one day--any one you like--in any case, for I never see you and greatly do desire you.

P.P.S. I shall see you tomorrow week at Holland Park.[5] What is the dinner hour?

[1]WMR (RP, p. 339) records in his Diary that DGR invited Brown, Scott, and Nettleship to dine with him on 18 Dec. Nettleship was a recent acquaintance who "obtained some temporary recognition as a painter of wild animals" (D-W, p. 687, n. 2).
[2]Presumably an engagement at Evans's, famous for its musical parties and suppers (Oxford Companion to English Literature). "Christie" may be a reference to the Christy Minstrels, a troup imitating Negroes, singing Negro melodies interspersed with jokes (Oxford Companion to English Literature).
[3]A member of the prominent London Greek colony.
[4]F.S. Ellis, bookseller and publisher later of DGR's poems; holder of the bill due on the 21st.
[5]?At the house of C. Ionides.

89. DGR to CAH. (Printed D-W, pp. 680-81, dated December 1868-January 1869, but obviously written before 21 December.) JM has gone; DGR refuses theatre engagement on following night. Will reflect on poem question [i.e. exhumation of buried poems] and will send letter if he comes "to that conclusion." Browning has sent copy of Ring and the Book. Will meet bill due on 21st if possible, asks if it can be renewed with fairness to Ellis. Will see about drawings, cautions that none of JM must be parted with till photographed, directs that La Pias be photographed by Parsons.

90. DGR to CAH Tuesday, [22 December 1868][1]

Dear Old Thing,
I've been haunted with the idea that my P.S. about the bill yesterday was a
cross one--What a beast I was if it was! When you have done nothing but all
sorts of friendship and jolliness and salvation for me! It's much better the
bill is paid as I have just written to Ellis.[2] Don't think me a beast for
seeming put out. It was all the first moment, and I know of course that you
took all sorts of trouble for me, and that with a thousand other things to
think of. I'll see you tomorrow at Holland Park I hope. I've got another d--d
engagement for late the same evening which I suppose will force me to afflict
the dinner party with togs and to leave earlier than I should wish.
 Your affectionate
 Gabriel

P.S. About the Claret I should certainly like to have what you offer me.

[1]DGR had written on 15 Dec. that he would meet CAH "tomorrow week at Holland
Park."
[2]This time the bill was paid (DGR to Ellis, letter in HRC).

91. DGR to CAH Wednesday, [?1868][1]

Dear Howell,
Gambart has taken it into his head to engrave Janey's portrait--the one
belonging to her. I want to know who is really the best engraver. He recommends
some bloke of the name of Stackpole--the plan at present being to do it in
mezzotint which seems fittest for the picture. He tells me that Cousins--the
best known mezzotint engraver--has retired from the profession. Could you find
out for me through Ruskin or somehow something about engravers? I am determined
to have the thing done thoroughly well or not at all.
 I shall have your large chalk drawing done soon but am doing a good deal to
it. You ought not to part with it if you can help as it will be one of my best
and the drawings of Janey will rise greatly in value when the portrait is
published. The frame should be sent <u>here</u> when done as I always like to revise a
drawing after seeing it framed.
 Your affectionate
 Gabriel

[1]WMR (<u>DGRDW</u>, p. 65) thinks that it was in this year that "there seems to have
been some idea of getting this work [an oil portrait of Mrs. William Morris]
engraved, but it was never effected."

92. DGR to CAH [16 Cheyne Walk]
 Friday, [?1868]
My dear Howell,
I couldn't come today with you, and indeed only got your telegram at 5 o'clock.
 Taylor[1] has just been asking me to add to your botherations by a request as to
Ruskin, and in his state one can't refuse him, though I don't know what may be
possible. He has determined instead of going abroad to set his wife up in a
cigar business before he drops off his hook. He has seen a very eligible shop
in Fleet St., and feels quite certain of success. All he wants is a loan of
£1000! However I really believe the scheme is hopeful, and that the poor woman
is not undeserving of interest after all when we consider his conduct to her.
She is now behaving very well and his great wish is to see her settled before he
dies, in such a way as may prevent his relations from being able to tempt her
with a trifle for the reversion of the property she will eventually have by his
will.
 Ruskin is the only man he can think of capable of lending the money on interest
Would he do so?--the whole if possible--but if not, a part. I really believe
that Taylor's great business faculties would be sure to make the business begin
to be successful from the very outset, and of course he is deserving of the
most cordial interest on the part of every member of the firm which his efforts
have kept alive. It is a great question for him, and will I am sure have your

best consideration. He ought to have <u>some</u> money one day next week to secure the shop.

<div align="right">Ever yours,
D.G.R.</div>

Try and look in tomorrow or Sunday.
If absolutely necessary I would even write to Ruskin myself.

[1]Under date of 29 July 1868 WMR (<u>RP</u>, p. 320) writes that Taylor had requested him "to be one out of three trustees for his wife, on her coming into the reversion of his property...." As Taylor lived till February of 1870 this letter may possibly belong to the year 1869.

93. DGR to CAH. Monday, [1868#]. Plans to "shoot all Leyland's drawings" to CAH for mounting, doesn't know how to reward his "owlish labours." Invitation to dine on Wednesday.

94. DGR to CAH. Tuesday, [1868# or 1869]. Needs roses for <u>Sibyl</u> picture (Surtees 193, painted 1866-70). [Smetham was asked for assistance on background on 7 September 1869, Surtees p. 112].

95. DGR to CAH. (Printed D-W, pp. 685-86.) Monday, 25 January 1869. Refers to climax of Burne-Jones-Mary Zambaco affair. [See Introduction, p. 10.] Refers to exhumation of poems, "a ghastly business."

96. DGR to CAH

<div align="right">[16 Cheyne Walk]
Monday, [15 February 1869][1]</div>

My dear Owl,
I sent B. Carew[2] the portrait, but have no cheque as yet, and am in doubt whether he understands that it is to be 50 guineas though I suppose he must. He also seems to think that your proposal as to the <u>Palmifera</u> drawing[3] differed from mine. Mine is that it should be substituted for the 2 drawings remaining due on the original bargain and for Janey's head, making three in all. This was what you told him, was it not? I have told him that the <u>Palmifera</u> drawing is similar to one of <u>Beatrice</u> which I sold for 80 guineas.

As you are I understand to dine there tomorrow, (I am not asked) would you find out without seeming to suggest any difficulty what his ideas are as to the price of the portrait and as to the exchange question. He however I should think would probably broach the latter point.

Little Ope's frame was sent to Holland Park on Saturday. Some time when you are coming from there you might bring me back the other. Unless indeed I send for it which I <u>may</u> do.

<div align="right">Your
Gabriel</div>

P.S. I saw Whistler last night who said he understood from you that I would write about the etchings. I wish I could, old chap, but it is of real importance to me, I believe, not to write a word on Art, or it would be immediately said that I did so anonymously and habitually. You'd better ask William.

[Note on top of p. 1:] I hope dear Kitty is better. My love to her.

[1]The P.S. of this letter obviously precipitated the following letter.
[2]L.R. Valpy. See note 4, Letter 85.
[3]Marillier 179 lists a red crayon <u>Sibylla Palmifera</u> that once belonged to Valpy, but Mrs. Surtees was unable to trace it.

97. CAH to WMR. (Printed <u>PRT</u>, pp. 54-55.) Northend Grove, Northend, Fulham, S.W., Thursday morning [dated 18 February 1869 by WMR]. Has bought Whistler's etchings and is going to publish the Thames plates. Requests WMR to write preface and descriptions of plates.

98. DGR to CAH. 16 Cheyne Walk, 18 April [1869]. Invitation to join Whistler and others for dinner on Thursday, requests return of The Ring and the Book, black and ivory chain, and some sketches. Refers to George and Dragon thing (Surtees 146, dated 1868, once possibly in hands of CAH).

99. DGR to CAH [16 Cheyne Walk]
 Saturday, [15 May 1869]
My dear Howell,
I wrote to Sandys at the beginning of this week after what I heard from you of his subject of Lucretia Borgia.[1] I have just received from him a letter wherein he cuts me dead (!) and utterly denies the resemblance of the 2 designs.
 You told me that his design contained a glass reflecting L.B.'s husband and the Pope or a Cardinal. Are you certain as to this particular?
 Ever yours,
 D. Gabriel R.

[1]DGR wrote to Sandys on 10 May (HRC): "I have only just happened to hear of a subject which you proposed to paint. It is described to me as Lucrezia Borgia mixing poisons, with her husband and the Pope (or a Cardinal) seen in a mirror behind her. This so nearly resembles a design of my own that you must pardon my writing you a word about it." The ensuing break between the two lasted about four years.

100. DGR to CAH. 14 July [1869#]. Request for return of Knewstub's sketches. Has returned cabinet in case George Howard would like it. Invitation to CAH and KH to dine next week.

101. DGR to CAH. [July 1869.] Doesn't understand how CAH could praise "this blessed thing" [reference to cabinet of preceding letter]. If Howard doesn't like it and it belongs to DGR, he will give it to anybody willing to accept it; thinks the price charged "monstrous."

102. DGR to CAH. (Printed D-W, p. 712.) Monday, 16 August 1869. Is leaving for Scotland but is "disposed, if practicable, by your friendly aid, to go in for the recovery" of buried poems, only "absolute secrecy" essential. If poems recovered will give CAH "the swellest drawing conceivable" or "paint the portrait of Kitty."

103. DGR to CAH. (Printed D-W, p. 718.) Penkill Castle, 26 August [1869]. More on recovery of poems. News of JM "pretty well," and "if this were but well, nothing could be very ill."

104. DGR to CAH. (Printed D-W, pp. 735-36.) Penkill Castle, 3 September 1869. Is writing to KH to say how glad he is that she is well again. Details about recovery of buried poems. References to a "Janey drawing"(?a La Pia) and "Janey in a chair" (Silence, Surtees 214).

105. DGR to KH Penkill Castle, Girvan, Ayrshire
 3 September 1869
My dear Kitty,
I cannot refrain from writing you a line to say how rejoiced I am at hearing now of your complete recovery from such a painful attack of illness as I learned you had had. However I judge that all is fortunately well now.
 I shall be here possibly for a week or two longer,--possibly not quite so much.[1] I have been walking pretty regularly and I hope benefiting, but the heat has been such as to make exercise heroism. However there is a private and sheltered glen belonging to this house which is a refuge from everything, almost including oneself--the supreme bogey.

I have been working hard at some proof-sheets of poetry, mostly old things of mine, which I am about to print in a private form. I think I am getting them into a shape I need not be ashamed of, and if good I do not mind so much their being few.

I suppose you were hardly well enough to assist at the grand ceremony on Sunday last, but no doubt it was well attended.[2]

My news of Janey Morris continues pretty good, but I fear the days of miracles are past. However one must hope to find her improved on her return.

I hope on getting back to finish your portrait drawing. I believe it is like, as several people have recognized it spontaneously, though I cannot say it seems to me a striking likeness. Miss Spartali,[3] who was sitting to me lately, did not recognize it at first, yet ultimately thought it a successful portrait. I made 3 drawings of her head, the last I believe pretty good, though the first 2 were failures.

As I am writing to Charley with this, I can send my love to each of you personally.

<div align="right">Ever affectionately yours,
D. Gabriel R.</div>

P.S. Kindest remembrances from Miss Boyd and Scott.

[1]He arrived in London on 20 September.
[2]?The marriage of Luke Ionides.
[3]Marie Spartali, who married W.J. Stillman in 1871.

106. DGR to CAH. (Printed D-W, p. 744.) Penkill, 16 September 1869. Details about recovery of buried poems. Thanks to KH for letter and enclosure (?letter from JM). Encloses letter of introduction to Home Secretary (H.A. Bruce).

107. Without salutation but sent by DGR to CAH. (Printed D-W, p. 748.) 16 Cheyne Walk, Chelsea, 28 September 1869. Authorization for CAH to act for DGR in exhumation of poems.

108. DGR to KH. *16 Cheyne Walk, Chelsea, 8 November 1869. Letter of condolence on death of KH's mother.

109. DGR to CAH. Wednesday, [17 November 1869]. Hopes CAH and KH getting over "great trouble" [presumed reference to death of KH's mother]. Must fix another sitting for KH soon.

110. DGR to CAH. (Printed D-W, pp. 855-56.) Wednesday, [27 April 1870]. Is sorry CAH is in "troublesome position," would be glad if he could suggest course of action because of long-standing friendship and the "very special service" CAH rendered DGR "some months back and one you may be sure I have not forgotten."

111. DGR to CAH [16 Cheyne Walk]
 Friday, [17 August 1870+][1]
Dear Howell,
Would it suit you to take your pick of the drawings we were looking over the other day--the studies for my picture and the other odd ones--(including the Miss Wilding I did that day) and buy 20 at £10 apiece--£200 in all. I am wanting tin at once, and for that reason would part with them in that way if it could be had now. You could take most of the drawings at once, though I might need to keep one or two for use.

<div align="right">Ever yours,
D.G.R.</div>

[Note on p. 3 in CAH's handwriting:] Received £200 this 18th Aug. 1870 on account of the within drawings.[2]

<div align="right">C.A. Howell</div>

[Note at top of letter:] I shall be very busy tomorrow and Sunday. If you want to see me could you look in Monday about 5?

[1]As Friday was 19 Aug. in 1870, the day of the week would appear to be in error in view of CAH's endorsement.
[2]On p. 4 is a list of names of artists, including Boyce, with sums opposite their names but totalling something less than £200. As it would make no sense for CAH to give a receipt for the purchase of DGR's pictures, I can only assume that CAH somehow managed to sell or pawn pictures by the various artists for almost £200.

112. DGR to CAH. [22 October 1870.] Cover letter for following letter. Hardly knows how to make appointment with CAH.

113. DGR to CAH. 16 Cheyne Walk, 22 October 1870. Certifies that 20 guineas is price paid by CAH for drawing of JM (?Surtees 207F) returned to DGR by George Howard.

114. DGR to CAH. Friday night, [October 1870#]. Invitation to dine on Sunday and "talk over any thing you like."

115. DGR to CAH. Friday, [November 1870]. Is sorry about illness of KH's cousin Jessie Homan [who died in early December] and its addition to "anxieties and grief" of CAH and KH.

116. DGR to CAH [16 Cheyne Walk]
 3 February 1871
My dear Howell,
The little drawing (as good a thing as I ever did on so small a scale) should be entitled Lucrezia Borgia, Duchessa di Bisceglia.[1] The subject is the poisoning of her first husband, the Duke Alfonso of Bisceglia. You see him in the mirror, going on crutches, and walked up and down the room by Pope Alexander VI, to settle the dose of poison well into his system. Behind these figures is the bed, as they walk the room, and Lucrezia looks calmly towards them, washing her hands after mixing the poisoned wine and smiling to herself.
 Ever yours,
 D.G. Rossetti

[1]Surtees 124R.1, a water-color with monogram and date "1871" in the lower right corner.

117. DGR to CAH [16 Cheyne Walk]
 Monday, [1 May 1871+]
My dear Howell,
I was very sorry indeed not to see you the other day, but was at the moment caught in the very middle of a spider's web of work, with the devil sucking hard at me. Do let me have the screen back soon. I am glad to hear of your business matters progressing well. I am getting used up, and shall have I fear to bolt out of London now very soon[1] and leave my picture[2] to be finished when I return.
 With Love to Kitty.
 Ever yours,
 D.G. Rossetti

P.S. I don't know well what day to propose for your calling, if as you say you wish to see me about something. No, I find these won't do, as I lose my evening walk. I'll come up to you Wednesday after dinner if that will suit and if you'll be by yourself. Let me know. Of course I mean you and Kitty.

[1]DGR did indeed "bolt out of London" shortly later--middle of July--for
Kelmscott Manor, of which he and William Morris were joint tenants. This time
DGR remained for about three months. (See Introduction.)
[2]Dante's Dream.

118. DGR to CAH. *16 Cheyne Walk, Chelsea, Tuesday, [?May 1871]. Is intent on
getting house in country, doesn't want to part with any furniture.

119. DGR to CAH [16 Cheyne Walk]
 12 June 1871
My dear Howell,
The little water colour[1] (which is as good a thing as I ever did on that scale)
should be entitled
 Lucrezia Borgia,
 Duchessa di Bisceglia.
It represents the poisoning of her 2nd or 3rd husband, Alfonso of Arragon, Duke
of Bisceglia. You see him in the mirror, being trotted up and down the room, on
crutches, by Pope Alexander VI, to settle the last dose well into his system;
while the lady looks towards them, as they walk opposite with the bed behind
them; washing her hands after mixing the poisoned wine, and reflecting probably
on aims in life about to be providentially realized.
 Ever yours,
 D.G. Rossetti

[1]Cf. Letter 116.

120. DGR to CAH. Wednesday, [13 (actually 14) June 1871+]. Refusing offer of
port wine because of lack of "tin"; is concerned about illness of KH.

121. DGR to CAH. Saturday, [June 1871+]. Reference to things CAH proposes that
DGR take to country and to KH's illness.

122. CGR to KH 5 Gloucester Terrace, Folkestone
 31 July 1871
My dear Kate,
A letter from your husband has just been forwarded to me here, so full of
friendliness that I feel desirous to write one at least a quarter as nice to
you; and through you to thank him, with my Mother's love to both, for the news
he sends us. News literally: we did not know what you had suffered, though I
had heard without details of your being ill. I too fell ill at the end of April,
but am now convalescent; an improving fortnight at Hampstead prepared me for
coming here, and we hope Maria will join us in the course of the week. Do
endeavour for the sake of all who love you to make Upper Norwood your Hampstead;
and then I hope we may soon hear of your regaining health and strength at gay
Brighton. Would you believe that through all my illness I only saw Gabriel twice?
You know his nocturnal habits are not adapted to a sickroom.
 I hope your house is as beautiful as ever, and that you will soon again be
half its chief ornament. Admire the grace with which I say "half"!
 Still remember me, dear Kate, as
 Your affectionate friend,
 Christina G. Rossetti

123. CGR to CAH 5 Gloucester Place-Folkestone
 21 September [1871]
Dear Mr. Howell,
It is so many weeks since I have had news of dear Kate that I hope you will not
think me tiresome for begging a word from you. I hope that she has long ago
gained strength and been able to reach Brighton, and as I do not know where you
now are I direct this to North End. Pray give her Maria's love, and mine
affectionately, and tell her that though I have not written before I have not

been all this time without thinking of her. Our Mother, who will welcome such good news as you may favour us with, has returned to town and is keeping house with William; otherwise she would certainly join in our messages of remembrance to Kate and yourself.

<div align="right">Very truly yours,
Christina G. Rossetti</div>

We do not expect to leave here before the 26th; perhaps not then, if the sea air still seems advisable. I am comparatively strong again.

124. CGR to CAH 56 Euston Square-N.W.
 2 [January] 1872

Dear Mr. Howell,
The generous kindness with which you have sent me such valuable and rare autographs goes far beyond what I hoped for when I wrote to you. Thank you exceedingly--but ought I to accept a Sir Sydney Smith and a William Pitt? I will wait a day or two at any rate before despatching them, and give you time to reclaim them if by any means you may wish to do so; they are such treasures that I must not descend on them with the haste of a harpy.
 Four gems, with great reluctance I return to you; only lest they should still be of value to the Record Office, in which case I could not bear to have a hand in dispersing them. The Wilmington especially raises in my mind the question of possible value.
 Now I will boldly include you in my affectionate best wishes to my dear Kate for this new-born year. Your letter is one to cheer a sickroom and make its invalid inmate feel remembered.
 I will not on any account ask you for more autographs besides what you have already given me. What a treasure is Ruskin--and Browning is particularly wished for, though I was not sanguine of obtaining it. And to return to the Ruskin, how delightful is "dearest Owl"!
 My Mother desires to be cordially remembered to Kate and to you, and I remain

<div align="right">Very truly yours,
Christina G. Rossetti</div>

125. DGR to CAH. Tuesday night, [9 January 1872+]. Apology for not thanking CAH for "lovely little bottle." Hopes that CAH and his father [who had arrived several months earlier] can come with KH to see picture.

126. CAH to DGR. (Summarized in PRT, p. 86.) Northend Grove, 25 January 1872. Concerns portrait of a boy believed by CAH to be of Shelley by Hoppner which CAH hoped to acquire and present to WMR, as editor of Shelley's works. [In the end it proved to be not genuine.]

127. DGR to CAH [16 Cheyne Walk]
 [12 March 1872+]

Dear Howell,
Shall you be going into town tomorrow, and if so, could you oblige me by going and securing me a box for Thursday evening at the Queen's Theatre, Long Acre.[1] I don't want a big box, but it must be a thoroughly good one. Pardon my troubling you in the matter, but if you are not going that way please let me know at once and I'll go myself forthwith. I've no one else able to do such a trick properly. If possible, I wish they'd put a comfortable arm chair in the box and of course I'd pay for the accommodation.

<div align="right">Ever yours,
D.G. Rossetti</div>

I don't know what it will be, but enclose cheque.
If no good box, then the best 2 stalls to be had--out of draught and third row or so. But box is best.

[1]The Last Days of Pompeii, followed by Douglas Jerrold's Black-Eyed Susan, was being presented.

128. WMR to CAH 56 Euston Sq. N.W.
 28 April [1872+]

Dear Howell,
I mentioned to Christina your characteristically goodnatured offer of some
choice Sherry: she of course thanks you much, with some hesitation as to
accepting. Her preference would be for brown rather than pale. A little of this
she will accept with thanks, since so you choose it should be: but don't allow
it to be more than little.

 Since to-day week there has been some small improvement in her condition: and
this is as yet maintained--whether for long I hesitate to guess.
 Love to Kate.
 Yours always,
 W.M. Rossetti

129. DGR to CAH [16 Cheyne Walk]
 [16 May 1872+]

Dear Howell,
I had meant to attend to the Ashburton business this morning same time as the
coin, but forgot it then and sent on after the note for the Count to your care.
This on setting about it seemed the most direct plan. Now I get your note about
the matter--must take some other chance for introducing you.

 Thanks about the coin. Please send it on to them--Packer, 76 Quadrant. I'll
keep the earrings &c I suppose. The fact is F. took her usual plan for
ascertaining their value which was stated at £6. I may mention this as you are
not the owner.[1]
 Ever yours,
 D.G.R.

[On DGR's calling card: "Please give the similar silver coin instead of the
electrotype which I return."]

[1]But in Letter 354 DGR was to complain of CAH's behavior in the matter.

130. DGR to CAH. [16 May 1872+]. Request for CAH to inspect two wardrobes, try
to obtain larger cheaply.

131. CAH to DGR (Fragment) Northend Grove, Northend, Fulham, S.W.
 27 June 1872

My dear Gabriel,
I hope you are enjoying yourself and getting a good rest.[1] Here, we are giddy
with heat and I wish I was with you in cool Scotland. I have gone carefully
over the China and do not know where I can go and get you £800 for it in one
lump, but I can get you £550 or £600 cash for it and if you like will either
pay that sum into your account or send you cheque on to Scotland.[2] Of course I
need not assure you that I make no business matter of this. I do not wish to
gain one sixpence, any more than you would were you selling my pots for me.

 The rich man at Streatham Cyril Flower[3] is buying nothing just now, having a
lot of heavy building expenses on him, and T. Salt[4] does not care to spend
"even £400 in China". These are the two only persons I have spoken to on the
subject and in offering the collection I only said "the finest collection of
blue in England" not naming the owner.

 Should you accept my offer, the collection changes houses only as not a
single piece will ever be in the market for sale.

 Brown told me that Marks had made an offer, without saying one word to him on
the subject I find that his offer extends to giving you what you paid for as
many pieces as you have left, and any thing not coming from him at a low
valuation. He would deduct any thing you may have given away or broken, and buy
as low to sell as high as possible.

 This is not my offer, the things as I said before go to no dealer, nor will
they ever be in the market for sale.

 Should you accept or refuse my offer pray keep [The letter breaks off here.]

[1]Following a complete breakdown in health on 2 June and an unsuccessful suicide attempt a few days later, DGR had been packed off to Urrard House, Perthshire, in the company of F. M. Brown and George Hake, son of DGR's friend Dr. Thomas Gordon Hake. (See Introduction, p. 17.)
[2]DGR's break-down was accompanied by a financial crisis as well as a physical one, and his fine collection of blue china offered the most obvious source of ready money. In the end WMR accepted Marks's offer.
[3]Cyril Flower (1843-1907), barrister, M.P. 1880-92, created Baron Battersea in 1892. In 1877 he married Constance de Rothschild, daughter of Sir Anthony, Bart.
[4]Sir Titus Salt (1803-76), a rich manufacturer of Bradford; M.P. 1859-61; created baronet, 1869.

132. DGR to CAH Stobhall [sic]
 28 June 1872

Dear Howell,
I am moving today to Graham's hunting-lodge as Urrard House is to be occupied by the family. My address will now be D.G.R., Stobhall, Care of Mr. Haggart, Stanley, Perthshire, N.B.

I have just received your friendly letter, but am not well enough to be writing at much length. I wanted and want at least a sum of £700 for the china, as it is for a special purpose needing that amount. If you can get it me, it will be an act of great friendship. If this is possible, it will be best to pay it over to William at once, unless he has otherwise arranged with Marks.

Post-time is just come, and this as other things makes me brief, but what I have said is enough to a friend like yourself.

 Ever your affectionate
 D.G. Rossetti

133. CGR to CAH. 1 Heath Cottages, Hampstead, 4 [July 1872+]. Thanks for "very valuable present...love to Kate, of whom I hear a sad account again."

134. WMR to CAH. Somerset House, 8 July [1872+]. Request for CAH to identify Leyland's pot which Marks cannot identify.

135. CAH to WMR. 8 July 1872. (Printed PRT, pp. 61-62.) Has identified pot, had it put aside; got DGR's Botticelli. Much hurt that WMR said nothing of DGR's health, offers to nurse him back to health as he did at Speke Hall in 1868.

136. WMR to CAH 56 Euston Square
 9 July [1872+]

Dear Howell,
Much obliged for your kind attention as regards the pot, and more for your exceedingly affectionate expressions regarding Gabriel, in the sincerity of which I fully believe. I shall at once send Marks a cheque for £8 for the pot, which may then, whenever he likes, be restored to its place in Cheyne Walk.

Certainly there is at present no hurry whatever for selling the Botticelli. Its sale sooner or later will be prudent, but for awhile is in no sense necessary. Pray take your own time.

I enclose the last two letters I have received concerning Gabriel. As regards his bodily health they are, though not exactly good accounts, still not exceedingly amiss: but the real point is not touched in them. I suppose you know it now--the state of his mind. The subject is too painful for me to dilate upon, and in other respects not fitted for written correspondence. I should very much like to know from you what was the condition of his mind when you and he were at Speke. Of course I know that he was madly in love,[1] and can believe in anything in the way of hypochondria on that account, and as concerned the state of his eyes. But had he any and what sort of positive hallucinations?

Please return the enclosed as soon as done with, and stick to your good resolution of saying nothing to anybody.

 Yours as of old,
 W.M. Rossetti

[1]DGR's love for Janey Morris was, like Dickens's attachment to Ellen Ternan, long kept secret from the public but well-known among a circle of friends. WMR, as family chronicler, is always honest in what he relates but is frank to state that he tells only what he chooses to tell and leaves untold what he does not choose to tell (FL, II.257), thus: "wherever I can be at peace, there I shall assuredly work...." Not until publication of Doughty's life of DGR was the excised portion restored: "but all, I now find by experience, depends primarily on my not being deprived of the prospect of the society of the one necessary person." (I quote from D-W, p. 1062; in the life the passage is printed as a separate sentence.) Certainly the secret was known not only to WMR but to F.M. Brown, W.B. Scott and Miss Boyd, and Dr. Hake and George, CAH, and doubtless others. (See Fredeman, Prelude to the Last Decade.)

137. CAH to WMR. (Printed PRT, pp. 62-63, with omission of references to DGR's hydrocele and delusions.) 10 July 1872. CAH grateful for affectionate letter and enclosures; encloses letter written to DGR but will not send it without WMR's sanction. Will come and tell what happened at Speke Hall but will not write it. DGR's hydrocele made walking there very painful, DGR cured by CAH of two serious delusions--that he suffered from fistula and that he had rupture of the navel.
 At Speke Hall CAH allowed DGR brandy weakened with water at bed time only, urges WMR to write friends to limit whiskey to two glasses at night, denounces chloral as "damned stuff" once prescribed to KH but thrown out window by CAH.

138. WMR to CAH Somerset House
 12 July [1872+]
Dear Howell,
I have no objection to sell those drawings attributed to Wainewright [sic].[1]
There is however one of them--with a floating female figure and a warrior--that Gabriel, I apprehend, would not wish to part with. I have written to Dunn to retain this one, and any other that may be particularly good and not bawdy (I doubt whether there is any such), and to deliver the rest to you for the £8 you propose. If you consider that sum too much, after the aforenamed deductions are made from the designs, I will take £6. You will excuse me for adding that, in the present state of our finances, ready money is a real consideration to me, and that I should not wish to hand over the designs until their price comes into Dunn's or my hands.
 I will henceforth send you on letters from G. Hake if convenient: but of course have often to retain them till answered--or to send them to his father, produce them to Brown, &c &c.
 I see no objection (but rather the contrary) to your sending on the enclosed letter to Gabriel, save as regards the final suggestion of your paying him a visit in Scotland. As to the prudence of making any such proffer to him at the present moment I have great doubts: and in those doubts I think the satisfactory course would be to say nothing about it. I therefore return the letter: but of course can't dictate to you if you differ from my view.
 I am myself a decided enemy of the whiskey-dosing system in which Gabriel indulges: the friends who are about him resist his wishes in this respect as far as possible, but can succeed in only a very partial degree. It should be said however that Marshall does not oppose the plan beyond a certain point; and as to the chloral he considers that it can't at present be dispensed with. As to that again I wish Gabriel could be induced to try the experiment of courting sleep without it: but here also (though much inclined to your side of the question) I can't interpose, beyond general drift of correspondence, to contravene the medical directions.
 Nolly Brown[2] will probably go to Scotland this evening, to replace Scott. The latter however wrote a conflicting telegram yesterday, and till this point is settled we remain in some doubt as to the upshot.
 If you can come and give me information (as you had proposed doing yesterday) I should of course be much obliged.
 Yours,
 W.M. Rossetti

[1]See Note 1, Letter 30.
[2]Oliver Madox Brown, son of FMB. It was Dr. Hake, however, who relieved Scott.

139. WMR to CAH. Somerset House, 24 August [1872+]. DGR much improved, speaks of returning to Cheyne Walk in October. WMR apologizes for not sending CAH letters from DGR to WMR.

140. CAH to WMR. (Printed PRT, pp. 63-64.) 28 August 1872. Thanks God for news of DGR's improvement, is much against his return to Cheyne Walk, offers wing of own house, independent of rest of house, for use by DGR. [End of letter lost.]

141. WMR to CAH 56 Euston Square
 1 September [1872+]
Dear Howell,
Several letters to write, so please excuse brevity.[1]
 Sincerely concerned to hear you have been ill.
 Have you written to my Aunt? If not, would you return me her letter and then I will inform her of what you say.
 I agree with you in deprecating a return to Cheyne Walk on Gabriel's part. Brown is of the same opinion, and Marshall very strongly so. Have already written to the Hakes about it: Dr. Hake however thinks it would at present be harmful to raise the question direct to Gabriel. Whether or not he can be persuaded to give up the house I feel doubtful: the present appearance is that, when he leaves Scotland (possibly towards end of this month), he himself does not intend to inhabit Cheyne Walk at once, but go somewhere out of London-- where I know not. Your offer of a part of your own house is most friendly and generous--worthy of your known preeminent merits in that line: as to the probability of its taking effect I really can at present form next to no opinion.
 It seems to me there would be little or no advantage just now in returning the Botticelli to Cheyne Walk: would you return it or keep it as most convenient to yourself.
 I am not clear as to the precise drift of your proposal that the £2.2 you have advanced on our behalf for the Mazzini subscription should be "entered against the drawings of Chelsea," and you to remit the balance of £2.18. Does this mean the Wainwright-Fuseli drawings?
 Have written now asking Gabriel about the show-case for china. I looked at it the other day: fancy it is very well worth the £5--have little idea whether or not he would like to part with it, but (as you say) it is of no particular practical use to him at present.
 Yours,
 W.M. Rossetti

 The news of Gabriel continues to be very good. He has again sent for painting materials: just received them, and seems likely to set to forthwith and vigorously. Dunn will probably go to Gabriel in a day or two, and Dr. H. return.

[1]This letter, a reply to the preceding one from CAH, supplies in the last paragraph some information concerning the missing part of CAH's letter.

142. WMR to CAH. 16 Cheyne Walk, 7 September [1872+]. DGR accepts offer of £5 for china cupboard--"ready money transaction." DGR improved and painting again, may remain in Scotland through month.

143. CAH to WMR. (Printed, PRT, pp. 64-65.) Northend Grove, 11 September 1872. Is delighted with good news of DGR, will bring WMR £7/18 for Wainwright-Fuseli drawings and china cabinet. The Botticelli sent off to King of Italy by Pinti without consulting CAH.

144. WMR to CAH. Cheyne Walk, Thursday night, [12 September 1872+]. Is flurried about news of Botticelli, wants it back or money for it.

145. CAH to WMR. (Printed PRT, p. 65, with minor omissions.) Northend Grove,
26 September 1872. Will come on Saturday and have gossip with Fanny and WMR,
discusses china sold to Marks. "The principal thing is Gabriel's health. I
danced about (or rather we did) when your letter came. Of course he is all
right and the greatest man in England, and all that is needed is to take care
of him."

II. "Ever Affectionate" Agent

30 September 1872 to 15 July 1874 (Letters 146 to 368)

146. DGR to CAH Manor House, Kelmscott, Lechlade
 30 September 1872
My dear Howell,
William, in writing on various matters, mentions that you seemed desirous to
have some deals with me for pictures.[1] I want to set about one or two here (from
J.M.) and as they are not yet engaged, I had an idea of writing about the first
I do in due course to Pilgeram & Co.,[2] as I am desirous to keep in the market
and not be dependent on one or two private people only. I may probably be
doing a full-length _Pandora_ (small life size)[3], that narrow upright picture
with the apple (you know the drawing)[4] and a very important one seated in a
tree with a book in her lap,[5] for which you saw the drawing of the head--the
best I have done. I would of course try to make the prices lower to you than to
a person who meant to keep the pictures, but still they would be high priced
works. Is there a chance of any of them suiting you, and of the tin coming to
me by instalments _whenever I may need it,_ which as you know is my necessary
plan? I had rather _deal with you than with Pilgeram & Co._ if feasible, but if
not, I suppose they would be prepared to buy again, as they have sold the last
they had of me to advantage.
 I'm all right at present, and hope to be doing some good work. With love to
Kate.
 Ever yours,
 D.G.R.
What has become of the Contessina? Such models are scarce.

P.S. I would like to get your answer independently of further enquiry on your
part from any mutual friends--notably from Leyland--whether they would buy. You
see I have a lot of commissions from him and Graham and should wish to extend
market in other quarters. The man who bought the _Bower Meadow_[6] from the dealers
is a rascal named Walter Dunlop at Bingley, who is an old foe of mine, and with
whom I could not deal personally. The pictures I shall be painting now will be
a great advance on my best hitherto, as the last thing or two I have done prove
conclusively.
 William says also however that you think of going for 2 years to Japan--I am
afraid that would be too far off for transactions.

[1]An agent was henceforth indispensable to him, and so began a more formal artist-
agent relationship than had previously existed between DGR and CAH. The
disadvantage of having CAH as agent was his lack of capital. (See Introduction,
p. 17.)
[2]Pilgeram & Lefèvre.
[3]Mrs. Surtees says that this picture "appears never to have been begun." In
1871 DGR had painted a large oil (51½ x 31, Surtees 224).
[4]_Proserpine_, in which an apple was originally intended as the fruit.
[5]_The Day Dream_ (_Monna Primavera_, Surtees 259): a drawing of this subject, date of
execution uncertain, hung over DGR's mantel piece in 1879, and when it was seen by
Constantine Ionides, he commissioned an oil painting of it, which DGR completed
in 1880.
[6]Surtees 229, sold on 2 June 1872 to Pilgeram & Lefèvre for £735 and sold by
them to Dunlop.

147. CAH to DGR[1] Northend Grove, Northend, Fulham, S.W.
Strictly Private 3 October 1872

My dear Gabriel,
Many many thanks for your kind letter. I was from home or I would have answered
by return. Of course I am anxious--and always have been--to have a picture or
as many as I can get of yours, and as you know, nothing but want of means has
kept me from fulfilling my wish. Things are of course very different with me
now, but I have had a hard fight very much by myself and having learnt a good
lesson I have made up my mind to fight as little in the future as possible. In
order to come to any satisfactory arrangement with you I feel that I must see
you on the subject, the thing is too long to correspond about but I will gladly
run down and see you any time you may name say in two or three weeks. I name
this time being very much engaged and having promised to go and stay with

Clabburn[2] for a few days, still I can put this off and stretch any point to come and see you if for nothing else, to spend an hour or two with you.

I wish to have your pictures, and extend your market for your and my sake, but in this case I think you would have to leave Pilgeram & Co. out of the market, and here is my reason. They have Gambart's old connection and among them a lot of men who do not know me, such men would of course look to Pilgeram for any thing they might want of yours and they as men of business convinced they could get their pictures direct from you would often crab one of mine by saying "We expect such and such an one which is better than 'Howells,' got as a matter of friendship from Rossetti." As to Graham and Leyland you need fear nothing from me, I never sell them (or attempt to) anything modern and modern or old if I depended on them at all for any thing, I should have to buy a cab and keep it ready to take me off to the Union at a moment's notice. I told William about Dunlop, he paid 1000 guineas for the Bower Meadow and gave the two water colours sold to Graham either for £200 or £300 I think the latter. How foolish to write to Heaton about the "Silence,"[3] I told William enough about it for him to see that I was the person to act in the matter. Heaton[4] of course wishes to make money and for this reason asks you £250 for the drawing. "The Works of Art Co." is not Heaton or anyone else but myself, i.e. it would not stand one day without me, the money is theirs, but the things are mostly mine and as to their being able to keep the place open for a week without me they might as well think of flying. As regards the "Silence"--here is the whole affair (On this subject and the whole contents of this letter not a word to anyone. I trust to your honour.) I knew that you would be wild at the drawing being sold with the china, and that you would fight to get it back, and so laid my plans to have it safe for you at any cost, to begin with we gave Marks £135 for it, next to prevent its being sold to anyone I told Heaton to put £250 and not a farthing less, but gave him no reason for so doing, and said nothing about the chance of your wanting it back. Let us see each other, and you will find this by far the best plan. Don't overwork yourself all at once after a long rest, little by little, you can make a lot of tin before you know where you are. Your market is splendid paint what you like and there will be five men for each picture. Kittys dearest love to you and mine always,

> Your affectionate
> C.A. Howell

Excuse the scrawl I am so tired. Without wishing to bother you Dunn was working on that Palmifera for Valpy,[5] give it a few touches if you can and rid yourself and myself of that debt, he does not worry for it but he sighs so, I am always saying "it is coming."

[1]Partly printed in PRT, p. 87.
[2]A Norwich manufacturer and art collector known to both DGR and Sandys. Whether the visit referred to by CAH was the occasion of his purchasing DGR's Magdalene and saving it from auction (see DGRDW, p. 82) is uncertain.
[3]Described by WMR in the note attached to this letter as "an important crayon-drawing by my Brother, which, at an early stage of his serious illness, I had sold, along with his collection of Oriental blue china, to Mr. Murray Marks the Art-dealer." It was subsequently sold by Marks to Aldam Heaton. (See Surtees 214.)
[4]In a note attached to this letter WMR writes, "Mr. J. Aldam Heaton was connected with Howell in an association named The Works of Art Company."
[5]Surtees 193B mentions a red crayon study which originally belonged to Valpy, which she dates c. 1864. Unless the date is incorrect, this must be a different picture. WMR (DGRDW, pp. 85-86) refers to a Sibylla Palmifera in the possession of Valpy in April 1873.

148. DGR to CAH Kelmscott, Lechlade
 22 October 1872
Dear Howell,
Thanks about the coat business; but I have for some time owed you a letter on more important matters, and should have written before now had I known exactly what work I was taking up first.

First about Heaton. When I wrote to him I had no idea that you had any connection with his scheme. I made him an offer (in exchange) which I believe

would have been to his advantage: viz: large drawing "Donna della Fiamma,"[1] oval full face head of Mrs. M. and if necessary a pencil drawing or two besides. He said his partner was in London and would call on William to see the things; but seeing and hearing no more hitherto, I wrote to him the other day asking him to get a photo of <u>Silence</u> taken as at first agreed and think no more of the matter as one cannot be hanging fire for ever. The photo will serve me if I want to paint the <u>Silence</u>.

I have already said that I should much prefer dealing with you to any other <u>intermediary</u> purchaser I know, though of course if <u>private</u> purchasers came straight to me, I should deal with them, unless they wished for work already engaged to you. Thus, <u>if we came to any precise and settled agreement which ensured progressive payments to me as the work went on</u>, I should be happy to engage not to treat in any way with Pilgeram & Co. while such agreement lasted; though I could not promise this <u>on any but the most definite grounds</u>, as, having bought of me to their advantage hitherto, they are, I doubt not, quite ready at this moment to continue the connection if I offer them anything; and moreover, they have given me lately the highest prices I could expect from a dealer, or indeed, I might almost say, from any one.

I am now working on a picture which I expect to have finished shortly, from that tall upright drawing you know of Janey with an apple (or pomegranate I shall probably make it.)[2] It will be of the very best order of my work--i.e. much superior to anything I did before the last year. Will it suit you at 550 guineas?--and if so, how soon could you pay me one half on account? <u>I have not yet mentioned it to any one whatever</u>; but failing you, I should probably offer it to Pilgeram, as I have already so many special commissions from Leyland and Graham. Please do not mention to any one the price at which I am offering it to you as I should, according to the prices Pilgeram has been giving me, feel justified in asking more from him; but, as I say, am desirous to open a permanent business connection with you if feasible.

I write to you by preference to making any appointment just now, as the house is very full and I don't know exactly what other visitors may be coming. I also should like to see you and talk the matter over, but it seems, as I say, rather difficult at this moment, and I do not think it impossible to settle by correspondence--at least for the present.

Have you been, or are you going, to Clabburn's?

I am extremely well and never fitter to do good work. With love to Kitty,

I am yours as ever,
D.G.R.

I have told Dunn to send me Valpy's drawing to finish. You do not say what has become of the Italian lady.[3] Neither do you mention what William reported to me of your views on Japan, which would seem likely to affect any permanent business relations between us in a way rendering consideration necessary before I dropped connection with Pilgeram & Co.[4]

[1]Surtees 216, dated "1870."
[2]<u>Proserpine IV</u> (by Mrs. Surtees' numbering).
[3]Presumably the "Countess" of Letters 146 and 149.
[4]CAH thought of going to Japan at about this time but never did so.

149. CAH to DGR Northend Grove, Northend, Fulham, S.W.
 30 October 1872

My dear Gabriel,

Pardon my not having written ere this. I have been very much engaged, to say nothing of being anxious to give you a final answer respecting the picture.[1]

I will take it with pleasure, and am very much obliged to you for the preference. In all future cases however I should like to see you beforehand respecting every transaction, that we may consult each other, and combine respecting price etc etc.

The 250 guineas are at your disposal as soon as you may wish to have it, and the balance on delivery of the picture.

I must impress on you the absolute necessity of early deliveries, I am anxious to make as important a market for your work (for both our sakes) as I can, but in order to do this with success you must in turn do your best to aid and encourage me. On the quality of your work or even subject I need scarcely a

line, all you have to do is to let me know size and price, and when I can, you will find me as ready to buy as you are to paint.[2]

My partner in this matter I must tell you is our old friend Parsons. We are going to deal in a swell way, if possible, he having a rich capitalist friend ready to back him with necessary funds.

Of course all important pictures are only sold privately by us. He hopes you have no objection to his being with me in the affair and is as you see equal with me in all feeling respecting any transaction with you.

The Countess has left London for Jersey long since.

If I go to Japan I shall be represented in London just as if I was here, and my agent shall have orders to obey your orders.

With mine and Kitty's love.

<div style="text-align: right">

Ever your affectionate
Charles A. Howell

</div>

P.S. I see I have said "the 250 guineas" I should have said the 275 guineas.

I will do anything you wish respecting "Silence". Let me know, but do write exactly what you want.

[1]Proserpine IV. (See preceding letter.)
[2]This and the following paragraph appear in PRT (p. 92), with the word small for swell in the second paragraph.

150. DGR to CAH

<div style="text-align: right">

Kelmscott, Lechlade
1 November 1872

</div>

My dear Howell,

Our bargain being concluded, there is no time like the present, and I will be obliged for your cheque by return,--viz: £288-15/--being one half payment for the picture of Proserpina--the other half to be paid on delivery.

I must give you a few additional details however. When I first wrote you about the picture, I was doing it on a scale somewhat reduced from the drawing--the picture I then offered you being about 40 x 19 inches. I shortly afterwards thought that the work rather lost dignity by reduction, and forthwith began it again on the precise scale of the drawing, which I believe will result in 43 x 21 or thereabouts when finished, but the quantity of background will determine precise measurement. In the original picture, however, the head, hair and shoulders are all but finished and thus remain as a second picture for sale, being as good painting as any I ever did. (The new picture will be better than any, I trust.) This second (the original) picture I propose at present to cut down to a head and shoulders only, and would put it in to you at 200 guineas if you like to take it also, though to others I should ask more. Its size I suppose would be about 19 x 16. I think I did not mention to you that the subject is Proserpine. I enclose extract from Lemprière[1] copied by Dunn. You see the passage about the pomegranate. I may possibly write a sonnet and introduce it in one corner of the picture if suiting composition.

Of course I believe thoroughly in Parsons as a capital fellow and old friend, and am glad he is with you. No doubt you and he would consider it as fatal as I should to have my pictures (or any "speculation" ones) shown in a shop or in any promiscuous way. It seems to me that at your stage of affairs, a "swell" business could only be ensured by some one doing the travelling business without reserve, and the only man really capable of this would be yourself. But you are best judge. Is your connection with Parsons involved with the Bradford connection also?

My wishes about the Silence I explained exactly to Heaton before I knew you had anything to do with him. Do you like to call yourself on Dunn at Cheyne Walk, who will show you the things I offered? I am sick of Heaton and Brayshay's delays, and unless you take it up, am disposed to drop it. Before my knowledge of your connection with H. also, I asked him if at any time he would like to buy chalk drawings and he says Yes. In fact he answers Yes as supposing apparently that my question referred to works of mine generally, but I only said chalks, as it is convenient to know where to place these without asking this that or the other buyer if they want them. Now however I should offer you any such things first. I have just finished one here from little May Morris who is the most lovely girl in the world. It is a drawing to the waist holding a heartsease and might be called Heart's Ease.[2] It is as full in colour as a picture and very

highly finished, besides being most unusually attractive. Size--2 ft 4 3/4 x 19 inches--shape upright. F. and D. are making frame for it. If I sell it now I shall want 100 guineas and don't doubt I could get 150 if people saw it, for it's just the thing to sell. I feel much inclined to keep it myself, but can't afford I suppose.

<div align="right">

Ever yours affectionately,
D.G.R.

</div>

Please send me back the extract.

P.S. I have omitted to answer you as to time of delivery of the Proserpine--I trust to let you have it in about a month. Should it be longer, it will be in the interest of the work, but it shall not be much longer in any case. I mean always now to go straight ahead with things (as I have always done lately) and not keep them long in hand as of yore.

P.P.S. I said nothing to Heaton about my knowing you were his partner, as I judged from what you said that you did not wish this.

[1] I.e. J. Lemprière's Classical Dictionary.
[2] Not the pencil drawing of this title (Surtees 194). WMR gives two different accounts of this drawing (DGRDW, pp. 81-82), which Marillier lists as No. 379, "Portrait of Miss May Morris. (Crayon?), Sold to Howell and Parsons and by them to Prange." The market history of the drawing is given by CAH in Letter 218. (See also Letter 156.)

151. WMR to CAH

<div align="right">

56 Euston Sq. N.W.
1 November [1872]

</div>

Dear Howell,

That matter of Pinti and the Botticelli recurs to my mind.[1] Gabriel, if he fulfils his expressed intention, is likely to remain at Kelmscott some 5 or 6 weeks yet: but my own belief is that he will soon find the place practically inconvenient at this season, and will be back in London within a fortnight or so. It would be most unpleasant for all parties to be then compelled to quibble and shirk over the affair of the Botticelli, or else to make open avowal of a troublesome mishap. On to-day week I returned from about a fortnight at Kelmscott, and circumstances have as yet prevented my getting round to Cheyne Walk: assuming however that the Botticelli is still not there nor in your own hands, I should be very glad if you would tell me what can now be at once done. I said at the time that, telegrams notwithstanding, weeks or months would elapse before the picture returned to England, and I fear I was right.

Barring the lameness--which continues without apparently giving him any serious trouble--Gabriel is in very good health and spirits: but every now and again he says something which shows that anything likely to agitate him, or to revive a certain train of ideas, ought to be carefully excluded. Christina not so very much amiss, considering.

Best regards to Kate.

<div align="right">

Yours very truly,
W.M. Rossetti

</div>

[1] In Letter 143 CAH had informed WMR that the Botticelli had been sent off to the King of Italy by Pinti (a dealer).

152. CAH to WMR. (Printed PRT, pp. 65-66.) Northend Grove, 2 November 1872. Is delighted with good news of Christina and DGR, whose Proserpine he has bought. "Hang the Botticelli business;" if DGR savage about it, CAH will buy it and hand over tin to DGR.

153. CAH to DGR

<div align="right">

Northend Grove, Northend, Fulham, S.W.
5 November 1872

</div>

My dear Gabriel,

I was too busy to write fully yesterday, or even earlier than this evening. I however left a line for you at Wigmore Street[1] and told Parsons to send you cheque for £288.15.0 which I hope you have received. I am most anxious to see the picture that I may the sooner enjoy its beauty. I enclose Dunn's extract,

and if you find you can introduce the sonnet I think it would add very much to the interest of the work.

I am glad you like Parsons. Of course neither of us would dream of a shop. Parsons is going to keep the shop under his house for small ordinary things, but no picture of yours would be near it. No doubt all travelling etc. etc. will fall on me, and you must do your best to let me have things as quickly as you can in order that we may move on.

My connection with Parsons has nothing to do with Bradford, for the present it refers to your work, I being anxious not to scatter it about but to have one ready, definite, and organised plan to treat freely with you with no further necessity than that of seeing Parsons, as in one hour or so, we can always see each other.

My position with Parsons as regards your work is simply this--Parsons friend finds the necessary money to pay for the pictures, and we two (myself and Parsons) agree to divide both profits or loss.[2]

As regards the Silence as I said before I did all I could to keep it for you, and today took Brayshay[3] to William at Cheyne Walk, that they might talk the matter over, Dunn produced your letter in which you offer the two chalks in exchange and a few pencil things. Heaton also writes to me in this sense, and Brayshay picked some of the sketches out, and Dunn will write you on the subject so that you may accept the exchange or not. I must tell you that I have nothing to do with this transaction, and do not get a penny by it.

Of course all offers you will always refer to me. Now about the first project of Proserpine and little May, I should like to have both very much and though I would on no account dream of attempting to reduce your prices, I very much wish you would take off the guineas in all cases, if you can do so at once, we will take both for the £300. In the first place, I never can get the extra shillings on any picture, the artist can get it from private customers, but the dealer never can, this reduces all profit very much, and if you will knock them off I assure you that at first at least, it will be almost all our profit. We are not going to stick on heavy profits all at once, I wish to work your market as I did Watts',[4] little by little and in a sure way. The ratio of profit might be put down as follows by you. Picture bought of you for £400 sold by us for £440--£20 for myself and £20 for Parsons, if we give guineas we should just make half which would be little indeed.

We are not going to tell lies about the work, we shall ask our price in a straightforward way, and get it or decline all offers. Now Gambarts' do tell lies, and bargain away like Jews. They swear they give 50% more for the pictures than they do, and at last get all their pull out of exchanges for Frith and Hook,[5] and so on, and this we are most anxious to avoid with your work. It is easy to make money by shelving all dignity, but in placing your pictures we wish to do so with as much respect as we can, and are anxious to show them.

I am quite sure that as a good business man you will agree with me, and see that it is no wish to bargain on my part that leads me to say all this.

Let me have a line respecting the two last pictures, and if you accept, and are not pushed for cash perhaps you will let us have them for cash on delivery, i.e. if as I presume they are ready or nearly ready, that we may have something to go on with at once.

With our best love,

<div align="right">
Ever yours affectionately,

Charles A. Howell
</div>

[1]The business address of the Parsons-CAH partnership.
[2]This and other brief excerpts printed in PRT, pp. 92-93.
[3]W. Hutton Brayshay, described by CAH in a letter of 8 Dec. 1871 in the HRC as "a rich man in Bradford, a friend of mine who likes to see pictures, and sell pictures, and exchange pictures...."
[4]G.F. Watts.
[5]James Clarke Hooke (1819-1907).

154. DGR to CAH Kelmscott
 7 November 1872
Dear Howell,
Let me notify to you also (I have written to Parsons) receipt of cheque 288/15/-
on account of Proserpine price 550 guineas. It goes on capitally and will be my
best picture.[1]
 I have mentioned 2 points to Parsons--1st that of copyright which must (as you
doubtless understand) remain exclusively mine and 2nd the great desirability of
getting a guarantee from purchasers now and in possible future cases that the
picture shall be lent for exhibition if needed. The one which lately went from
Pilgeram & Co. to Dunlop would I fear be lost for this purpose very much to my
regret, seeing that he is no friend of mine.[2]
 Will you oblige me by getting 2 sets of labels printed according to enclosed
M.S.S. to stick on back of pictures and drawings.
 I shall be very glad to hear from you as soon as possible in answer to my last.
 Ever yours,
 D.G.R.

I wish you would send one of the labels when printed to Heaton to put on the
drawing of Silence. I will have 300 copies of each label. Of the picture labels,
200 should be printed for oil and 100 for water colours.

 line for title

 drawn in chalks
 by D.G. Rossetti

As this drawing is not "set," it would require great care if ever removed from
its frame.

The copyright of this drawing is the exclusive property of the artist, and the
drawing cannot be exhibited without his permission.

 (blank line for title) leave a good space here in case
 of quotation

 painted in (oil colour
 (water
 by D.G. Rossetti

N.B. The copyright of this picture is the exclusive property of the artist, and
the picture cannot be exhibited without his consent.

[1]In a letter of 6 Jan. 1874 to F.M. Brown, DGR gave the complex history of "this
blessed picture," which he had begun "on seven different canvases--to say nothing
of drawings" (D-W, p. 1253). In 1882 he added an eighth, a replica for Valpy.
[2]Dunlop had commissioned The Boat of Love at a price of 2000 guineas and, after
"long delay and silence on Rossetti's part, cancelled the commission" (Doughty,
pp. 322-23). The picture that Dunlop bought was The Bower Meadow.

155. CAH to DGR Northend Grove, Northend, Fulham, S.W.
 8 November 1872
My dear Gabriel,
It will be easy to secure the right of borrowing any picture for purposes of
exhibition, and I have no doubt that I could get you Dunlop's (though I do not
know him) should you ever require it. I will get you the labels printed as you
wish, but before doing so might I suggest one or two points. First instead of
having them printed it would I think be better to have them in facsimile of your
handwriting and signed "D.G. Rossetti." This carries more weight being the
counterpart of your autograph. I enclose a copy of the facsimile of your and
Brown's certificate to me which I have had done like this, in order to preserve
the originals. If you like this idea all you have to do is to write out three
very carefully, one for water colour, one for oil, and one for chalk and I will
get them done at once.

My next suggestion is that you should strike out "and the drawing cannot be exhibited without his permission." I will give you my reason for advising this course. First no one can impose conditions in a contract of sale which are not recognised by law, for should such conditions be broken the artist or vendor would have no redress, i.e. if I buy a picture of you on such terms, and send it the day after to the Royal Academy you could neither un-hang it, or claim it, or stop me from hanging it. Dunlop dies tomorrow and leaves his picture to the National Gallery, it will at once be hung at South Kensington without your being consulted.

Again someone might some day wish to spite you and say "damn the conditions I will exhibit my property where I like," and thus place you in an unpleasant position by making you feel that you must remain quite powerless in the matter.

For my part I would never dream of exhibiting any thing of yours without your full consent, and I do not believe any other gentleman would, for such therefore the condition is needless.

Again once establish such a condition and men who get up exhibitions will go and borrow early pictures of yours on which there is no such restraint and thus represent you not at your best where they like.

I hear Prick of Liverpool has got up a fussy exhibition where he has works of yours. I have not seen them, but I know that such a person would do anything, at any cost to show off, quite regardless of all feeling in the matter, and knowing no more of the qualities of a picture than I know about hats.

Heaton writes to me that he has sent you a proposal for a little water colour head of Christ on behalf of a friend etc etc. This is all nonsense (quite betwee us) the friend is of course a parson or a church, and Heaton is dealing like myself and on any commissions to you would get 10 or 15 per cent, now I do not wish to interfere with Heaton, but I do not wish him to declare all over Bradfor that he can get any thing he likes from you therefore if you have not accepted, do you mind referring him to me? I do not wish to gain any thing in the transaction but I wish you to lend me a hand as much as possible to strengthen my position when it does not hurt yours. The reason I was able to double and more than double Watts' prices[1] was owing to his referring everyone to me. This of course you cannot do but I think it would be fair to do it to all dealers who might apply to you. In case we ceased dealing any day (of course I see no danger of any such thing) you would find that some one else would readily take my place though no doubt it might be less comfortable through the fact of my being--as an old friend--able to tell you all about myself, and hear as much about your private wants etc etc as you might care to tell me of. Do your best to let me have something as soon as you can.

<div align="right">

Ever your affectionate
Charles A. Howell

</div>

P.S. Some six weeks since I saved the Magdalene from public sale, I bought it of Clabburn and have buried it in Bradford, I mention this as at one time you damned the picture and said you feared having it about. I bought it for this reason and there's an end of it.[2] I have such a deal to tell you that I shall be glad to see you as soon as I can.
Private.
P.S. In your business letters respecting pictures, money etc etc never put any thing of a private nature, do that in a separate P.S. All serious proposals, and correspondence you will always make and carry on direct with me, this gives me the only hold I have, and ensures my position, it is as much to your advantage as to mine. If you are not hard up send me the £14 I paid for that batch of jewellery you had. I require it, but would not ask you for it until I wanted it badly.

This is a most dreadful thing about poor Graham I am told he is quite wild and broken-hearted. The eldest boy and the one he cared most for![3] I am so sorry for him I could almost go down to him, and wait on the poor old man. Just send me a line of advice, and say if you think I ought to write to him, he has always been kind to me, and the lad was such a fine fellow I could not help crying when they told me he was dead.

Don't neglect to send me a line about this.

[1] CAH makes this assertion several times. Although a few letters from Watts to CAH are preserved in the HRC--enough to show that CAH was trafficking in Watts's

pictures--I am unable to determine how much exaggeration may be in the assertion.
[2]This does not tally with the history of the picture as given by Mrs. Surtees
under 109R.2.
[3]The boy took poison, mistaken for medicine, and died at age 15.

156. DGR to CAH

Kelmscott
8 November 1872

Dear Howell,

Thanks for your very satisfactory letter. I shall do my best to work in every
way with you to our joint advantage; and while I hope my work may not fail to
prove market value, as hitherto in other hands, I think none the less that you
and Parsons, by your unreserved willingness to accept my proffers, show a degree
of enterprize and camaraderie which must enlist my desire to help you in every
way I can. I really believe that by keeping this in view, we may ere long make
good way together.

I am quite willing to take pounds instead of guineas for the 2 smaller
transactions--viz: £200 for the first head of Proserpine[1] and £100 for the
drawing of little May: and would adopt the same course for the future in all
small transactions; but fear I could not apply the rule to larger ones.

For instance, the Proserpine picture will be the very best I can do; and
though I consider it even to my own interest to sell it you, at this our first
start together, for the lowest price I can afford, I cannot forget that to any
one else, even a dealer, the least I should have asked would have been 700
guineas, and that I have every reason to believe from recent instances that at
least 800 guineas could be got for it with certainty by judicious dealing.
Indeed I believe it might fairly pretend to the character of a 1000 guinea
picture, with good working to back it; and I think if you try for less than 700
at the very lowest, you will be throwing away a certainty. And indeed the only
thing which would prevent my continuing our connection would be in case I found
that the pictures I sold you, going into other hands below my usual tariff,
thus compelled me to lower my prices to private purchasers. Pardon my speaking
thus plainly, but believe me that I, for one, shall be only too well pleased to
hear of your making a larger profit.

Had I not asked 550 guineas, I should certainly have asked you £600 for the
Proserpine, round sums being natural; for £550 would have been less than I
could have taken; and I fancy in all important cases my old habit of guineas
(always accorded to me even by Gambart) will stick to me.

I will send you the drawing of May as soon as the frame reaches me, to be
paid for on delivery--£100. Also the head of Proserpine whenever I take it up
to put background etc., though this will probably not be till the larger picture
is done. This also (head of P.) to be paid on delivery, £200.

I have written an Italian sonnet for the Proserpina, which I shall introduce
on a cartellino in the right hand top corner of the picture. By the bye I think
it very desirable for you not to begin working smaller things of mine at all
seriously till you get the picture which I will make as soon as may be.

About the Silence question I hear today from Dunn, with sketches of his,
showing me what 7 drawings Mr. Brayshay chose, most of which are well worth £20
apiece, besides the 2 large drawings which alone are I believe a good trade
equivalent for the Silence. I cannot give more than 3 of the small drawings, as
I am writing Dunn,--otherwise the question may drop.

About poor Graham, the matter is indeed a sad one. I had a letter from him
notifying it (and which William could show you,) which proved that, much as he
must be overwhelmed, he was at any rate able to write with resignation. I fear
nevertheless the most serious results for him. His brotherly conduct to me this
summer has made this terrible blow received by him now dwell with me very
mournfully. I can see no objection whatever to your writing him a letter of
sympathy.

Ever yours,
D.G.R.

P.S. Private
 I cannot exactly recall the jewellery transaction. Are you sure it is not
represented by one of 3 counterfoils in your name which I find in my effete
cheque-book?--viz: 20th January £12
 29th January £2-19
 26th April £26
(This last was a writen order, but I noted it on a counterfoil to assist in
keeping accounts.)
 Pardon my asking the above question, but the written order might possibly
have escaped your memory. On hearing from you that this _is_ an extra sum of £14
I will immediately forward cheque.
 I believe I have forgotten for 3 letters to say, Love to Kitty, but have not
forgotten _her_.

[1]Renamed Blanzifiore (Surtees 227); cut down from one of the rejected Proserpines

157. CAH to DGR. (Printed PRT, pp. 93-94.) 9 November 1872. "Damn the Brayshay
business." Discussion of financial dealings, with documents showing DGR
indebted to CAH. Mention of supposed portrait of Lord Darnley by Antonio Moro.
"Here's memory and history, now fork out and look cheerful. All my accounts are
as clear and accurate as this...."

158. DGR to CAH Monday, [11 November 1872+]

Dear Howell,
 I shall probably be writing more at.length this evening, but must save today's
post to ask you to look at once at above things of mine (cutting from Athenaeum).
I suppose they come from a trumpery sale of Miss Bell's[2] I heard about, but
don't know what they might be. If one is that beginning of a water colour
drawing of the Passover in the Holy Family[3] which Ruskin used to have of mine,
I'd like to buy it and finish it, or would buy anything of my own worth working
on or good for anything.
 Ever yours,
 D.G.R.

[Accompanied by drawing on p. 3.]
P.S. I've changed my signature to cheques.

[1]At top of page:
"To Artists, Collectors, and Others--
For Sale several valuable Original Drawings and Water-Colour Sketches, by
Edward Berne, [sic] Jones, Dante, [sic] Gabriel Rossetti, Professor Ruskin,
Prout, and the late William Hunt, selected from a Private Collection--May be
viewed at Mr. Jones's, 34, New Bridge-street, E.C."
[2]Miss Bell, a schoolmistress, was a friend of Ruskin. Her pictures, including
some Rossettis, were auctioned at two different sales.
[3]Surtees 78.

159. DGR to CAH Kelmscott, Lechlade
 11 November 1872
My dear Howell,
Before going on to other things, _do_ see about getting me that Antonio Moro (!)
portrait--Zucchero[1] I should say. It would look so stunning here. Also there is
a bloke you might call on who has got that Breughel garden picture of mine to
clean. His name is Sherlock and he did live in New Quebec St. but I rather
think has moved. He has had the thing an age by him. You'd find him in Directory
When that way, give him a look up; but do send me the other picture, as it
would really give me pleasure-- ·
 I quite agree with you as to the usefulness of referring applicants to you
when feasible; and shall do so in all cases of dealers if our connection takes
stable footing. As to the Heaton business, I said to oblige him that I would
colour an old pencil sketch of Christ or Ned Jones for £25, and have had it
sent here for that purpose. You may depend on my consulting your interests and

viewing them from your own point of view. I am very glad you bought that Magdalene sketch of Clabburn.[2] I hadn't heard of the show at Liverpool containing things of mine.

John Marshall strongly advises me to continue in country air, and Dunn has been looking at several houses for me nearer London than this, but hitherto without success. If you hear of anything really good--not at all London but not so far as this--you might let me know; but I fancy the best after all may be to stay on here, as I fancy I could somehow push on with work, and there would be conveniences in some ways more here than elsewhere. One thing is this house is fearfully likely to be cold in the winter. My studio is hung with old tapestry which leaks everywhere with wind. I want to find another set of thick tapestry or curtains to hang over these as the readiest way of shutting draughts out. Do you think you could readily find such through Marks or other channel. I would rather hire than buy and don't mean at all to get swell things of great expense. Indeed economy is my present goddess. Another thing I want is a light screen easily moveable but capacious. Those Japanese paper screens--6 leaved-- such as a very old one I have at Chelsea--would be probably the most available. Would you mind going to Hewitts when that way and seeing if they have any. I want one badly, or some screen.

When I see you (which I hope to combine ere long) I want to talk over several things very seriously. One is the getting up a collection of some dozen or so of my latest and best things and exhibiting them in the Spring. What is your opinion about this? And would it be in your line to manage such a thing? Gambart some 5 or 6 months ago pressed me very much about it, together with engraving the large picture, but I don't want to do it with him. One leading question is, what good gallery could one get? All however is quite a question in my mind as to advisability.

Now there is another point I wish to mention in strict confidence. I fear Brown must be very short of commissions at present. Do you think Parsons would combine with you to give him a commission of (say) 400 guineas? I would do anything in my power to facilitate this if you didn't see your way clearly. If there were any loss on the work, I would gladly indemnify you by work of my own, or take any course you might propose that I could manage to adopt. Please think over this and let me know. Of course all my connection with such a plan must be a secret from B.

The Proserpine gets on fast and I must be ordering the frame. I really don't know what to do better than the one I have adopted for most of my heads, only instead of leaving the flat round the circles plain, I should try a pounced pattern as in that Venetian frame [sketch]. I must write to F. and D. at once with measurements.

I suppose I shall be getting the frame for the drawing of May very soon, and will then send it forthwith to Wigmore Street. By the bye I wish when there Parsons would make me a good sized photograph of it. Also of the Proserpine when sent.

The lithographed facsimile you mention as enclosed was omitted from your letter. When you send it I'll settle my mind on that point. I think you are quite right as to not putting the phrase about exhibition. However you know all exhibitions (or nearly all--certainly the Academy) profess not to exhibit any work unless bona fide the property of the artist,--and the point which this must be taken I suppose as intended to secure--is the artist's consent to its exhibition.

Love to Kitty, whose reflected image I rejoice in seeing so rotund. I re-enclose one of my autographs, but the other has somehow got absorbed into a vortex of papers on my table. When I do see it again I'll send it.

Ever your affectionate
D.G.R.

[1]Zucchero or Zuccaro, the name of two Italian brothers who were leaders in the Roman Mannerist School. Of them Federigo spent a few months in England in 1575 (Britannica).
[2]See Letter 155 and n.2.

160. CAH to DGR Northend Grove, Northend, Fulham
 12 November 1872
My dear Gabriel,
Thanks for cheque. I have seen the whole of the things, there is only one
rubbed faint careless pencil sketch of yours which no doubt Ruskin picked off
the grate no more lines than this [sketch] just the kind of thing I have seen
you tear up often. The Jones'[1] are something too disgraceful, and if we had
been friends I would have bought them all for him. If you care for him, and
care to write, ask him to go to the place and buy them up. They will do him a
lot of harm and on this score are worth any money to him, people see the
Athenaeum and rush to see the things. Mr. Jones the man who has them is a house
agent, and poor devil seems puzzled at the things, "people go in and get out
at once laughing." Jones must have done these things when staying at Miss
Bell's for a lark and to please the children. They are all Miss Bell's, it
seems Ruskin has turned his back on her, and the poor devil has gone to ruin.
Jones told me she was in awful trouble and quite ruined. The sale you mention
was also hers, and for your sake I sent a man to run up your things and buy all
that went for shillings. This he did. I got all except two of your wife "at
Hastings" for which Ellis paid about £15 each. I did the same thing for Jones,
but please do not say a word on the subject Jones would not care a damn for it,
and Ellis would hate me for life. I paid £70 for the lark but if it is any
service to you I am bound in frankness to tell you that it is part of my
business policy to make people pay for your and Jones' things. People think I
am mad, but they are most welcome to any thought they like on the subject. I
can have my laugh now and then.
 Leyland made me pay him £200 for the Carol,[2] and now tells me that he is
going to make you buy back the Lucretia[3] for £200 or £250--to be deducted from
other work! Now take my advice, get Dunn to frame it at once, write him a nice
note and deliver it. He has nothing small of yours and you need fear nothing
this one must come into my hands also. The Dante and How they met themselves[4]
I bought of him also, so that he has nothing left that he can sell. Of course
you must not compromise me in any way. I can be of use to you outside but you
must never peach. I do want you to make a lot of tin, and please God if I can
at all help I will do so with all my might. I told the House agent to withdraw
his ad: as it only brought ridicule on him, and this he has promised to do.
 Your affectionate
 C.A. Howell

[1]I.e. Burne-Jones's. CAH and Burne-Jones had parted company before this time.
(For the break between them see Introduction.)
[2]In a note attached to this letter WMR says that he is uncertain about the
Carol but supposes it a water-color once owned by Ruskin. It is not, he says,
either the water-color or the oil named a Christmas Carol. I am unable to
connect the picture with Leyland.
[3]Lucrezia Borgia (Surtees 124). Mrs. Surtees says that "after the sale of [B.W.
Windus'] pictures in 1868" it "was acquired by Leyland." As DGR's letter of 5
Dec. 1872 (infra) makes clear, Leyland bought it from F.S. Ellis.
[4]WMR supposes the Dante to be identical with the Dante and Beatrice of Letter
163. How They Met Themselves, he says, is well known as both a pen-and-ink
drawing and a water-color. The original pen and ink and brush, dated "1851 1860"
was executed for Boyce. There were two later water-color replicas, neither of
which I am able to connect with Leyland. (See Surtees 118.)

161. CAH to DGR Northend Grove, Northend, Fulham, S.W
 13 November 1872
My dear Gabriel,
Thanks for your nice letter and all enclosures. You shall have the A. Moro, or
Zucchero as soon as possible, but the man who has it has been very ill, or it
would have been sent before. The Breughel was finished two months ago and sent
to Cheyne Walk. It is there in the drawing room now. As regards the show at
Liverpool, I have not seen it, but I am told that there are things of yours
exhibited.
 I think John Marshall is right and if I were you I would stick to the country,
it will do you no end of good. How would Richmond do? There are a lot of fine
old houses in the place, and as a rule the rents do not run high. As to screens

it so happens that I was at the Docks yesterday selecting one from a lot just
arrived from Japan, I found a very fine thing which I bought for £30, but there
are a lot of the 6 leaved ones such as Farmer & Rogers sell for £10 at £4 each
and if you like drop me a line and I will run down and buy you one which Foord
& Dickinson can pack up and send off to you at once. These four pounders are
Japanese paper, and very good, painted with flowers reeds etc etc and taller
than you, and as light as a feather. As regards tapestry the affair is more
serious. Tapestry has gone up fearfully and any rag is worth £20. Then again it
would be impossible to hire it, besides it is bad policy to hire any thing for
use, by the end of the year you have paid the full value of the thing, and
sometimes the owner will say "this is worn, or damaged" or any thing else, and
make you pay for it. If the walls of the studio are good, you can render it
free of drafts by taking down the tapestry, tapestry though it looks cosy was
never meant to <u>warm</u> a room and when it gets old and loose all drafts find a way
between it and <u>the</u> wall and out they come wherever they can. If you want it up,
the best and cheapest way to cure the drafts is for me to buy you some old
carpets felt or any thing else of the kind, then get a woman down and line the
room with them <u>behind</u> the tapestry now hanging. Send me the height of the room
and let me know <u>about</u> this.

We will undertake the exhibition with pleasure. I think it most desirable,
but of course I should have to see you to settle details etc etc etc. The best
room in London is the New British Institution in Bond Street and this I can get,
only the rent is very high, but that should not be considered in the <u>least</u>. It
would be better to have it when every one is in town, but when <u>nothing else</u> is
going in order to concentrate all attention on our exhibition then again we
must make friends with the press and give a dinner or two and thus secure the
most we can good and indifferent. This should be done entirely by myself, you
helping me only on the sly as far as a few friends are concerned. For the
monthly periodicals we could go on preparing notes on the pictures which would
help Swinburne, and "such like." Then have a very swell private view and invite
every nob in the kingdom. All these things want working in earnest, every little
matter well thought over, to ensure success.

Parsons shall photograph every thing for you. What say you to a fine selection
of photographs forming a handsome folio to sell in the exhibition, <u>you as far</u>
<u>as public knowledge is concerned having nothing to do with it</u>? This would bring
in a lot of tin, and do good. I could sell any number of photographs but my
answer is always "not to be had." When the picture does not photograph well the
photo can always be worked to any thing in black and white, and then rephoto-
graphed. This is a point which deserves your serious consideration.

Be sure I am right about the omitting the phrase about exhibition. From
standard exhibitions such as the R.A. you are quite protected. All you have to
look to is the International and fussy small things got up by "Kintra folk."[1]
I will see what I can do for Brown. I wish always I could be of use, but you
have no idea how hard it is. I bought the "coat of many colours" and the
"Elijah" from Leyland to save them from a bad fate, and am now trying to buy
the "Chaucer" which he wants to sell,[2] and which Mrs. Leyland runs down every
evening, and to every one. All this you must keep to yourself. Leyland is a
queer hard chap about pictures, obstinate as a mule, and Brown (indeed every
man) must hold his own with him or he is done for, if Leyland got the slightest
inkling that I discussed matters with you in this way, I would never learn any
thing more from him respecting his art transactions, and to know what he thinks
is quite as valuable as his tin for one can always please him the better by
working to his pulse. Brown is affectionate and I am sure true to me but I
think he might have treated me a little more frankly than he has done. He never
asks me to his parties now. Not that I want to go, for I have trouble enough to
refuse as many as I can (for it seems the fashion now to ask you to dinner, or
send large "at Homes" on the slightest chance acquaintance, and urinal
encounters) but I feel it as a marked slight, when I see that <u>every body</u> is
asked except myself. It matters but little to me if Lord this or Lord that
forgets me, indeed not caring for Lord that a single damn I am glad he does
forget, but caring for Brown I cannot help feeling the damned thing. Kathy[3] was
married; she was Kitty's bridesmaid and not a word from Brown on the subject to
me! I had bought something for her and sold it again for I cannot make a fool
of myself by offering her any thing as if I wished to force myself on what they
have kept from me. Brown asked friends and foes, and no doubt knew that he had

to ask Ned Jones as an old friend, and that therefore he could not ask me, but
he might have sent me an affectionate line on the subject, and even stated the
fact that Ned must be asked, and this would have cheered me, and I would have
been quite grateful to him, and naturally kept away quite content. However all
this is only chat, but I do hate to love any one better than they love me.

By this same post I send you all the certificates I have, if Government create
the appointment at the International no one has the chance I have, at least so
they tell me.[4] (The certificates I now send you are all lithograph so you need
not send them back.) Do you think Morris would give me one, it would be
invaluable to me, but I fear asking him, as I should be more than grieved if
he refused me. He has no reason to refuse me that I know of, but people say, I
am told, "Morris never sees Howell now, Howell owes him a lot of money, and as
usual began by avoiding him, and so the friendship ended!" This was said the
other night at some damned club to which Colvin belongs, and is of course most
cruel, but what can I do? It seems a wonder that I have left a single friend
with a shirt on, but this the world seems to think is because they wear flannel,
a material I do not care for. If you care to break a lance for me, and show
these to Morris and repeat all I have said about it I should be very grateful,
if not never mind. Here are 30 friends at least who cannot complain, and seem
to have some kind of good word or other to say. The crusade against me is
among five or six, the rest do not know me at all[5] but shortly please God I
will clear up somehow, and a mistake will be found here and there.

<div align="right">Ever your affectionate
C.A. Howell</div>

Pardon scribble I am so tired.
Do you mean that Kelmscott/Lechlade is sufficient without Berkshire?

[1]Kintra, "adj. Belonging to the country, rustic, rural" (English Dialect
Dictionary).
[2]Jacob and Joseph's Coat, a water-color of 1866-67 acquired by Leyland, a
replica of Chaucer at the Court of Edward III, finished in 1867 for Leyland,
and Elijah and the Widow's Son, several versions of which were painted between
1864-68, none of which I can trace to Leyland.
[3]Cathy Brown was married to Dr. Franz Hueffer on 4 Sept. 1872.
[4]CAH was a frequent candidate for positions that he never got, each time
gathering numerous testimonials. This vacancy was for a post in the ?Internationa⟩
Arts Society (PRT, p. 92).
[5]"Do you think...know me at all..." in PRT, p. 92.

162. DGR to CAH [Kelmscott]
 14 November 1872
My dear Howell,
Will you tell me what the things of mine were that you got at Miss Bell's sale,
and what of mine was there besides that you did not get. Was the Passover
beginning in question there at all, or that head of my wife in oil colour called
Regina Cordium[1] which Ruskin had? One thing from that sale (no doubt) has been
sent me by a man at Manchester who bought it from a dealer there and wants me
to finish it for him. It is a seated figure of a girl playing on the harp--the
head in colour, the rest scrawled.[2] Was this one of yours? I am surprised if
those 2 sketches in pencil of my wife (which I believe I remember) fetched £15
each. I think you must be under a mistake. I dare say I may try and get them
from Ellis if he got them cheap.[3]
 About Leyland. He wrote me some weeks since about his Lilith.[4] I was already
seeing about it and am now finishing it here. When I send it him I think I
shall send the Lucretia too. Assuredly I shall not take the latter back at a
fancy price. Leyland wrote me again yesterday apparently in high spirits. He
has ousted his partners at last for good and starts the firm under his own
name on 1st January. He tells me he is coming to London in January this time--
earlier than his wont.

<div align="right">Ever yours,
D.G.R.</div>

You put Berkshire on your letters. This is Gloucestershire. But no county is
needed. Better without.

[1]Surtees 120.
[2]Identified by Professor Fredeman as The Harp Player (not in Surtees); originally sold to Mr. W. H. Doeg.
[3]See Letter 160.
[4]Lady Lilith (Surtees 205); begun 1864 from Fanny Cornforth, repainted at Kelmscott from Miss Wilding; sold to Leyland for £472/10/0.

163. CAH to DGR Northend Grove, Northend, Fulham, S.W.
 15 November 1872

My dear Gabriel,
As far as I can remember there were but few things of yours at the sale,[1] and certainly nothing of importance. I have not got the catalogue, or rather I cannot find it for I am sure I kept it. There was however nothing of importance, nothing in oil or water colour, and here follows the list of I am sure every thing.
The drawing you have girl playing on the harp,[2] fetched £10.10.0 had a glass over it, was knocked down to the man I sent (I told you I did not go to the sale myself) but "some one else" perhaps Ellis? claimed it, as his bid, and there was no dispute.
St Luke preaching[3]--[sketch]--Howell Drawing for the Leyland water colour I bought,
Dante and Beatrice[4]--pencil--Howell
Dante sitting half pencil half pen and ink very beautiful [sketch] Howell £11.11.0
Benjamin Woodward being knighted by Alma Mater [sketch] Howell[5]
One pencil indication of a figure scrawled as you call it [sketch] Howell
Another St. George very dirty and Dragon[6] [sketch] no doubt done as a lark--Howell
Pencil very delicate and beautiful your wife reading inscribed "Hastings"
Another, quite the same time and quality--both under glass but no frames.[7]
My agent said "A Mr. Ellis" and I certainly understood £15 each, it might perhaps be both. Either way I was very sorry for I would have given any thing for them to give to Kitty for her little room and I wish I had gone, as my chap was a fool. Not a scrap more of yours, the other things the man bought for me were Ned Jones and Ruskin sketches. You must excuse my drawings, as works of art slight, as things of beauty bloody. These sketches of yours I bought for a friend of mine a great lover of yours and a good chap, and I have them not here to copy from.
The Passover[8] and Golden Water[9] Ruskin still has, they are the only things he has never parted with. The Regina Cordium he sent to America ages ago, and I heard that you had written to him on the subject but that in answer he evaded the question and said he had "not sold it." Write to him and borrow it, if he lends it to you I am wrong, if he does not I am right. Only remember in all these things my name is never to be mentioned by you. I told him it was a damned shame and that he ought to get it back, perhaps he has done so since. Try--his address is Brantwood by Coniston Water--Lancashire.
He has sold Denmark Hill, and "retired," to what Crawley[10] calls "a something similar in feeling to a 'Halp'" [i.e. Alp].
I wish Leyland all success, but I saw a Liverpool man today who told me that Leyland's Liverpool enemies are so numerous and loud that he seems to hurry through the streets, and stands there almost hated. He tells me that there will be war to the knife for years to come, and that Leyland will have to fight harder than ever. It seems that over night some one posted up the office doors with placards--
"Skunks, and robbers kick over the ladder up which they climb."
Of course I am obliged to hear in silence, I will have no row with any one unless it be for some one I love dearly, but if this is true, Leyland proud as he is must be miserable and I am very sorry for him.
 Ever your affectionate
 C.A. Howell

I never had the Kelmscott address down in my book, and when you returned from Scotland not remembering it I asked Brown.

[1]Of Miss Bell's pictures.
[2]See preceding letter.

[3]See Surtees 102.
[4]See note 4, Letter 160.
[5]WMR in a note attached to this letter says that Benjamin Woodward had been the architect of the Museum and Union building in Oxford and that "in saying that a drawing by Rossetti represented 'Benjamin Woodward being knighted,' Howell meant that it represented a man being knighted and the face of the man was evidently founded on that of Woodward."
[6]Called by WMR "a slight specimen" (DGRDW, p. 83).
[7]The drawings here are undoubtedly Surtees 465 and 466.
[8]Surtees 78.
[9]Surtees 107.
[10]Ruskin's servant.

164. DGR to CAH Kelmscott
 20 November 1872
My dear Howell,
Thanks for your trouble about the screens. If as high as the one of that sort I have at Chelsea, they will do,--if not, perhaps I may be returning them as you say it will not matter to you.

I had a good laugh in my easy chair (as no doubt others had in Christie's rooms) at your startling synopsis of that sale. Above all, what in the world can "Benjamin Woodward and the Blessed Damozel"[1] be like, and who in the world can have compiled the catalogue and gone in for chaff to this extent? Your sketch of the above recalls nothing to me, nor do the 2 following ones, but if they have anything to do with me at all I should think they must be rough scrawls of poor Lizzie's. But who can have christened the one in question, or why poor dead-and-gone Woodward's name should be lugged in, are matters which pass my comprehension. If the happy possessor can spare them I should really like to see these 3, and if the one of Dante seated is sent with them, I will finish it as a return for the indulgence, and return all with the care due to such treasures.

About the exhibition project, I have been considering, and think further deliberation necessary,--should moreover like to get the views of a friend or two.

Thanks for the sheaf of lithographed papers. I dare say I may adopt that style but don't feel sure. As to what you ask me about Morris, I am afraid there is no choice but to say at once that I know he would not do it. I am very sorry for this and would much rather not have to say it, but you know what influence would prevail with him.[2]

I shall be very glad if you can see your way to a deal with Brown, and would myself, I repeat, do anything that might facilitate such a move. I am sure that, as a man of the world, you will not on consideration think B. at all blameable towards you as to the points to which you refer. To balance necessities between friends in such a case is very difficult, and with a man of Brown's age and standing it must be admitted that the older the friend the earlier his claim to consideration. I do not mean that this case and others in our circle do not call for a frank construction on your part which is trying sometimes to render: but I am sure Brown likes you sincerely. As for parties he has not been giving his routine ones for a long time I know.

About the tapestry here, I have solved the difficulty by shifting my paintings operations to another room which is not quite so Icelandic in climate. I shall write you further news of work ere long, and send up the chalk drawing when I get the frame.

 Ever your affectionate
 D.G.R.

Do get me that Zucchero portrait.[3] We are getting a room in order here, and it would be the very thing. I'm almost inclined to say, if there's danger of more delay, send it as it is.

[1]DGR's misreading of what is admittedly almost illegible. See preceding letter.
[2]That of CAH's enemy, Ned Jones.
[3]See Letters 157 and 159.

165. DGR to CAH Kelmscott
 21 November [1872+]
Dear Howell,
I have got that <u>Lucrezia</u> of Leyland's sent here <u>without</u> the frame. I have some
sort of notion that when I projected adding to it at one side I gave <u>you</u> the
old frame which you said would be of some use. Is this so, or fancy? <u>I</u> am
disposed now to send it off to Leyland with the <u>Lilith</u>[1] which is nearly finished
now, and in such case don't want delay through F. & D. making frame for
<u>Lucrezia</u>. So if you had the old frame still and no particular use for it I'd
be glad of it again.
 Ever yours,
 D.G.R.

[1]See n. 4, Letter 162.

166. DGR to CAH Kelmscott
 2 December [1872+]
My dear Howell,
Today I am sending off <u>Lilith</u> (finished) to F. & D. who have to use it partly
as a model for frame of <u>Proserpine</u>, after which they will back it up and hang
it at Leyland's.
 <u>Lucrezia Borgia</u> I have sent to you, and told F. & D. to send you the frame
they are making for it. I have explained this satisfactorily to Leyland, as you
did all the mounting of the drawing.
 I have not heard yet whether you wish May's drawing sent on at once.
 Ever yours,
 D.G.R.
There was a little picture of <u>Greensleeves</u>[1] which I worked on for Agnew and
sent back to him about a year ago. It is now perhaps the best <u>small</u> picture I
ever did. I altered the title. I have wondered since what had become of it,
having heard nothing in reply. Have you ever seen or heard of it since? It
would need varnishing which could be done now I suppose, and then would look
very rich and deep.

[1]Apparently Surtees 113 <u>My Lady Greensleeves</u>, a water-color of 1859 which DGR
repainted in 1871. If so, Agnew sold it to George Rae. Marillier says that DGR,
annoyed at some criticism of the original drawing "daubed the background all
over, spoiling some very fine work" (p. 102).

167. DGR to CAH Kelmscott
 4 December [1872+]
Dear Howell,
I judge from what you say that you have not told Parsons of my proposal not to
receive the £100 on May, but to put it towards the debt on <u>Proserpine</u>. If you
have <u>not</u> done so, I will (as you say the matter is unimportant) still receive
it on delivery of the drawing, since Christmas bills are so near at hand. I
therefore delay sending the drawing to Parsons till I hear again from you (by
return) and will then send it off on Friday, writing to P. at same time.
 About the grate fender &c I am sorry you should have had all the trouble, but
could not think of spending £13, and find that the grate you mention is smaller
even than the one we have here which we reckoned small. I wonder whether Marks
has any on hand. Perhaps I had better drop him a line and propose a chalk
drawing.
 The table we have for the room is an oval one--size 5 ft 8½ x 4 ft 6. The
cover should of course fall well over the sides. Is that inlaid table of
Chapman's still on the market, and what is asked for it? That would probably
need no cover. What are its dimensions? The fireplace of the room persists in
smoking. Do you know anything of cures for smoky chimneys?
 Thanks about seals. The screens have not only not arrived yet, but no word
comes from F. & D. as to their having received them for me. I yesterday wrote
them a post card about it.

I shall very soon no doubt have the £200 <u>head</u> of <u>Proserpine</u>[1] ready to deliver.
F. & D. are making the frame for it (or have an order from me to do so) but
when I shall get it I don't know.

<div align="right">

Ever yours,
D.G.R.

</div>

P.S. Of course I am very anxious Brown should get the Cambridge affair[2] if he
wants it. I fear Colvin must have known his ground was pretty safe before he
started. To elect a man who can't draw a line would be an innovation, though I
don't know whether the terms of the bequest require <u>practical</u> knowledge. Can't
you give B. a commission? Write me again about this. I fancy he would like one.
 I am wanting to give a wedding present to the Hüffers,--something nice and
useful too if possible, but I can't think what. Can you help me by a suggestion.
If you know of any thing suitable to be had, and would get and forward it to
them, I'd send you the tin, and write at same time to Hüffer.

[1]Three unfinished canvases of <u>Proserpine</u> were "cut down and converted into
heads," according to Marillier (p. 170), who was able to trace only one. It was
renamed <u>Blanzifiore</u> and belonged to Howell at one time. Marillier gives its
dimensions as $15\frac{1}{2}$ x 12 3/4. This is apparently identical with Surtees 227
(dimensions 13 x 16). But in Letter 176 DGR gives the dimensions as 18 3/4 x 18.
Is DGR writing about one of the two heads that Marillier was unable to trace?
[2]The Slade Professorship of Fine Art, which went to (Sir) Sidney Colvin (1873-85)
as did the Directorship of the Fitzwilliam Museum a little later (1873-85).

168. DGR to CAH [Kelmscott+]
 5 December 1872
Dear Howell,
What Leyland gave <u>Ellis</u> for <u>Borgia</u> was I think 120 or 140£, but you should know
best, as all was transacted through you I believe. For all I did to the drawing
since the sale at Christie's I never asked or got a penny.

<div align="right">

Ever yours,
D.G.R.

</div>

[Line at top of page:] No news yet of the screens seals or table covers.

169. DGR to CAH [Kelmscott+]
 6 December [1872+]
Dear Howell,
Thanks, but the seals are bestial, as you say. However I've kept the only
endurable one--with head on Carnelian,--and enclose cheque £1/11/6.
 You don't answer the question in my last as to the drawing of May--so
probably I shall keep it till I hear again from you.
 I return the other seals with this by registered packet.

<div align="right">

Ever yours,
D.G.R.

</div>

170. DGR to CAH Kelmscott
 7 December 1872
Dear Howell,
Many thanks for all suggestions. With yours, I heard from Parsons and answer
him with this. May's drawing leaves here Monday. It would only hang about if
sent off on a Saturday.
 About <u>Marks</u>, <u>you</u> only shall have all offers in the way of exchange for goods.
You are quite right. But I will rely in such case on your getting me the goods
advantageously, as I can't be buying at very big prices.
 About Chapman's table, I must reflect when the table covers arrive.
 About the Hüffers. The two cabinets are too dear, and I don't know whether
the chest of drawers would be of much use to them, as no doubt they already
have one for bedroom use. It has struck me that a nice mantelpiece or bracket
<u>clock</u> would be the best present if they haven't got one yet. Do you know of any?
I couldn't be going <u>any</u> length in price.

<div align="right">

Ever yours,
D.G.R.

</div>

P.S. I am badly wanting a second hand Turkey carpet in good condition for a room 15 ft 8 inches square. Also 2 pairs of good window curtains--warm and ample--for 2 windows 6 ft wide in a room 8 ft high.

171. CAH to DGR Northend Grove, Northend, Fulham, S.W.
 9 December 1872
My dear Gabriel,
I expect the delight of seeing May tomorrow. About buying any thing you require advantageously what answer can I give you? Do you for a moment suppose that I would put one penny profit on any thing I sold you. Pardon the question, but in this case I must continue an injured innocent. I do not know of any clock except one I have here and which if you have set your heart on my[1] clock I will let you have. I gave £12 for it at Christie's, and it will cost about two to put the fret work into, it is all wanting. [sketch] It is old English like the one you have only half as large again and much more important, on the face under the dial it has a little kind of Stothard picture not so good as Stothard[2] but very pretty of two lovers on a garden seat (like Smetham's sofa) under trees and flowers and looking at them the moon which works with the clock. When there is no moon there is a blue spot full of stars, the spot being the size of a shilling. When the moon begins to show this spot works away leaving as much of the noble planet visible as it ought to leave, and when the moon is full it all shows and is painted with a round chubby face looking down on the couple. The garden scene notwithstanding the presence of the moon is broad daylight and sunny. [sketch] The chest of drawers however is better worth the £17 than the clock £12 and £2. The chest is really a drawing room chest of drawers like you see in the swell old English houses and looks quite like £50. But I will do just as you like.
 Till the end of the year you must send me tin. I have very heavy payments to make and every penny is an object. After, you can do as you please, and pay as you like. As to turkey carpet and curtains you must let me know how much you want to spend. Next Saturday I am going to a sale in the country there are carpets and curtains and every thing. I am short of money and am only going to buy a picture, but if you like you can send me £20. If I find any thing would do for you I will buy, if not return you the £20.
 Ever your affectionate
 C.A. Howell

P.S. That straw table cover washes like cloth. Chapman's table would require a table cover, it looks bare and cold without.

[1]CAH wrote I clock.
[2]Thomas Stothard (1755-1834), English illustrator and painter.

172. DGR to CAH [Kelmscott+]
 11 December 1872
Dear Howell,
The clock by all means,--it seems the very thing. I hope it will be in thorough working order, as otherwise it would prove a disappointment to the two lovers, in spite of their reflected selves on the dial plate. Will you kindly see about it at once. I judge you think it necessary to restore the fretwork, but hope the delay will not be very great. When ready, the address is
 Dr. Hüffer, 5 Fair Lawn, Lower Merton, S.W.
 In writing to Brown I have mentioned the coming clock, as it seemed desirable in case clocks were proposed as presents from other quarters; so no doubt the intended recipients will be all impatience. The chest of drawers I fancy might not be so useful, as I understand the conjugal dwelling to be a very small one.
 I send the £20,--14 being for the clock. I will send more when necessary. I don't want to pay a big price for curtains nor even carpet, but the latter especially is a primary necessity, and the curtains too will be wanted. Can you give me an idea of what you think they would come to?
 I fear I must be unlucky in my forms of expression. How could it ever seem that I meant, in using the word advantageously, to indicate anything but the necessity I was under of stimulating you to buy for me in the cheaper and not the dearer market? It is most kind of you to take so much serious trouble on

my behalf, and only your readiness in doing so makes one less assiduous in often (as one should) expressing a full sense of it: but I do feel it thoroughly, and in this as in other matters you are of most friendly service to me, where no one else could meet the requirement.

May's drawing left for Wigmore Street on Monday. I said nothing to Parsons as to the money, so I suppose he will send it on receipt of the drawing. I hope it will please you and him. I think it thoroughly one of my best.

I am now going on successfully I think with the separate head of Proserpine. I mentioned the size to Parsons as 16½ broad x 18¼ high inches. This I adopted because I remember Gambart always telling me that an upright shaped head was far more saleable than a horizontal one. The dotted line on the sketch shows the picture thus reduced (by the loss of a bit of hair behind the head but only tint elsewhere;) and to this size the frame has been ordered. Yesterday however it struck me you might possibly prefer to have it the full size which would be 20½ broad x 18¼ high inches, the proportions being much as in the outer limits of the sketch. If you wish for it thus you will have to stand any expense incurred by commencing another frame. The one already in hand is frame No. 4 among those I ordered, if you wish to speak to F. & D. about it. On the idea striking me, I yesterday sent a postcard telling them to postpone going on with it till they heard again. [A sketch of Proserpine in the middle of this paragraph.]

No signs as yet of the case from F. & D. containing screens and tablecloths, though I got a note from them some days ago announcing it.

Ever yours,
D.G.R.

173. DGR to CAH [Kelmscott+]
 12 December [1872+]
Dear Howell,
I have today received the £100 from Parsons for the drawing of May.

I think Leyland is certainly mistaken about the price paid for Borgia.[1] I cannot remember receiving an additional penny after the first price paid perhaps nominally to me but in reality to Ellis; and I always remember these things. I did not intend to charge him for the new frame which F. & D. are making for it, but shall tell them now to send him the bill as he expects it.

I fancy the price he asks may be too high to sell easily again for so small a thing; though in fact this is worth a great deal more than any other small work he has had of mine, either oil or water.

Ever yours,
D.G.R.

[1]See Letter 168.

174. DGR to CAH [Kelmscott+]
 13 December 1872
My dear Howell,
The screens and table covers came to hand yesterday. There is a surprising and puzzling difference between the 2 screens. One is a genuine and fine Japanese product, both as to the silver-patterned outside and the pictured inside. The other, in both respects, is a most inferior imitation, whether Japanese at all I know not, but should almost think it must emanate from the French manufactory of oriental goods at Lyons, of which I have often heard. They are not nearly so large as the one I bought at Hewitts for £2/10/- about 12 years ago, (I think only about half the size and lower,) nor are they, like that one, fitted with chased metal mounts. I must say that comparatively they seem very dear, and are too small to be thoroughly useful. Still, in the absence of others I shall take your advice and keep them.

As to the table-covers, I am very sorry for your kind trouble, but really neither of them would be of any use. The grass-cloth one is not wide enough, and the other is altogether too small for anything, besides that, being only the half of a larger thing, the pattern is unsightly. The grass-cloth one would be a bad proposition even for Chapman's table were I to buy it, about which I am quite uncertain. I had better return them to you by mail forthwith.

I hope the chalk drawing[1] pleased you, as it did Parsons very much.

Have you still got that organ which I saw in Kitty's boudoir? I thought at the time one might make a good picture out of it, and might perhaps try if I had it down here.

Please let me know what you think a carpet and curtains should cost me. I thought perhaps F. & D. would send the Zucchero with the screens but they didn't.

Ever yours,
D.G.R.

P.S. I want the carpet much as soon as possible,--certainly before Xmas Day. Do you think you can find me one?

P.P.S. Just now I get the drawing of Silence from Bradford most seriously injured with great smears across the face as if a handkerchief had been flicked over it carrying away large tracts of the chalk. I can restore it, but not with the original freshness. Had any one else bought it, it would have been worthless. Where or by what damned beast this has been done, of course I don't know but suppose most likely at the photographer's at Bradford where no care was probably taken of it. They must be a set of louts not to look after a thing they have paid good money for.

Now let us get those labels printed at once. Never mind lithographing, but let's print them as I sent them with any modification you think desirable. No drawing should ever be sold without one attached.

I have written to Heaton.

[1]Of May Morris.

175. DGR to CAH [Kelmscott]
 Saturday, [14 December 1872+]

My dear Howell,

About the head of Proserpine, I believe to make it agreeable on the larger scale, I must increase it at least an inch at the bottom of the picture. I will write about this to F. & D. when I know exactly--probably today,--so the dimensions last sent to them by you would not be correct either.

I am heartily glad you like the drawing and hope you will make a good first transaction of it. Understand one thing always--that I shall only be pleased and not indignant in the least if you make cent per cent profit. I am very anxious to establish a satisfactory relation with some one who would take all I wanted taken, in case I went abroad and could not be corresponding endlessly with private people; and I know that advantageous dealings are quite necessary to enable a dealer to undertake such responsibility. It strikes me that if Heaton was asking £250 for the Silence, this of May should be worth a good profit.

I send your letter on to Janey, as I know she will like to see her little one's praises.

It is a pity, if blue is so cockahoop in the market, that Marks should have given me so poor a price for mine. £2 a plate, it seems, would still have given him cent per cent, to say nothing of the leading pieces. Probably the £4 plate was one of mine.

With love to Kitty.

Ever yours,
D.G.R.

About parcels, the line of railway to Faringdon is the Gt. Western. Small parcels can come for a trifle by Passenger Train. P.D. Company I believe we have never tried.

176. DGR to CAH [Kelmscott+]
 [16 December 1872+]

Dear Howell,

I hear from Dunn that Marks has some more green Utrecht velvet. If first-rate, in good condition, and not extravagant in price, I would take a good quantity. Supposing you can get it, I would make it an exchange matter with you for work, not money.

Ever yours,
D.G.R.

[Line at top of p. 1:] Do send the Zucchero.
P.S. Monday.
 Today I find out the final right dimensions of the Proserpine head--viz:
18 3/4 x 18, upright.[1] Nothing is lost on any side but waste tint, and 1 1/4 inch
is added at bottom of picture (hand and shoulder). I write with this to F. & D.
giving dimensions and explanation.
 I have got that lac screen of Chapman's down here--you know it. It is perfect
except for the notching at the top and the absence of one side border. I feel
disposed to have it done up, but it is an awfully heavy thing and should be put
on castors or small wheels which however must not raise it so as to let the
draught in to one's feet. What do you suppose it would cost to have it
thoroughly restored by Bartlett?

[1]See n. 1, Letter 167.

177. CAH to WMR Northend Grove, Northend, Fulham
 17 December 1872
[An omission about a poor artist named Baily, whom CAH gave £5 and sent away.]
..."That damned Botticelli" has really made me hate the noble master. It is of
course quite safe, but as you say damn the thing!
 Here is letter from Pinti received on the 14. Do you mind calling on him
yourself on your way home and saying all you have to say. If Gabriel comes
before it arrives say I have it, that it was sent to me when money was wanted,
and that I have stopped the sale and hold the picture, then I will stand all
the damned blow up, and free you from every thing.
 Ever yours,
 Charles A. Howell

Please send back both documents.

178. DGR to CAH [Kelmscott+]
 Wednesday, [18 December 1872+]
Dear Howell,
 It's hardly worth while sending you the screen. To any but the most competent
inspection it is precisely the same as the other (as I said) and answers the
same purpose practically. Did you look minutely at the two? A first glance
would have deceived even you.
 I thought you had asked me £80 for the organ when I saw it. £200 is out of
the question, as I could but make one picture out of it, and it would be of no
other particular use to me.
 I am sorry you left out the damns when you read my letter to Heaton.[1] He
needed them, though one could hardly write them to him direct.
 It is astounding certainly to hear of Hewitts asking £33 for a paper screen.
What must all one's belongings be worth if one were to sell them? On the other
hand if the supreme lac one you speak of at the sale did not go greatly beyond
£50, the disparity in value is again incomprehensible, nor could it be worth
my while at that rate to be spending £30 to restore a damaged screen of the
same kind. There is no reason to suppose that any of the picture part of my
screen is deficient, and I suppose what you say may account for the absence of
the side border, though I judge that in 2 of the 3 instances you mention,
there was no border at either side.
 I have not found Bartletts so extra exorbitant myself. They did up that sofa
of Smetham's for either £6 or £9--I forget which, and the big corner cupboard
in the first floor dressing room they did a whole lot to for £5 I think.
 I should like to hear what a suitable new carpet would cost me. I dare say
you are right. Also I am anxious to get the velvet if I can do so reasonably.
It would do for curtains table-covers chair-covers and all.
 About my china I still think I was unlucky with Marks. He certainly did give
£40 for the two large dishes, and they were cheap at it. For the 2 hawthorn-
pots (for which I paid him £135) he only gave I think 70, certainly not more
than 80. So in this one item he much more than recouped his outlay on the
dishes, and many other items seem to have fallen proportionately in value since
he sold them to me. As for the rough pieces you mention, in the studio and
bed-room, they formed no part of my collection and should never have been

included in it at all. Of course they were of little value. What you mean by
the collection being considerably <u>diminished</u>, I do not know. I had never given
away a single piece of any great value, and not more than half a dozen that
were valuable at all.

Janey was pleased with your letter and means to call at Wigmore St. to see
the drawing[2] framed.

<div style="text-align:center">Ever yours,
D.G.R.</div>

P.S. On examining the Lac Screen I perceive you must be quite right about it.
The thickness of the bordered leaf at one end is lacquered a sealing-wax red,
and so is the thickness of the picture-leaf at the other end, whereas the
intermediate thicknesses which join each other are not so lacquered; thus
showing it complete at both ends. There is <u>no</u> part of the picture deficient.
[Line on p. 1:] The table cloths were sent <u>back</u> to you 2 days ago.
[P.S. on p. 1:] If any musical instruments (such as I had from you before for
instance) were to turn up, I would like to have them, as one can often make
pictures out of them.

[1]About the damage to <u>Silence</u>. See Letter 174.
[2]Of May.

179. DGR to CAH [Kelmscott+]
 Thursday, [19 December 1872+]
My dear Howell,
This blessed velvet seems to go up in the market every time I hear of it. The
last was 8/- a yard, which seemed dear, and now by God this is 12/-! Perhaps I
had better deal direct with Marks for an exchange, for then I can cheat him in
return, but don't want to be giving <u>you</u> indifferent work, and certainly won't
pay cash. You do not tell me however of the <u>quality</u> of the velvet, though you
mention its good <u>condition</u>. I suppose it is <u>not</u> like some you once offered me
which I thought pale and cold. Suppose you just put a scrap in an envelope. I
should want at once enough for 4 or 6 large curtains and 2 large table covers,
but would take a stock for use if I could have it reasonably. Of course my
proposal to you would be for chalk drawings, but on second thoughts, if suiting
you better, I would pay cash for a certain quantity, only it must not be at
Marks's <u>exchange</u> prices which are always of the most Hebraic order. This is
perhaps not so much amiss in an exchange, but if I pay money it must be with
common sense.

I see you are right about the embroidered table cloth, but it is strange, as
I remember thinking it must be folded and trying to unfold it. However I don't
think it's the right thing for a table unless a boudoir one that is never used.

I may probably be up just for Xmas Day at my mother's, but improbably for
longer. However if I <u>am</u> longer in town I shall be anxious to see you and shall
keep you informed.

<div style="text-align:center">Ever yours,
D.G.R.</div>

180. DGR to CAH [Kelmscott+]
 Saturday, [21 December 1872+]
Dear Howell,
I think it is possible now I may be coming up for several days to London, but
still it is uncertain. I shall try and make an appointment with you if I do.

About my china, I gave a good lot of ordinary pieces to Miss Boyd two or
three years ago for a shelf at Penkill, and included for high places out of
reach various damaged pieces. No doubt the spill-pot you ask about was among
them. I most certainly never gave away the large cheese-dish or flower pot,
and remember seeing it quite lately at Chelsea. It must surely have gone to
Marks. It might have been in kitchen when you saw the things.

I have been designing some note-paper and envelope devices for Janey, and
shall want you to get them made properly for me if you will. At present I have
sent them to her to look at, but shall have them back at once and then send

them you or hand them to you perhaps if we meet. I am also designing a seal
with ornamental handle. I suppose Barkentin is the only man who can make it.
 With love to Kitty,

<div align="right">Ever yours affectionately,

D.G.R.</div>

It must be a treat to you to have your brother[1] with you.

[1]This is the only mention of a brother visiting CAH, although as CAH remarks
in Letter 282, it was an extensive visit.

181. DGR to CAH 56 Euston Sq.
 Tuesday, [24 December 1872+]

My dear Howell,
Here we are.
 I expect to go to Chelsea tomorrow night, and stay there Thursday and Friday,
returning to Kelmscott Friday evening. Of course I want to see you. Can you be
at Cheyne Walk as early as you like on Thursday--say 11 or 12, stay all day,
to dinner at 7, and evening afterwards? Sleep there if you like. I have a few
friends--Dr. Hake, Son, Brown, and possibly another or two but not more, coming
on Thursday evening after dinner.
 I hope you can come, as I have much to gabble about.

<div align="right">Ever yours,

D.G.R.</div>

Tomorrow (Wednesday) of course I stay here. We should be very glad to see you,
I need not say, if you can look in daytime before dinner, and I shall be in
all day. Dinner is a family affair to which no friends are asked, and no doubt
you observe the same law at home, or may when you're as old as we are.

182. DGR to CAH Kelmscott
 Sunday, [29 December 1872+]

My dear Howell,
I now forward you the note paper sketches for Strongitharm[1] (always supposing
that the strength of his arm admits of his dealing with such small work). The
address is too large--it should be the same size as yours, and the same kind
of lettering as yours. You will see I have marked the other address on the
paper in pencil. I suppose Turnham Green is S.W.--is it not? No doubt you know
they are moving from Queen Sq.--the whole of that house being needed for the
business.[2] I want a good squad of the paper made at once. Some might be like
the paper on which the sketch is made, and the rest of a thinner, slightly-
ribbed, and quite unglossed paper, like the first lot Jenner & Knewstub made
for me. The subsequent lots I had from them were thicker though similar in
kind, and less adapted to the pen in my opinion. You might send me a few
samples of paper. Of course they must copy the sketches quite exactly both in
size and in every detail. The yellow is of course meant for gold embossed. As
for the purple of the heartsease, that must be just as I have made it--not a
jammy mauve or magenta. I fancy these colours are what I shall adopt, and
would like to have (besides a first proof in these colours), another in gold
throughout, another in silver throughout, and another in silver with the
heartsease in their own colour. I did not understand for certain whether you
meant Strongitharm was the man for the device as well as the lettering, but if
not, you will know where to go,--perhaps not to Jenner & Knewstub, as they are,
commercially speaking, even as it were a sleeping lion, and I do not wish to
rouse them particularly. I should mention that the device and address are to
be printed precisely in the place where they stand on the sheet I send you.
 I forgot to ask--Did Parsons photograph the drawing of May before it left
him? I hope so, as I have promised Janey one and want one myself. If not done,
I would like to borrow it again for the purpose. You should send him one of
the labels for the back of the drawing. No drawing of mine should be without
this.
 I find no letter from Heaton here, and send him with this a postcard
requesting answer to mine.
 I mentioned to you Fanny's watercolour of Lucrezia[3] which is at her house,

36 Royal Avenue. I would sell it for her for 200£ properly finished. P. & L.[4]
gave me 200 guineas for one just like it. At present it is very unfinished but
in a good state for finishing. I wish you would go look at this and the other
things she has. There is a large drawing of herself with a fan made lately,
which is one of my best and worth £100.[5] Also a large Margaret.[6] I should like
to sell £500 worth of the things for her and so make her a fund begun or buy
her a little house. If you heard of a good one, she and I would like to know of
it. Her present one is so small that it hardly affords room for a good class of
lodgers. You can write her a line before calling, if you think it better, to
secure finding her at home. Address Mrs. Cornforth as above.

By the bye, between Leyland you and me, I certainly am not the one who ought
to pay for the frame of that small Lucrezia. What think you?

I have brought down here the 2 Heaton samples of cloth to show to Janey. What
is the price per yard and the width? I hope you are pursuing with that blessed
Jew[7] about the velvet. I shall be needing a lot, but would like a small sample
put in an envelope. By the bye, as I mentioned, he carried off all my hot water
plates and dragon tea-cups and saucers. All these I'll buy back for cash, with
a profit to him if he likes. Would you kindly see to it. Also a large dragon
bread-plate for which I gave 5/- but will now give £1.

Did I mention that I find F. is the happy possesser of the dragon flower-pot?
Good bye.

<div align="center">Your affectionate
D.G.R.</div>

I hear you have the Botticelli portrait still.[8] I don't want to sell it now.
Please send it back at once to Chelsea.

How about Hüffer's clock? I hope it will reach them soon.

[Line on side of p. 3:] I hope all this can be done within the next fortnight
while Janey is here.

[Line on side of p. 4:] No, it must be done under your eye or by Parsons [i.e.
the photograph of May].

[Line on side of p. 6:] Parsons can go with you if you like. He knows F.

[1] John Strongitharm, seal engraver.
[2] The move of the Morrises to Turnham Green must have been made about 1 Jan.
Morris, writing to Aglaia Coronio on 23 Jan., says, "...We have cleared out of
Queen Sq. as far as our domesticity is concerned: I keep my study and little
bedroom here, and I dare say as time goes on shall live here a good deal: for
the rest we have taken a little house on the Turnham Green..." (Philip Henderson
[ed.], The Letters of William Morris to His Family and Friends, London, 1950,
p. 52).
[3] Marillier 240, a replica formerly owned by Fanny. Apparently identical with
Surtees 124R.1.
[4] Pilgeram & Lefèvre.
[5] Woman with a Fan, with monogram and date "1870" (Surtees 217).
[6] Baum (Dante Gabriel Rossetti's Letters to Fanny Cornforth, Baltimore, 1940,
p. 47) asserts that "the 'Margaret' is variously named 'Margaret with the
Jewels';" studies for it were begun in 1867; the oil, much later and never
finished, is called "Gretchen, or Risen at Dawn" by Marillier. Surtees (253)
entitles it Risen at Dawn. WMR is uncertain whether a crayon drawing named
Margaret, done in 1870, had anything to do with the Margaret or Gretchen of
Faust or with Risen at Dawn or not (DGRDW, p. 73).
[7] Marks.
[8] See Letter 135 and passim.

183. DGR to CAH [Kelmscott]
 New Year's Day, 1873
My dear Howell,
I hope but hardly believe the blessed F. & D. are already sending the Zucchero
on. I write them a card with this.

You asked me about the Tristram drawing belonging to Leathart.[1] I now learn
he is telling Dunn to send it on to Brown at once--what to do with I don't know,
but am writing to ask Brown. However I am telling Dunn to keep it a day or so

as you may wish to call and see it. If you do, go at once. No doubt L. would
take what he gave--200 guineas--not less certainly.
Address G.S. Hake Esq.
 here
 I return the labels which seem all disproportioned in type. The signature at
bottom seems useless. The caution on the chalk label should be larger.
 Ever yours,
 D.G.R.

[1]A water-color of 1867 (Surtees 200); originally sold to T.H. McConnell, who
sold it to James Leathart for £200. On 25 May 1872 Leathart drafted a letter to
DGR in which he said that the drawing did not come up to his expectations and
asked DGR to undertake to sell it for him (Surtees, p. 114).

184. DGR to CAH [Kelmscott]
 Thursday, [?2 January 1873]
Dear Howell,
 I forgot to mention the other day that what I said of Leathart was said in
confidence. It would not do for Brown to know that I had mentioned the matter.
 Janey and Top are here but poor Janey is too unwell to sit this time.
 Your
 D.G.R.

185. DGR to CAH Kelmscott
 3 January 1873
My dear Howell,
 I am sending you with this a rough sketch by book post--Desdemona's Death Song--
being the scene in Othello where she sings the willow song.[1] You may perhaps
have seen it before. As soon as the Proserpine is done (which is now getting on
again, I am glad to say), I shall set about this picture on a life scale. I
have made a study for Desdemona from Miss Wilding, and shall get her here to
paint it from--the action quite changed from the sketch which is only a rough
first notion. I shall paint it boldly and full of colour--every thing straight
from nature--like Leyland's fiddle picture.[2] I want to know whether Parsons and
you would give 1600 guineas for it, which would be the lowest price I could sell
it for. However I must premise that I consider the first offer of it due to
Leyland, but should like to know beforehand whether you would take it in case
of his boggling at the price I shall ask him. It will be a stunning picture and
no mistake, I am certain, and sure to be highly popular--more so indeed than
anything I have done--the subject being so well known.
 Please, as soon as you have done with the sketch, return it, packed just as
I send it. Don't let Leyland see it if he calls on you.
 I should like a nice old staircase clock here. I understand an aunt of George
Hake's has one which she has put at an auctioneer's--Richards, corner of
Hornton St--near Kensington Church--to be sold, as she does not care to keep it.
It is in going order, and of the lacquered black kind. Would you call when you
can, see what is asked for it (which George does not know) and tell me if it
would suit. If so, indeed, you might buy it right out at any moderate price
and have it sent here.
 What is Brayshay's answer about the pencil drawings?
 I hear today from F. & D. asking if they shall gild the frame of the Zucchero
before sending it me! Surely they should have gilt it long ago, as I understood
from you they had had it by them for that purpose ever so long. I've told them
to do so now if they can within a week. I wish if you're passing there you'd
keep them up to the mark.
 Thanks about Fanny's Lucrezia Borgia. I should of course be much obliged to
you to get her a larger sum than 200£ for it, but don't see it's fair you
should take all that sort of trouble for nothing. I will adopt either plan--the
one you propose or selling it to you for £200--as you like. However it must
first be sent here for me to finish, and this cannot be till Proserpine is
done. I don't think F. would sell her blue pots but you can try.

Thanks about the note paper.
All best wishes to Kitty and yourself for the New Year, from
Your affectionate
D.G.R.

[1]DGR did a number of studies for this picture, which was never painted.
[2]Veronica Veronese (Surtees 228), with initials and date "1872"; bought by Leyland for £840.

186. CAH to DGR Northend Grove, Northend, Fulham
 6 January 1873
My dear Gabriel,
I will see Brown respecting the Leathart picture. The Heaton divan stuff green or red is 1½ yard wide price 15/- per yard.[1] You can have all you want but must give me a month for any order.
 The velvet measures about 80 yards and Marks will not divide it so that if you want it it will cost me £43. Tomorrow I will send you sample. The sketch duly to hand, most beautiful, and well known to me. As yet I have not been able to see Parsons, but will let you know the result as soon as I catch him for a long chat.
 Today I am off to see about the staircase clock.[2] Brayshay is going to send a sketch of the 3 sketches, but I assure you that what he had he chose out of a batch of 5 which Dunn said he was authorised by you to submit to him. I do not understand F. & D. I gave the order for gilding the frame six months ago.
 I have been to see Fanny and had a very long chat with her. She says she would rather I did not take Parsons. I have offered her £20 for the 4 pots.[3] Two worth say £4 each. The cheese one £4, and the other from which I see the cover has departed £8. I will give £150 for her portrait[4] and the Margaret[5]-- £200 for Lucretia when finished, and a fair price for Loving Cup[6] this with the £100 she has should buy her a nice house, and I am going to look about and help her, that nothing may be done in a hurry. You must not be surprised at my offering only £150 for the two drawings. Her portrait is truly splendid but it is so full of individuality such a very living portrait that I fear I shall never be able to sell it as a picture. Be this as it may I have determined to hand over to Fanny or towards the house any shilling I may make on the things above what I may pay. Indeed the best thing you can do is to write to Fanny and tell her to leave all to me, and to deliver any thing I may send for at a moments notice. Parsons will not do for this transaction, first of course he has a strong notion about making profits, second he seems to have an idea that Fanny cannot have any thing very fine, and only such works as you would give a girl when you did not quite care to sell them. This is quite between us. Let me have a line on the subject.
 Your affectionate
 C.A. Howell

[1]Answer to a question in DGR's letter of 29 Dec.
[2]Not the wedding present for the Hueffers but for Kelmscott.
[3]Excerpts from this paragraph appear in PRT, p. 96.
[4]Woman with a Fan, for which Fanny sat.
[5]See n. 6, Letter 182.
[6]Surtees 201R.2.

187. DGR to CAH [Kelmscott]
 7 January 1873
Dear Howell,
The only modification needed in the labels is in the one I return. I see 2 others as enclosed. The sentence in question should be very prominent.
 I would like to get your answer about Desdemona[1] as soon as may be, because of writing to Leyland.
 I had a note from Parsons about the drawing[2] not being photographed. I hope you will really get it back for the purpose, as the young lady's Mamma is very anxious to have a copy. I mentioned to him in my reply how very necessary it is that all such drawings should be pasted up at the back before delivery. I

hope this was done in the present case,--otherwise an accident will inevitably destroy the thing sooner or later. Prange should be got to do it if not yet done (but not remove the drawing from the frame before doing it) and a label should be sent him to paste on the back.

One thing surprised me very much in Parsons's note. It seems the lion's share of the profits went to Marks![3] Why? Is he a partner of P.'s and yours? Tell me this.

About Fanny's china, I must keep the piece given me by Leyland, both on account of the gift and because it is just a piece which might serve one day to paint from. I suppose this is the one you value at £8 and say it has lost its cover. Now I sold it with a cover, and a cover I will have in buying it back. Will you kindly take the measure of the top and make Marks find the cover forthwith. Pardon trouble, but I hate crippled things.

I will write F. about your offers which I think very handsome. But I could not allow the profits on sale by you to belong to any one but yourself if you pay for the things in the first instance. I presume you would buy in this case for the Bradford Company. I send you with this a note relating to a matter I spoke about, which note I think it better to put in a separate form, in case you wish to show it to Heaton or Brayshay. I may mention that Heaton lately asked me whether I could let him have more chalk drawings, and also pictures, so I suppose F.'s properties would be acceptable at Bradford. I did not reply to the enquiry, having told you I should negotiate always through you.

Ever yours,
D.G.R.

P.S. If you know of any very nice jewellery or ornaments, you might get them sent here to look at. On second thoughts I'll send to Parkins & Gotto for one of their prospectus books.

[1]On 13 Jan. Parsons wrote to DGR that the Desdemona was "too great an undertaking for him since he had no adequate facilities for showing it" (HRC).
[2]Of May Morris.
[3]WMR (DGRDW, p. 81) says that Marks procured the drawing of May Morris (?from Howell and Parsons) and sold it to Prange for £170 but received in part payment a small oil, The Christmas Carol, in exchange. He then sold the Carol to Alderson Smith for £170. On p. 82 WMR states that Howell and Parsons bought the drawing of May and "the first experimental version of Proserpine for £300." CAH's letter of 19 Mar. 1873 contains a not very clear explanation of the transaction.

188. DGR to CAH Kelmscott
 7 January 1873
My dear Howell,
I wish the Bradford Company would pay me for a pencil sketch, price £15, which I sold through our friend Heaton to a Reverend Mr. Russell. I only sold it because Heaton wished so, but being sold, it must be paid for, and I am quite unused to the least delay in matters of this kind, large or small. I said I should be happy to have it back (indeed would prefer this) but Mr. Russell it seems wishes to keep it, so once again comes the burden--let it be paid for. The Bradford Company could then write to Mr. Russell telling him that they and not I were his creditors.

Ever yours,
D.G. Rossetti

Angeli Papers.

189. DGR to CAH Kelmscott
 9 January 1873
Dear Howell,
Two things are wanted for the Moocow[1] in its new house. It is going to make its bedroom half into a sitting room, and so a screen is needed to divide it. The room is 7 ft. 2 inches high. The screen should be a convenient height in relation to the room,--certainly a good deal higher than those I had lately through you. It must be the most beautiful screen that can be found, but quite

light so that it can be lifted about easily, and many-leaved, so as to go thoroughly across the room.

The other thing wanted is a little set of bookshelves to fasten to the wall. They must be quite small, and the most beautiful bookshelves that can be found.

Do find these 2 things for the Moocow at once, and let me know of them, and I shall be eternally grateful.

Your affectionate
D.G.R.

P.S. You know the house at Turnham Green is a small one, so things must not be too big. I hope you gave that address as well as this for the note paper.

[1]Janey Morris.

190. DGR to CAH. (Postcard, 13 January 1873.) About condition of Richards clock.

191. DGR to CAH Kelmscott
 17 January 1873
Dear Howell,
I believe Janey must leave here on Tuesday next. I should be extremely glad if a proof at any rate of the note paper and envelopes could be sent to show her before she left.

She will see about getting bookshelves made herself when in London, as you know of none in the market. Thanks for kind offer. The screen is too b--y dear.

I thought of course you knew Parsons had written to me about Desdemona. I enclose his letter. Sketch came back to-day. I hope he will excuse my answering points to you as it is easier to correspond with one on all points. If he and you found it advantageous, the Proserpine or any work of mine could be shown at Chelsea, where light is good. This always unless too inconvenient to Dunn, who now lives there altogether. You would have to ask him this. I hope I am not to understand from P.'s letter that anything like an exhibition of the Proserpine is contemplated, as this would not suit me at all.

I am at last quite satisfied with the Proserpine.[1] The figure is all done now, except drapery and last toning. I have not told you all the trouble it has given me, in the determination to make it my best work. Suffice it to say now that I have begun it 5 times on 5 different canvases. The last is a complete success I believe. Of course it cannot pay me in the least, and I must be more on my guard in future. I hope to be sending it you before very long now, but cannot as yet succeed in getting the frame out of F. & D. who have become more dilatory than ever. It is now promised me in 3 days. Could you come down in a week or two hence and see it and what else is here?

About Sir W. Armstrong. He doubtless would be a good man for the Proserpine, unless he is too great a fool to buy a good thing.[2] What pictures has he? I believe he has most of my china. Brown made his acquaintance when in Newcastle, and I write to B. with this for information.

There is a drawing at Chelsea--Miss Wilding with a lily[3]--sort of Saint-- which you once asked about and I told you belonged to Rae. It doesn't. Price £80 as it is. Dunn could show it you (in the old china room) but take care you don't displace things in looking at them, as I put them all in order to know about when I send for any.

Had you any particular reason for saying the old portrait was Darnly by Sir A. More?[4] Did you look up the arms in the corner, and does date 1578, aetatis 27, concur? I should think not.

I may as well send you a letter of Graham's part of which refers to the question of exhibiting my works.

If Russell has paid the £15 in at the Bank, it must be since 1st January, as my pass-book, made up to that date, shows no sign of it. I cannot be writing more to Heaton about it, but send the pass-book back to Bank today with inquiry.

Ever yours,
D.G.R.

P.S. I incline to think that it would certainly be better, and give the picture more importance, if the Proserpine were shown at Chelsea. It ought to be a £1000 picture to you,--800 at the very least.

[1]All of this refers to <u>Proserpine IV</u> in the Surtees numbering.
[2]Nothing came of this prospect, which originated with CAH.
[3]Is this Surtees 244A, dated "1873?" If so, the date may have been altered later. Another version of the picture is entitled <u>Sancta Lilias</u>.
[4]Refers to the so-called Zucchero portrait. It remained in DGR's possession and was sold at Cheyne Walk in July 1882. In the sale catalogue, it was described as of the "School of Sir Antonio More," and fetched eleven guineas (D-W, p. 1123, note 3).

192. DGR to CAH [Kelmscott]
 Thursday, [?21 January 1873][1]

Dear Howell,
How about your last truncated letter?[2] When comes the rest of it?
 About the clock--couldn't you get Richards to get a clockmaker to look at the works and say what they need? I don't want to buy a dummy clock of course, but if <u>not</u> dummy, it is of about the same date as this house or not much later, and would do well here.[3]
 The old portrait did come at last.[4] It might almost or quite be Holbein or Antonio More for the splendour of colour and merit of the head, only the hands are so faulty as to be a poser as to its being the work of a master. Still it <u>must</u> be by some first-rate man--Zucchero probably or perhaps the elder Porbus.[5]
 I find Janey has determined to have a curtain in the place she first projected a screen at Turnham Green; but might like a screen too perhaps. Bookshelves still needed--must have glass in front.
 Ever your
 D.G.R.

[Line at top of first page:] Won't they lend you the clock to see how it goes at home?

[1]CAH dates this letter 21 January, a Tuesday in 1873. I think the day of the week in error.
[2]Missing from the Texas collection.
[3]See n.2, Letter 186.
[4]The so-called Zucchero.
[5]Or Pourbus, 16th C. Dutch painter.

193. DGR to CAH [Kelmscott]
 22 January 1873

My dear Howell,
I don't hear from you. Why?
 Please send pattern of green velvet. I may probably be taking the lot and giving you some drawing for it, if it really seems worth £43. I think some of it would do better than anything else for the curtain (instead of screen). So please send me pattern at once. Also let me hear again about the clock at Richards's.
 I find I was mistaken about Brown having met Sir. W. Armstrong. He only went to see Moore there, and found in his room (he is painting there) a huge Horsley and a huge Burchett![1] So I should think the gentleman must want something <u>very</u> fine of mine to stand such neighbours.
 It is a nuisance if your business is always to pay huge dues to Marks before you can secure a sale.[2] Besides I don't like the notion of my best works being sold from a china shop and perhaps knocking about there <u>en attendant</u>.
 You know, besides the <u>Proserpine</u>, you are to have a head of same (£200). I have now made a <u>third</u> picture out of another of the beginnings I told you of but this is so <u>entirely</u> different in dress and arrangement as to be quite a separate picture. It will be a very good and <u>remarkably attractive</u> one--price 250 guineas <u>and very cheap at it</u>. It's just upon finished and F. & D. are making the frame. So Parsons might send me the tin as Xmas bills are dropping in. It is called <u>Vanna Primavera</u>,[3] after one of the ladies in Dante's <u>Vita Nuova</u>,--the love of Guido Cavalcanti. The picture will be finished tomorrow, and the frame is to be done in 10 days.

The frame of the larger Proserpine has just come at last, and suits the
picture splendidly.
The parson Russell has paid a few days ago.
I'm sorry Strongitharm has not sent the device yet. Janey left here yesterday.
I hope it is coming soon, as she wants it much. It should be sent to me here
of course.

<div align="right">
Ever yours,

D.G.R.
</div>

Is Hüffer's clock delivered?

[1] John Callcott Horsley (1817-1903), painter of genre scenes and portraits;
Richard Burchett (1817-75), painter of historical scenes, headmaster of the
School of Design, South Kensington, 1851.
[2] This relates to the drawing of May Morris. See n. 3, Letter 187.
[3] A title that I do not find in DGRDW, Marillier, or Surtees. DGR uses the name
Vanna and Monna interchangeably in referring to the picture. This may be
Surtees 259, The Day Dream, also entitled Monna Primavera.

194. DGR to CAH [Kelmscott]
 23 January 1873

Dear Howell,
Here is another postal venture.[1]
The picture of the child and flowers is getting rapidly to a finish.[2] If I
send it to you, is there a prospect of a ready sale otherwise than through
Graham or Leyland? With these 2 I could deal myself more conveniently if
advisable to offer it to either. So do not mention it to either of them. Of
course my only reason for thinking it better to deal with them myself in this
instance is as being more rapid and straight-forward and thus more calculated
to get rid of the Parsons affair in a summary manner.
 The picture should be sold for 600 or 650 guineas as I don't aspire to get a
large profit for Parsons. It is a very good picture, full of work and material
and much like Leyland's fiddle picture[3] in colour and execution. If you think
you could get readily an outside purchaser for such a picture, please let me
know at once.

<div align="right">
Ever yours,

D.G.R.
</div>

I shall call the picture either Spring Mary buds or The Bower Maiden.
Size 44¼ x 28.
P.S. Had you better come down for a day and see the picture?
P.P.S. I want a speedy answer, as, before any steps are taken anywhere, I must
learn from Parsons whether he is willing to accept a buyer at 600 or 650 guineas.
Could you communicate with him or had I better? I am sick of him. Do not do
anything on this head without writing me first.
P.P.P.S. I don't know but what, in any case, I might have to offer the picture
in the first instance to Leyland, lest he should feel jealous of having missed
it, especially as it is a very cheap picture even at 650 guineas. You see he
believes that I am working at present only on his Roman Widow,[4] and so I would
be but for the imperative necessity of getting this matter off my hands. I
shall soon now make great way with his picture.

[1] On the same day DGR had sent CAH a postcard informing him that a station had
been opened at Lechlade, to which all parcels should be directed in future.
[2] The Bower Maiden or Marigolds (Surtees 235), painted from Annie, a cottage girl
and house assistant at Kelmscott; sold to Graham for £682 after being declined
by Leyland at a higher figure.
[3] Veronica Veronese.
[4] Also referred to as Dîs Manibus (Surtees 236).

195. DGR to CAH Kelmscott
 25 January 1873
My dear Howell,
It is surely I who am unlucky in expressing my meaning always. How could I
attach any blame whatever to you in any matter of which a question was raised
in my last? Pray believe that I am quite convinced that you attend to my
concerns and interests as no one else would or could.
 You do not answer on the question of possibly showing pictures of mine which
are bought by Parsons and yourself in my own studio at Chelsea.
 The note paper &c looks certainly a little louder than I expected; and on th
paper, the heartsease flowers are rather coarsely cut. It seems to me these
might be made rather lower in relief, more like the leaves, and some unnecessa
scratches on the petals removed. The centres, which I had drawn correctly as
heartsease, are not so cut, but have a sort of rose centre substituted (on the
paper,--the envelope is correct). Why is this? The one seen from the back alon
is rightly cut, and I suppose the executant thought that the starry centre
would look too much like the end of the stalk at the back of the other one: bu
at present they are quite incorrect and no one would know them for heartsease.
Even the shape of the top petals is not righly given. I dare say the man lost
my sketch before the thing was done. I am sorry for this.
 I am sending the samples on to Janey to get her views, and will then write
you again. The gold colour looks louder than I expected, and the natural flowe
colour would be louder still, so I think that idea can be given up. The silver
is quite my favorite, but I fear this would certainly blacken. How about this
point? The S.W. would have to be changed to W. I will mark the exact place for
the address before returning you the papers. I think the silver one would look
very nice on an unglazed paper, which being rather warmer in tone, would show
up the grey silver very delicately. The other address is
 Kelmscott Manor, Lechlade.
I will mark this on the paper when I return it.
 About the velvet, I am sorry to have missed it if good, but the small sample
sent looks dimmer and rustier even than the last lot I had from Marks, and
compared with the piece I now enclose, is as mud to meadow. I send this that
you may judge if you could get it exactly reproduced in Holland. If so, I shal
be only too glad to take 100 yards. This is a sample of a lot I once bought
from Mother Hart (Newcastle St.) at I think 7/6 the yard and is greatly superi
to any other green velvet I ever met with.
 All right about clock. I await your further tidings.
 I hear today from Fanny who seems anxious to sell the drawings in question i
you will give what you proposed, which I told her at the time, i.e.--£200 for
Lucrezia when finished,--£150 for her portrait drawing and the Margaret, and a
fair price (which I suppose we might reckon £150 for the Loving Cup, to which
I would also do what may be needed.[1]
 What say you? And do you hear of any available house to be bought?
 Affectionately yours,
 D.G.R.

Love to Kitty.
P.S. I am very anxious to get you down here and have a good jaw, but want much
to have the Proserpine ready for last finishing before you come. So I'll write
further, but trust you can come when I am ready.

[1]For all this, see Letters 182 and 186.

196. DGR to CAH [Kelmscott]
 28 January 1873
My dear Howell,
I have today received 2 letters from Parsons, the first enclosing cheque £288/
but expressing a view that it had better go to completing the price of the
larger Proserpina, "pending events" respecting the Vanna Primavera.[1] I answer
him by this post, saying that such arrangement would not suit me equally well,
and entering into other details. I dare say he will show you the letter.
 Janey is of opinion that the silver is too like wedding stationery, and no
doubt she is right. So we had better adopt the gold, but perhaps they could ge
a more delicate tint of gold. Also they might try and make the flowers less

heavy in cutting, as I suggested. I must say that altogether it looks very
different from my sketch which they have managed to lose. I would like to see
also proofs in plain stamping and also in a delicate warm grey, such as I have
sometimes used for my own paper,--very faint,--fainter indeed than mine. All
proofs should be on unglazed paper, as the tone is quite different, and the
unglazed is what would be ultimately needed. I believe really the best plan
would be to cut the whole device smaller in scale, preserving of course exact
proportions; but this I suppose would entail double expense.
　How about Brayshay and the sketches?[2]

<div align="center">Ever yours,
D.G.R.</div>

I have an unaccountable letter from Richards about the clock, by which it seems
expenses would be run up to nearly £10. I enclose it. Please return, in case I
answer direct.

[1]See n. 3, Letter 193.
[2]See Letter 186.

197. DGR to CAH　　　　　　　　　　　　　Kelmscott
　　　　　　　　　　　　　　　　　　　　31 January 1873
My dear Howell,
The paper and envelopes had better be half-and-half of the 2 enclosed qualities.
No 10 3/4 A. is I think much the same as what I am writing on, but if anything
mine seems perhaps the best. I should like a good lot made right off, but don't
know how much a ream is. I should like to see specimens in colour as per my
last on these 2 papers. What would it cost to cut the dies again on a rather
smaller scale? They look a little loud I fancy,--What do you think? This
address had better stand as

<div align="center">Kelmscott Manor House
Lechlade.</div>

"Kelmscott Manor" sounds perhaps a little big, though I find they call the
house so here. The W. in the other address had better be on same line as you say.
　Sandys's idea as to the flowers is original and beautiful, but I had meant
them all for heartsease. Certainly two of them now look rather more like forget-
me-nots, only are too big in that case. The man ought to be made to cut the
centres correctly as in my drawing and on the envelopes. The envelopes should
be the size of that on this letter.
　Come as soon as you like. When shall it be? However it might possibly be not
quite convenient for a week to come; but let me know what time suits you best
and I will write back at once.
　Have the Hüffers got their clock at last? The delay becomes a weariness and
an affliction. Will you kindly expedite it?
　Has anything ever been done about that fellow Lekeux[1] and the little box.
Did you send the Botticelli to Chelsea? I think of getting it down here.
　How about Fanny's pictures? By the bye, she assures me she unpacked Leyland's
blue pot herself when sent back by Marks, and that there certainly was no lid.
He must be mistaken and must have left it behind accidentally.
　I asked you about buying a drawing of Miss Wilding--price £80.[2] How about it?
It seems Parsons called at Chelsea to see it, but Dunn was away. I have not yet
heard from him in answer to my last. I am afraid we shall not do so much
business as I thought possible, if there is hesitation at taking a moderately
priced picture after so good a profit on the chalk drawing and so great a
sacrifice on my part (as it turns out) in the price of the large Proserpine,
for which I could get very much more than I am asking you and Parsons.
　I want you to do me a favour,--i.e.--to make me a sectional sketch of the
arrangement of the frame mouldings next the picture in Leyland's Lilith,--also
of those on the outside of the frame. I told F. & D. to copy these mouldings
exactly, and certainly my impression is that those in the Proserpine frame
lately sent here are much commoner and less varied. I am quite certain about
the pounced pattern on the bevilled flat in the Proserpine frame being very
inferior to that on Leyland's fiddle picture which I told them to look at and
take a copy of and adapt to the Proserpine frame. They have no excuse about the
Lilith if different, as the picture was sent them by me for the purpose.
Wilkinson declares in answer to my objections that the mouldings are the same,

but as he "thinks" the pounced pattern is also so, I don't think his belief goes
for much in the matter.
Please do as I ask as soon as you can, as I want to fix the error if it exists
as I believe. I should like you also to see how much I have improved the Lilith
picture by what I did to it down here. I think it is now as good as the fiddle
picture.

<div align="right">
Ever yours,

D.G.R.
</div>

[1]John Henry LeKeux (1812-96), engraver and draughtsman.
[2]See n. 3, Letter 191; see also n. 3, Letter 193.

198. DGR to CAH. (Postcard.) Kelmscott, Tuesday, [4 February 1873]. Is writing t
Richards declining clock, advises lady "to get it back, after which we can
negotiate."

199. DGR to CAH Kelmscott, Lechlade
 5 February 1873
My dear Howell,
I send you a letter received this morning from Parsons, together with the
draft of my reply (with which I return his cheque).
I should like to see you the earliest day you can come down. It is possible
Dunn may be coming down with a gypsey model who is going to sit to me, but if
your arrival and theirs coincide, we shall still have room for all.
Looking at a January time-table, I find trains as follow, from Paddington to
Lechlade--

	dep:		arr.
	10:10	----------	1:10
	2:15	----------	5:35
	6:30	----------	9:40

The only change on the way is at Oxford, only by the first-named train you wait
at Oxford only about 10 minutes,--by the other two, half an hour. Let me know
exactly when to expect you, and George Hake will meet you at Lechlade.

<div align="right">
Ever yours,

D.G.R.
</div>

Another note from Richards today (which has crossed mine sent yesterday).
P.S. Parsons's letter rather seems to indicate that he would like to come and
see the work I am doing. I should not object to this if suiting you.
I wish when you come (if you have time to get the same) you would bring me a
riding whip such as can easily be carried in the skirt pocket of an ordinary
shooting coat. The pocket would be 12 inches wide, and the whip (being of course
pliant) might be a few inches longer. It should have a good solid butt end.
Suppose you come Friday if not tomorrow (Thursday) evening.

200. DGR to CAH [Kelmscott]
 15 February 1873
Dear Howell,
This humbug Richards is rather too strong. He wrote to me for the 5/- and I sent
5/6 as he complained of postages lost. Of course there was no bargain concluded
or I should have stuck to it, and what I objected to was not the £2 for mending
the clock but other charges including 6/- to his clerk!
I should have begun by saying how very sorry I am to hear of your having been
so ill. I don't yet quite understand the nature of the attack, but you can tell
me when I see you, as I hope, on Monday and I trust the change may do you good.
I suppose this letter will reach you by Monday morning, so have telegraphed
meanwhile and asked you to telegraph back what train you come by, as there would
be no time for a letter. If, as I said in telegram, you could combine with Dunn
to come together, it would save one of two journeys to meet you. But if not,
never mind. I have telegraphed same to Dunn.
About the house and Fanny's pictures, I am thankful for your steps taken in
the matter. Of course the money would be in plenty of time when the house was
found, if a quite eligible house. Otherwise it would be wiser in F. to keep the

money till a desirable house turned up. In any case we both know her well enough to be sure that she would stick to the pictures till money or house was delivered.

About Brayshay, he did send me sketches of the drawings, and I was sorry to find that both the unauthorized ones were such as I should not wish to part with,--one being specially such. I wrote him asking him to return these 2 and promising to send him equivalents when I went to London. This he declined to do, wishing for the equivalents first, and referring to Heaton as interested in the matter also and unwilling to take my view. I then wrote to Heaton enclosing Brayshay's letter, and offering to send a large drawing or two I have here, that they might choose one for their two. If I find that they persist in taking every advantage on the strength of an oversight needing to be remedied, I will never deal with them again in any way.[1]

All else when we meet.

<div style="text-align:right">Ever yours,
D.G.R.</div>

[1]The Angeli papers contain a letter from Brayshay to DGR, dated 6 Feby. 73, rather strongly worded, incorporating the views set forth by DGR in this letter.

201. DGR to CAH. (Postcard.) Tuesday, [18 February 1873]. Needs labels for pictures, is sending picture to Graham which needs one. "When am I to expect <u>you</u>?"

202. CAH to DGR[1] Northend Grove, Northend, Fulham, S.W.
 25 February 1873

My dear Gabriel,
Here we are surrounded by snow and cold, and England and every thing damned, and damnable. I have not been able to start owing to the weather. Tonight I write a stinger to Parsons, leave things to me.

I cannot tell you how much I wanted to stay, and how jolly I was with you.[2] What a comfort it is to stay at a house where one can wear slippers all day, and go to bed at any time, and get up at reasonable hours, and eat pike without being expected to go and get it yourself, especially when by mysterious dodges you have to entice him from counties far away, for my experience of pike is that it is always at some enormous distance from me--like trumps at Whist--and most damnable to catch.

I went to Barkentin yesterday and am going tomorrow again to see what he has to send. Is Barkentin tick? Otherwise one should never order anything from him, he keeps nothing of the kind, and charges the devil for every thing he gets. The best plan--I have learnt it to my cost--is to pay for all such things cash, however hard up one may be. I have also ordered some others from another quarter and will send them to you when they arrive. I am going to look out for a fine country place and live in it for good. I can do all my work by letter writing and at worst I can always have chambers in London.

Why not sell Cheyne Walk and all in it that you do not care for? You would get a lot for the lease I am told and the things would also fetch a lot, and then you will save money fast, I am going to do the same being tired of making lots and spending it.

The School Board have got me elected by "an overwhelming majority!" notwithstanding my having refused to serve. I found all papers on my arrival at home and though you will laugh, I am most pleased with it. It shows that my position is bettering every day, and that my enemies after all have not made much way against me. For this same post Canon Cromwell, Byers, Cullerne, and others have canvassed as one might for Parliament and I have their names, now, sent to me as those of my Colleagues, not only without having asked for one single vote, but having most positively refused to serve, giving reasons which if any thing would have elected me to the presidency of a board of infidels, and crowned me King of Whores.

One of the two, either the school Board is composed of a set of idiots, or it is destined to do wonders for England.

You stick to me, and we will see what can be done, I want to do those frescoes in the house of Commons--even at a loss--before I bring out my book,[3] and I am

anxious to do both before a year is over. In a few days I will send you a careful letter that you may forward it to Cowper,[4] but before doing this let me know if you think that the book (provided it is a sensible one, and full of <u>practical</u> truth) would help me to get the work. I fear that the Waterloo will be <u>ruined</u> sooner than I anticipate, I saw it today and it is rotting fast, the mill is so much injured that most of it would have to be repainted again--in size and gall--given the case that they are taken down and laid on <u>canvas</u>. In ten years the picture will be nearly gone. It is like the human skin, once destroy as much of it as cannot be brought back, and with wonderful rapidity it spreads round the scar till all is dead, and hopeless.

The Waterloo is <u>sucking</u> in water from the Thames as fast as it can, and wind and frost drive <u>it in</u> inch by inch, as water through a wall will always seek the warmer side which unfortunately in this case is the inside of the hall where the frescoe stands. The Trafalgar is also going but very little, in fact only Nelson's hat (and round it) is covered in bloom but this would brush off only I am not going to say for when wall and roof are old enough they will then let in water and snow, and the drier the frescoe is, the quicker it will go.

Quite enough of bother for you, but I am most interested on the subject.
<div align="right">

With best love
Ever your affectionate
Charles A. Howell
</div>

[1]Portions of this letter are reproduced in <u>PRT</u>, pp. 97-98.
[2]Howell and Dunn had visited DGR for three days, and the talk lasted into the wee hours of the night (D-W, p. 1142).
[3]Nothing came of this project.
[4]I.e. William Cowper-Temple.

203. DGR to CAH. (Postcard.) Kelmscott, [26 February 1873]. Labels arrived both from CAH and printers. DGR objects to sample of drawing paper sent by CAH.

204. CAH to DGR Northend Grove, Northend, Fulham, S.
 1 March 1873
My dear Gabriel,
Many thanks about <u>Borgia</u>,[1] but your letter puzzles me a little, you say this subject is the poisoning of her <u>first</u> husband the Duke Alfonso. I thought that she had been married <u>first</u> to Giovanni Sforza, and that after being divorced from him, she had married Alfonso of Arragon who she and her brother Caesar polished off in order that she might marry Alfonso d'Este. No doubt I am wrong about it all, and wish you would tell me how far, for I have no book to look into for information and some how I seem to have gathered this information from something or other in the days of my youth.

Here are new proofs, the die being ground down, scratches taken off, and heartsease centres corrected as well as I could.[2] By the plain impression you will see that the die is not cut too deep. It is only the colour that makes it look a little too strong. I think it beautiful and not a bit loud, and say "too strong" quoting your own words on the subject. Both addresses are beautiful, beautifully cut, and to my mind <u>quite right</u>, and I hope you will think the same.

The grey is wrong in tone but all this can be altered.

To cut the die afresh will cost double as this one must be paid for, i.e. the block of steel and labour.

If you are pleased with all send me minute instructions respecting the colours and how many of each, position of each address etc etc and I will send you new and final proofs. Please also try <u>this</u> paper, I think you will find it good for drawing if so let me know, and I will get you a block made.
<div align="right">

Ever your affectionate
Charles A. Howell
</div>

[1]The reference here is apparently to DGR's explanation of the figures in his <u>Lucrezia Borgia</u>. Mrs. Surtees (124) says that the history of the original water-color of 1860-61 is confused; she also lists a replica of 1871. Further, Marillier (p. 240) states that an undated replica went from Fanny to Fairfax Murray (doubtless the one mentioned in DGR's letter of 29 Dec. 1872, D-W, p. 1112). It may have been the occasion of CAH's question and DGR's explanation.

[2]A reference to the writing paper that DGR had designed for Janey.

205. DGR to CAH [Kelmscott]
N.B. [2 March 1873+]
Hüffer's Bloody Clock
(To be continued in our next)
My dear Howell,
The above inscription will head my letters till results occur, with the same
certainty with which that awful bore Cato wound up every speech in the Senate
by shrieking Delenda est Carthago.
 Thanks meanwhile for all information, and for the Jewellery, some of which is
jolly, but all (as you will agree) pretty high in price. I expect possibly in
about a week's time a visit here which would determine the question of purchases,
so with your leave will keep the things till then. Thus I should like also to
have the watches down in as few days as possible 30 or 40£ certainly does seem
a long price for one. Therefore I think the best thing would be to send both
some good English and some good and agreeable Geneva ones for choice. Good and
agreeable absolutely the watch must be.
 I have no final answer yet about the Telegrams, but of course I shan't bother
you about it, only you'll know another time.
 Brayshay has accepted one of the studies I sent in lieu of the 2 others which
are to be returned. He and Heaton seem disposed to keep the other I sent for
choice, and I have named a low price, as it is naked and (though not ashamed)
unsaleable.
 I have had a model here for 4 days[1]--she went yesterday evening. I repainted
from her that head in Leyland's picture, and have made a drawing from her--
naked and almost to the knees--of a Siren playing on a lute.[2] It is one of my
very best things, and the unpopular central detail will eventually be masked by
a fillet of flying drapery coming from a veil twisted in the hair so as to
render it saleable. I might be offering it to Parsons but for existing
stupidities.
 Ever yours,
 D.G.R.

P.S. I began with Cato, and must wind up by congratulating you (in re
(Richardicê) School Board)--on your resemblance to Cincinnatus taken from the
plough by the peremptory claims of his country.
 The Maclise matter is most important and interesting, and of course I would
do anything I could towards forwarding such a result.

[1]Sent by Dunn. Is this the elusive "Miss Kingdon" mentioned several times by
DGR but not by WMR, Marillier, or Surtees?
[2]Ligeia Siren (Surtees 234).

206. DGR to CAH [Kelmscott]
re Hüffer's Bloody Clock 3 March 1873
(To be continued)
Dear Howell,
In last writing, I did not ask whether you saw Leyland, who I hear has been in
town. Did he seem pleased with the changes in Lilith?[1] He ought to have written
me on the point. I rather meditate offering him the Siren drawing just done, as
it is quite like a fresco in colour and would hang well with pictures. I shall
very shortly be sending him his Loving Cup, much improved.
 Barkentin has sent 2 Geneva watches which are agreeable enough. I have written
him about them. He has sent no prices with them, saying he only sends them for
size to get an English one made which would take 2 months! Thus I may perhaps
take a Geneva one, if I can get one I thoroughly like and he can quite recommend.
The pencil cases sent are right enough. He says no English ladies' keyless
watches are made except to order! One of the Geneva ones sent is keyless.
 Ever yours,
 D.G.R.

How did Leyland like Brown's Don Juan, and does he bite at B.'s Sardanapalus?[2]

In which the head of Miss Wilding was substituted for that of Fanny.
[2]Leyland bought the <u>Don Juan</u> (Ford M. Hueffer, <u>Ford Madox Brown/A Record of His Life and Work</u>, London, 1896, p. 272).

207. CAH to DGR Northend Grove, Northend, Fulham, S.W.
 4 March 1873
My dear Gabriel,
Leyland has been here three times, but only spoke about the pictures once. He seems to consider the <u>Lilith</u> much improved, most certainly he does not care for <u>Don Juan</u>.[1] I said of course that it was a very fine work, but Leyland--half silent--did not seem to take the same view. All he said was the water is most rummy, and all the rocks look like the Pantomime scene at Astley's.

I am sure that he will not bite at <u>Sardanapalus</u> or any thing, just at present at least for he seemed to dwell on some enormous cheque he paid his partners. As long as he keeps to Queen's Gate he will not buy much more, for he really is not a collector, and only buys a thing when he wants it for a certain place.

He is never taken with the beauty of a certain pot or any thing, he only sees that such and such a corner requires a pot and then he orders one.

The watches Barkentin has sent you are the two I picked out, Geneva you will get nothing better. I may tell you that it is rather a prejudice people have about Geneva that make some of the finest watches in the world, many of them are quite as dear as English, and hundreds that pass for English are only Geneva with English names put on.

 Ever yours affectionately,
 Charles A. Howell

[1]Which he bought, even so.

208. DGR to CAH [Kelmscott]
Hüffer's Bloody Clock 4 March 1873
(To be continued)
Dear Howell,
My statements were loose. Alfonso of Arragon, Duke of Bisceglia, was Lucrezia's 3rd husband. He was not poisoned, but poniarded and afterwards strangled in bed, but I used the poison as more typical of Lucrezia, and never reckoned on such searching historical acumen as you display. I'll write the letter over again if you like.[1]

Thanks for the note paper specimens. I'll refer and report.

I remember when here you mentioned something about a piece of furniture-- inlaid I think, and I think a species of secre'taire. How about it? I should like to get a very nice secre'taire if price not impossible.

Two more watches from Barkentin today--one keyless. I judge them to be Geneva.

Do you ever meet with furniture like that piece I had from you which you saw again here?--the one inlaid with ivory and mother-pearl. I would almost buy bits of that kind, they are so pretty and paintable. How about my borrowing your organ one of these days?

 Ever yours,
 D.G.R.

Tell me of your first instalment at the meetings of the School Board as Catholic Representative.

[1]All of this refers to CAH's letter (No. 204) of 1 Mar.

209. DGR to CAH [Kelmscott]
H-----'s B----y C---K 5 March 1873
Dear Howell,
You will see that the heading of this letter is modified to suit what you tell me of the evaporating condition of the crises. The last skeleton word must not be taken as disparaging to the Dr.'s matrimonial prospects.

By this time I presume you are in proud possession of a pike caught yesterday, in a base and underhand manner, out of the fishing season, by George, and conveyed to town by Dunn the same day.

Your letter teems with objectionable diagrams and inexcusable sentiments. However I should not have brought myself to the use of the fillet in the <u>Siren</u> drawing (which is not yet there either), had I not conceived that the flying veil would improve the composition. I shall put it or not as I find this to be the case or not. The drawing is finished in colour all over with careful background of leaves and sea. It will be a valuable one, and in my character of poor devil, I think I shall have to turn it into tin, much as I should like you to be its possessor.

As to watches, Barkentin has sent so many relays of the same, that I fancy I shall have to suit myself out of his lot, but would gladly see any others you are sending.

I return one of the grey note-paper specimens, on which I have endeavoured with white paint and pencil, to indicate a diminution of the heartsease-flowers which would I think be very desirable, only it must be done with judgment and not deform the blossoms. The top petals in each blossom should be less diminished than the others, being the largest in nature. The grey should be fainter and with more yellow in it--less cold--and might be made so faint as only just to tell on the paper. The design would not then look so large. I should also like to see one in silver with blossoms and name and address in gold.

With love to Kitty.

<div align="right">
Ever your affectionate

D.G.R.
</div>

210. CAH to DGR[1]

<div align="right">
Northend Grove, Northend, Fulham

5 March 1873
</div>

My dear Gabriel,

"Huffer's Bloody Clock" is now before me going like mad, with my chronometer. You said it was to go well, and I am regulating it. Tomorrow I shall take it to Brown myself.

Never mind about writing again on Lucrezia. Of course not. How can I find out every thing about the darling bitch? had she more than three? If so who the devil was the first?

That furniture is not to be found at all, when it does turn up it costs three times as much as you gave for your piece. The Secretaire is gone, and is now beyond all hope.

About the organ I fear it would scarcely be paintable. It is so important and full of detail, and the figure would have to be painted with its back turned (if it has to play on it). Of course you are most welcome to it, but before you decide it would be better to see it here any day you may come up to town. It would be out of the question to send it by road in winter, and if the horizontal pipes got out of place, which they would easily do, there is only one man in London that can put it right and when it arrived from Italy he charged me £25 to do it. There is nothing in England like it, and anxious as I am to serve and please you, I should not like to have it ruined.

There was nothing particular respecting the first meeting[2] to which I was summoned last Saturday, except that Canon Cromwell lost all his dignity during a hot debate between myself and Mr. Edward Chambers "the honourable member for Hammersmith," an old gentleman without any hair and coloured like Colvin all over his head and face. Canon Cromwell called on the honourable member for Rome and Fulham[3] for information as to the means of 400 Fulham children of all denominations now in want of education, the honourable member rose at once and declared that after careful investigation he found that only 270 children were legitimate and 130 the offspring of love and vice, male parents being absent, or unknown, female parents being in consequence the property of the British public, and the joint production of the two, the noble acquisition of Church and State. That in my opinion parents in wedlock could afford 2d per week for each child, but that I considered 2d for love children too high, considering that the local Venus had no particular, or settled income, that if the Board could reduce the charge for illegitimate children to 1d per week I could myself pay the fees for the said 130 weekly ("Hear Hear" from Dr. Spaull, who no doubt thought I could give him some private business) "hear hear" from the Board, Dr. Spaull being a "most respectable man"--"<u>Carried</u>" "that children without means be rated at 1d per week, the noble manager for Fulham being willing to guarantee the education of 130, helpless ones, <u>the more noble</u>, being a representative of the

Church of Rome, and having spoken quite regardless of creed, and making no
exception to any religion." Profound bow from Canon Cromwell, the Fulham manager
looking most respectable, black frock coat and large collar sticking up.

Mr. Edward Chambers immediately rose and said if rates were reduced to 1d for
his honourable Colleague, rates must be reduced to 1d for the million! Canon C.
objected, and said it was the duty of the Country to aid the charitable, and it
was the duty of the country to aid Cincinnatus in this case. Was the honourable
member for Hammersmith going to pay the fees of 2d for all who could pay? He
demanded an answer to that.

Mr. Chambers answered that he was not, that he was able to educate his nine
children in a Liberal manner, and pay for it, and therefore "let those who could,
do the same." But this was not a question of who paid, it was a question of
eternal damnation! (sensation!); and he would prove it. Did the Revd. Canon
know that parents were not willing to pay even 2d? did the Revd. Canon know
that in consequence the Catholics received their children into their schools
for nothing, and baptised them in private in the hideous faith, the parents
knowing nothing about it, and the poor innocent souls being condemned to Hell
and everlasting damnation!!"

The honourable member for Fulham rose "to order" at once, he denied in toto
the representations, and allegations of the honourable member for Hammersmith.
His Holiness' friends were too busy at present to attempt the conversion of
children, were it otherwise they would attempt the conversion of children's
parents, and the member for Fulham would ere this have called on the member for
Hammersmith and tried that gentleman's reason, he the member for Fulham could
not see that the rite of Baptism performed on an innocent child ignorant in
distinction of creed could ever condemn it to damnation except at the hands of
a Hammersmith God, and certainly Mr. Chambers claimed no higher distinction
than that which he had that evening shown himself entitled to hold. Mr. Chambers'
children often came up the country lane and they were very fond of Mr. Howell's
swing. "Supposing that when I got them safe into the garden, I was to shave
them all, and send them home with a ticket to the effect that henceforward they
should be considered as Mohammedans would the honourable member for Hammersmith
consider that he could not for the future prevent the establishment of seraglios
at home?!" Canon Cromwell kicked up his little legs, screamed, upset the inkstand
and brought me home in his carriage. Chambers was seen no more! Tonight I see
that I am called next Saturday. I shall go on for 3 months and then resign and
go in for Odger[4] and in ten years go to Parliament. What say you?

This afternoon I met Janey she did look so well and so beautiful! She said
she was coming to see Kitty, but I fear she is not, I wish she would, for we
would care for her visit more, than for that of any one else.

<div align="right">Ever your affectionate

C.A. Howell</div>

Excuse dirty paper I am hard up for more or rather any.

[1]Brief portions of this letter appear in PRT, pp. 98-99.
[2]Of the School Board.
[3]I.e. CAH.
[4]Presumably a reference to George Odger (1820-77), prominent trade unionist and
unsuccessful candidate for the H. of C.

211. DGR to CAH [Kelmscott]
H - -' B - y C - k 7 March 1873
Dear Howell,
I find the above inscription becoming very decomposed, but as yet it refuses to
disappear altogether. I hope the next report may clear off its last vestiges.
By the bye, the fretwork had better be done, you know; only if rheumatic gout,
dropsy, &c succeed each other in opposing that result, I suppose we must wait
God's time and the doctor's; only I should like the thing to be made complete
as soon as may be, being a wedding present.

I enclose a guide in colour for Strongitharm. The tint of this paper I am
writing on is I believe much the same as the 2 of Whatman's which I selected
from the book of specimens you sent, and this is warmer than that on which the
device is printed.

What larks you seem to be having with the school board. The "Hammersmith God" was a great hit. I should like of all things to see you in Parliament for the fun of the thing; only I believe you would demoralize the country, render England uninhabitable, force the Royal Family to emigrate, and transfer the British Court from London to Melbourne.

The watches you alluded to have not arrived yet but I suppose are coming. I expect the advent of the Inspecting Committee of One[1] on Tuesday next.

I remember the organ very well. Kitty sat and played at it and I perceived that the figure and instrument composed beautifully. I have got those 2 instruments you bought for me down here, Dunn has strung them and set them to rights, and I am going soon to paint 2 pictures from Miss Wilding with them about the size of the fiddle one, as Leyland wanted others of that kind for his drawing rooms, and a series of musical pictures would look splendid together.

<div align="right">Ever yours,
D.G.R.</div>

Janey expressed to me also an intention to look up Kitty.

I think you should write George a line about his Pike, as his exultation was great at sending it to you.

P.S. I now find the correct address[2] is

Horrington House, Turnham Green Road, Chiswick, W.

I don't know if this can well be altered.

I had better enclose another Borgia letter. She was first affianced to a gentleman of Arragon, but when her father was made Pope, he dissolved this and married her to John Sforza. This was again dissolved and she was married to the Duke of Bisceglia. He being polished off, she married the Duke of Ferrara.

[1]Janey Morris, for whom both the writing paper and the watch were intended.
[2]Of the Morrises.

212. DGR to CAH [Kelmscott]
Hüffers Bloody Clock 9 March 1873
Dear Howell,
I find that under warmth of feeling (in the absence of final results) the above inscription has started once more into full relief.

Your letter to hand, but not yet the watch and bracelets.

About the die, I suppose you are right I was thinking of what can be done in woodcuts, but there of course the parts to be printed are in relief. Still, you might ask, as I know these people have dodges.

The Siren drawing (Ligeia Sirena as I call it)[1] is rather larger than that of May, being 30½ x 21½; and much more laborious than that, owing to the amount of figure, and the background and other arrangements. To anyone else I should price it at 150 guineas at least, but from you I will take 100 guineas, only you must pay for the frame which I expect daily from F. & D., and which is not an ordinary chalk-drawing frame, but a frame similar to that of the little oil portrait of Janey which is here; this drawing being quite a picture. Also you would have to get it photo'd for me, as I mean to paint it. Also if you buy it, I must have the tin at once, and the drawing will reach you as soon as I get the frame.

<div align="right">All to thee,
D.G.R.</div>

[1]See Letter 205.

213. DGR to CAH [Kelmscott]
H---'s B---y C---k Tuesday, [11 March 1873+]
My dear Howell,
Your packages arrived today and have been inspected. The bangles were only 2 in number--the one, which you tell me is a complete native costume in itself was absent. I am not quite sure whether I shall be keeping the gilt bracelet, but shall not keep the other. The watch you send is very much nicer than any of Barkentin's, and though I feel rather awkward towards him in the matter, I must certainly keep this one instead of his. I judge that you or rather Mores prices it to me at £16/10/- Is this so? I shall be sending the tin very shortly--in a

very few weeks at latest. Of the jewellery sent in your former parcel, I am keeping Coral necklace £8 and 2 Gipsy rings £4. All the other things I don't keep I will return in a day or two, but don't know that I can see to packing them before that, being busy.

I shall write forthwith to Barkentin and return his watches, keeping 2 pencil-cases. I suppose I had better be his first informant on the point, and must apologize and explain that a watch suiting me better was spontaneously offered from another quarter.

Richards's b--y Clock came here and is now installed on the staircase.[1] It seems to go all right. I suppose you heard no more from that hero.

> Ever yours,
> D.G.R.

[1] As on 4 Feb. DGR had sent a postcard to CAH informing him that he had declined Richards' clock, I suppose that DGR through CAH had negotiated directly with the owner and thus had incurred the anger of Richards.

214. CAH to DGR Northend Grove, Northend, Fulham, S.W.
 13 March 1873

My dear Gabriel,

"Hüffer's Bloody Clock" has gone to Brown's as bright as ninepence. I have ordered the Turnham Green address to be cut again as it would be a pity to have it wrong.

The flowers cannot be made smaller, nor could they in wood unless the block was plugged, and the flowers cut afresh on the new wood.

About the Siren, just now I could not send you the 100 guineas having much to pay during the next three weeks, and being so put about to meet all, that I wish to ask you to lend me £30 by return of post, as Saturday I must make up £300.[1] Never mind if you have but little at the Bank for if such is the case I will pay the £30 back to your account during the coming week after Saturday, and advise you of the fact. I do not like to ask--as you know--but I am worried-- and as you know also I pay back when I say I will do so.

Try and get your full price for the Siren, and if you do not place it let me know that I may prepare myself.

All right about the jewellery any thing you like, and that suits you best. Of course the £16/10/0 is the price charged to me, for the watch, and of course also it is what I charge you. I knew that my watch would be the best. It is the very finest made, and Barkentin would have charged you £25, or £30. Yes you write to him, I am not supposed to know any thing about it. Does Janey know how to set the hands? I only ask not knowing if the watch she lost was keyless. Well, of course you wind it with the top knob, and to set the hands you press the little knob on the side, and set them with the same knob by which you wind the watch, while you are setting the hands you must press the little knob down all the time. [Sketch]

How do you like the Pay clock?[2] No I have not heard again from the noble professional. I showed Sandys the letter and he roared, he says this Richards is quite a bully and lives by it, that he is the strongest man in England, and no doubt intends to jump upon me some day or other, of course if he does, as I am no boxer I will treat him to one or two Portuguese bull fight passages that will astonish, and floor him. He is trying to get some employment from Gladstone, and asked Rose for a Testimonial, Rose did not send it, and Richards called on him, Lawson came down saying that Mr. Rose was engaged and would be engaged all day, and Richards left. About one hour after this he calls in at the Arundel [Club], and there finds Rose smoking a long clay pipe! On the spot he sits down and writes a long letter and hands it to Rose!

The letter is something terrific. Richards begins by declaring that up to the present he has always considered himself a man and a gentleman, but now that he can reflect, he sees the depth of degradation to which he fell when he so far forgot himself as to ask for a testimonial from the biggest and lowest skunk on the Rolls! He winds up saying that he must struggle to forget this galling and humiliating proceeding in having asked for any thing at the hands of the Patriarch of vice and low debauchery!

Rose is not going to answer, he says that no one ever does answer any communication from Richards.

With best love,

Your affectionate
C.A. Howell

[1]Refused by DGR on the plea of poverty in a two-sentence letter of 14 March.
[2]A reference to the Richards clock--why "Pay" I cannot explain.

215. DGR to CAH [Kelmscott]
 Sunday, [16 March 1873+]
Dear Howell,

It was very stupid of me not to send the jewellery as I might have thought it would be of use. It goes to Lechlade this afternoon, but whether the righteous Postmaster who is a vestryman will register it on Sunday I can't tell, so don't know whether it will reach you tomorrow or Tuesday. I have kept, besides what I said before, the Topaz locket, which I gave to little Jenny for her birthday, and made a miniature of her Mamma for it. I enclose your list showing what I have taken. The 2 bracelets return to you also.

I am alone again now here with George and the surrounding community of Pike. I am not sorry you did not take the Siren drawing,[1] as I really had offered it cheaper than I could afford, as I afterwards still further perceived in doing the background parts.

I have finished Leyland's Loving Cup[2] and shall be writing him and forwarding it in a few days. Does he come to town regularly?

What a lark about Richards and Rose! I hope I have not lugged some nuisance on to your head, but fancy he has got his quietus. The clock looks wonderfully well on the staircase-head and really seems a part of the place; it goes right but is hardly in prime condition.

Tell me some more larks about the School Board.

You know, what between watch and jewellery, I now owe you or yours £36. Shall I settle it by a drawing or by tin in due course?

Ever yours,
D.G.R.

[1]DGR offered the drawing to Leyland, who refused it (D-W, p. 1151). In the end CAH got it as part of the commission for the sale of the large Dante's Dream to L.R. Valpy (DGRDW, p. 88).
[2]A reworking of the 1867 oil (Surtees 201). WMR (DGRDW, p. 76) says that DGR "had in 1870 proposed to take [it] back from [Leyland], but this arrangement was not carried out for some while yet...."

216. CAH to DGR Northend Grove, Northend, Fulham, S.W.
 Monday, 17 March 1873
My dear Gabriel,

The jewellery duly to hand, many thanks. You were quite right in keeping the large old English locket, it is a beautiful thing, and the portrait in it must look stunning. No, you must send me the tin, and try and let me have it on the 26th just as I said in my former note when sending you the things. Of course I would love a drawing a dozen times sooner, but I have a good deal to pay, and must pay it, and as the drawing would be some time, and I might be very much longer selling it, I cannot manage just at present. If the following arrangement suits you, send me the tin, I will return it again shortly, and then take the drawing.

Just now I want more help than ever, a letter just received from my Brother informs me that the King of Portugal has proposed me as resident (London) first Secretary to the Portuguese Embassy, and that the government is stirring in it. If the thing is carried I must meet it as much out of debt as possible and be quite ready for it. Once in my hands every thing is all right, and then I will make swells buy the right thing, I shall deal, of course, but others will do the work, and I will only advise both buyer and seller.

It is damned nonsense being hard up at all, I am tired of it, and will stand it no longer if I can help it.[1]

You need fear nothing about Richards. Has he written to you again, or asked for my letters? I saw my lawyer this morning and told him all about it, and he laughed about the "profession" and said that auctioneers of the kind were not only tradesmen but very shady ones, and that real respectable tradesmen would not admit them or regard them as any thing better than brokers men, he says that if he writes to you for my letter, or your opinion on the subject, you are not to answer at all, as any answer in court would be that "a gentleman of Mr. Rossetti's profession, and position could not possibly find time or inclination to answer every insignificant communication addressed to him, it being trouble enough to fill a waste basket every morning" This he says any judge would accept at once, and stop everything.

If Richards meets me, and falls on me, all I shall do is to guard my mug, which is easy, then give him in charge, and bring an action against him for assault. I should take care to declare him the brother of Col. Richards, and the Col. has such a damned name that it would be quite enough. You see that Charles Reade has just got £200 damages against the Col. as editor of the libel.[2]

I have only had one meeting[3] since the row, and Mr. Chambers again rose and asked for the limits of each Parish, i.e. how far from, say the William Street schools Northend, could British parents send their children to the said schools? Canon Cromwell answered that there were no limits as to Parish, that the school Board rate was one, and the schools one. That a man in Chelsea might perhaps have a sister in Fulham, and it would then suit him better to send his child to the Fulham schools, where the child would be taken care of by the aunt during the interval, between morning and afternoon school hours. That all the Board enforced was that children up to a certain age should be sent to school, no matter what school, and when parents lacked means then the Board had good schools for them all, and parents would send their children to the one they liked best or suited them best--and down sat Cromwell. Up got Chambers, and said again--"Then Mr. Canon if such be the case will you kindly inform me what is to prevent people in Cumberland and Northumberland and Richmond and Barnes from sending their children to the schools--at Northend and Hammersmith--for which I am manager?" "The Canon replied that he had clearly laid down the law of the school Board, but that no doubt his friend Mr. Howell could answer that second question from his Honourable Colleague far better as regarded the why's and wherefore's than he himself could undertake to do. My noble self seeing Pike Chambers afloat and waiting about, at once got up for a lark, and said-- "Mr. Canon Cromwell places me in a most difficult position, and the deep searching mind of our worthy colleague Mr. Chambers almost drives me to move that the London school Board do adjourn for three years and bury itself in the study of science, not forgetting geography particularly called for on this occasion. This branch of Science gentlemen is not the one in which I am strongest--though a fellow of the Royal G. Society--otherwise I could not have come here this evening. Zanzibar would claim me as the Columbus of Dr. Livingstone, and I would be unable to answer the manager for Hammersmith. As it is, I feel the difficulty of solving the question, and can only follow the course pursued by all great men when pushed for an answer, i.e. quote the words of some greater man, and as a matter of course do it in Latin. Such a course would--however--I fear--involve my honourable friend in deeper research and bring him to puzzled extremes which I am most anxious to avoid. Will you therefore allow me to follow the example of our humble but festive friend Micawber and without quoting, simply follow the laconic style adopted by that gentleman when unusually pressed on any question of importance. "When," said Mrs. Micawber "you have flung your gauntlet to Society, and the noble deed is done, suppose Society does not take it up--what then?!!" "Coal!" muttered Mr. Micawber. As a full answer to Mr. Chambers, may I humbly mutter "distance"!?

(Terrible row, and laughing.)

Cromwell brought me home again, he is most festive and nice, and Chambers does now know what to do. He told Hook (our Chairman) that he was quite sure I was paid by the Pope, for he had seen me twice in the underground as if I was going to Finsbury and that he knew all about Cardinal Wiseman[4] who was "always going Finsbury" and that it would come to this, that either he, or I would have to resign. That Mrs. Chambers had already said that when they came to have boys on the School Board the best thing was to withdraw, and show that he at least, was not a boy.

<div align="right">Ever yours affectionately,
Charles A. Howell</div>

P.S. <u>Of course</u> pardon about tin but <u>of course</u> you understand me, lend a hand if you care to.

[1]This and the preceding paragraph are in <u>PRT</u>, p. 100; one or two other quotations appear on p. 99.
[2]In the <u>Morning Advertiser</u>, of which Col. Richards was editor and which had charged that Reade's play <u>Shilly-Shally</u> was indecent; judgment for Reade on 1 Feb. 1873 (Malcolm Elwin, <u>Charles Reade</u>, London 1931, pp. 240-41).
[3]Of the School Board.
[4]Nicholas Patrick Stephen Wiseman (1802-65), Roman Catholic prelate; cardinal from 1850. But Wiseman had been dead eight years before this letter.

217. DGR to CAH Tuesday, [18 March 1873]

Dear Howell,
All right about the wash-stands if yours is equal to mine. Let Dunn be arbitrator!
 Today I send Leyland his <u>Loving Cup</u>. Is L. in London?
 What is Prange's address, and what are his initials? He has asked me more than once to tell him when I had anything to offer him, and there is no need I should not do so with him as with another.
 Ever yours,
 D.G.R.

[Line at side of page:] If you don't know, I can send letter through Rae.

218. CAH to DGR Northend Grove, Northend, Fulham
 19 March 1873
My dear Gabriel,
Many thanks about the wash stand, Dunn shall have mine and examine it well.
 Prange's initials are F.G. Prange the address "Liverpool" only. He lives in some cottage or other, but Liverpool finds him, his Father being consul for some small state or other. I never wrote any other address.
 Of course write to him but before you do so I think it right to tell you that if I <u>were you I would not do it</u>. There is a vile book written by him with illustrations including <u>every ones</u> work, Whistler, Brown (I think), yourself certainly, a fearful daub purporting, I suppose, to be from a picture by you and so on. I saw the thing at a friends house, and tomorrow will borrow it and post it to you that you may see and judge.
 Of course you know I have nothing against Prange except his health, some time since he called on me and wanted something of yours, I was very hard up and had about <u>six</u> things but received him in the breakfast room, gave him a smoke and told <u>him</u> I had <u>nothing</u> of yours to sell and that your work was not to be had in a hurry. This I did to raise your price, same plan I followed with Watts, the thing that really answers and which the artist cannot do.
 It was Prange that gave the £170 for little <u>May</u>, but he gave no money, he gave only the water colour <u>Xmas Carol</u> he had had from me for what I paid you for it viz £100, and charged the extra £70 as his profit. I had nothing to do with it, it was done through Marks as you know, but as I had an offer from A. Smith of £170 for another <u>Carol</u>, or the same if I could get it, I ordered Marks to accept, and thus we got the £170 not from Prange but from Alderson Smith. These are the facts, and as an old friend I think you ought not to risk <u>any thing</u> by offering any thing of yours to <u>such</u> as Prange. He is poor and always glad to gain £30 or £40 when he can, and it would be bad policy on your part to <u>offer</u> any thing to him. If he comes and you <u>happen to have something</u>, well and <u>good</u>, sell it to him for as much as you can get, but to <u>write and offer</u> any thing is <u>bad</u>.
 Even with this exchange; before he took <u>May</u> he asked Marks "if he could get his £170 for the drawing should he require it--say in a month." Marks' answer was of course mine--"Certainly Mr. Howell will take it at the price."
 Prange went off quite pleased with this.
 All this as an old friend, loving you dearly, and knowing what can be done, and <u>all for your own guidance</u>.

If you want to make money begin at once, make a few drawings and send them to me. Let us work together, let me sell for you, and in two years if I do not make your market as solid as Millais' my name is not Howell.

I do not want any thing, but be convinced that I am right, neither Leyland or Graham or any one else are worth a damn unless they are held up by their armpits by some one outside. If you and Brown and Ned Jones had held me up by all possible means, I would have done wonders. There was a mistake--certainly not on my part--and I found myself alone. I then had to look to myself being as little selfish as I could (because I hate selfishness) and as far as I am concerned have done it, but just fancy what it might have been with such support!!!

A dealer called on me today to ask if I would say yes to £1500 to Ned Jones for some large picture or other and that if I would he would pay Jones for it at once. Of course I said no, and this is the position in which I have been placed! Jones thought he could floor me in a minute and the absurdity is something too wonderful. Of course I have not his genius--God has not given it to me, but if we come to a question of common money making Jones would have to paint ten times as much to make what I can and then he would have the trouble of finding purchasers.

<div style="text-align: right">

Ever your affectionate
Charles A. Howell

</div>

219. DGR to CAH [Kelmscott]
19 March 1873

My dear Howell,

I have bidden a long farewell to Henry Fuseli, R.A.[1]

Your School Board Reports should be embodied in a Blue Book, which will not be the only thing about that Institution which will look blue if you go on much longer.

I have heard no more from Richards, and should pay no attention if I did.

I can't quite make out your P.S. which runs:--"Of course pardon about tin, but of course you understand me. Lend a hand if you care to." I do not gather precisely what this refers to. Do you mean as to paying promptly for the watch and jewellery, or anything else? I care very much, as I think you know, to meet any wishes of yours whenever I can; but am often hard pressed myself. For instance, such tin as I shall be receiving between this and the 25th will only be enough for my own most immediate calls. I will manage to send you £20 on account of the things bought, but fear that is all I can do at present. I buy these things of Mores, do I not?--not of you? You see that whenever I have bought such things, I have always had all needful tick (sometimes a year or two!--never less than 6 months,)--and this would have been the case had I bought of Barkentin. I think you will agree with me that £8 for the coral necklace, £7/10/- for the topaz locket, and £4 for the 2 pearl rings, are anything but low or even moderate prices; indeed the first item especially--the necklace--seems to me very highly rated. Thus if I pay such prices, I cannot be paying cash too,--at any rate not when inconvenient. Otherwise no one likes better than I do to be rid of a debt as promptly as possible.

<div style="text-align: right">

Your affectionate
D.G.R.

</div>

P.S. It is true that, when I have bought jewellery belonging to yourself direct from you--such as the silver belt, the turquoise beads, &c--I have paid cash generally; but you have always asked me moderate prices--I should say scarcely half the rate at which these last things were priced.

At this present tariff, I believe the belt would have cost £20 and the beads £30.

[1]CAH was offering DGR a painting by Fuseli. (See following letter.)

220. CAH to DGR Northend Grove, Northend, Fulham, S.W.
 20 March 1873

My dear Gabriel,
Here are the proofs you want. The address had to be cut again and we must pay
for both. The flowers cannot be cut smaller. If the design has to be reduced
it must be quite a new die, and you must draw it out again, as they will not
take the responsibility of having it cut from this on their own hook.[1]
 All right about Fuseli, only it is such a damnably comic thing in oil, and I
thought it might do for the staircase. I still think I shall buy it. My P.S.S.
are always sleepy I write late at night, and to you I write any how. This P.S.
means lend a hand for the 25th say up to £50 or the £36 or any thing up
to the £50. "Of course you understand" me means that you know that I never ask
for tin if I can help it, and that when I ask you it is because I am indeed
hard pressed. "Lend a hand if you care to," does not mean if you care to help
me for of that I am sure, but if you care, or can, or don't mind writing to a
swell say Graham, and asking instead of two hundred which you may require, say
£250 which we may require. That is what I meant, but I see I put it badly. You
are wrong about the jewellery, none of it is from Mores except the watch. It
is all mine and the prices you have paid me or have to pay are just what I have
to pay. The blue needle case for instance I sold today for £40 to a dealer!!--
and this should give you some idea of what things are fetching. The watch from
Mores is not bought for you, I only buy for myself now and in my name, it is
trade cash price and I have to pay Mores at once, indeed I expect the bill
every moment. Of course you could get the same watch on tick from Barkentin, or
Mores but there is just this, that it would cost you £25. I do not agree with
you in the least about the coral necklace or any thing else. Two months ago I
had to get a pearl ring just like the two you have kept, for Lady Otway, and
as I could not find one old English (they are all Queen Anne) in the market I
got one made by a working Jeweller, bought the pearls myself and paid 6/- each
for them and the ring when finished cost me £9!!
 For Janey's blue beads for which you paid me either £14 or £15, I will send
you £35 or £40 by return of post if she likes to part with them, and double
the money you have paid for any of the other things. The little things I have
sold you from Kitty's casket, I have only parted with when hard pressed for
money, and with her leave, and often by her request and of course never charged
you a farthing beyond the price I myself paid years ago when it was easier to
pick up things.
 You know all about the beauty of jewellery, but you do not know its value.
I will give you an instance. Kitty had once the finest and largest clear
carbuncle known, this was mounted in real marcasite, English work made during
the reign of Queen Anne. It had belonged to her great great grandmother "The
beautiful Lady Murray" and it was one of the few family things she had. One
night you admired it and she gave it to you at once, and we both felt delighted
at having something to give you, something we valued, not because of its tin
value, but because of family nonsense. Well some time since we went to a little
party at Brown's, and on a string of penny beads Lucy had this thing round her
neck: and Kitty cried a little, and I convinced her that it was right for Lucy
to have it, and then she was very happy and so it was all right. But if you had
known about it you would have given it to Janey and I would rather a thousand
times she had it. You will say we were fools not to tell you about it. Of course
we were not, because if we had, you would have refused it, and we wanted you
to have it.
 Don't take it away from Lucy, but some day ask her to take care of it, and
to keep it safely. I rely on you not to say a word on the subject or to feel
uncomfortable about it.
 With dearest love

 Ever your most affectionate
 Charles A. Howell

[1]All of this refers to the note paper for Janey.

221. DGR to CAH [Kelmscott]
 [21 March 1873+]

Dear Howell,

Of course I should never have thought for a moment of writing to Prange, if I had known before of the exact nature of the purchase from Marks. As it is, there is one thing that either you or I must write to him,--that is, the necessity of care with the chalk drawing of May, as I should be very sorry if it were destroyed, as it inevitably will be the moment any one fancies the glass looks dirty. Will you kindly not fail to write him at once about this, or else I must. Send him a label and tell him to paste up the back of the drawing at once without removing it from the frame. If that is done it will inevitably be destroyed. I wish you, with all your ingenuity, would find some method of fixing these infernal chalks. I do some of my best work in them--perhaps better than any painting I do--and it is all to the dogs one day. One cannot use thin paper set from the back because the sheets have to be joined; and indeed I doubt whether setting from the back would answer when the chalk is very thick.

I should like of all things to put some things of mine in your hands to sell jointly to best advantage and wait time; but this last point has always as you know stood in the way. Else I should have been only too glad to have "supported" you, as you say, long ago in this way, believing firmly in your powers as a salesman and market maker, and feeling confident that you would have no equal as a dealer as soon as your chances were complete. Perhaps I may yet do so ere long. I shall certainly try to.

By the bye, Fanny writes me complaining that you made her deliver up some cups by my authority. I can remember nothing of such matter. Please explain. What are the cups?

It's not worth while sending me Prange's book. I don't know what it may be, but such bungling rubbish only makes one savage.

 Ever yours,
 D.G.R.

222. DGR to CAH [Kelmscott]
 23 March 1873

My dear Howell,

You may be--you are--sure there would have been no hesitation on my part in sending the £50 you mention for the 25th, did I not find it quite impracticable. As it is, I enclose (with difficulty, but necessarily from what you say) the £36 for the watch and jewellery.

You tell me not to be uncomfortable about the pendent and Lucy, but I am most inevitably most uncomfortable from your account of the matter. My own strong impression is that I had the pendent in question from you, together with a locket, one day very long ago, in 1865, when you came in while Janey was sitting to me for those old black chalk drawings one of which is here now. The locket I gave to Janey then and there; the pendent (which I certainly thought you told me had belonged to Mrs. Siddons), I must have given later to Lucy Brown, if it is the one I am thinking of, somewhat thus:--[sketch] the black of the sketch very deep red and the rest a kind of glittering white. If it is something else, I am at a loss to remember what. If you retain your impression of the matter, be sure I shall get it back from L.B. as soon as may be (taking care there is some exchange avoiding the least awkwardness on any side, and mentioning no names), and that it shall return to Kitty with my love and her pardon. I had not the least idea of its value--still less of its family interest--or should never have accepted it; as I don't think it fair, even in friendship, to take what is more valuable to your friend than to yourself.

The colour of the enclosed specimen will do excellently. Please get a good quantity printed now as soon as may be on the 2 papers I chose from your specimens. Half may be in this colour and half in plain stamping,--2 thirds of the whole bearing the London address and one third this address. Half of the whole should be on the unglazed paper I chose--the other half on the slightly glazed paper I chose. A few extra quires--say 3--might be done in all gold, but only if they can get a paler and pleasanter gold, not so bright and burnished as the enclosed. Jenner & Knewstub certainly used to print my device in a much milder gold. These gold quires should be half of the unglazed and half of the slightly glazed paper. Will you tell them, when the paper is ready, to send it

according to the addresses on it, <u>here</u> and to <u>Turnham Green</u>. You understand, <u>all</u> gold, not gold and silver together as enclosed specimen.

The Fuseli might possibly tempt me if one could see it before engaging to take it.[1] Could it be sent to me?

The <u>Siren</u> drawing is coming a stunner now, and should be worth a lot of money. I should like to put it in your hands on the plan you were alluding to, if I can afford to wait for a sale, but perhaps may have to get rid of it,--not to <u>any one</u>, however for less than 150 guineas even now. I have added a little drapery with great advantage to the composition,--to say nothing of its improving the market.

<div align="right">Ever your affectionate
D.G.R.</div>

Will you pardon my saying one word as to the 15 initials following your name in that School-Board circular. I assure you they are likely to produce an injurious impression with numbers of people. There are so many men who possess many distinctions of this sort without ever using them that their use becomes exceptional and rather undignified. Pardon my saying this (which I do as being a little more English by habit perhaps than you are), but had I taken up the circular without knowing you, I should have wondered a little disparagingly who could be the gentleman with the 15 initials.

The envelopes of course to match the paper; but of these there should be a good <u>extra</u> number sent quite plain, neither with coloured nor plain stamping, as Janey often <u>seals</u> letters.

[1]See Letters 219 and 220.

223. DGR to CAH [Kelmscott]
 25 March 1873
Dear Howell,
I hope the cheque (£36) which I sent on Saturday reached you safely.

Today I learn from Brown that that b____est of clocks has not been delivered!!'!'!

Really no amazement can meet the event. The notes of astonishment, as you see, are like "monks tumbling down a staircase." Pray explain.

<div align="right">Your
D.G.R.</div>

John Rylands.

224. CAH to DGR Northend Grove, Northend, Fulham, S.W.
 7 April 1873
My dear Gabriel,
What is H U P? I have been waiting to hear from you.

"Hüffer's bloody clock" was delivered by myself this day at 6 p.m. into the hands of F. Madox Brown Esq![1]

Enclosed just received from the Vampire[2] who seems to regret not having enjoyed gout a little earlier in life.

All my future letters will be headed "Valpy's b----y Palmifera"[3] until it does come, its absence has cost me pounds of flesh, rivers of cold sweats, oceans of ink, deserts of cream laid, and barred the door to my asking Valpy for dozens of small helps in all sorts of ways that would have helped me along.

A Frenchman in want told Kitty that his wife had "constructed into the globe 9 infants" and that "he had nothing to keep them on but the perspiration of one eye lash." This is about my state, we have not constructed the 9 infants, but what this Frenchman calls the perspiration of one eye lash, and Brayshay the sweat of his brow, is all my landed property. Therefore wake up![4]

Write to me.

<div align="right">Ever your affectionate
C.A. Howell</div>

P.S. Understand that in your interest I told Valpy when the drawing was sent that he would have either to replace the frame or return it. So that you can have either its cost or the frame as I told you before.

The frame is a misfit like the one on May's drawing. I am going to write to Williams to go and measure it, and find out the real cost. I understood it £12 (Valpy would never say pounds for the world, he considers it low, and modern) but as you see Williams seems to think £20.

Important business to see you on, i.e. making Valpy my Parsons. He seems willing. When can I come and look you up for another day? On this subject not a word for the present, not even to the Vampire.

[1]Followed by more than a dozen exclamation marks.
[2]L.R. Valpy.
[3]See n. 5, Letter 147.
[4]This and the preceding paragraph appear, with omissions, in PRT, p. 100.

225. DGR to CAH Kelmscott, Lechlade
 8 April 1873
My dear Howell,
Our correspondence seems suddenly to flag. I mean before long to submit some piece of chalk work to your good offices as to setting.

Miss Wilding is down here and I am getting on with new work for Leyland. He seemed greatly pleased with the Loving Cup.[1] Does he keep it or make it over to you?

The Proserpine is close upon finished. What is the last news of Parsons?

Don't you think I ought to get a receipt for that tin about the watch etc. from Mores?

Leyland said something about coming down here for a visit on way between London and Liverpool,--staying a day and night I suppose. I said I should be delighted as soon as I had work in a state to show. Do you think you could come down same time and help to enliven us?

One serious word, my dear Howell, about that--blessed--clock! When is it to reach? I am really quite weary of the matter and feel small towards the recipients as it was promised so long ago for a wedding present. What are you doing about it? Now seriously, isn't it a good deal like making a fool of one?[2]
 Ever yours,
 D.G.R.

P.S. Dunn (who is here) tells me that oil sketch of Magdalene[3] has arrived at Cheyne Walk. How about it?

[1]An oil of 1867 (Surtees 201), from which DGR painted three water-color replicas. DGR got it back "about a year ago" (D-W, p. 1135), reworked it, and sent it back about this time "much improved by late work" (D-W, p. 1159).
[2]This paragraph is crossed out. See following letter.
[3]See Surtees 109 R.2.

226. DGR to CAH [Kelmscott]
 Wednesday, 9 April [1873]
My dear Howell,
Last night I wrote the first sheet I now enclose, and this morning I get yours. As regards the clock, admiration and astonishment are active, yet exclude daubs--[1], as I have a letter to the same effect from Brown, and two witnesses can hardly be mistaken even as to so improbable an apparition. However, I would be greatly obliged if you would still bring your unflagging zeal to bear on the fretwork question, as I do hate to make a crippled wedding-present. Brown's admiration of the clock is unbounded, but he says the fretwork is absent. I suppose the man can make it to the size and fit it in still, can he not?--and I think the price of his work was included in that of the clock.

I will answer Valpy's note when you explain about the frame. I can make nothing of it and had better tabulate my difficulties.
 I. What frame was it? Did it come from Chelsea--is it an ordinary gilt oak reed frame,--or what?
 II. Why a misfit?
 III. Why is May's frame a misfit? It was made for the drawing and sent here. I find it down (I suppose) in F. & D.'s Xmas bill, with date of Nov[embe]r

described as "A reeded gilt wainscot with gilt oak flat and carved patera, Best plate glass over inside, £5/14/-." I suppose this entry refers to it. Is this item to be paid by Parsons or myself?

IV. Why in the name of Hell should any frame for this d--d Beatrice[2] be charged to any one either £12 or £20? I suppose it is simply the usual reed pattern, is it not?--and a larger frame of that kind which I have here (sight 41¼ x 30½) is charged in F. & D.'s bill £9/12/6; and even about that I have been making a row with Williams. The frame for Proserpine is charged £25/15/6 which, as I have told Williams, I think very high, having been used to pay for such frames £18 to Green, with but little difference in the work. The double frame for Graham's Beatrice is charged £30/7/6 which I have protested against when the price is compared with the large frame made for Graham which was under £100. But everything and all creation is licked by this monstrous charge for Valpy's frame. When you explain as above, I will write him. The drawing is here and I shall try and send it him by the 20th but cannot as yet be certain of doing so. What is his present address to send it to?[3]

V. F. & D. are thieves and I shall change my frame maker as soon as I can find a good one.

I am interested in the plan you mention--Valpy vice Parsons. I shall be delighted to see you here again soon. I fancy any day after next week would do, and will write again. Will that suit you? The Leyland plan couldn't be made to combine as yet, I fancy, since I want to get some of his work more finished first; but you could come again when he came.

Brown mentions about your prospects at the Portuguese legation. I think you should take it and extend your influence.

<div align="center">

Ever yours,

D.G.R.

</div>

[1]Sketch showing two figures with the torsos in the form of exclamation marks, but with long legs in the process of kicking away 2 question marks.
[2]Surtees 168R.3, an oil dated "1872" and sold to Graham for 900 guineas, to which £170 was added for the predella.
[3]The reference is evidently to Valpy's "bloody Palmifera" and the frame for it.

227. DGR to CAH [Kelmscott]
 Saturday, [12 April 1873]

Dear Howell,
I have got on Valpy's drawing,[1] but how am I to send it to London without frame? It could not be packed safely so as not to rub. The sight measure is 36 x 29 inches. I wish you would try and send me a frame of some sort at once if you can. It should have a white mount to look well. Of course to vamp up a duffing thing of this sort always takes as long or longer than to do a real fine thing right off from nature: but I dare say if you can send frame I can get it to him by the time he wants--20th I think he said. What is there to pay on it when done? That might lend strength to one's elbow.

<div align="center">

Ever yours,

D.G.R.

</div>

I have made a stunning study for a Leyland picture.

[1]See preceding letter and n. 3.

228. DGR to CAH. [16 Cheyne Walk], Tuesday, [?Wednesday, 16 April 1873+]. Is in town for the day, wishes to see CAH. [DGR saw CAH, WMR, G. Hake, Fanny, and Boyce (Boyce, Diary, 16 April)].

229. DGR to CAH 16 Cheyne Walk
 17 April 1873
My dear Howell,
Dunn is making a white flat for Valpy's frame (or rather the one I lend Valpy),
and it will go down so finished to Kelmscott and return to you in a few days
with the drawing in it. I may (if ready) enclose also Leyland's drawing which
I cannot get finished here, so take with me. I suppose Leyland is not now in
town or you would have said so. If you mention my coming to him, let him
understand I was obliged to get back forthwith:--else I should have tried to
see him.
 I am leaving out the large lacquered dish and the Chinese stool for you. Also
a brass covered box which I want nicely done up. The brass should be left as it
is, the leather replaced by a new bit cut just like it, and then the leather and
all the iron work including the nails (many of which are in the middle of the
brass plates), should be gilded and lacquered to a deep copper colour or nearly
that, so as to make a pleasing variety with the brass. The box will also have
to be lined again with some sort of paper. I enclose in it 3 pieces any of which
would do, but there is not enough of any one sort. Perhaps you could get
something else from Marks, unless these can somehow be made to do, but I fear
not.
 The work-table will have to be on castors to make it useful. My impression is
that a deep thing would be much better than any shallow dish for the centre
place below, and I have found a rough piece of red lacquer which will exactly
do. [sketch] However at the same time I find a bamboo stand which fits the
large dish with the fishes so exactly and looks so well that it almost seems a
pity to be making the other stand at all. I wish you would call and look at it
as it stands on this bamboo thing in the drawing room, and give your opinion.
Perhaps it would be better to cut down the legs of the bamboo thing and make
it lower. In any case the bamboo, if used, must be cleaned and brightened up a
little (which I would get you to see to) and must also be refastened with
little nails at the centre of the turning point of the legs, but this I think
is absolutely the only point in which it is imperfect. Will you kindly see to
it all as soon as ever you can--I leave out for you to look at then
 I. The fish dish
 II. The bamboo stand
 III. The rough lacquer basket
 IV. The Chinese Stool
 V. The brass covered box containing the 3 papers.
Your 7 drawings all follow me to Kelmscott without delay. I will work on them
in the evenings and let you have them very soon. I'll beg your acceptance as a
free gift of the large standing female figure of any use to you. The 8th
drawing (a Dante) is at Kelmscott.
 I have today written to Fanny's land lady telling her to put the house in the
name of Mrs. Hughes, and giving myself and you as references. So if the land
lady (Mrs. Evans) should apply to you, please kindly answer.
 I go back tonight to the country and will hope soon to see you there.
 Ever yours,
 D.G.R.

230. CAH to DGR Northend Grove, Northend, Fulham, S.W.
 23 April 1873
My dear Gabriel,
Just correct enclosed for me and let me have it by return, if you can, I wish
to get rid of it--and start other startling justifications.[1]
 I have just left the Vampire in speechless convulsions, shading his eyes and
every part of his body with everything he could find.
 The drawing looks most splendid and is not muddled at all, I am delighted
with it, and the Vampire is simply nearly a corpse.
 This printed letter seems fearful in punctuation etc.[2]
 Do not put any thing at the end respecting any one else--Ruskin gave £100
with much more ease than I gave £10 and did nothing besides, and there is no
more reason for me to mention him than there is to mention any other his equal
in charity though he may have given only 10/-.
 Ever your affectionate
 Charles A. Howell

Besides the subscription list mentions every one.

[1]This was an article on the Cruikshank Testimonial, which DGR calls a "prospectus," that appeared in the Daily News. See Letters 232 and 240.
[2]As one may easily believe!

231. DGR to CAH [Kelmscott]
 24 April 1873
My dear Howell,
I return the bills accepted, and am much obliged for your kindness in putting
your name also to them, the more so that it is a favour I should hesitate to
ask more than almost any other, being exceedingly fidgetty as to results in
such cases, and most unwilling as a rule to lend my own name. I would not
refuse to do so, after your kindness, in a similar case for you (such as you
say may occur in a few days), though I could only do so on a complete
understanding that there was to be no renewal of the bill beyond original date,
and that it was not for a larger sum than the present. To have a bill hanging
over me like a nightmare for an indefinite time is impossible to me. I myself
shall pay these enclosed to the hour,--of that you may be quite sure, so that
there is no anxiety in the case. At one time I used to accept dozens of such,
and always paid them to the hour, having an utter horror of renewal and
bedevilment.
 So if you will be wanting my signature, and cannot absolutely promise to take
the bill up when due, I could not think of accepting such a favour on my side,
and would ask you just put the enclosed bills in the fire and let me find the
money some other way.
 I hope you will pardon what I say above; but we should both be very sorry
to have eventually a row on such a matter; and this blessed subject is one on
which I have always felt so strongly that I think it better to say just what I
think at once. To do as Sandys does--get money by bills and never think what
may come of it[1]--is quite out of my reckoning, and I could not do it more for
another than for myself.
 If after the above homily you do pay the £200 into my bank, I suppose it will
be at once, will it not? I would ask you to write me a line when doing so, as
the bank people never send a word at all when payments are made by others to
my account.
 Your drawings must be on their way to me, and shall be attended to first of
any such work when I get them. I wish you would find your way here in a day or
two,--why not? I expect Janey and the kids towards end of next week, but till
then there is room. Why not come Saturday (if the bank matter can be settled
before then) and stay till Tuesday or Wednesday or later? I could talk so much
better than write about many things, and your presence would stimulate me to
get some of your drawings finished and you could take them back with you. I
have several things I could show you. I have about a dozen large chalk
drawings here now which I shall gradually (and shortly) get finished, which
will all be quite satisfactory and marketable, and which I would dispose of
reasonably though not ridiculously cheap,--still I would give any one a good
bargain of them. I have Bradford in my eye, as they have asked me for drawings;
and other applying quarters also. I should like you to look at them with me,
and at other things. And I dare say I'd find another drawing to give you
besides!
 Many thanks about Fanny and the house. I shall no doubt hear her views.
 Is that stamped note-paper ever to turn up? It has been I suppose about
4 months in hand.
 I will write to Scotus[2] and try and get some more of that gilt paper to line
the box with. He gave me the 2 pieces and perhaps has more.
 About the bamboo stand, I never meant the lacquer basket to be used [sketch]
if the bamboo was adopted,--only if the wooden stand were made. It could hardly
be adapted in any way to the bamboo, as it would prevent it from folding up
and lifting easily. Janey's view however is that the bamboo as it stands is
decidedly too high for her purpose, as she wishes the dish to be within reach
while she sits on a low chair at work. So (though you are quite right about
damage to appearance) I think we must absolutely have the legs cut down to the
height we meant to make the wooden stand. Will you kindly see to this at once,

and to having the stand brightened up a little and made quite firm in the joints:
then let it go to Turnham Green.
 Hoping to hear from you by return
1st as to Valpy's drawing having reached him
2nd as to the money matter
3rd as to your visit here
and 4th as to the bamboo

<div align="right">

I am your affectionate
D.G.R.
</div>

[1]Sandys was notoriously impecunious and unreliable in money matters.
[2]William Bell Scott.

232. DGR to CAH [Kelmscott]
 25 April [1873]

My dear Howell,
On re-reading your proof, I should most certainly cut out the chaffy part. I
think it has weak points, and that it would be quite sure, in a serious
document, to offend many not in the least aimed at. You will see what I propose
as a substitute. "My friend" or "friends," occurs 5 times in the proof: this I
have endeavoured to abate. I have not struck out the paragraph about begging
letters; but should advise you to do so, as it seems personal to yourself only
and a little irrelevant.[1]
 Poor old Valpy! What an impressionable old brick he is! I have the most
wonderful letter from him, and have answered it. If he likes to keep the
Palmifera frame, I can spare it, only must find what it stands me in, which
would be much more than an ordinary chalk drawing frame. I mention this on my
own hook--not by his suggesting, so don't name the matter as from me, nor perhaps
at all unless he were to raise it. He speaks of hanging over his sideboard "the
large drawing of Miss Kingdon when draped, as I have managed to arrange."[2] What
does he mean? I think I remember your showing me an unfinished drawing which
you had had mounted and which must be the one he means; but who is to finish it
unless myself?

<div align="right">

Ever yours,
D.G.R.
</div>

 I am very strongly of opinion that the chaffy part should go out.
 There must be somewhere at Chelsea, several large drawings like the one I
gave you, only not mounted:--viz: one of the figure at foot of bed/One of Dante/
One of Love. You are welcome to these if you care to have them and can find
them. The opposite figure was I fancy as good as the one you have.
 I should risk the temptation to satire, or the attribution of it, were I to
spate the significant answers, or equally significant silence, with which my
appeal was met on various hands. It will be remembered that Mr. Cruikshank's
name was intimately connected with Teetotalism and with Volunteering as well as
with Art; and the classes having strong opinions on these subjects made me, in
numberless instances, their inexpensive receptacle: while sympathisers with
Mr. Cruikshank's views had generally to confess themselves poor, and to regret
the absorption of all available funds in the furtherance of the "good cause."
Besides such cases as these, however, I may mention, as among my official
experiences, that seventeen persons, from different parts of England, wrote
inquiring solicitously respecting Mr. Cruikshank's eyesight. On my answering
that it was excellent, and as perfect as the youngest, some, apparently
horrified, never wrote again, while others wrote saying that they were half
blind themselves, and that Mr. Cruikshank ought to feel only too thankful for
such blessings as friends, and eyes to see them with. It may also be told here,
respecting Mr. George Cruikshank himself, I wrote volumes, and in all cases
sent an answer on every imaginable point, from the date of his birth to the
date of my letter, and in many instances had to give minute information
respecting his father, who was born exactly 125 years ago!
[On side of p. 2:] Cruikshank's answer "by return" suggests funny impecuniosity
so I cut it out.

[1]Much of this letter relates to the Cruikshank "prospectus" which CAH sent DGR
in his letter of 23 Apr.

WMR (DGRDW, p. 86) mentions "Miss Kingdon (a drawing which the owner [Valpy] wished to get draped.)" Miss Kingdon does not appear in the index of Surtees or Marillier. I presume the picture to be Ligeia Siren (Surtees 234).

233. CAH to DGR Northend Grove, Northend, Fulham, S.W.
 29 April 1873

My dear Gabriel,
Neither in Heaven's or Hell's name can I answer your question. Yesterday Monday the 28th April the 8 a.m. post brought me two letters from you, one dated 24th enclosing the bills, the other dated 25 enclosing the proof. This morning I received the third one[1] howling away at me like mad and saying all you ought not to say and which I must now answer being forced by all my friends to be always on the defensive.

As to getting money at exorbitant interest who on earth asks you to get it? This interest is not exorbitant it is 10 per cent for the time, these are the lenders terms, and other lenders charge 60 and require good security. The man is at home and receives his clients, he does not come here to force me to take £200 for you, and when you or I call we know what we have to pay, if such payment be exorbitant, and money can be got easily any other way and for the asking, why then of course it is foolish to avail of the only means at my disposal. I wish you would try to borrow some yourself, and then tell me your experience. Of course you may do so of Leyland or Graham they get their 60 per cent from you in another way, but as I cannot paint pictures they do not lend me any, or if they do, ask for it the next day, and are worse than my butcher.[2]

As to delays in your letters you must see your local post master, I have nothing to do with it, and as they do what they please with Telegrams, perhaps they also please themselves about letters and do what suits them.

As to my giving the bills without money, I do not see why you should judge me a fool at once, and the lender a rogue really you are hasty and always afraid of what may happen to you.

The responsible person for these bills is myself, the man does not know you from Adam, and your being the accepter is worth no more to him than if you only endorsed the bills, your accepting makes it legal and shows that you have had the money--you say it would be nice if they came on you without paying a penny. If you did not pay the bills when due they come upon me and not upon you at all. So much on this head, and you may set your mind at rest. The money as I telegraphed is at the Bank and you can draw on it. I waited and the man waited for the bills till late on Saturday evening (I have twice had letters from you by the 6 p.m. post) and at 8 p.m. I sent word that nothing had arrived he then left by the last train (he lives at Byfleet and on Monday never comes to town), so that yesterday I could do nothing, and today I did at once what I had to do.

As to your being so punctual with me I am always grateful and show it to you in every way I can, and if you neglect any thing concerning myself I am always amiable and nice to you, for I take one thing with the other, and you can never say that I flew at you as you fly at me. We both have bad tempers but yours is far stronger than mine, and that is my consolation.

For the proof I am most thankful though as you see by this damnable circumstance I did not get it by return. I took it to the printer at once and expect it tomorrow, when I will send it to you, and you can return it, if you approve it at your convenience. You are at me again about the damned trinkets, and the large outlay, really it worries me? Why the deuce did you buy it? First you ask me to send it, I buy a quantity (all of which is sold for double the price I paid and asked of you) and send you the batch saying distinctly that you could have six weeks credit, but that I wanted the money by a certain date, and more distinctly that you need not keep a single thing. Well you did keep £21 worth had the six weeks credit, and paid by the date, and now you speak of the large outlay etc etc. What interest have I in selling you jewellery or any thing else, what do I gain in the matter?

Worry, worry, worry--I shall never send you any more, or if I do, I will turn Barkentin, charge you a heavy profit, give you long credit and, rob you, then you will be pleased, I shall be a cad and have your thanks, but that I do not mind for I would be any thing to have them. I have never had credit from you, still you have never heard me grumble, you have always said that not the want of will, but the need of money forced you to it, I am a poorer man than yourself,

and why should you not give me credit for the same motive, really it is too bad to want one law for yourself and another for me. When William sold me the drawings by W.[3] which he was "going to burn" for £5, he wrote to me saying that on receipt of the £5 he would send me an order for Dunn to give me the drawings! I did pay the £5 and told William what I thought on the subject. A few days after he wrote saying he would take £5 for the glass case, but that it must be cash before delivery, "and this time you are not to blame me for these are the instructions I have received from Gabriel"!!

Confess this is a good ten pounds worth of humiliation. For days I was miserable about it, for I knew that you could not want the £5, and that if you did want it it might have been put in another way, or I might have been trusted with it especially when you had owed me £16 for eight months for which I had never asked.

Never mind the "homily" about bills, I did pay the money into your bank and it matters not whether you aid me or not, but I will give you my reason for asking. First of all I also pay my bills to the hour and if I did not I should not have the credit I have now (I have none with such as Jones, but he or those like him do not count in matters of credit). I have given many more bills than you, and they have always been honoured, my bill book is now before me and this last four years I have given bills for £17,000 and as no bill of mine is refused in the market I conclude that they must be worth something. This month has been a heavy one for me over £1,500 and as I have no capital you may fancy how I struggle and work, well, this man I got the money from lends me £200 at a time, and as I had to get it for you, and wanted it myself, I thought you might help me in another direction. You say that you would not refuse I having put my name to these, well I was also more confident in asking having done it for you twice before once as acceptor for £60 which you renewed twice @ 60% and once for £250 at no interest £100 of which you renewed. It is quite right not to sign bills, or to be mixed up with them with certain people but this should not be the case with old friends like ourselves, for either we are honourable and serious men or we are not. Some time since I lent my signature to a friend of ours for £700 and I would do so again and again if needed. Pinti lends me his to any amount, and I lend him mine, and we never had a word on the subject.

About Valpy and Miss Kingdon, pressed for money I sold him the whole batch for what I paid you, Miss K. is the one you mean, but all finished. Miss K. and the studies you said you would finish and I have sold them finished, I have to give you £30 on the lot, and on the Miss K. which I told him I had arranged for you to finish I will pay what you like. Of course he means you, who else is to do it? As you say? Only you know his round about mysterious way, sometimes I really cannot make out when he writes about "the man" (meaning Christ,) whether he is speaking of himself or myself or whom. Lately he has taken to writing tracts signed L.R.V. and the place here is flooded with proofs which on my soul I do not know how to mend.

Now there's a dear, do not let us have another word about money, I have written all this because your letters have worried me so, and I would rather say every thing that comes up than keep a word from you.

<div align="right">Your affectionate
C.A. Howell</div>

I am not well besides I cannot hold my head up for cold and but for this and the cursed bills I would have come down on Saturday and brought you the money as I intended even before you mentioned it in your letter of yesterday.

[1]This letter is missing in the Texas collection.
[2]Elsewhere CAH says that Eyre obtains money from a butcher to lend to CAH.
[3]Wainwright. See Letter 30.

234. DGR to CAH [Kelmscott]
Saturday, [3 May 1873+]

Dear Howell,

Many thanks about the bamboo stand (which I suppose reaches Turnham Green today) and about the box. All you say is good on latter head, but perhaps if the lock-plate is bright iron, the nails had better be so too. About the leather, the copper colour is a good idea if the nails were made copper, but if they are bright iron (which I fancy is better) plain brown leather might be best. Scott

has now left at Cheyne Walk two more pieces of the <u>green</u> gilt paper, which, with the one already in the box, will suffice for lining it, I presume, and perhaps, as I said, look better (if the tone of the whole is to be light) than the red gold would.

I understand you had a difficulty in getting some thing at Cheyne Walk. I am writing to Dunn to give Emma orders to deliver all you require to you or your messenger.

<div align="center">
Ever yours,

D.G.R.
</div>

235. CAH to DGR [Northend Grove, Northend, Fulham, S.W.]
(Fragment)[1] [?c. 5 May 1873]

you must have meant <u>answer</u> to your own, which I never received till very late after date.

All post cards are stamped by the P.O. like letters, and I enclose another for you to see, bearing as it should the London and Lechlade post mark, and "days number" to spoil the stamp. Then the unstamped card seems to have been rolled up and kept in a pocket. Damn the post office! My telegram said, "Both letters, with bills and proof only arrived yesterday. The money is at your Bankers. I write tonight. To my name of course I gave the double l and to yours the double s.

I constantly receive telegrams I cannot make out. The other day I wrote to a man who has things of mine on sale and asked him to send me a certain £10 provided he had received it, adding that being short of money he must excuse my asking.

I got a telegram from him saying "Crops of cheques have arrived will remit tomorrow." As the man had over £1,000 worth of things to sell for me I concluded he had sold at least £200 or £300 and accordingly gave myself a rest and stayed and played croquet with Kitty and her friends, instead of going after other tin which I required for the following day. Well, when the morning post came I received £10--and the telegram should have said "crossed cheque has arrived etc etc"--!! Fancy the state of rage!

No, none of your letters seem to have been opened, but others from other people have (not sealed), and in many cases in a brutal way for the envelope has been torn and pasted and smeared down again. Perhaps I have had 60 such cases.

Sealing wax is quite safe and a crest much safer than a monogram, for no respectable engraver dares to copy that unless he is sure he is doing it for the owner, and in most cases he can look up Peerages and books of the kind. It is for this reason alone that I use our crest.

No cast of a seal can ever be used <u>more than once</u>.

About Valpy's Miss K. there is no mistake, you never agreed to finish it in the transaction as it stood, but on my paying you to do so, and that is all I said in my letter.[2] In all matters of this kind you can always trust me for details, as I keep a memorandum book and enter every thing like a diary.

I am really glad you mention the matter of Graham and the Bradford Co. as it enables me to prove my complete loyalty to <u>you</u>, in all matters. Of course I have nothing to do with Grahams stupidity or with the Bradford Co. dealing with him. I am no <u>partner</u> in the firm and only keep it up outside and sell and consign to them myself, but when Graham told me a <u>lie</u> and said he had heard from them offering things of yours, I at once wrote to Brayshay and said that as far as <u>I</u> was concerned I did not care for what they did but that I would allow no poaching on your ground either from him or Heaton and that if such a thing as offering your work to Graham or Leyland took place again, I would at once cut them on all business transactions. I enclose you part of Brayshays letter explaining the real state of affairs, and received more than a month since. Read it <u>carefully</u> and send it back.

Graham is a damned humbug and there is no mistake about it. You shall have the little <u>Lucretia</u> if it is not sold, in a weeks time when ever you like. I wish I could get something good of yours soon, to keep up your market for your and my sake. I buy what comes up of yours, and have now such a lot of tin locked up, for my small means that I do not know which way to turn.

I will come down as soon as I can, but I work hard, though no one suspects it, and never can count on "tomorrow" for time.

No Sir, no letter from you respecting china was ever <u>unanswered</u> by me. When you were selling the china I wrote to you and offered you £600 for it, and offered myself as a dog in case you took to sport. I got <u>your answer</u> by return, stating that the sum you required was £700, that you felt <u>ill</u> and could not be writing, and that I must see William on the subject. I took this as <u>answer</u> to myself saying "do what you can and don't write again." Well I did see <u>William</u>, but he thought Marks' offer better than mine, and took it giving the <u>Silence</u> of which I had never thought. And now as you speak about it I may as well tell you that if <u>I</u> had been more consulted in the matter, not a pot would have been sold, and every thing in the way of tin would have been done for you, I may mention that when I called on you at Brown's, and every one was allowed to see you--Morris Huffer etc etc (I saw them both leaving the house after I had been there <u>one hour</u>) though you told Brown you would like to see me, I was not allowed to go in, I felt very much inclined to God damn the whole thing, but instead of that I offered Brown £400 which I had taken in my pocket to stop any gaps you might have, and this Brown refused. If you doubt it ask Brown, and now damn every thing. And when you <u>find out</u> (it will take a life time) that of all your friends I am as true as any, and <u>the one</u> that in a matter of business could do more in 24 hours than the whole lot in 24 years when needed, come to me and you will always find

<div align="right">

Your affectionate
Owl

</div>

[1]This fragment, beginning <u>in medias res,</u> was attached to CAH's letter of 20 September, written in Liverpool. Internal evidence, as well as DGR's answering letter (following), indicates a date of c. 5 May for it.
[2]See Letter 233.

236. DGR to CAH [Kelmscott]
 Wednesday, [7 May 1873+]
Dear Howell,
The wild tale of Graham's handwriting is funny.[1] All right old chap.

I don't see how you were to prevent the china being sold, though I believe most thoroughly and heartily in your good will, and friendship (more than in any one's but a very very few), as does William also I assure you, who expressed himself to me on the point very strongly at that time, and I dare say did so to you. I have full trust in your affection for me and am cordially grateful for it: and if I had a chance of reciprocating proof of friendship, you should not find me behindhand in anything I could undertake.

When at Brown's I only saw <u>one</u> of the two men you mention--viz: Hüffer, who, as a member almost of the <u>family</u> could not have his spooning cut off by my whimsies. The other was there I remember, but I did <u>not</u> see him, nor any one else except Dr. Hake one day, and a bootmaker who sold me a very bad pair of boots of which I should like to plant the right one--new still because unwearable--in the seat of his trousers. He lives in Totenham Court Road.

The post is certainly a nuisance. I'll keep the post card for a day or two, to judge whether it is better for <u>me</u> to make some complaint here first. The letters which were so long delayed being sealed and I suppose unopened when they did reach you, one is almost led to suppose the whole thing an accident as regards them, though as regards this post card I do suppose it was kept back in uneasiness about the other delay which had probably by that time been discovered at Lechlade. The postmaster is a very useful man to me--being a good carpenter and the only one--and a civil man always; so I should hesitate to make complaints in the first instance against him to any one but himself (what say you?) particularly when his dangerous illness and his daughter's wedding at the moment are considered. It certainly does seem most strange that among all our letters of those two days, these two (both of them to you) should alone have been delayed: but if the seals were all right, no gain could accrue by delay that one can see, and one must perhaps suppose accident.

<div align="right">

Ever your affectionate
D.G.R.

</div>

Will you hurry the bloke about the brass-covered box, as I have made a present of it. I hope the dish and stand got to Turnham Green. How about that

eternal note paper? The recipient will be at a new address I believe before it reaches the present one.
P.S. The Proserpine[2] is just finished, though a little last glazing will be needed, and for this it will have to remain with me till quite dry.

The house is just now in occupation again, but shortly if you are able and willing to come I should be very glad to see you here. I am as anxious as yourself that you should have some pièce de resistance from me which may give you a chance of working my market a little. I am very sorry to hear of your frequent attacks of poor health, and fancy you hardly take enough systematic exercise and change.

[1]This may relate to something in the missing part of CAH's preceding letter. Graham's handwriting is often indecipherable.
[2]Proserpine IV.

237. DGR to CAH [Kelmscott+]
 [8 May 1873+]
Dear Howell,
I am not surprised at your being vexed at the difficulties raised by Emma at Cheyne Walk, and wish you had let me know before.

Many thanks for all trouble with the stand and box. Janey is here now, so there is no hurry for a week at least. I should think myself the best thing would be to have all the iron work of the box--lock-plate, nails and bands, copied exactly either in iron or copper. Copper would look well and could not cost very much I suppose for such simple things. If painted at all, it should I think be a mild sage green for the whole of the iron work, but I don't fancy the notion of paint, as I think the surface may be too rough for it to look well, and moreover I fancy it might be liable to peel off.
 Ever yours,
 D.G.R.

Please take care the lock put on is a good and safe one.

238. DGR to CAH [Kelmscott]
 10 May 1873
Dear Howell,
Many thanks for all your kind trouble. The dish and stand will doubtless be most welcome on the owner's return.

I look on your conduct in respect to Fanny's pictures as very friendly and am duly grateful. The Loving Cup needs a day's work at least to make it presentable. Will you let me have it at a favourable moment for that purpose,--whereof I will duly write you word. It sets my mind much at rest on F.'s account to know that, by your means, she is beginning to realize something against a rainy day. About the house you found for her, I ought before to have remembered that it would not be feasible at present for her to be any great distance from Cheyne Walk, as her superintendence of servants is useful there. I will finish the Lucrezia[1] very shortly, and will at the proper moment borrow yours.
 Ever your affectionate
 D.G.R.

[1]Besides a water-color replica (124R.1), dated "1871," Mrs. Surtees alludes to a second, untraced, replica of 1871 (p. 77, n. 4). The reference here must be to the two replicas, one of which belonged to CAH, the other to Fanny.

239. DGR to CAH [Kelmscott]
 14 May [1873]
Dear Howell,
I enclose you note received this morning from Parsons. I answer today that the picture[1] is done substantially but awaits final glazes, and must be quite dry, before receiving them, which may cause a few weeks' delay.

I duly received Cruikshank papers.[2]

I have been reading a French big book on Goya. Why don't you, who know Spain, work up the materials, which are abundant in this book, together with your own observations on Goya's etched works, into an article or series of articles, for some good magazine? I believe you would easily find a quarter for them, and you might begin literary work and spread your influence.

Write me. And if there are unanswered points in my back letters, answer same.

<div align="right">Your affectionate
D.G.R.</div>

P.S. You might send me your <u>Lucrezia Borgia</u>[3] as soon as may be, that I may seize spare time to work on the other one.

[1]<u>Proserpine IV</u>.
[2]See Letters 230 and 232.
[3]See preceding letter and n. 1.

240. DGR to CAH Kelmscott
 22 May [1873+]
Dear Howell,
What <u>has</u> become of you? I hope you are not ill. I enclose a bewildered note from Heaton and my answer, which I send you <u>before</u> sending it to him in case you had any objection to what I say of <u>Magdalene</u>.[1] Return it and let me know at once.

I saw an article on your Cruikshank prospectus in <u>Daily News</u>, finding fault with what you say of "illustrious names." Certainly the subscription list contains very few leading ones or almost none. Was there a more imposing <u>Committee</u> List? I thought of asking this question before when I first saw the proof, but forgot.

<div align="right">Ever yours,
D.G.R.</div>

[1]See Surtees 109R.2.

241. DGR to CAH [Kelmscott+]
 Friday, [23 May 1873+]
Dear Howell,
Janey returns to London on Monday. Before or on that day therefore (if not already sent) please kindly without fail send down the dish and stand to Turnham Green as she would like to get them on her return.

<div align="right">In haste/ever yours,
D.G.R.</div>

No doubt I shall get a note from you tomorrow in answer to mine of yesterday.
[Line at top of page:] The exact address is Horrington House Turnham Green Road. It is on right hand side of main road.

242. CAH to DGR Northend Grove, Northend, Fulham, S.W.
 23 May 1873
My dear Gabriel,
Very many thanks for every thing. I have not been ill, but very hard at work clearing arrears to be as free as possible should I determine to accept the Embassy affair.[1] I have not written to Heaton as they do bore me so much--strings of questions on every <u>imaginable</u> point, and every thing mixed up with religion "true faith" etc etc. So that I let four or five run and then answer them in one. After you told me you would work on the <u>Magdalen</u> I sold it to them for £220. He then asked how much you were going to charge, and I unwilling to bore you, or interfere with other work have been waiting to see what terms of exchange <u>I</u> could offer them for it. Don't write <u>this</u> letter, write saying that you have the picture at Chelsea (Fanny has it hanging in her little room) and that on looking at it you find that to mend it, it would entail more labour than new picture that you have to send me a batch of drawings and that you have not the least doubt that I will give him good value for it back again in drawings, that indeed you know that such is my intention provided they prefer such a

course.[2] For God's sake don't offer them 10 drawings or any thing like, I shall get very much better terms and am most anxious to keep all the drawing business in my own hands. If once they think they can get drawings from you they will only work for themselves, and it is part of my policy to prevent them from saying "we get these direct from Rossetti," every one knows now that all slighter drawings come from you to me and this enables me not only to regulate, and increase the price but to feel the pulse of the market and know exactly what men are growing up to want of yours, and how little by little I can go on spreading the market and increasing the price. Leyland and Graham will not buy slight drawings, and will not give the price for fine ones, they have both told me they are going in for "fine pictures" instead of drawings, and you should know this, another thing is that Heaton fishes for my people, I am always catching him at it, and if once he gets Graham or any one like him it will be bad for both of us.[3] Another thing is that they have played the devil with the business, and if they go on as they do now it cannot last six months. If pressed for tin they sell any thing under its value and at a loss, but before doing so, think nothing of asking £80 for a slight sketch of yours and then letting it go for £20!!

This is a fact, and ruin to the seller and the artist.

Yes I saw an article in the Daily News but what can I answer? Of course there was an imposing committee list, I enclose it, but the men would not subscribe and laughed at poor Cruikshank. The Daily News asks what leading poets for instance there were. Well, Top, yourself, Tennyson, Swinburne, Lord Houghton, Lytton, Christina on the subscription list, and a host of little ones, if I answer, and publish the names (The Editor has the Committee list) I must declare these people mean for refusing even a shilling and this you know cannot be done.

I am getting all the iron work made new for the box, and will take care that it turns out beautiful. The delay in the paper is owing to the Whatman Mill strike and the impossibility of getting it good enough at once.

In haste for post.

<div style="text-align:right">Ever your affectionate
C.A. Howell</div>

[1]Which, like other positions to which CAH aspired, never materialized.
[2]DGR wrote to Heaton on 24 May as advised by CAH (D-W, p. 1173).
[3]"For God's sake..both of us" appears in PRT, p. 101.

243. DGR to CAH [Kelmscott]
 24 May 1873

Dear Howell,
First about the post office. I suppose the opening along the top of the envelopes was of course made by yourself to extract the letters. The fast[en]ing both show unquestionable signs of having been tampered with, but the envelope in my handwriting hardly seems to have been thoroughly opened after all as far as I can judge. However that point makes no difference. Both bear postmark 14 May, so I suppose almost certainly the misdeed is a London one and both were opened by the same person, whoever that may be. I should certainly, in your place, take instant action in the matter. Do you mean actually that such things are of frequent occurrence with you?

The Rose business is difficult to deal with.[1] It must on the whole be interpretable as oversight I suppose, and if you name it to R. I suppose he will rectify the matter. The best thing I should think would be for Lewis to authorize you to send his letter on to Rose.

If you sent the Daily News the Committee List I don't see what their article could mean, unless to extract a note from you convicting certain eminent persons of meanness; but I should think this were less the object than to disparage those whose names do appear on the subscription list, where however Tennyson (whom you mention as there) is not to be found, nor Swinburne either surely. I think you must let the matter go by, for the reason you name.

I am sending such a note as you suggest to Heaton. But my offer of 10 drawings for 250 guineas to the Bradford firm was not meant as an exchange for the Magdalene sketch--the P.S. about the latter being an afterthought. The fact is, I shall be touching up a number of drawings I have here and making them really valuable--not slight--and I want to sell a lump of them somewhere to bring grist

to the mill. Can you manage this for me? If not, I must offer them elsewhere when ready. I have sent quite a short note to Heaton now, with no mention of drawings. Let me hear again.

<div align="center">
Ever yours,

D.G.R.
</div>

It really can't need to register what I return, as my letter is sealed.

[1]There is no clue to this "business."

244. DGR to CAH. Friday, [30 May 1873+]. Wants CAH to come to Kelmscott at once to talk business. "Thanks about the dish and stand which are vastly admired."

245. DGR to CAH [Kelmscott]
 Tuesday, [3 June 1873+]
My dear Howell,
Am I ever to hear from you?
 I find suddenly however that this house will not be at my disposal till about Tuesday next. Could you come about then? Dr. Hake and a friend are here now, and I am expecting the Browns soon, but if I find I have a presentable enough room to offer when you can come, I shall try and see if Kitty could come too, as that would be very nice and George could row her about to any extent.
 Now do give an answer of some sort and don't be a resolutely invisible and inaudible Portuguese person.

<div align="center">
Ever yours,

D.G.R.
</div>

246. CAH to DGR [Northend Grove, Northend, Fulham, S.W.]
(Fragment) [c. 10 June 1873]
I want to come down at once but how can I manage it? 24 hours is the most I can spare so that you must arrange things so that I can run down and back again.
 The Bradford people[1] have made a mess of their affairs and gone to the devil for want of business habits and greed of tin, i.e. they have so scolded their first customers, that they have flown away disgusted and the shop is going to be closed. I am wanted down there at once to see after what they have of mine, but I will wait your time and convenience, and keep ready for you. Never mind about room for me, any thing will do, I can sleep with your maid, or chuck myself into any other hole that may turn up. Kitty would like to come above all things and sends dear love to you but just now it would be impossible to leave Northend, with people staying and coming daily. Later on I should like to give her say 2 or 3 days with you and George for like myself she is very tired.
 I am off today to see if I can get the 250 guineas for the drawings, and thus ease your ark. Just ease mine by accepting the enclosed for £50 which is all I shall require instead of the £200. This I am not going to discount, but to pay away as cash with a batch of real business bills, this one for £50 making up a sum, and going also as a business bill. Make it payable at your bank, and when the time is up I will pay the £50 to your account that you may meet it.
 Can you send me a note to Cowper or Bruce, or Defrey or any one else. I am going to ask for the secretary's place at the Royal Academy, I am told it would be of great use to me, that they cannot easily get a man, and that it all goes by government influence.[2]
 A strong introduction to any swell (besides my swells) from you would be of all the value in the world.
 So many people come here now, such as Baron Stern, Rothschilds, and other coves with mountains of tin, that I have been thinking it would be wise for you to send 3 or 4 of your finest chalk drawings for me to hang up in the drawing room. I would then swell about them, declaring "not to be had," "not for sale etc etc," and thus perhaps get you one or two new valuable men, who up to the present have bought things which they now hate for very large prices which they can never get back. What say you? I have been thinking this would be a splendid plan, they would be things you intend to keep for yourself and which would be as safe here as at Kelmscott, and would be seen surrounded with beautiful things and show to the best advantage.

I am determined to get on to make lots of coin or croak, and if I do not croak you will see. Have you heard about Sandys' "little girl?"[3] Theatrical London (after some private shows) has gone clean mad about her, and Robertson and Marie Lytton have engaged her for three years at £30 a week and three benefits and <u>all</u> expenses and dresses found. She is coming out in <u>King John</u> and Robertson is trying to get the best Theatre in London, and engaging a whole company for her. I am told that the whole affair is unparalleled in the annals of the English stage as a start. She comes here to consult me about every thing and is going to fund all the tin except £5 a week for the kids. Sandys is in a state and ill with excitement.

Pardon delay my dear boy and believe that it is never want of love, as to being offended you must know such a thing to be impossible as far as I am concerned.

<div align="right">Ever your affectionate
C.A. Howell</div>

What I propose is that if I get you one or two swell buyers, they shall come direct to you. I want nothing, but if this nothing makes you uncomfortable you shall give me 5% on all you sell them.

[1] I.e. Heaton & Brayshay.

[2] An advertisement of the vacancy was enclosed.

[3] "Miss Clive," who made her "first public appearance on any stage" as Constance in <u>King John</u> on 21 June (<u>Athenaeum</u>, 28 June, p. 832). CAH of course had advance notice of the part.

247. DGR to CAH [Kelmscott]
 12 June 1873

Dear Howell,

Here is the bill. No doubt you mean to meet it punctually, as your not doing so would put me to the greatest inconvenience.

I know what it is to be busy, but no amount of preoccupation can prevent one's writing a line to say so.

The <u>Proserpine</u> leaves here for Parsons this day by Passenger Train.

I have already said so many times that I should like to see you here if you can come, and that it is very desirable from a business point of view, that it is no use my repeating it. If you really mean to come, name any day you please and I will expect you.

About the R.A. I don't think the post would suit you, as I am confident what they really want is a superior clerk. As to Cowper and Bruce, they are people I never see by any chance, and I have already been writing them more than once on account of friends. You will perceive that to be <u>always</u> doing this when I never see them is impracticable.

<div align="right">Ever yours,
D.G.R.</div>

Suppose we try to end a 6 or 8 months' job, and get that letter paper sent to Turnham Green. If the paper I chose cannot be got, of course another as like as may be will do as well.

248. DGR to CAH [Kelmscott]
 15 June 1873

My dear Howell,

I judge then I may expect you on Saturday the 21st. As to equipages, bring an omnibus and a river steamer if you like.

I have several pictures finished or in progress at <u>my own disposal</u>, and want to see you about them, so that we may talk over matters,--not necessarily to put them in your hands at once. But it would be very well to come to some systematic understanding as soon as possible. I heard yesterday from Parsons who sent cheque for balance of <u>Proserpine</u>, and told me he would write fully next day, but I have nothing from him this morning. Should he (conceivably) view the picture as not a popular one, I <u>might</u> be able (I may say to <u>you</u>) to send another of a more ordinary kind instead almost at once; but then the <u>Proserpine</u> must not meanwhile be shown about and discredited. I say this to <u>you in case</u>, as I rather fancied I scented some dissatisfaction in Parsons, and don't want him to

be discontented with his first bargain of importance with me. See him and let
me know exactly what you think, and express to me just your views simply from a
business point.

The Browns are here and will remain awhile. By the bye I find Hüffer is huffy
about his clock not having the fretwork and won't fetch it from Brown's till it
is completed. I wish you would kindly see to this, as I don't want to make him
an imperfect present.

<div style="text-align:right">

Ever yours,
D.G.R.
</div>

249. DGR to CAH [Kelmscott]
 17 June 1873

My dear Howell,
Two questions once more,
 I. Are you coming on Saturday 21st?
 II. Is Parsons dissatisfied with the picture, as I <u>hear</u> nothing from him?
 Now please don't let the answer to these repeated questions be that of a
stock or a stone--viz: Silence. If that happens again, I shall have to give up
writing to you for good.

<div style="text-align:right">

Ever yours,
D.G.R.
</div>

250. CAH to DGR [Northend Grove, Northend, Fulham, S.W.]
 18 June 1873

My dear Gabriel,
I was just going to write. Yesterday I was from home until six p.m. when I went
to Parsons to be <u>astounded</u> with the <u>Proserpine</u>. It is <u>all</u> one can wish in every
respect, the execution above all seems to me more complete and vigorous than
that of any previous work, and I only wish I could keep the picture for myself
at once. Parsons <u>seemed</u> much pleased with it, but to tell you the truth I do
not understand him, and never can make him out. You seem to be under the
impression that he is not a fool respecting pictures, well you should see what
he buys, and how he really loves what he does buy.

I told him that I thought it most strange that he should not have written to
you, and that apart from friendship I considered such conduct ill mannered, and
unsatisfactory.

To this he answered that he was going to write, but that when he did write he
was pressed for time and anxious to send you the cheque. I think that he was
quite offended when you sent him back the cheque[1] as since that day he has never
been here. However we will talk matters over when I come down which will be
next Monday by the <u>2.30</u>--arriving at <u>5.25</u>.

I am sorry I cannot come before but am hard pressed for time and it is as
much as I can do to be free by then.
 Love to all.

<div style="text-align:right">

Ever your affectionate
C.A. Howell
</div>

[1]See Letter 248.

251. DGR to CAH [Kelmscott]
 19 June 1873

My dear Howell,
I will now expect you then at 5:25 on Monday.
 I enclose an odd note from Parsons,--odd as regards its close which certainly
seems to me to indicate disappointment. I really view the question as purely
one of business, and if he does not see his way with the picture, should wish
him to have said so, as a guidance to me in future possible transactions. But
we can talk of all this and other things when we meet. I am very glad that the
picture does not disappoint <u>you</u>. As to price to be asked, I should certainly
think myself that it were better to limit yourselves to what can <u>readily</u> be got,
as a costly picture hanging on hand at this outset of affairs would be

discouraging. At the same time 850 guineas would not be an exorbitant charge
according to the prices my latest things have fetched in various quarters.
I shall be very glad to see you on Monday.

Ever yours,
D.G.R.

252. CAH to DGR Northend Grove, Northend, Fulham
 20 June 1873
My dear Gabriel,
This letter of Parsons is really rum. I cannot make him out. I shall see him
today, and will let you know all about it on Monday. Leyland is here, a picture
of despair, silent, and scowling at the day. He seems more sour and unhappy
every day, and the other morning informed me that he had no money, and would
have none for a long time to come!!
Every day brings me a fresh wonder, and I am getting so bewildered that I have
half a mind to retire, i.e. buy a crib in some desert, sell all I have and go
and live on a settled income which I suppose I could command now, were I to put
out my fire, and send all irons to the devil.
I shall come to Lechlade.
In haste,

Ever your affectionate
C.A. Howell

253. DGR to CAH [Kelmscott]
 Tuesday, [24 June 1873+]
My dear Howell,
Your plea is of course a very valid one for the delay, though I was much
disappointed yesterday at your non-arrival, and am very anxious now to see you
on Wednesday. We must consult about various matters by word of mouth. I really
believe our interests might, by proper management, be made to work together,
and there is no one but yourself who has the least sense or enterprize.
One thing I have not yet named to you: viz: that I have a second Proserpine[1]
here, painted with very hard work in the last fortnight on a fresh design
modified in proportions but otherwise the same as the first. The new picture
is somewhat larger in area and has additions to the background. It is, between
you and me, very superior to Parsons's picture, but having been painted so
rapidly, I have not yet got its frame which is ordered. I want much to show it
you and talk about it. Of course it must be disposed of in some way which will
not interfere with Parsons's market. It is on the whole the finest high figure
picture I ever painted. I have other things "biling" too, but really must see
you. So I trust Wednesday will be the final date, and that I shall not fail to
hear from you, as you say, tomorrow morning.
I have seen about "Miss Clive" in Daily News, and she has no friend better
pleased than I am. I always thought her a great-hearted girl, and always said
she was a genius.

Ever your affectionate
D.G.R.

[1]Proserpine V.

254. CAH to DGR Northend Grove, Northend, Fulham, S.W.
 30 June 1873
My dear Gabriel,
Excuse poverty--hard up for paper. Love to Miss Wilding, and I saw her friend
yesterday and gave her the letter myself. Called on Graham yesterday. He had
gone to Scotland but is expected back this evening. I left your note, and mean
to call tonight. The pictures arrived all right. The glass of the Siren
drawing[1] is cracked right across one side of the flat. Crack measures four
inches--[sketch]. I have written for a new one and will ask F. & D. to fit this
one cut down to your next small frame. In all cases when you order a frame for
a chalk drawing order also a backboard, I was aghast to find the Siren without
one. Suppose a screw or nail had gone through it or water got into the case or
any thing else! I have ordered one in this case. The crack is owing to your man

having screwed it down <u>too</u> tight, and strained the frame. Note these remarks or
the flying of glass will often occur, and if it should break it might be fatal
to a fine drawing and quite ruin it--the rabbet of this frame is not deep enough
for the thickness of the strainer by a quarter of an inch, so that when your
man screwed the two battens he screwed them too tight across the frame thus
[sketch]. These screws have pressed the strainer and flat against the glass and
thus cracked it.

When the strainer does project beyond the rabbet your man is to screw them
down thus and without battens. [sketch] This will always protect all glasses
from any strain.

Yesterday I called on poor Clive with your flowers, and found the poor thing
down with rheumatic fever. She was taken ill on Saturday morning. They are truly
unfortunate and poor £500[2] is in a dreadful state. I told him all you said and
he is going to write to you. I showed him the two little drawings, he was quite
aghast, and says he never saw any thing so beautiful and perfect in his life,
really he was quite moved by them. Do make it up, one has such few friends[3]
what is the good of cutting them short one's self. Kitty is in a state of
delight about all the roses and is going to write to you. With Graham being away
and Leyland not in town this week it will be better for us not to come down
until some business is realised. I wish to see what tin I can bring you, and I
also find that I have a sale on at Christie's this week, some old stock of
mine, old pictures which I am going to reduce to tin.

I will write again, but answer this and say if I shall be right in selling
the <u>Siren</u> at the best for 200 guineas at the worst 150 guineas. The oil picture[4]
@250 guineas at the best and 200 guineas at the worst.

Love to you all.

<div align="right">Your affectionate
C.A. Howell</div>

[1]The <u>Ligeia Siren</u> drawing (Surtees 234) had nothing to do with Graham.
[2]CAH's nickname for the impecunious Sandys, who seemed always in need of £500.
Miss Clive was the woman who passed as his wife.
[3]A portion of this paragraph appears in <u>PRT</u>, p. 90.
[4]Unless this is <u>Blanzifiore</u> (Surtees 227), cut down from one of the discarded
<u>Proserpines</u>, I do not know what it is.

255. DGR to CAH [Kelmscott]
 Tuesday, [1 July 1873]
My dear Howell,
I do not hear whether to expect Kitty and yourself tomorrow. Arrangements are
made, and nothing could give us all greater pleasure. However, in case you <u>are</u>
detained for a day or so, it occurs to me to write you word that in case
Graham does not seem to bite at the <u>Proserpine</u> when he sees the sketch, it
might be as well to show him the other sketch also, (or perhaps in any case) as
Leyland would well deserve that I should sell the picture over his head, and
it ought certainly to be worth 1000 guineas. It is going on swimmingly (head
and neck finished) and is <u>the</u> best I have done from Miss Wilding.[1] I mention all
this <u>only in case convenient to you</u>. Otherwise never mind showing the
<u>Proserpine</u> or the other or anything.

We want you here very much as soon as you can come. George will have to go to
Oxford in a week's time about, and he would be wanted for boating Kitty. I
suppose he cannot stay later than the 8th and will then be away for some days.
On the 17th I expect Janey and kids.

Recurring to the picture, it ought certainly, now that I see what it will be,
to fetch 1000 guineas <u>at least</u>, and I don't know that I could maintain my first
proposal to Leyland, as he did not close with it.

By the bye Dunn says he gave you a <u>Pandora</u>[2] photo for me? Is it a <u>good</u> one?
In that case please let me have it when you come.

The new picture will be I should think about half a foot taller than the
<u>Veronica</u>[3]--width much the same I fancy but may be wider.

<div align="right">Ever yours,
D.G.R.</div>

[1]A reference to <u>La Ghirlandata</u> (Surtees 232), sold to Graham for £840.
[2]Surtees 224.
[3]<u>Veronica Veronese</u> (Surtees 228), painted for Leyland in 1872.

256. DGR to CAH Kelmscott
 2 July 1873
My dear Howell,
Your news of Sandys and poor Mary grieves me most deeply, and I have written
enclosed to him which please send or deliver. It is a sad matter indeed, and I
fear such a misadventure is enough to cancel the engagement, is it not? That
she will not recover I cannot bring myself to fear.[1]
 We are all greatly disappointed here at the prospect of your not coming with
Kitty after all at present. I wrote you yesterday of George's engagements, and
hope it may be possible for both of you to turn up in a day or two. We have all
been looking forward with great pleasure to your visit.
 I enclose a letter from Graham, but you have probably seen him ere this. The
price you mention for the oil head will do perfectly, but really the <u>Siren</u> is
one of my very best things and should fetch £200, should it not? Are you getting
photo done?
 Yesterday I painted the hand and lilies in that old head of the <u>Blessed
Damozel</u>[2] which I showed you. The frame is here, and a day's work will now make
it fit for sale.
 That blessed glass! Do you know the new one will be the third to that drawing,
and 3 I got to Parsons's <u>Proserpine</u>! Nor are these by any means the only
mishaps of the kind. They are always happening.
 Love to Kitty whom I still hope to see soon, and believe me
 Your affectionate
 D.G.R.

[1]Shortly after her initial appearance on the stage Miss Clive had fallen ill.
[2]Surtees 244: commissioned by Graham in Feb. 1871 but not finished till 1877.

257. CAH to DGR Northend Grove, Northend, Fulham, S.W.
 3 July 1873
My dear Gabriel,
Early in the morning yesterday I sent <u>Beloved</u>[1] and <u>Siren</u> on to Graham, having
appointed to call at six in the evening. I found him really quite broken down,
and was very sorry for him, in fact he was almost crying and I felt how hopeless
it would be to attempt any business. At last the girls came in and he cheered
up a bit. First, I am to try and buy the <u>Beloved</u> for his uncle, as the old
gentleman will have nothing but a "bright picture." This I told him was almost
out of the question. Next he was quite wild with delight at the <u>Siren</u>, and said
he would buy it for his brother Robert's sake, as it was just the thing he would
have bought at once, but that the price was "awfully high." I asked him 200
guineas seeing how he bit at it. Next I offered the <u>Proserpine</u> yours for 800
guineas and on this picture I spoke for half an hour, no go--"too sad, Mrs.
Morris's face and the deep earnest expression of it, always brings me to all my
sorrow, I cannot help it, I have felt it for some months, and now it is so
strong on me, that I could not look at the picture without such emotion as
renders me quite unfit for any work, it brings before me the two terrible events
through which I have gone one after the other, to say nothing of the poor girl
in Switzerland. All this I would not for worlds say to Rossetti, he might think
I only excused myself, and I cannot bear to heap <u>my</u> troubles on him, sensitive
as I know him to be."
 Next I brought out Leylands picture,[2] and explained all about the plan of
colour etc etc and asked 1000 guineas. With this he was quite in love, and
seemed quite to cheer up, price seemed to frighten him and at last I said, "You
must clearly understand, that all matters transacted by me for Rossetti, as far
as you are concerned, would be with the intention of aiding and facilitating
his stay in the country, saving him and you from endless letter writing, I
should request no payment either from him, or you for any trouble in the matter,
as I feel that such a course would always leave me freer to advise you (he had
said that he would always take my advice in the purchase of pictures valuing my

taste, and certain knowledge of market value, a consideration for him, should he die soon, and have so large and young a family) and say boldly what I did think."

Here are his exact words in answer, but you must keep every thing I tell you to yourself. It is important that you should know exactly how you stand with your purchasers, I will always tell you all they say, and if once they have the certainty that they are safe in speaking to me, they will say all they feel, you can know it as between us, and thus all uncertainty is done away with regarding their mood and their taste.

Here goes Graham's speech--"Well Howell you know I do want Rossetti's pictures but I really cannot afford to pay his prices, to offer him less than he asks I cannot. I am his friend, I feel sure that he is most conscientious, but I find that he measures my means, by the value of his work, and my purse is really below it. To refuse any thing of his on the ground of price I dare not, and cannot. If I was to say that I can at times afford only say £700 when he wants £1000 he would not believe me, and might take it as a simple excuse, were I sure that such would be his construction I would be more than pained, I have already lost two or three things of his, through being unable to reach the price, and lately I found that the only way I had was to decline buying on the ground of being really full, this would save me the mortification of sometimes offering less, though I have to suffer the disappointment of going without the pictures. Now in this case, if you can get me the Siren and the Ghirlandata for £1000 I shall be glad, only my wife must not know that I have the Siren."[3]

I said I would write to you, and that the only stipulation I would make was that in all cases in which he bought through me he would pay full cash down at once irrespective of any advances on old or promised work, to this he agreed.

On reaching home I found the enclosed which he had sent by hand after me, and I find a row about the Siren, as you see, this morning comes the second, offering the 800 guineas cash down and at once, and this is better than £1000 for the two. What say you? I have half a pact with Graham to get Heugh[4] for myself as a customer for any thing Graham may not take of yours and all this is worth considering.

At present Graham is one's right hand, and if all be well I can work him up to no end of use. Consider all these matters well, and write to me by return.

Send me back his two letters. Damn Leyland, he is no good, Marks being very pressed for money has just sent in his bill of £90 to Leyland with a note stating facts, and Leyland has sent back a cheque on a/c for £40!!!

At least you could paint another for Leyland, and coin is so scarce that £840 cash down might be a consideration.

About coming down I am most anxious to start but fear it cannot be this week, such mountains of work before me! Let us see what can be done in the next few days.

Today I send to Graham's for the picture of the Beloved (the Siren is here). Do you think it will be safe to keep it here (the Beloved) over Sunday next? A lot of people would see it, and it might be of great use, it could then go to Rae's first thing on Monday morning.

This is a beautiful letter for poor old Sandys and I will take it tonight. He too is very ill, not only anxiety, but yesterday lifting her[5] by himself from the floor on to the bed, he nearly broke his back, and it is so strained that he is in great pain cannot sleep or lie on it, so that you must not expect an answer for some days.

Poor things! I am so sorry for them, the fever has left her but the pain is dreadful, up to the present there seems to be no fear of Miss Lytton withdrawing the engagement, I saw a very kind letter from her to Clive last night, but who knows what will come, as the illness drags on and they have to keep up the Queen's with a most expensive Company and empty houses!

They keep advertising Clive every night and this is I think a very bad plan, it draws the people and then they have to listen to an excuse and a lot of sticks.

The Siren has now the new glass, backboard, and is pasted up all done under my supervision. I have written to Parsons to name exact hour for the photo as I must be present.

As soon as Blessed Damozel is ready send it to me I think I can sell it at once.

It is dreadful about the glasses especially now that they are so dear. The best would be to have all your frames for <u>oil</u> pictures without glass, keeping one with a glass to try the effect of <u>all</u> pictures in it, and when finished send them up to London, and let F. & D. fix the glasses at the last moment for delivery. I would always see to it, for you, and you would save much, and run no risk of wounding a picture.

In haste for post with best love

<div align="right">Ever your affectionate
C.A. Howell</div>

[1]Surtees 182, an oil originally painted 1865-66; it was commissioned by George Rae in 1863 for £300. Mrs. Surtees says it was "retouched in 1873." As it still belonged to Rae, I do not know how it could ethically be offered to Graham. Perhaps it was as well for CAH and DGR that he rejected it.
[2]Presumably <u>La Pia</u>.
[3]Because of <u>its</u> nudity.
[4]J. Heugh, a friend of Dunlop's, with both of whom DGR fell out.
[5]Miss Clive.

258. DGR to CAH

[Kelmscott]
Thursday, [3 July 1873]

My dear Howell,
Brown came after I had written you yesterday, and has reassured me as to Miss Clive, whom he saw acting the night before! However I am glad it has been the occasion of my writing to Sandys.

I forgot to say that I would like a photo of the little <u>Proserpine</u> drawing, as well as of the <u>Siren</u>. [struck out] However it just occurs to me this the <u>Proserpine</u> had better be done later, as I think of copying the ivy branch into the background of the sketch.

We are wanting garden seats here against Janey's arrival. Do you think one could be got with an awning such as I once had from Arthur but returned? Also a second is wanted for the back of an arbour. It must not be more than 5 ft 3 inches long, and should have a back and be as comfortable as possible. Do you think you could easily look me up these.

As to the desirability of your and Kitty's visit, you have my views and those of the society already.

<div align="right">Ever yours,
D.G.R.</div>

259. DGR to CAH

Kelmscott
4 July 1873

My dear Howell,
I am writing a line to Graham, but if you would see him again on the picture matter, it might save him letter writing at this distance and substitute much easier word of mouth.

I should really be gratified for him to have the <u>Ghirlandata</u> picture,[1] and am sure if he saw it, even in its present stage, he would perceive at a glance that it belongs eminently to the class of work he prefers, and moreover that it is far ahead the most likely to please universally of any work of mine he possesses. I am thoroughly satisfied with it (to the measure of such satisfaction as one ever gives oneself) and should be very glad to know it was his. But the price should really not be less than £900 which is no great advance on 800 <u>guineas</u>. I know he could not but think so too if he saw it. Indeed he would admit this price to be more clearly a moderate one than in most cases with my work, as regards market value. But he shall decide the point of price.

<div align="right">Ever yours,
D.G.R.</div>

[1]Bought by Graham for £840 (Surtees 232).

260. DGR to CAH [Kelmscott]
 Saturday, [5 July 1873+]
My dear Howell,
How sad about poor Clive! Will it really end badly?
 About the garden seats. One should be with an awning, and I shall be happy to
pay for same: as this is to stand out in the garden. The one for which I gave
dimensions, however, is merely to go at the back of an arbour and the awning
would be of no use. It should be rather low with a back to it, and might as well
have a cushion to fit it and make it comfortable.
 Thanks about the frames for the 2 sketches which are beautifully mounted.
 Ever yours,
 D.G.R.

Thanks about the hammock.

261. CAH to DGR Northend Grove, Northend, Fulham, S.W.
 7 July 1873
My dear Gabriel,
Sorry no better could be done with Graham, better luck next time. For the present
he must have £840 pictures until we are in a position to place the picture before
him quite free from all advances, and seemingly in no hurry to be exchanged for
money. As far as all business being a matter of business goes, all right send
any coin you please. The position I wish to obtain for you is easily managed, a
few heads and a few chalk drawings and all will soon be right.
 In all cases besides any private letter to me, write always when you can and
when necessary a line that I may show.
 As to Beloved of course not, not a word to Rae when you can paint or begin a
bright picture for him and I will make him pay for it.
 Of course I encouraged old Graham about "Found."[1] I told it was "in a splendid
state, just as such a picture should be before being finished," i.e. every thing
so disposed that it could be finished without further consideration, and that it
was your intention to forward it to him as soon as completed. This was a truthful
but mixed statement, and being vague it pleased the old chap beyond measure. He
hates any thing positive, and needs keeping up. He asked me about the Blessed
Damozel, and respecting that picture I told him you were doing wonders, that you
had cast the first one aside regardless of work and value, regardless of all
money considerations, and begun quite a new picture as splendid as your conduct
in all such matters. This so pleased him that he had the girls in at once to
tell them of his good luck. The fact is that his letch for tantalisation is
something wonderful, and I believe he would gladly allow you £500 a year for
spoilt canvas.
 Send the Head of B.D. as soon as you can, of course I shall offer it to him,
and if he takes it he shall pay as much as one can get.
 Now Leyland. On Saturday morning he was at my bedside at 9, and hung about the
place, like a picture by Fuseli. "What did Rossetti think of my not sending him
the money?" "Well he thought it rather inconvenient to go without during the two
or three days necessary to procure it elsewhere, but he wrote to a bloke I know
who for years has been thirsting for work by him, and sold him at once two
small things—heads—for double his need. He sends you his love, and did not
write at once, as he thought it better to wait till you could go down, and he
had something to show you. As there is no ceremony between you, and you could
not send him the money, he thought he would write as soon as there was anything
fresh to discuss."
L. "What sort of picture is the one he offered me with the three heads?"[2]
 "Oh, very fine indeed," and here I drew him the picture in pen and ink, and
talked about nettles, and things till he said "damn it all, the best thing would
be for us to run down and go and see Rossetti, and choose from what he has."
"That just at present glad as he would be to see you would be rather difficult,
the house is full of people, he is working hard, and no doubt would rather see
you when work is more advanced."
L. "You see Howell three heads would never do for me, the pictures must run
round like music notes, a head in each, that one may follow them round the room,
only it is the devil to say so to Rossetti, as of course he knows best what to
paint, but then, one knows what one wants, and Rossetti might get offended
thinking that this or that picture was refused because it was not so much liked.

"Not at all, now for instance in the case of this three headed picture which you refused, without knowing it you did him a service, for he wrote to you on the spur of the moment, but on consideration and after your saying you did not want 3 heads he soon saw that it would be ruination to paint this for 800 guineas as it could not pay at all at less than 1000 guineas."
L. "There is the other difficulty, for he must really paint me the single figures at 800 guineas and know that I cannot give more. Whistler told me of the Proserpine at Parsons, and I have been to see it. What a splendid thing it is! What is the least price you can take?"

"Well the least price is £840, but I do not advise you to buy it, as Rossetti has painted another worth ten of this one, and which is quite the thing for you, it would perhaps be a little higher in price but that you can know from him."

Did I think you would send it up, could he see it, to this I answered that nothing was ever coming up except for delivery as things could so easily be sold from Kelmscott. He then asked if I thought you would like the following for it.

400 guineas cash. The water colour Lucretia,[3] the £200 paid on the Pia[4] and cancel the Pia commission. I said I thought not, and promised to sound you on the question, so do not write to him until we have quite discussed the affair and both know what to say.

The question to be considered is can you being free of the Pia (I think he gives you £840 for it) work it off with any one else for £1050? This would reduce your debt to him by £200, enable you to have £420 more cash at once, and counting every thing, i.e. the £210 more to be got on Pia from some one else, realise the sale of your Proserpine at £830, having the Lucretia thrown in, the same being well worth £150 and thus Proserpine would stand sold at £980. All this is worth considering, and remember that my wish is to rid you as soon as possible of all picture debts, that to do this I must do the Bob Lowe[5] business, and finance away even at the cost of a little apparent sacrifice. In the long run you will find that I am right, and that you benefit by such a measure.

The advantage of having two such men as Leyland and Graham quite free, is enormous, Leyland as you see by this £400 business is worked up, and has come to a stand still like a half bred horse, he is mean, and the only way to get him back, is to loosen the traces, and ease this debt which to him seems enormous.

If indeed now that you have Miss Wilding you could keep her, and rapidly paint a picture for Leyland and receive for it as little as possible in cash it would be the right thing. If you can, let me know what you have to paint for him, and how you stand with him as to each advance.

I never do show your things together, the Siren is by itself in the drawing room. The Beloved I expect F. & D. for it every moment--in the breakfast room, and the snowdrop head[6] in my little room where I have nothing but drawings in black and white--placed on a beautiful chair with light to the left of the spectator. If the things are ever so good they should never be shown together, they stand alone as a surprise in each room, and when people want to see them again and again they have to run about all over the place, and trip up against the furniture till they have to sit down, and buy what is nearest at once.

A lot of people saw Beloved yesterday and the sensation is enormous, Dilke[7] came yesterday and was so delighted that he brought his wife today,[8] she is about to be confined and can scarcely walk with the weight of the second future President.

I had lunch with them yesterday and Brown's picture in the dining room looks very fine, Dilke tells me that Brown is going to alter the hand for him. He likes Brown very much and thinks him a very fine fellow.

Damn the thing, how can I come, when so much has to be seen to.

The garden seat with awning cannot be got, must be ordered from Antwerp price £6 not £5 as I thought. As the fine weather is on now, I will send you mine at once and put it down to you at £4. I have had it for nearly 3 years but it is quite new, only the awning is very faded with rain. Next year you can get a new awning for it for 10/- and as I have a lot of cane chairs under the trees I will go without the seat if such a thing suits you.

The block for the Beloved is not ready it must follow the picture.

Graham will never know that the new Wilding head[9] is the old B.D. but I will see when it comes.

Our love to you all and we must come later. Tell Brown I will write to him if I can tonight. Leyland knows Brown is with you. I told him before he came up about Davis,[10] but he does not know that he has been up and returned again. I have told him that he is painting a very beautiful picture.

With best love.

Your affectionate friend,
Charles A. Howell

The Grahams want to sell their Watts' pictures--not the Endymion--and offered them to Agnew, Agnew refused saying Watts had no market, and his things would not sell, this our Graham has told me, and wishes me to take charge of them. I am damned if I sell one, even if I got £1000 by so doing.

Poor Clive is much better, and £500 also, he is so delighted with your letter, and is going to write, only I told him never mind about writing now, I have told Rossetti all about it, and he knows you are too much worried to do any thing. Poor chap has been nearly half cracked and lives on brandy--entre nous--I am going to stop it if I can, and last Saturday I spoke very strongly to him on the subject. Of course nothing can make him drunk and that is just the Devil of it, for it is enough to kill any one to fly at the bottle every moment. When I am worried I cannot drink, only when I am jolly.

Private:

There is a report all over London that Solomon[11] has assaulted his mother with the intention of ravishing her, and nearly killed the old lady!

[1]Never completed by DGR.
[2]The Beloved.
[3]See Letter 115.
[4]Surtees 207.
[5]Robert Lowe was Gladstone's Chancellor of the Exchequer (1868-73).
[6]Blanzifiore.
[7]Sir Chas. W. Dilke (1843-1911). At this time he was a rising politician, but subsequently his career was damaged.
[8]"I never do show...wife today" in PRT, p. 101.
[9]Surtees 244A, a drawing in black and red chalks; possibly Surtees 244C.
[10]William Davis (1812-73), landscape painter. On 24 April WMR noted his death (D-W, n.3, p. 1165). The second he of the following sentence must refer to Brown who had visited DGR. In Letter 1355 (D-W) DGR says that Davis left a wife and ten children.
[11]Simeon Solomon.

262. DGR to CAH. Monday, [7 July 1873, misdated 14 July by CAH]. Needs "a really comfortable sofa," gives dimensions.

263. DGR to CAH [Kelmscott]
 Tuesday, [8 July 1873+]

My dear Howell,

Has Silence set in again? I am telegraphing to you today, as I really want to know what is going on. I don't want Graham's matter to fall to the ground through delay, and suppose he would give an answer Yes or No when he saw my letter I asked you to show him. Otherwise I had better have answered direct the letter he wrote to me in which he mentioned having offered 800 guineas through you, but I thought it more advisable the matter should be carried through by yourself as commenced, as a precedent for future transactions. If I do not hear from you tomorrow morning, I had better write him I suppose, as I shall judge something prevents your seeing him.

I wrote you yesterday about a sofa. Another thing much wanted here is a card-table. One of those green-baize-covered folding tables would be best, but failing that, an ordinary pembroke table would do. Could you see about this?

Ever yours,
D.G.R.

264. CAH to DGR Northend Grove, Northend, Fulham, S.W.
(Fragment) [?9 July 1873]
and you can always paint something for him. Let us get in as much coin as
possible I have a dream of getting you "well off" if I can and you will aid me.
 Sorry you have been worried about the Graham picture rest a bit and it will
come all right.
 The abandoned picture on which Leyland advanced you the £250 must have been
the "Palmifera."
 Must catch post.
 Best love.
 Ever affectionately,
 C.A. Howell
 Over
Results of Siren.
 Graham who had not been here for a long time, has dropped in twice since its
arrival, asking if "any little thing has come from Rossetti, any thing light or
small, or that would do for a Boudoir--"!!

265. DGR to CAH Kelmscott
 9 July 1873
My dear Howell,
Yesterday I wrote you a fidgetty letter which please pardon. I see now that your
letters of the 7th are somehow a day late in delivery.
 I have not yet got Graham's cheque. When I do, you must tell me whether you
would like me to do my duty (and pleasure) in your regard by coin or by higher
rate in drawings or paintings. All your moves have been just the right ones, and
I certainly shall not starve on painting for Graham at this rate of payment.
 About Leyland, your proceedings and views are quite correct. The best would be
certainly that I should paint him a picture, putting as much of its price as
possible to liquidation of the debt. I must see what I can do, but don't see any
prospect of keeping Miss Wilding at present later than about middle of this
month, as I trust Janey and kids are coming after that.
 About the Proserpine here, I don't think I feel much inclined for the bargain
Leyland proposes. I don't care to take back pictures--to wit, Lucrezia--in any
case; nor do I think it would probably be wise to rescind the commission for
La Pia which is a "painful" subject and might not easily find another purchaser.
Still I might possibly do this if he would drop the question of taking back
Lucrezia and add the value he places on that to the cash paid on Proserpine or
else to the debt discharge, which is my very best picture and not to be parted
with in a makeshift way. However don't mention my views to him till we have
corresponded again on the point. It needs consideration. I am now promised the
frame of Proserpine in a week from now, and the picture would then be finished
with a day or two's work.
 Have you offered Parsons the snowdrop head?[1] I will soon send you the Blessed
Damozel head, and am not sure but that he ought to have it, poor fellow, as for
his £200, as he does not seem to prosper as yet on the big Proserpine.
 I have got the nicest of letters from old Sandys, and am delighted to hear the
"little girl" is better at last. I suppose she is safe now.
 How do people like the Siren drawing?
 I have been very unlucky for 3 days past with my picture, and have daily taken
out my work on the drapery. However the picture is quite safe--head and hands
finished.[2]
 Today we are going out for an excursion of the river in 2 boats, and I hope to
freshen myself up. I trust certainly to make at any rate a drawing from Miss W.
for Leyland's Roman picture--the widow subject[3]--before she leaves, even if, as
I fear, I have not time to begin the picture itself.
 It is provoking--very provoking--to miss your visit and Kitty's after all, but
I suppose it cannot be helped. Thanks about the bit of Greek Carving, which will
be precious to me, and for which I will send sketch. Thanks also for the
sacrifice of your own garden seat which will be a great gain here.
 Ever your affectionate
 D.G.R.

Brown sends love. My mummy and sister ditto to you and Kitty.

P.S. You ask me for details as to advances made by Leyland. £500 was an advance on the proposed large picture of Dante and ladies in a boat,[4] but is now to go to any other work substituted for that;--viz: these musical subjects. The rest (£550 as he says) was an advance long ago on La Pia and something else (I can't remember what) which came jointly I think to 1400 guineas. This something else being I suppose abandoned, the 550 seems to stand to La Pia at present.

[Written on the side of p. 4:] Frankly, if I took back Lucrezia, you don't think I would sell it very readily, do you?

[1]See n. 6, Letter 261.
[2]A reference to La Ghirlandata.
[3]Surtees 236, also called Dîs Manibus.
[4]This would seem to be The Boat of Love, an unfinished work which Mrs. Surtees (239) says was first proposed to Leyland and later commissioned by Graham "but abandoned owing to a disagreement about terms."

266. DGR to KH Kelmscott, Lechlade
 10 July 1873

My dear Kitty,
 I wrote Charley yesterday, so he knows his letters reached me all right now. It has been a great disappointment to us all here to miss your and his proposed visit, but I will hope it is only deferred till some other moment, only should have enjoyed it greatly during my mother and Christina's stay here. Both have been in the best spirits and health all along,--Christina quite wonderfully benefited and improved. They propose returning to London on Wednesday next.
 I have been delighted for some time past to hear of the apparently permanent re-establishment of your health. I suppose you never were so well before since I have known you. My mother and Christina send kindest love, and so do the Browns.
 Will you tell Charley that, as I have not yet received Graham's cheque, I am writing him just a line today to say that I have heard the bargain is effected with him for the picture.[1] This may give him a jog if he has not yet written to Glasgow. I think with Charley's help I shall drive a flourishing trade from this nook of the world without the insufferable bore of writing myself to people offering them pictures I cannot show them.
 With love to Charley and yourself.
 I am ever your affectionate
 D. Gabriel R.

[1]La Ghirlandata.

267. DGR to CAH [Kelmscott]
 11 July 1873

My dear Howell,
Graham's cheque £840 to hand.[1]
 Let me hear from you as soon as may be.
 I have made a capital chalk drawing for Leyland's picture of The Roman Widow which I shall call Dîs Manibus--being the inscription (D.M.) to the divine Manes with which the tablets on the sepulchral urns always commence.
 The hymn the lady is singing is of course also addressed Dîs Manibus, so the title fits as well.
 About the Proserpine, I believe I have now made up my mind to let Leyland have it if he likes for £840--i.e. 400 guineas cash down, and 400 guineas remission of debt.
 With the Lucrezia I will have nothing to do.
 Ever yours,
 D.G. Rossetti

[1]See n. 1, preceding letter.

268. DGR to CAH [Kelmscott]
 Sunday, [13 July 1873]
My dear Howell,
Enclosed is a mysterious communication from Rae. What can the picture be doing?[1]
Will you look up the railway people about it. I am sorry to give you so much
trouble. Will you write Rae a line.
 Would you also kindly call at once on receipt of this on an Italian model who
lives close by you--Colorossi--8 Lown Terrace (as he writes it,--I suppose
Lawn, or perhaps Lower) Northend. He has to send me some Italian Chemises of
the embroidered peasant kind, and I dare say would benefit by your aid in sending
them off, though I have sent him full directions. If you see them, please notice
whether they are all right--i.e. in good condition and not with crochet work
substituted at the neck for the original embroidery.
 Is there any jewellery wandering about which would be nice to get?
 I hope to hear from you immediately in answer to my last letters.
 Ever your
 D.G.R.

[1]The Beloved (Surtees 182), which CAH had borrowed for DGR to retouch. On 7
July CAH was expecting Foord & Dickinson to call for it at his house to ship
to Rae. On 16 July (following letter) DGR has heard that Rae now has it.

269. DGR to CAH Kelmscott, Lechlade
 16 July 1873
My dear Howell,
Enclosed is the £50. Of course it is yours simply, and a real good drawing
besides, as commission on the Ghirlandata bargain, if that will suit you; and
little enough too. I will find your drawing ere long, or you shall choose one.
But tell me frankly if this seems to you fair and sufficient; as I really don't
want to be shabby because you are my friend.
 Sofa, card-table, &c. you must let me know the price of, and I will send it
forthwith. The sofa should be with thoroughly padded back sides &c--indeed
those that show no wood work are best I think. The squab should be about 30
inches wide and the whole sofa 70 long, but a little less might do if you
found a nice one ready. The squab must be a removable one. So far my ideas,
but you are best judge. Of course it must have good cushions.
 Rae has got his picture as I hear.
 I will look out a sketch for the fragment.[1]
 I should much like the green service sent down here I think, as it would
serve me, especially the hot water plates, and I would ask you to get me
another when you can for London use,--particularly some hot water plates for
this second purpose also. But can such things be safely sent here? I will either
settle by money or sketch as you like.[2]
 You say--"Send word at once from what station I can send the things from here
in the cheapest and best way." I suppose Paddington is the only starting-point
for Lechlade.
 I shall be very glad indeed of the silver chain &c for George, and much
obliged for your kind trouble with it. The poor fellow has been suffering much
more than was anticipated with the operation for that tumour in his cheek, and
is still at Oxford. He will return here however on Monday.
 My mother and sister returned today to London after a stay which has been
very pleasurable to us all and most beneficial--wonderfully so--to Christina.
Miss Wilding is also gone today, much improved.
 Janey and kids are to be here definitively on Friday.
 I should like to have a dozen at least of the silver bangles. By the bye,
the Italian chemises have come, so perhaps I may have troubled you on that
point unnecessarily.
 Of course I shall be very glad to see you when ever necessary on business,
to say nothing of the wake-up which your company gives one. Just at present
however you will judge that I shall be glad to be alone awhile with the new
comers.
 My present views about the Proserpine are these. I would part with it to
Leyland for 400 guineas down and 400 guineas remission of debt, and would then
(if he is fool enough to wish it) consider the bargain for La Pia as cancelled.

But I am not <u>eager</u> to sell the <u>Proserpine</u> in this way in the least, as it is sure market value and my best work; only if it would put Leyland in a good temper to get 400 guineas of the debt paid off this way, I will do it; especially as I cannot now be asking him down to see things (not being alone), till some 3 months hence at earliest. Nor can I at present be going on with the <u>Roman Widow</u> picture. The <u>Ghirlandata</u> (which he might have had if he had pleased) is <u>now paid</u> for and must be finished first. I shall be making however a pen and ink drawing of the <u>Roman Widow</u> immediately, which I can send you if you judge wise to show it. Of course you will tell him just as much of all this as you think best, and give me your further advice in the matter.

There is no hurry whatever about the <u>Siren</u> selling and you are quite right that it is wise for things to be kept by you to show. If I can, I may probably send you some of my own drawings from here, as the little drawing room where they hang will probably be dismantled. Today I am moving into the tapestry room again as a studio; and I don't think we have furniture for the little drawing room as well as the large one, my former studio when you were here.

The frame for the new <u>Proserpine</u> has just come from F. & D. and also the 2 charming little frames for the pen and ink sketches.

I rejoiced to hear from Dunn that poor Clive was well enough to dine at your house, but it seems nevertheless that she was taken ill during dinner.[3] Love to Kitty.

<div align="right">Your affectionate
D.G.R.</div>

P.S. I forget whether I told you that I had a most affectionate letter from Sandys in reply to mine. I hope it will not be long before I see him somehow. Were I remaining any time before the new inmates arrive, I should have tried to get him and her down for a visit. I am vexed it is not practicable just now.

[1]The Greek carving of Letters 265 and 270.
[2]See Letter 270 and Letter 382.
[3]In a letter of 20 July to George Hake, DGR says that Miss Clive became so ill that "it has been impossible to remove her from [CAH's] house" and that "two doctors [are] having to visit her daily" (D-W, p. 1201).

270. DGR to CAH [Kelmscott]
 20 July 1873

My dear Howell,
How sad about poor Sandys and Mary! I am writing to him with this.[1]

George is delayed a few days longer with a fag-end of his operation not anticipated. He seems to have suffered a good deal. If you can write him an amusing letter to cheer him, his address is 53 St. John's Street, Oxford. He will not be able now to be here for several days.

I have got completely settled in my new studio now, and the 7 drawings from the little room below now look so much finer than they ever did before, with the dim tone of the tapestry behind them, 5 in row on one wall, and the 2 others turning the corners, that I don't know I can persuade myself to part with them. Nevertheless I believe it would be advantageous for some of them to be on view with you.

About the "per centage" question in our dealings, had I offered terms they would have been the same you made with Watts, so you see I must view the £50 in this case as very moderate commission.[2] Indeed, were you to be adding buyers of your own to my list, you would have to tell me your terms which would only be fair to yourself. At present, Graham only being in question, who belonged to me already, the case is somewhat different. Nevertheless you have been of great service to me on this occasion, as I have a repugnance to writing about pictures I cannot show people, and should almost certainly not have written to Graham at all on the point.

Thanks about the table. I shall be particularly glad of the garden-seat as soon as it can come. About the sofa, your idea seems a capital one, as I judge you mean the squab to draw out from <u>under</u> the back thus leaving a hollow at base of back;--not merely to draw out from <u>against</u> the back, so as to leave a little pit between squab and back unfit to lie on. I find the total <u>length</u> of the sofa should probably be (including arms) about 76 inches, not 70 as I said.

About the marble fragment. It is beautiful but perhaps hardly sufficient in extent to be of much service as a guide in the play of drapery. Moreover I find it necessary to lay it on its back in the window-seat, where its beauties are totally lost: as it belongs to the order of things which, if once set on end anywhere, will infallibly, at the devil's moment, reduce yourself to its own lopped condition by tumbling on you with its whole weight, or else smash half your works or possessions to atoms. Thus, being unable to do it justice, I think I will return it with your leave.

About the green service, I forgot how many hot-water plates you said it included. I think it might be wise to send a proportion,--say half-a-dozen--to Chelsea.[3]

About the bangles, all right.

I shall be immediately sending the head of Blessed Damozel to Dunn, that he may get F. & D.'s gilder to Chelsea and have the whole blank part gilded, which I find will be the best ground for working it up on. When it returns to me, I will finish it and send it you.

Now that Janey is here, I may probably give further revision to the Proserpine. The frame has come.

The Ghirlandata cannot of course be done in a day, though I hope to get on with it steadily and readily.

<div style="text-align:right">Ever yours,
D.G.R.</div>

Bravo about the Marquis of Westminster.[4]

Thanks to Graham.

[Line at top of p. 1:] About cover for the sofa, a couple of loose brown holland ones would do as well as anything, or perhaps something rather darker would answer better for cleanliness.

[1] DGR's letter to Sandys appears in D-W, p. 1200.
[2] On La Ghirlandata.
[3] See preceding letter.
[4] See Letter 273.

271. DGR to CAH [Kelmscott]
 Monday, [21 July 1873+]

My dear Howell,

I forgot to say, in reference to Graham's boudoir query, that I have finished a chalk drawing of a head of Miss W.--head only--which (if he doesn't object to chalk for his purpose) is as pretty and complete and likeable as anything of mine. Had I better send it you, or wait till I have others ready?

Again as to the sofa question--I forgot I believe to say emphatically that the cover should be removable and washable,--and not have a horrid hot surface of any kind. I suppose chintz or holland must be the thing, and two covers should be made, to use one while the other is washing.

<div style="text-align:right">Ever yours,
D.G.R.</div>

272. DGR to CAH Kelmscott, Lechlade
 22 July 1873

Dear Howell,

There seems no end to my bothering you about this blessed sofa. It never struck me before that there may be a difficulty in getting it through these narrow doors and staircases, while windows here are still more impracticable. I fancy the back and arms must be made in one piece to take off, as is a sofa I have here, which would not otherwise have been possible to move from room to room. I find the door of my bedroom (which is one door through which it would have to pass) is a little over 32 inches wide,--so the back being removed, I suppose it would then go through the doors.

Janey is yearning for the garden-seat in this sudden suffocation of hot weather. The hammock also could be a blessing. When come they?

<div style="text-align:right">Ever yours,
D.G.R.</div>

273. DGR to CAH [Kelmscott]
 24 July 1873
Dear Howell,
I dare say I shall be sending you the head of Miss Wilding today or tomorrow;
but you will have to stick it in a frame of some sort to show it, as it has
none. I mark the limits to cut it to, and then you can get F. & D. to make me
the permanent frame for it at leisure if necessary, unless you sell it bang off
to Graham or some one in the provisional frame. I generally have these heads
with plain grounds framed in a <u>white</u> mount and outside 3 reed mouldings--but if
you think gold more saleable, put that.
 I enclose £25. Shall be very glad of seats sofa &c., and of George's chain. He
is here for a few hours today but returning to Oxford,--not very brilliant, poor
fellow, a troublesome complication having turned up. His address at Oxford is
53 St. John's St. He asks me to ask you about his stockings.
 I hope Miss Clive goes on well.
 As for Graham's Marquis, it strikes me as an innocent <u>ruse</u> on his part to get
his <u>Ghirlandata</u> sooner. As soon as <u>can</u> be, he shall have <u>it</u>. It strikes me he
might send the Marquis the big picture "to amuse the mind" (as Kiomi[1] said when
asked why she stoned a raven to death). However perhaps that is not thought
good enough for him; and indeed (as Kiomi again said) "A toad wasn't made for a
side-pocket."
 The head can be sold for 50 guineas. I'll see to your Dante sketches, and have
a lot of others to work up too you know. The head I send was one of these.
 I send your letter about the railway, and hope you may prosper.
 Ever yours,
 D.G.R.

[1]Kiomi or Keomi, a pure-blooded gypsy girl who served as one of the models in
<u>The Beloved</u>. WMR says she became known to DGR through Sandys (<u>FL</u>, I.242); Mrs.
Surtees says that she was Sandys' mistress (182D).

274. DGR to CAH. (Postcard.) Friday, [25 July 1873]. Is sending chalk head.
Hammock has arrived, "voted fine fun by big and small." Wants George's chain as
soon as possible.

275. DGR to CAH [Kelmscott]
 Monday, [28 July 1873+]
My dear Howell,
I wish you were a more methodical correspondent. I suppose you have the £25
cheque and the chalk head safe, but you never say so.
 I am getting on with Graham's picture. How about Leyland? And what news of
Sandys?
 The hammock I find was not very weight-worthy, though fortunately we discovered
the bad state of some of its fastenings before any accident occurred. I suppose
there is not another in better condition to be had.
 Nothing else has come since the hammock.
 Ever yours,
 D.G.R.

276. DGR to CAH [Kelmscott]
 Thursday, [31 July 1873+]
Dear Howell,
The sofa came yesterday from Arthur, and is a great success. Who ever designed
such a lovely chintz? There is no little bit sent to fill up at the back when
pulled out (as you said there would be) but it seems not at all needed, so
probably the plan was altered. Two cushions only are sent, but they seem
sufficient.
 I shall be very glad to get the garden-seats and card-table. When are they
coming? Also the chain &c for George. The poor dear old fellow has been
suffering a good deal. He is just back here now, and getting all right again,
and I know he would be cheered by the gift in question.

No doubt old Sandys got my letter addressed to your care. I am delighted to hear he is at work again and Miss C. better. All will now go well. How about her engagement?

 Ever yours,
 D.G.R.

P.S. About the drawing and case--I have just such a grooved case here, and must have been several fools not to think of sending it. However, send yours too, as it will be of use. But I'm not sure whether the drawing sent is one of the present standard size which the case should be made to contain. That size is 30½ x 42 inches. Other near sizes could probably be fitted in somehow. For the half standard size I have spaces provided in my case here.--

277. DGR to CAH [Kelmscott]
 Friday, [1 August 1873+]
Dear Howell,
A garden seat has come, but not the one with the awning, and nothing else has yet arrived.[1] The seat sent is convenient and fits well in the place, but it is so profoundly hideous in colour (sort of purple and bronze) that, had I known, I would have got it painted green before being sent down.
 George is back. There is no particular news.
 Ever yours,
 D.G.R.

[1]On 5 Aug. DGR inquired whether card-table, china, garden-seat with awning, or "anything whatever" was coming (postcard to CAH).

278. CAH to DGR Northend Grove, Northend, Fulham, S.W.
 6 August 1873
My dear Gabriel,
Busy again and away, or I would have written before. Of course the garden seat is hideous, but I thought it better to send it at once, this one was made short for you, and as to colour they are painted by the hundred in a hot house, and they will only do them all alike. This coat of paint will wear a bit, you will have all the comfort of it during the hot weather and when Janey leaves you can get it painted green in half an hour. Glad you like the sofa. I designed it for comfort and not beauty. The chintz is mine and I am glad you like it. Everyone says that the Morris chintzs are pretty, but do not wash, and I thought I would design something which though far short of a Webb or another Webb would wash, and if you are pleased I am. I was also anxious to prove that things to be decent for every day use need not cost 20/- per inch, and this chintz is cheaper than any other chintz made for house use. I wonder the little bit has not gone for I designed it especially that you might convert the sofa into a bed for the children in case of need. I have not seen Arthur but let me know if you want the bit and it shall be sent. Two cushions is what I ordered and I think all that is needed.
 The other garden seat wanted something doing to the back and did not go for this reason it follows with the card table.
 The chain for George is giving me grey hair the damned fools will not get it right.
 Old Sandys got your letter and was much comforted with it, Clive is going on all right but he is in heavy bothers as to tin. The old story. I have not seen him for some days but am going to call tomorrow.
 The case I ordered is specially to carry drawings backwards and forwards by Rail and save them from all risk. I shall be glad to get Blessed Damozel as soon as done. Four or five people have wanted the white flower picture,[1] but kick at the price viz 200 guineas.
 I send by post some jewellery but there is nothing to be had.
Norman Pendant 5. 0. 0
 do Earrings 4. 0. 0
 do Silver Necklace 15.15. 0
Old English Cats Eye
 Brooch 5. 0. 0

```
Topaz & Pearl
   Brooch              5.10. 0
Norman Cross           4. 0. 0
Earrings to match      4. 0. 0
Old French Earrings
   Turquoise Hoops     3. 0. 0
   In haste
```

<div align="right">

Ever yours affectionately,
C.A. Howell

</div>

P.S. Tomorrow I send you an early Greek Flint Cameo of great beauty. It is
mounted in 22 carat Gold modern. But the Cameo belongs to the finest class of
early Greek Art and is worth double the money wanted viz. £52.10.0.
 This I send for you to look at as I do not expect you to spend such a lot of
tin, and I can sell it at once for almost any thing I like.

[1]Blanzifiore.

279. DGR to CAH [Kelmscott]
 6 August [1873]

My dear Howell,
I return an awe-inspiring cheque which (alas!) is none of mine. I can pretend
neither to so prodigious a payment nor to so flattering a patronymic. Has
Simeon Soloman perhaps changed his name for a more appropriate one, and secured
through you a large order for artistic facetiae?[1]
 Thanks for the pretty parcel, which has not yet been shown. You shall hear in
a day or two about it. I am anxious to see the cameo, though the price is beyond
me.
 About the chintz, you astonish me. Did you really make such a fine drawing
yourself? In that case there are few indeed to equal you for force and beauty
of execution in such things. I had almost settled in my mind that Sandys alone
could have done it so vigorously, remembering a Japanese card I once saw him
design.
 About the Blanzifiore head, have you offered it to Parsons for his £200
commission as I suggested? You know I wished you to tell him that I considered
it very preferable to the head he and you bought, but which is here still if he
prefers having that. However I am really anxious about Parsons and the Proserpine,
which I suppose is still unsold. How about it? I neither wish it to wander about
the market unsold nor do I wish Parsons to be a loser by it. Indeed I am
determined he shall not be if I can help it.
 By the bye, if this Blanzifiore will not fetch 200 guineas, my market must be
going to the dogs. Four or five years ago, I painted a head with not very much
more work in it which you may remember (called Beatrice) and which I sold to
Hamilton for 400 guineas.[2]

<div align="right">

Ever yours,
D.G.R.

</div>

P.S. Lately I wrote Graham about the Davis family, and hinted he might subscribe.
To my surprise I have heard nothing from him. I hope he is not ill.
P.P.P.S. Could you go to some special sweetstuff shop (there is a great one in
Oxford street near the Princess's Theatre) and send some down for the kids.
Those long [sketch] things full of sweets are often good.

[1]This is explained by DGR's letter of the same date to F.M. Brown (D-W,
pp. 1204-05). CAH had enclosed a check drawn by himself to one Signor Orazio
Buggioni in the sum of £972. The reference to Solomon, a pederast, is of course
a pun.
[2]It is unclear what this "head" is. Neither Brazillier, WMR, nor Surtees lists
a Hamilton as a purchaser of a Beatrice by DGR. WMR, however, refers to a
"Beatrice watercolour" of 1867, priced at £315 but does not name the buyer
(DGRDW, p. 57). In 1868 Graham's partner, a man named Hamilton, bought a water-
color copy of Venus Verticordia for £300 (RP, pp. 302-03), and it has generally
been assumed that he was acting for Graham. Perhaps he was not and may have
owned at least two of DGR's works.

280. DGR to CAH Kelmscott
 14 August 1873
My dear Howell,
I receive the enclosed from Parsons, and enclose to you also a draft of my
answer which goes by same post as this.
 The wonderful box of sweets has arrived and been duly appreciated. Also the
Indian bracelet which is charming, but very brittle I fear, as it seems already
coming asunder. I had better return it you for repair--had I not?--and when made
all right, would willingly buy it. The cameo you spoke of has never arrived. I
am anxiously expecting the card-table and the other garden seat both of which
would be of real service.
 As to the Proserpine matter, I wish you would write me without fail by return
any additional information you can give me in the matter or any suggestions you
can offer.
 Ever yours,
 D.G.R.

 Please return me P.'s letter and the draft of mine.
 I should be glad to see P. down here (with you if feasible to you) at any
convenient moment if desired by him; but it would be of no use if he finds my
work not disposable in his market,--no arrangement I could make would meet this
difficulty. Indeed I am not able to judge as yet what course I should be able
or inclined to adopt in any case. Give me your advice without reserve.
 Have you seen Leyland? Or Graham? When is the drawing of Miss W.[1] coming back
to me?

[1]See Letter 271.

281. DGR to CAH [Kelmscott]
 16 August [1873]
My dear Howell,
I send another note from Parsons and a rough draft of an answer which I have
not yet sent to him. What do you think of it before I do so? The picture of the
little girl with the flowers[1] might be substituted perhaps, as one which will
not take me long to finish and would thus cause me no great momentary loss. But
it must be remembered that it would probably sell readily elsewhere and thus
bring me money easily instead of merely bringing me back Parsons's Proserpine,
which, his bungling and all things considered, would be sure to lie on hand with
me. Thus this seems the moment to come to some understanding as to what benefit
I am to derive if I consent to such unusual compromises. The proper thing would
be to place you and me in communication with the capitalist[2] and have his word
pledged to some arrangement.
 I should like to come to some understanding with Leyland about the other
Proserpine.
 I send you back the jewellery, and (in a second packet) the Indian bracelet.
I see the box of the latter bears "Pickett, Working jeweller." Could you
persuade Pickett to work on this particular jewel till he renders it saleworthy,
which you will see at a glance it is not at present?
 I hope you will let me hear from you again at once.
 Ever yours,
 D.G.R.

 Janey does not think that the marble table would be of use in this garden.
I shall be glad to get the chalk head and will return it with others when your
case comes.
 The other chintz you send me is almost as beautiful as the first. Really there
is no reason you should not be as good an artist as any one else if it were
worth while to be a poor devil of that sort.
P.P.S. Janey wants to know the price of the blue chintz per yard and where it
can be got.
 I ought to have explained that, in the way the sofa is made, the supplementary
piece in question would evidently be unnecessary. The back is so well plumped
out that the seat draws forward without leaving a hollow.
P.P.P.S. We have come to the conclusion that the jewellery (though some is very
nice) does not include anything specially desirable. The Norman gold pendent &c

I should keep, but some time back bought a finer one. So I shall be returning them to you with thanks. We should be <u>very</u> glad of the card-table, garden seat and George's chain.

Should still like much to see nice jewellery, as little May has been sitting to me and I want to make her a nice present.

[1]<u>Marigolds</u> or <u>Bower Maiden</u> (Surtees 235).
[2]Parsons's unidentified backer.

282. CAH to DGR Northend Grove, Northend, Fulham
 18 August 1873
My dear Gabriel,
I am more than delighted at your liking my chintz than I can tell you, but as I said before what is the good of doing any thing? No one else likes any thing, and one might go on working till all is blue and starving for it, as long as Jackson & Graham and all the other felons their fellows exist. As to my being a "poor devil of an artist" I should like it above all things only I know I cannot be one. I could build houses, and paint them, and fill them with fine things, and design carpets and hangings for them, but I could not paint pictures or draw fine and beautiful <u>women</u> and if you cannot do the latter you cannot be an "artist" at all, but only a fair workman, such as hundreds we have had (all forgotten or unknown) since Queen Anne. Again and again what is the good of doing any thing? I am really sick of every thing, tired out and worn at 32 and every day brings me fresh reason to lament that my father did not limit his abilities to 13 instead of fourteen children leaving me out of the worlds roll, amusing roll which I would gladly kick, if it would only promise to kick me in turn <u>beyond it and for good</u>.[1]
About Leyland I have egged him on to your <u>Proserpine</u>, till he wanted to take the train and go and see it still he would not advance a sixpence from his first hint to me. At last I said "Very well I will write to Rossetti and propose what you wish," upon which he stopped me saying "No do not do that as I cannot make offers to Rossetti, the thing must come from him and if he makes any advance we will see what can be done."
 Now write to him in your <u>own way</u> as follows.
 My dear Leyland
 I have now completed what I consider to be one of my very finest works
 <u>Proserpine</u> (here give size and describe the picture) the sketch for which
 or first attempt you may have seen in Parsons' hands. It is quite finished
 and nothing would please me more than to have it in your hands together
 with what you have of mine. Etc etc etc.
 State that it is your intention to have 1000 guineas but that considering he has been waiting some time for work of yours etc etc you will let him have it for the same price as <u>Veronica</u> as follows 400 guineas down and 400 guineas off account. Say nothing about me, or <u>Lucretia</u>, or any thing else and let me know what he says.
 Do not mention <u>Pia</u> he wants that and wants <u>Proserpine</u> to hang on another wall facing <u>Demophoon</u>[2] by Ned [Jones].
 Now you know all about it play your cards.
 Your very sleepy affectionate
 C.A. Howell

[1]Excerpts from this paragraph appear in <u>PRT</u>, pp. 101-02.
[2]<u>Phyllis and Demophoön</u>, a water-color of 1870.

283. CAH to DGR[1] Northend Grove, Northend, Fulham, S.W.
 19 August 1873
My dear Gabriel,
Jewellery to hand, I will see to the bracelet for you at once. You do not enclose Parsons' note but only your answer which I return. The answer will do very well, but please add *"<u>It is a great pity you did not answer my first inquiries and tell me at the outset that the picture did not please you or seem to you promising, and that you should have also kept your thoughts</u> from Howell leading him to suppose, nay (from all you said to him) to rest perfectly sure that you were not only satisfied but quite pleased with the picture."

"*As well as <u>five or six</u> offered you by H. which have come into his hands from outsiders <u>and all</u> of which he assures me has since readily sold to good advantage, ~~and which he offered to take with you, not that he needed the help~~ ~~to secure them or felt in the least doubtful as to the success of their sale,~~ [sic] but because he thought it would be but right toward yourself and myself not to divide my market, but to work the same steadily together, for all important and unimportant work of mine."

"*Or his hands he (Howell) having had no less than sixty eight works of mine pictures and drawings (in six years) all of which he has sold readily."

Not a word about the picture of the little girl.

Say to Parsons, "As you seem to be backed by a gentleman of means and taste (quite unknown to Howell) who evidently directs all your business transactions, I shall be delighted in your interest to communicate with him on this or any other subject."

Let us see what answer he gives to this.

In great haste for post

<div align="right">Ever your affectionate
C.A.H.</div>

[1]The haste with which this letter was written no doubt accounts for the difficulty of fitting the asterisked passages into the letter.

284. DGR to CAH [Kelmscott]
 19 August [1873]

Dear Howell,

I have sent my letter to Parsons, adopting in part your suggestions, but have not offered to correspond with the "backer" as I don't wish to seem eager about him. If I <u>do</u> make such a substitution of pictures, there should really be some advantage to myself secured. I have suggested to Parsons that he should talk it over with you.

The garden seat has come, but to say truth, is so ragged as to its awning, that Janey thinks it will be no ornament to the garden and doubts whether to put it up. It would have been better I think to get them to make a new awning.

The little ruby locket is very pretty, but I don't know as yet whether I shall keep any of the things. All the things I have got through you have always been quite <u>specially</u> desirable, but I know it is not possible always to secure such. How soon do you actually start for the country, and where do you mean to go? As for taking that <u>Blanzifiore</u> head, I should not wish it to go unless in company with other things of mine, as I told you I do not think it quite a success, and don't want to be making unfavourable appearances from this distance. Better return it to me or to Chelsea if not readily saleable. I should like to be sending you the <u>Blessed Damozel</u> head but have been daily at work till now on Graham's picture.[1] On this account I wish to know when you <u>do</u> start, in case you liked to take the head with you and I could let you still have it in time.

<div align="right">Ever yours,
D.G.R.</div>

P.S. Since I wrote above, the garden seat has been put together. I fear it is not in a state in which any lady would view it with favour, and as it is only wanted here during the female regime, it seems unfit for its purpose. The awning is pretty nearly in rags, and the 4 eyes of the iron supports where they rest on the 2 central pegs are all 4 broken out so as to be in danger of slipping and causing accidents. This being thus, shall I send it back to you? A new one would be welcome.

When the bamboo stand is set right (which can be done at once as Janey is not going to call and see it) will the man merely leave it at Horrington House (which is in the main Turnham Green Road and has its name on the door posts) together with the lacquered fish-dish, and let <u>me</u> have his account.

I am writing to Leyland to tell him I am finishing his <u>Blessed Damozel</u> drawing.

[1]<u>La Ghirlandata</u>.

285. DGR to CAH Kelmscott
 21 August 1873
My dear Howell,
I send you a rather striking note from Parsons with draft of my answer <u>sent</u>
<u>today</u> as it would not do to show any hesitation in replying. What he means by
the last part of his letter I don't know. The fair thing, if I consent to an
exchange of pictures, would be that at least he bought something else I wished
to sell, or took a picture of a larger value from me, paying the difference.
However, it would not answer my purpose to let some other work again remain
unsold on his hands, and so get a report abroad that my market was gone. When I
am ready with some offer, you and I must make terms with him. My impression is
that one clause should certainly be the confiding of the new picture to <u>your</u>
hands for sale. Otherwise it will just hang on his d--d wall again.
 I wish you would tell me one thing without reserve. You have no impression--
have you?--that anything I said to P. or you before this commission could in the
least bear the interpretation that I engaged to reconsider the bargain in case
of non-success on his part with the picture. I have all his and your
correspondence, but lack time to rummage among the letters.
 Another thing is,--it will not do, if the <u>Proserpine</u> he has is to return to me--
that it should remain gibbeted on his wall as valueless. If he has made up his
mind that he cannot sell it, he should put it quite out of sight till it returns
to me on our arranging about another picture; and he should tell every one that
he has disposed of it. Would you make a point of seeing him and putting matters
as you best know how.
 Thanks for details about Leyland. I will write when ready to do so, but want
if possible to get Graham's picture off my hands first. It makes way rapidly to
an end, and I should like you to see it, for it is a success.
 Please let me know as exactly as may be <u>how long</u> you expect to be away from
London.[1]
 Ever yours,
 D.G.R.

 I cannot find P.'s former letter which you said I had not enclosed to you. Are
you sure you have not mislaid it?

[1]He was going to Broadstairs; see Letter 287.

286. DGR to CAH [Kelmscott]
 Monday, [25 August 1873+]
Dear Howell,
More Parsons, as you see. He is really amusing with his quaint ideas. I send you
my answer before forwarding it. Please let me have it again at once, with your
opinion and answer to enquiries in my last to you.
 Ever yours,
 D.G.R.

I am getting Graham's big picture sent to Chelsea for Dunn to reduce and begin
to lay it in as regards the background, but the figures will have to be painted
entirely by myself, as well as the colour throughout. Graham, in his last to me,
revives the subject of exchanging the large picture for the reduced replica.
Indeed I had better send you his letter. Please return all.

287. CAH to DGR Northend Grove, Northend, Fulham
 25 August 1873
My dear Gabriel,
Just back from Broadstairs or I would have written before. I got ill and required
sea air for two days.
 See enclosed from Graham and let me have it back. The <u>Globe</u> gives a lot of
swells' names expected at Graham's next month and it might do a world of good
if I could send him the picture in time for the feast.
 Parsons is either mad or has got leery. I went to him to know the meaning of
so much humbug <u>and told him what to do in order to sell the picture in a week,</u>
<u>viz to send it in my name to the Bradford sales</u>. It now is quite clear that he
wishes to sell the picture <u>himself</u> in order to gain credit with his backer. He

not only refused to adopt my suggestion, but said he did not care if he sold it or not, that I had better now mix myself up in the question as it now rested between you and himself, that he held me quite irresponsible for any loss in the matter, and that he would rather wait and see what you would do in the matter. I pumped him dry, and putting two and two together this is what I have made of it viz.

Backer.

"You would go in for Rossetti instead of buying Frith as I told you, very well, sell the picture and prove what you can do. Howell you say can sell any thing of Rossetti's, he may, but I am not going to find money and place you in Howell's hands for him to do as he pleases with my capital and buy pictures from his friend whether I like them or not etc etc."

Now please write to Parsons and say that you will come to terms with me on the subject as soon as you have any thing you can offer, that will lead to a just arrangement between all parties. Then when you send me Graham's picture, write again to Parsons saying you have sent me a certain picture to deliver and that on payment of 450 guineas and delivery of his Proserpine you will paint him another of the same kind.

I am sorry about the garden seat, but I told you it wanted a new awning. The rest is all right and if painted afresh is quite new. Perhaps it is not properly put up or has been broken by the way as the four eyes left here quite perfect, hundreds of ladies having sat under their peg without risk. However send it back by all means, only I cannot send you another as there is no such thing to be had they come from Antwerp and I am told the man is dead.

Send back the jewellery if you do not want it else I shall have to pay for the lot. Things are rarer every day, and only now and then something really desirable turns up. I shall not be off to the North for some time, besides I run up and down staying only a few hours. All right about Blanzifiore, I have kept it and be sure I never bring a thing out unless I see a fair chance.

Of course not. You never said any thing before this commission to lead either myself or Parsons to believe that you engaged to reconsider the bargain in case of non-success.

As to Parsons' letter the lost one, you certainly never did send it to me. It must be at Kelmscott or you have sent it to some one else.

Send me my whip in a little packet, I left it with you. I esteem it much, and miss it every day, get a little box made for it and I will pay the cost.

Send Damozel as soon as you can. How is cash? It must be getting low and I want to get some in for you. Tell me if you have paid either of those bills as I have not seen the man and have no notion as to the date. When paid and the Bank returns them let me have them cancelled that I may file them and number them in my bill book.

Excuse this letter, I am so tired that I can scarcely write.

Ever your affectionate
C.A. Howell

288. CAH to DGR
Northend Grove, Northend, Fulham
26 August 1873

My dear Gabriel,
Your letter to Parsons is a model of sense and justice. Nothing can be better. Of course accept at once Graham's offer of exchange.[1] I will get the coin for the large one and £1575 is not to be despised when money is so tight. Millais told me the other day that the secret of his rush at portraits is simply owing to the difficulty he has encountered for the last two years in selling pictures for the price of 3 and 4 years ago.

He has three important pictures painted in the last three years unsold, and has made up his mind to hang them up and leave them to his children.

I wrote last night late. No doubt you will get it with this.

Ever your affectionate
Charles A. Howell

P.S. You will remember that four years ago at Chelsea I said "let Gambart go out of business, and Agnew get rich enough to care less for business and the very high prices will fall." You did not agree, but facts are proving it. There is a reaction for men of the last generation, for every thing old English and for old Masters. You have no idea of the number of flash pictures which some

years back would have sold at the private view in one hour and which this year were returned to the artists.

[1]Of the very large Dante's Dream for the smaller replica.

289. DGR to CAH [Kelmscott]
 28 August 1873
My dear Howell,
After what you tell me of your offer to Parsons to send the picture to Bradford with a certainty (as you assured him) of sale, his conduct becomes more seriously unfair towards me; as the substitution, if effected, can only be so at a cost of great trouble and loss to myself, and the Proserpine would return to me quite useless for I know not how long. Do you object to my quoting to Parsons (if I think well to do so) the passage from your letter in which you mention this offer of yours to him, and also the passage in which you assure me that no word of mine previous to the commission or later could possibly be interpreted as undertaking what he says I did? Please let me know by return if I can use your words to him.
 I will see to whip and jewellery. The little seal among the latter I will keep.
 As to the garden seat, the accident from what you tell me, must doubtless have occurred by some strain on the journey. There are some half dozen lengths of iron bar, in every one of which the eyeholes are broken through. [sketch] I suppose my only plan is to return the seat as it is; though with these bars mended and with a new awning (which cannot be got here) I should be very glad to take it.
 Will you pardon the constant trouble I am giving you, and let me refer again to
 I. Card-Table (very greatly wanted.)
 II. George's chain
III. Service of China
 IV. The endless matter of the note-paper. This is now some 9 months old. Really if they will not furnish it after all, they should let some one who will do so have the die and print it. It is a complete mystery.
 I have often meant to mention--do you ever come across costume draperies? These are invaluable to me, as a picture can be made on the strength of a good thing of the kind. Or properties such as the harp you got me, without which I should never have painted this Ghirlandata. Wareham used to have costumes often, but if you were to go to him don't say they are for me, as I found him a beast latterly.
 [Unsigned]

290. CAH to DGR Northend Grove, Northend, Fulham, S.W.
 28 August 1873
My dear Gabriel,
Yesterday I formally sold the Dante's Dream[1] to Valpy for £1575 and trust that such arrangements as I have made will meet your approval.
 For two most important reasons the sale of this picture for any thing like its value is next to an impossibility. First its size is far beyond even the best and largest of London houses, and next to that the fact of Graham turning it out is in itself most damning to its sale. Graham of course turns it out on the ground of size, but many would be only too glad to distort this fact, and run down the picture either in spite or for the purpose of reducing its price.
 When Graham first spoke to me of the chance of selling the picture and expressed doubt and fear as to its being a reliable investment, I at once (I thought it was the only thing to do) asserted that I could sell it in 24 hours, but God help me had he accepted, for at the time I certainly had no Valpy or any one else for it. Fearing it would come to a near push sooner or later, I set to and began to cultivate Valpy on the subject but chance nearly settled

the question for us, and I have had to fight for its sale to the risk of laming
myself considerably in the matter.

Some months since Valpy lost the savings of some years in a damned slate mine,
and for a time all chance of buying any thing went. In order to buy this picture
he is going to sell all his important water-colours. I am charged with their
sale and have agreed to do the whole work for nothing, next I bought from him
clean off yesterday a batch of rubbish (seven bad water-colours) for £130 and
for these I should be glad to take half the cost price. This I really had to do
to encourage him, and under the circumstances I think it would be fair to allow
me a commission of £200 on this sale. To make this commission fall on you is to
me really painful, but what can I do? Valpy takes the matter as one of friendship
(not business) between us three, and could not be asked for a commission and
though I am sure Graham would pay it if asked to do so, it would be very bad
policy, and injure your position with him now made quite solid and lasting by
the sale of this picture. Graham looks more to pence than you think, and the
ready sale of a picture which in his mind "would never sell at all during his or
your life" will render your market quite solid with him. It will open the way
to another large picture and no doubt make him spring £100 or £200 with all
confidence on £800 pictures. All this must be considered and depend on it I am
right. The proper course with Graham is to take the picture at once quite in a
light way, saying "of course, certainly, Howell can sell it at once," and not
a word about money. He must not know that I claim any thing or in any way have
to dodge the affair for such knowledge would be as fatal, as his having to pay
the £200. As to the price for the small one you must settle that with him, i.e.
if besides the large picture you wish him to give you any money.

I never thought about the damned frame which is a serious item. I have no
doubt that Valpy would pay for it but just now I must not mention it to him. If
things came to a push the matter could be met by Valpy paying the cost of the
smaller frame, or I telling Graham I forgot all about the frame and you must let
that go and count it as a very small commission.

I think it fine and plucky of poor old Vampire to go in for the picture, for
to him it is a far greater thing to do than it would be for any other buyer we
know to do ten times as much, and he deserves all credit, consideration and
kindness in the matter. Not knowing that you contemplated firing this thing off
in 3 months I gave Valpy 18 for the completion of the small copy and delivery
of the large picture to him, and we agreed that during this time we should go
on paying to your account, not stated sums but such sums as could be paid in,
making the same as large as possible, and advising you each time of such payments.

If you agree to the justice of my demand the course would be not to give me the
£200 in cash but to send me a receipt for it as though you had had it from me.
Thus.

<div style="text-align:center">Kelmscott Lechlade.
Date.</div>

> Received from Leonard Rowe Valpy Esq. (through Charles Augustus
> Howell Esq.) the sum of £200 on account of the sum of one thousand
> five hundred and seventy five pounds the same being the price to be
> paid me for my picture of Dante's Dream of B. D. etc etc.
>
> <div style="text-align:center">D.G. Rossetti.</div>

You should send me two copies of the receipt both stamped and on mine write
"Duplicate copy for C.A. Howell Esq.

<div style="text-align:center">D.G. Rossetti."</div>

With this purchase of drawings from Valpy I shall owe him about £200 and will
wind up my account with him handing him your receipt as cash. This he has agreed
to, I representing to him, not that you would give me a six-pence commission but
that our accounts were always so free and friendly that I could transfer my debt
to him to you, and settle it afterwards at my convenience with you. This was
another sop at which he clutched at once.

I hope Gabriel that you will consider I am fair in all this and not a grab,
for believe dear fellow that if I could do things better for you, my life would
be all the lighter and brighter.

Of course you can tell Parsons that you have heard of my offer to sell the
picture in Bradford, and to forgo any share of profit to myself in order to
please him and end a difficulty which should never have arisen between himself
and yourself. You can also assert that I am confident that you never engaged to
exchange pictures or any thing of the sort though you must word your letter so

as not to interfere with your note to him saying "you would never allow him to lose any thing by your work."

I am sick of Parsons, you have no notion what a fool, and what a bad business man he is, with an attempt at Irish sharpness which is all summed up in such real paltry meanness that I am really quite ashamed of it. The wonder is the man does not starve. If I had a backer of this or any other sort I would make a large fortune in ten years. Instead of which I have to scrape about like a cat for coin, and sometimes undertake such large payments and ventures that the wonder is that I keep sane at all. Of course they have smashed the seat by rail. It would be wiser to send it to Oxford and have all that is needed done to it. Send it to Mr. F. Margetts, Ecclesiastical Furniture Maker. He lives opposite the "Mitre." Mention my name to him and tell him to do what is needed. It would be better to send only the top rod for the awning (with the old one for size) and the broken bars the rest is all right.

I will see to all the other things at once. All right about the coin I will see to the £50.

Yes let us keep sales to ourselves. This sale to Valpy will do more good than any thing especially for small work, for it will be all over Lincoln's Inn Fields that a <u>cautious</u> brother lawyer has bought a large picture of yours for a large sum, and <u>sold</u> a lot of things to get it etc etc. The 18 months is better than the three, for we can nail the transaction as a sure one you can go on finishing work and knowing that the coin is sure and coming in.

I should have said also that in wanting the receipt for the £200 I look on it as a bond securing the transaction, for if Valpy came gouty again and died, I would make the Executors hold by the bargain or forfeit all monies paid.

Of course Wareham is a beast. I will look out for draperies but every thing is <u>so</u> dear, I am often frightened at the price as compared to that of olden days.

Write at once and let me know how we stand.

<div style="text-align:center">Your affectionate
C.A. Howell</div>

Of course I can break the arrangement with Valpy should you wish it. I have not bound you, I have only to the extent I tell you bound myself.[2]

[1]The original painting which was too large for Graham's house.
[2]In view of subsequent correspondence on this point there would seem to be some shiftiness on the part of CAH.

291. DGR to CAH [Kelmscott]
 29 August 1873
My dear Howell,

I believe the step you have taken in selling the large picture without delay to Valpy is on the whole the best step that could be taken at present, only it would perhaps have been better to wait till I had Graham's definitive consent to the picture becoming mine to sell <u>from this moment</u> and to there being no further question of its returning to him. At present, as you saw in his letter I sent you, he requests that it may be re-hung in his house before his return at end of October. I therefore write with this to him saying that I fully expect to have the replica ready in 18 months from this date, and asking him whether on that understanding, he will consider the large picture mine to dispose of from this moment, as I should have to get paid for it by instalments as the replica proceeded, and for that purpose must be its real owner.

I never dreamt of saying that the replica would be ready in 3 months or little more <u>from now</u>. You know my habits. I meant that I expected to work on it <u>myself</u> for about that amount of time, but my work on it would of course be carried on with other work and would therefore stretch over a much longer period; besides which there is Dunn's preparatory work to do before I get on it at all. Thus I trust certainly to have the large picture ready for delivery to Valpy (with Graham's consent) in 18 months from this; but if, by any chance, there were any degree of delay, we should have to give Valpy a sop in the way of a chalk drawing.

I consider the great use you have been to me in this matter to be fully worth a commission of £200, and shall be willing to draw up receipt you propose on getting Graham's answer to the letter I write him today. The commission is certainly at a higher rate than the one on the <u>Ghirlandata</u>, but I am not unmindfu

that you are probably sacrificing to this large transaction opportunities of making Valpy useful to yourself in smaller ways. I am very anxious that our interests should work together.

Pending Graham's reply, I will however ask one question, to be answered quite freely by you. Would you be willing to accept in lieu of £200 commission the Blanzifiore and Siren drawing now in your hands?

If not, at what time would you realize the £200? Is it to be now, from Valpy?

As to instalments on the picture from Valpy to myself, I had much rather these were only made when I asked for them; as tin coming in when not absolutely needed is liable to be spent in unexpected ways and so to be still lacking when the need comes. There is no fear but I shall be making calls on the fund in due time--soon enough probably,--but I would rather have dates of payment at my own option.

The large picture is now at Cheyne Walk, but there seems as yet to be a difficulty in hiring a big easel to mount it on. Perhaps Valpy had better not know it is there already, as he might be for making pilgrimages to it and interfering with Dunn's avocations. Whether I shall come to do my part to the replica in London or get the picture sent here, I am as yet uncertain.

I quite agree with you that Valpy's conduct is very spirited and fine. For a buyer of English water-colours to show this genuine enthusiasm for so opposite a class of art as mine is what I could never have expected to meet with; and his conduct personally to myself has always been of the friendly and considerate order which cannot but enlist one's affection. I am glad the large picture should be his rather than another's, seeing that my fast friend Graham has no facilities for showing it to advantage.

You may be quite certain no one will hear from me a word about commission to you on this or any other occasion. I have held my tongue entirely about the Ghirlandata.

The jewellery goes to you today, minus the little seal which I keep.

Ever yours,
D.G.R.

292. CAH to DGR Northend Grove, Northend, Fulham, S.W.
(Fragment) 31 August 1873
My dear Gabriel,

Most freely and only too grateful to have Siren and Blanzifiore, but is this not too much?

You do not seem quite to understand my letter as to the £200. In the first place you consider it a little too high, in the second you ask when I would realize the £200 from Valpy! First my little business with Valpy is worth about £250 a year to me as clear profit, besides this, at a push I can almost always run in and borrow up to £50 for an emergency. This will be quite done away with for 18 months in order that every farthing may go into the little fund to pay for your picture. This without counting on any cash I might wish to borrow, equals £375 out of my pocket during the 18 months. Any dealer or agent selling the picture for you would charge you ten per centum on the price sold which equals £157.10.0 i.e. £42.10.0 less than my £200. The dealer or agent, unless he likes you, or sees chances of making a lot of money with you, only gives the picture house room and does not care much whether he sells it or not for he is playing with your property, but this is not the case with me.

Next as to when I will realize the £200. I now owe Valpy a balance of £70, and in order to aid him to buy the picture I purchased of him the following rubbish.

A Water Col. sketch T. Taylor	16.
A Damned birds nest. W. Hunt	55.
Awful sketch pencil D. Roberts	6.
Three sheep by Jenkins	22.
A Boat by Andrews	20.
Another Boat by May	15.
	£134.

this with the £70 my old debt to him increases said debt to £204, which of course I have to pay in hard cash.

These damned drawings of his have been for sale in my hands for over three years, every thing has been tried, auction, green horns, picture dealers, exchanges for china etc etc and every thing failed, they will never fetch half the price I am giving for them but suppose they do fetch half which is £67 (I will gladly take that from any one tomorrow for the batch) my commission is reduced to this 67 and the £70 which equals £137/0/0 i.e. £20.10.0 less than any other dealer would get at 10 per cent. Besides this, in order to pay you, I have to work hard and sell almost all Valpy's water colours for which he pays me not a farthing!!

This will I think show you that the commission of £200 though heavy on you was really small for me. You may answer "this is not my fault my picture is worth double the money you have sold it for." Quite right, so it is, but I cannot sell it for more. Valpy went to Brunswick yesterday on business, when I got to the office I found him gone. He will be away a month, I can do as I please with him, and if you like, as soon as you have Graham's leave I will try and sell the picture for you from Chelsea for double, and if I fail plant it on Valpy as at first. If you like this course fear nothing from V. Leave things to me and I will do my best. Let me know.

Of course I would never realize the £200 from Valpy. Handing him your receipt for £200 as cash, I would simply pay him the old £70 and £130 on account of the damned water colours taken by me for £134.

Do you understand now? On the Ghirlandata I asked for nothing; when you kindly sent me £50 and promise of a drawing I was quite surprised, for really such a commission on a ready money business from an old buyer of your own is far larger than the £200 on the other complicated affair.

As to no one hearing of our private arrangements, I really would like to blow out "Rossetti pays me well for every thing I do" only people are such fools! Both Graham and Valpy if they thought you gave me £50 or £100 on any thing would want the thing for such sums less, thus it is the buyer who always makes the poor dealer a mean liar, expecting him to work for nothing, or believing that from the first he tells a lie, and that when he asks for £1000 he really only has to give £800.

The little Bracelet went yesterday. It will never

293. DGR to CAH [Kelmscott]
 2 September 1873
My dear Howell,
I never said your commission was high at £200, but the sum is a serious one to dock from the job's profits for myself, and so I offered the drawing and picture instead. For these, as you know, my price was £200 apiece. Thus, as you say you considered the commission on the Ghirlandata, as settled by myself, a liberal one, and as you view this in the same light, perhaps you will not think it unreasonable if I propose that both commissions should now be considered as settle instead of a drawing (over and above the £50 paid) being still due on the first. If you think of parting with the Siren drawing, I must ask you to get a photo: taken of it, as I shall doubtless need to paint a picture of it one day.

Thanks for the assurance that you will not fail to meet the £50 bill as it would be extremely inconvenient for me to do so, money being very short.

I repaired the chalk head in one minute, and might indeed (had I known the very slight nature of the injury) have asked you to do it in one minute, with the point of a bit of [illegible word]. Is it any use sending it back to you now, as Graham is away?

You must really ask Pickett (of the bracelet) not to persuade you of impossibilities. No bar could have been put inside, and the thing returns to me precisely as it left me, except that I think some solder (probably white) has been smeared a little over the edge, and the whole gilded (to an indifferent tint) to conceal it. I will give 30/- for it to paint from, but it would be no good for a present.

By all means let us sell the big picture if possible from Chelsea for an increased price; but I have not yet heard from Graham in answer. However I

suppose I shall do so at once and that it will be all right. So if we have a
month on our hands through Valpy's absence, let us try and turn it to account:
only do not let us let Valpy slip through our fingers; as he is a certainty. Of
course our interests go together, and if the price rises, so does your commission.
How about the Salts? or Baron Stern? You know the picture is really the
masterpiece of my life, such as it is. If you thought the date in the corner
(1871) against it as too old, you might rub a little Burnt Umber over it. I am
writing with this to Dunn to tidy the studio in case any one goes to see the
picture; and would be much obliged to you if on getting this you would go and
see that this has really been done (but of course without telling Dunn I named
it to you). Also see that the picture is in a proper light from the left side
of spectator, as I used to show it,--not gibbeted opposite the window as Dunn
has a mania for placing things. It should stand just beyond the large window,
with the small one having its shutters closed behind it; and should be at a
right angle or nearly so with the wall. Dunn had filled the studio with piles
of shabby rubbish when I was last there, which did not matter at the time; but
this should now all be cleared away and the room made to look as well as possible.
If there is anything--old pictures or drawings of my own--worth hanging on the
walls, they might be put there. If any one called now to see the picture, the
place should look as much like a studio and as little like a dusthole as
possible.

I will try and send the Blessed Damozel soon, but am pressed for time.
<div align="right">Ever yours,
D.G.R.</div>

Let me hear from you again at once.
How are Sandys and Clive? I should like you to take Sandys to see the picture,
only let it be in a good light, as I should not like him to see it at its worst.
I fancy Merritt should be got to varnish it now.

P.S. I may as well enclose overpage the descriptive passage and title of the
picture; in case you want to show it. The whole incident is of course in my
translation of the Vita Nuova (Early Italian poets) and the passage of verse
occurs in the piece beginning "A very pitiful lady very young" (page 269)
<div align="center">Dante's Dream</div>
on the day of the death of Beatrice: 9th June 1290.
Then Love said: "Now shall all things be made clear:
 Come and behold our lady where she lies."
 These 'wildering fantasies
Then carried me to see my lady dead.
 Even as I there was led,
Her ladies with a veil were covering her:
And with her was such very humbleness
That she appeared to say, "I am at peace."
<div align="right">Dante: Vita Nuova</div>
[Line at top of p. 1:] If any one goes to see the picture with you, the last
afternoon light is much the best for it.

294. DGR to CAH [Kelmscott]
 3 September [1873]
My dear Howell,
Graham writes me the enclosed which please return. The opening sentences seem
to warrant my considering the large picture as mine to deal with from this
moment. I write him again today taking that view, which no doubt is what he
means. If you read the rest of the letter, please observe that what he says to
me of buying the Blue Bower[1] is confidential.

He seems to forget that he paid guineas not pounds for the large picture, as
my bank book shows.

I am anxious to hear again from you in answer to mine of yesterday.
<div align="right">Ever yours,
D.G.R.</div>

P.S. Certainly I think you are quite right about making an effort to sell the
large picture for more money. Indeed if I could only afford to wait, the right
thing would be to resolve on not selling it till more money could be got. Some
one (but I can't remember who) certainly said some time ago that Sir W. Armstrong

wanted a _fine_ picture of mine. You know there was an article on this picture in the Athenaeum some time ago--if that would be of use to you. I believe the critic proposed to William to write a second, but of this I didn't avail myself. But it is likely I might shortly get another article written upon this and my last things, as the proposal came from Stephens[2] himself. Therefore any interval in the Valpy question should be seriously employed to consider whether one should part with the work at all at so low a price.

[1]See following letter and Letter 299.
[2]DGR's friend of early P.R.B. days; now art critic for the Athenaeum.

295. CAH to DGR The Rose Cottage Hotel, Richmond, Surrey
 5 September 1873

My dear Gabriel,

I have just got your two last letters, and am quite surprised about the Blue Bower, it was offered to me some days since, though no price is named, and yesterday I wrote Graham urging him to secure the picture. Knowing his way of asking about price and history, I said that Gambart had paid you but little for it, that he had received £500 from Agnew and that Agnew had sold it for a much larger sum. In fact I gave him all the information which without my knowing he asks of you. I must have a sort of name about your work for in all cases it seems they come to me. Mendel I am told is tumbled up; he has sold all his water colours, his plants, and seems to be about parting with his best oil pictures.

The changes of fortune with men that seem so solid only show how much they spend for show, and how short a time some of them seem to flourish. It was I who said that Sir W. Armstrong wanted an important picture of yours. Shaw[1] told me and I am now going to see what can be done in the matter. For Sir William [Armstrong] and Shaw I may have to use Marks as he is rather a god with both and in case of success would have to give him a sop. Let me know if this course would be unpleasant to you. I want the article from the Athenaeum, and by all means let Stephens write again. I also want a very careful letter from you placing the picture in my hands, naming price, and giving all details about it. Such a letter as I can show, and sell with the picture. London is quite deserted this season. Every one is away. The Ghirlandata drawing as commission I had cancelled the day you sent me the £50, so that every thing is settled as you wish quite to my satisfaction I having so much more than I ever expected or wished to have.

The Siren shall be photographed for you at once. Send me the repaired chalk head at once, and any other thing you may have, I want to try another bloke not Graham. Poor Pickett has never seen the bracelet, I gave it to another to repair. The bar is a steel spring between the hairs and the silver band under the little flower and no amount of wear will break it, however keep it to paint from, I will give it to you with great pleasure. I cannot sell it for 30/- having paid 50/- for it. Let Dunn paint out the date at once i.e. 1871--and write to him saying that you have handed the studio over to me that I may arrange it as I like. Poor Dunn is so sour, about every thing, and considers himself such an ill used Sir Joshua that every thing with him counts as an intrusion and I would rather you prepared him for my coming and shelving the lumber. As to light, function of picture etc etc I know all and remember all about it.

Sandys is worried as usual, and Clive goes on limping, and so fat that I cannot see how she can go on the stage next month. He shall see the picture and I will take Pinti to varnish it. He is better than Merritt and will tell us if it is in a state to varnish.

I find in my desk this letter from Parsons, which I send, it being better for you to keep all the correspondence in one batch. We shall then know where to look for things when needed and thus settle any question which may arise.

Just see this lady between the arms of the faithful Hardy,[2] and please hold your tongue on the subject, to Janey and George and every one else. She will make a splendid companion for the Ghirlandata and when you have the house quite clear I will bring her to you, and you can draw from her for three days, we can never spare any more time, nor can she manage to keep from home for any longer.[3] The portraits go by post registered. When you have seen them send them back to me.

 Care of Signor R. Pinti
 46 Berners Street
 Oxford Street
She has a lovely mouth and chin, and neck, and you can make any thing you like
from the rest of her face. Just now she is down here with me, needing rest and
cheering having lost a little baby, born six weeks ago, and which I intended to
present to you for it was so like the mother, that I wanted it well cared for.
Pardon my ways, but the Devil never does leave me alone.
 Ever your affectionate
 C.A. Howell

Tonight I shall be back at Northend for good.

[1]Norman Shaw, eminent architect and intimate friend of Marks.
[2]A photograph of CAH and the lady.
[3]It is impossible to conjecture on the basis of fact whether this is a
reference to Clara Vaughan, Rosa Corder, or some other extramarital connection
of Howell's. See Introduction.

296. DGR to CAH [Kelmscott]
 6 September 1873
My dear Howell,
No doubt you will think with me that the sale of the large picture requires
grave consideration from several points of view. It is my impression at present
that it would hardly be worth while to alienate it from Valpy except at a very
large extra profit, or on the certainty of securing a new buyer of a lasting
and important kind. You see Marks (if by chance Sir W. Armstrong bought it)
would no doubt ask a large commission, and I myself should insist on raising
yours. Thus extra profits to me would be considerably reduced; while a danger
would be run of offending the good and serviceable Valpy and losing his use for
the future. So take all considerations and act for the best. I hardly think
myself that a sale--for instance--for 2000 guineas would balance the inconvenience
with Valpy; unless there were a certainty of a new permanent and first-rate
buyer to throw into the balance. The extra 500£ would soon be made in other ways,
and Valpy be retained and done justice to.
 Marks ought of course to be willing to do his best in the matter, and eager
besides. Without me, Marks would never have been anything. I taught him all he
knows about pictures and brought him Huth, Leyland, yourself, Ned Jones and
Ellis, either directly or one through the other. Thus he ought to be bound to
my service in common gratitude. I have always been grateful to those who have
done half or a quarter as much for me, I know.
 I write with this to old Dunn about the date and your superintending matters
connected with the studio and picture. He is a dear old chap and a treasure in
his way, but he has got sour lately and no mistake.
 About the Blue Bower, of course you will not let Graham know that I showed you
his letter, though as it turns out the whole thing came from you. I told him
much the same as you did, but more vaguely; and said he might reasonably buy
the picture at my present scale of price, considering that I would immediately
remedy without further charge any points in which it is inferior to my present
work. I told him that after buying it he had better get it sent to me before
seeing it himself, and so see it first in the perfected form.
 I will try and write the letter about the large picture to you today, as you
request. If I fail to find time it must be for tomorrow. Stephens's notice of
the picture must have been in Athenaeum somewhere towards end of 1871 or
beginning of 1872. I write to William with this asking him to send it you if he
happens to have it. About getting Stephens to write again, there are one or two
points needing consideration, especially as I should like him to notice another
thing or two of mine at same time, and these would have to be at Chelsea. But
I will see what can be done.
 I heard from Sandys the other day and replied. I am grieved indeed to learn
of his fresh difficulties; but surely they might be kept at arms' length now.
What has brought them on his head again? I wish I could help him, but am hard
enough up myself. He did not of course ask me to do so. This reminds me--how
about the bill at bank? You do not name it, and today is the day.

As to Parsons I have not yet sent him that letter you saw, but shall probably do so forthwith.

About Leyland. If I write him respecting <u>Proserpine</u> the 2nd,[1] I suppose I can let him know that I heard from you of his entertaining thoughts of it. I should account for delay in writing by the fact that I did not choose to bring this picture into the market at all till Parsons had disposed of his which is now done. I should not raise the question of some details in his offer, but merely offer him the picture for 400 guineas down and 400 off the debt.

<div align="right">Ever yours,
D.G.R.</div>

[1]<u>Proserpine V</u> in the Surtees numbering.

297. DGR to CAH [Kelmscott]
 11 September 1873

My dear Howell,

I do wish you would be a more regular correspondent. Here have I been expecting a letter for days--and no word! Was that £50 paid into my bankers?[1] Whatever the answer, please let me know <u>without fail by return</u>, as the presence or absence of such a sum there would affect my power of drawing cheques at present. Now do not fail to let me know at once.

The drawing (head) has I suppose reached you by this.

Is there any news about the large picture? I wrote to Dunn as you desired and I believe you have heard from him. By the bye, I may as well mention that of course, if Armstrong or any one else wanted to bring or send any artist or other friend to advise him as to buying the picture, that is a course to which I should altogether object. If any difficulty of this or other kind occurred in a fresh attempt at sale, we would just stick to Valpy for good. Were I at my studio, no one could of course be brought or sent but by my invitation, and precisely the same must be the case now.

William tells me he sent you that <u>Athenaeum</u>.

<div align="right">Ever yours,
D.G.R.</div>

P.S. We are going to have a cook who has been to Brazil and talks Portuguese!

[1]Mentioned by DGR in Letters 293 and 296; mentioned also in a two-sentence note (not printed) of 5 September.

298. DGR to CAH [Kelmscott]
 Monday, [15 September 1873+]

My dear Howell,

Thanks for your telegram.[1] I am sorry to have troubled you about the bank business, but was obliged to be certain on the point. Today again no news from you, and I judge that nothing has yet been done about the large picture--about half of Valpy's stay in Germany being now I suppose over. Thus I almost fancy the best thing now will be to consider the picture as Valpy's, time being insufficient for other transactions and the certainty not a thing to lose. In that case I fancy Valpy should pay something down on the picture to secure the bargain, and some sort of deed be drawn up securing the picture to him on completion of the replica. It might be necessary to introduce a clause to the effect that in case my death meanwhile prevented the replica from being completed, the original would necessarily return to Graham, and my estate be chargeable with any advances already made by Valpy. Or would the proposal of such a clause as this alarm him? I don't mean to die particularly.

<div align="right">Ever yours,
D.G.R.</div>

[1]Concerning the £50 bill.

299. CAH to DGR The Washington Hotel, Liverpool
(Fragment) 20 September 1873
My dear Gabriel,
I am quite worn out with hard work and hard travelling but you have lost nothing
by it. All my men for the large picture viz. Baron Stern, Baron Grant, Dunlop,
Sir W. Armstrong and two or three others are out of town, and will not be back
for some days. I have asked Dunn to clear the studio first of all, as it is
full of rubbish this he is going to do, and about Wednesday when I shall be
back I will go and have a few hours work and make it as swell as I can.
 Here is Graham's letter. I can quite understand his being uneasy about Mendel
and not wishing to have any thing to do with the affair.[1] The fact is, it is
just on the cards whether Mendel is a ruined man or not, if he is Graham will
be a creditor to the tune of several thousand and for this reason wishes for
nothing in the shape of a friendly bargain. Mendel has already sold all his
water colours, and all his valuable plants taking down the green houses, and
now he must either get over it, or sell the remainder. The Blue Bower is offered
to me "(or any thing at Manley Hall)" by R. Wilson an Engineer, a gentleman
quite as rich as Graham, under whom I served in Portugal. I believe he is a
large creditor of Mendel's and his intimate friend. On no account is Graham or
any one else to know this. You ask me to tell you in confidence and I do so,
trusting entirely to you.
 About Ghirlandata, if not sent to London before Wednesday next you can send
it to Northend.[2]
 About the large picture be sure I shall make no blunder in any way, only do
write me the note and fix the price at 2500 guineas. If you get this on Sunday
(tomorrow) write it by return and send it here. I am just off to Chester but
will be back on Monday. Monday evening I leave for Bradford and Leeds and will
telegraph address. [The end of the letter is lost.]

[1]I.e. with treating for Mendel's Blue Bower; see Letters 294 and 295. CAH spells
the man's name indifferently Mendle and Mendel.
[2]CAH's address. By "London" he means the business office in Wigmore Street.

300. DGR to CAH [Kelmscott]
 23 September [1873]
Dear Howell,
As I have heard nothing as to your new address, but suppose from your letter
received yesterday (Monday) that you have now left Liverpool, I send this to
Kitty to post to you, enclosing 1st the note about the picture which you
wanted.[1] In this I have not stated, (but think it would be desirable that an
advance should be made by the purchaser to bind the contract) and he must of
course understand the exact circumstances, and above all the fact that he would
be called on to pay for the picture by instalments as the replica proceeded.
The names you mention as possible buyers include that of Dunlop. Now I'm sorry
to stand in the way of my own interests, but it is unavoidable here. That man
once behaved so badly to me that I could not possibly ask him to my studio were
I there, nor is it more possible when I am away. So his name must be struck off,
unless he chooses to buy the picture by report from you. Into my house he cannot
go. Nor Heugh neither, should he turn up in the affair. I had much rather lose
1000£ and stick to Valpy.
 Before hearing from you, I had written a letter to Leyland, but meant from
the first to submit it to you before sending it. Let me have it again, with
your opinion, as soon as may be. Surely Leyland gave only £120 or guineas--not
150--for that little Lucrezia. Ellis gave 70 at the sale--did he not?--and my
firm impression is that his profit was 50.
 Please let me hear again at once and return me the draft of letter to Leyland.
About the Ghirlandata, if Graham is impatient to get it in Scotland, I do not
know whether it can go to London at all. I should like you to see it, for it's
really a stunner.
 Ever yours,
 D.G.R.

[1]See following letter.

301. DGR to CAH[1] Kelmscott, Lechlade
 23 September 1873
My dear Howell,
I send you a description of my picture entitled <u>Dante's Dream</u>, my price for
which is 2500 guineas. I place it in your hands for sale, and you would, of
course, explain to any buyer the causes which would prevent its immediate
delivery. Some written agreement might probably be needed.
 [D.G. Rossetti]

D-W, p. 1219.

[1]Dr. Williamson says that this letter was found in the possession of Murray Marks—
how so, unexplained. The picture is of course the large <u>Dante's Dream</u>.

302. DGR to KH Kelmscott, Lechlade
 23 September [1873]
My dear Kitty,
I heard (yesterday) on Monday from Charley, who dated Saturday from Liverpool
and said he was leaving L'pool on Monday evening and would then telegraph new
address to me. I hear no more however and will ask you to post this enclosed to
him as I suppose you know where he is and it is rather pressing. I suppose he is
certainly no longer at L'pool, but if you know he is and are addressing it to
Leyland's office, please put it under another envelope, as I don't want L. to
see my handwriting. The address of Charley's letter from L'pool is Washington
Hotel.
 It would have been very nice indeed to see Charley and you here while the fine
weather lasted. There seems a last spurt just now, but I suppose it will prove
delusive.
 Affectionately yours,
 D.G. Rossetti

P.S. Charley talks of being back at Northend by Wednesday. But I suppose this is
unlikely. However you will know best.

303. DGR to CAH Kelmscott
 Saturday, [4 October 1873][1]
My dear Howell,
Your endless delays in answering compelled me to write to Leyland, and in doing
so I did mention your name as having told me he had heard about the <u>Proserpine</u>
from you.[2] I supposed there could be no objection to this, as you had yourself
told me to say "Howell tells me the <u>Lucrezia</u> is not important enough for your
collection" &c. I send you his answer received this morning, which please return.
 I mentioned also the <u>Lucrezia</u> matter,--offering to take it back for 120 guineas
(saying that I believed that was the price he gave, and asking him to correct me
if not,)--and for this to put 280 guineas to the debt and receive 400 guineas
cash--the price of the <u>Proserpine</u> being 800 guineas. Your idea of overpricing
the picture in order to cover the <u>Lucrezia</u> matter would not do I think, as at my
current prices it is not worth more than 800.
 I mentioned no picture except the <u>Proserpine</u>. You see he now asks me about
<u>Roman Widow</u>, and I shall write him much as in the draft you return me.
 Dunn has been here for a few days and returning to London I suppose on Monday.
You can get into the studio at Chelsea, the key having been left for you. The
<u>Ghirlandata</u> went to Scotland yesterday.[3]
 I may as well enclose a note from Parsons who as you will see consents to the
new picture being placed in your hands for sale. He has also packed the
<u>Proserpine</u>[4] and put it out of sight pending its return to me. As to the 200£ head
to which he refers, I shall insist of course on that transaction holding good
(though as I have told him, I am willing to substitute some other head for the
<u>Proserpine</u> head, as he could not sell the large picture of same subject,)--if
this clear bargain is repudiated, I shall not keep to the exchange arrangement.
 Will you tell me (<u>not in a month</u> but by return) whether you think you could
sell chalk drawings to the amount of the <u>Proserpine</u> as readily as a picture.
I suppose not.
 Ever yours,
 D.G.R.

[1]CAH has dated this letter "5 October 1873," but Saturday was 4 Oct. in 1873.
[2]Refers to Proserpine V.
[3]To Graham.
[4]Proserpine IV.

304. CAH to DGR Northend Grove, Northend, Fulham
 6 October 1873
My dear Gabriel,
You must not be put out when you find that I do not write by return, in this
case for instance I have had to go all through the black country on serious
business with hosts of letters following me and yours among them. I arrived at
home last Saturday late at night and this morning I get your letter. You are
quite right about Parsons this copy of his friends note will give you an idea
of the damned sort of thing I have had to put up with. Yes I can sell the chalk
drawings especially if you worked them all round say at the rate of 50 to 75
guineas. There are so many that will buy a "little" drawing and this would ease
you of a big picture would it not?
 All right about Leyland. Now describe the Roman Widow and I am sure he will
take it. I would have sprung the 120 guineas on Proserpine had I been you. I
must increase your prices and the way to do so is to let no chance slip, in
this case there being an exchange or something taken back there was all the
better ground for doing so.
 I found the whole of the North in a dreadful state owing to the New York panic.
No one will buy or look at a picture for the next few months, many have lost
much, and others are so frightened that they give one the impression of men
about to enter the Union. I shall be at your studio tomorrow and put every thing
in apple pie order.
 You rather cripple me respecting Dunlop and Heugh.[1] I was not going to offer
the large picture to either, but I think it unwise to close my door against them
for future transactions, i.e. in all cases where I can sell a work of yours as
my property. If it ever gets about that I exclude the men you dislike it will
have a bad effect and may deprive one of one or two men who might be brought to
buy through them. However I will always do as you please and be sure that I shall
always be one with you in all matters affecting your interests or your pleasure.
I shall see the Ghirlandata on Graham's return as he is sure to bring it back
with him.
 If you see your way to sending me Blessed Damozel soon do so, and I will see
if I can place it at once. Parsons be damned the thing is for me to make up his
capital and profit on chalk drawings and then have done with him, he is not
worth the bother he brings on one's shoulders. What are you taking up now? If
Leyland takes Proserpine you will deliver it at once and that will enable you to
turn to fresh work.
 Ever your affectionate
 C.A. Howell

[1]DGR had quarreled with both; see Letter 300.

305. DGR to CAH [Kelmscott]
 Wednesday, [8 October 1873+]
My dear Howell,
What I complain of in you as a correspondent is--not that you do not write long
letters by return, but--that you do not write the one necessary line which is
always sufficient for the moment. I also lead my life by correspondence, and
know perfectly that all necessities can be easily answered for the moment in
this way. The long letter can follow when possible.
 I sent Leyland that pen-and-ink sketch of Proserpine to look at, and described
the Roman Widow to him, but have not yet his reply. I strongly suspect he will
propose to visit me here. If he did so, could you come at the same time? I
should really find it indispensable to have a third person to keep the ball of
conversation moving; and you are best in the world at that. Now just let me
have one line on this point by return.
 Dunn has somewhat prolonged his stay, and will now I suppose leave here
tomorrow morning. No doubt you were able to get in at C. Walk if you went.

I get a letter from the wandering Scotchman Graham (who really might be the Jew,) to say that he is again (for the tenth time about) leaving his place in Scotland for some days, and will open the case containing my picture on his return. Thus it might have gone to London for awhile, which would have been useful. Scommettiamo (as my father used to say) that, as this is much the best picture I ever sent him, he takes a dislike to it when he sees it! However it is too bad to forsee disaster with that best of friends, whose raptures hitherto on all occasions have been only much beyond the mark.

I will try and send you Blessed Damozel when I can, but am fidgetted with things to set about. As for Parsons, I believe after all my shortest plan is to finish for him the picture of the little girl with the flowers.[1] But he must stand to his bargain about the £200 head,--not that it matters to me, but when I go so much beyond the mark of engagements as to make this substitution of pictures, he must really keep to a clear commission. If I sent chalk drawings, not less than a dozen would cover the mere money received, and these would take longer to do than finishing the picture. I am very hard up, and that bill for 120£ comes due before end of this month. However I dare say I shall have something coming in by then.

Of course, my dear boy, I should be only too glad if you could raise my prices; but, in my hole-and-corner style of existence, I think I am only too lucky if I can keep them up to their present mark, which I think it highly improbable can be for long.

Is Valpy back? Or when does he come? Are you not coming to the conclusion that we had better stick to that bird-in-the-hand, and that the bushes prove unpromising? Say the word, and I will write a line to Valpy myself to fix the bargain, which I think should be done in writing at the proper moment.

About Dunlop and Heugh, I cannot have them in my house, but any work which can be represented as your property at the moment can of course be sold to them if they will buy. I perceive clearly that their conduct at that now remote time must have depended on malicious reports made to them of my business habits; and they must now perceive clearly that the whole was a lie, from my long relations with Graham whom they know. The best for them would be to express regret for their misbehaviour, if they really care to have work of mine.

<div align="right">Ever yours,
D.G.R.</div>

[1] Surtees 235A is a colored chalk drawing of a little girl with marigolds dated "c.1874." I suppose this to be the picture in question.

306. CAH to DGR Northend Grove, Northend, Fulham
(Fragment) 9 October 1873
My dear Gabriel,
Here is the hasty line. What a fearful thing it is to be in Parsons position, I would give a fiver to know who the author of these notes is. This will show you how impossible it is to deal with any one elses money especially when that any one happens to be a fool.

I am as busy as possible just now but I will come like a shot and prop Leyland up. Telegraph to me and I am with you in ten hours.

No fear as to Graham not liking the picture he is all right. Of course blow Parsons here is his letter and yours to him.

Is yours finished? I have only received this sheet.

I am hard up also, and have a large payment to make after tomorrow, so there's a brick lend us your acceptance again for fifty on the same terms money to meet it to be paid into your account by me most faithfully in time to take said bill up.

About your £120 if you are pushed don't worry only send me another bill for £120 @ 3 months a week before this one is due and I will meet it for you and you will have 3 more months to breathe in.

Leave the large picture alone, I want to see if I can engrave it for you only I am at work on it and don't want to speak before my time in case of failure.

Dunlop and Heugh must behave sooner or later, only it must come from them and I will take care that it does. Of course I would not take either to your house.

Don't blame Parsons' backer in your letter. God knows who he is and let us do all in our power to avoid further enemies when we can do so by leaving them alone. I have paid dearer than any man living for holding my

[The letter breaks off here.]

307. DGR to CAH [Kelmscott]
 10 October 1873
My dear Howell,
I would accept your bill at once, but there seems to me a slip of the pen in it. It is addressed in the corner to yourself, as well as signed by yourself. Surely the address in the corner should be to me, should it not? If this is so, send me a second bill correctly worded and I will accept it and destroy the first. If the one I retain is correct, let me know and I will accept that.[1]

Excuse my remarking, however, that the time of its coming due is woundily near Xmas when all sorts of things come due, and that I hope it will not get forgotten.

I should be happy to "leave the large picture alone" (as you say), only it happens to be my sheet anchor at present. I do not hear again from Leyland yet, and strongly suspect he is sulky at the Ghirlandata having slipped through his fingers, and that he may slip through mine.

Nor do I suppose Graham will be game for another commission just yet, as I have 2 on hand for him already (to say nothing of the replica matter) both of which are wofully near being all paid up and will give me endless work to finish them nevertheless. Thus I am most anxious to know how we stand with Valpy. Is he still quite safe?--and had he not better be fixed at once, unless you see your way clearly in another direction?

As for engraving, I should really be obliged to you to explain. I do not doubt for a moment that all your steps are most friendly and judicious; but at this distance, and in a matter that is all-important to me at the moment, I am unavoidably anxious. Through whom would you expect to have a chance of engraving the picture,--and who would engrave it? Such a question as engraving is unfortunately, in the state of my purse, much less urgent than that of a new purchaser for the large picture.

As for "Old Clo" I fear there is nothing I need more than my old ones except new ones in place of them. However I'll look at my store, such as it is.[2]
 Ever yours,
 D.G.R.

If any "old clo" at Chelsea, Dunn could give them to you. But of course only old ones. Better not though, as it would probably raise a storm in a certain quarter.[3]
P.S. Just as I conclude this, I get enclosed from Parsons. This matter really gets too sickening, and the poor devil seems much to be pitied. I have written a draft of answer on spurt of the moment, and enclose this too. Will you let me have them by return, with your opinion. Or would it be better not to answer at all?

[1][Line on side of page:] Let me hear by return.
[2]Probably in answer to something in the missing part of CAH's preceding letter.
[3]I.e. Fanny.

308. DGR to CAH [Kelmscott]
 11 October 1873
My dear Howell,
I have received the enclosed from Leyland, which really seems very odd. Can you remember clearly what the price of La Pia was to be? My impression is certainly 900 guineas. At any rate his speaking of our engagements being for the Perseus[1] and La Pia at 2300 jointly is unaccountable. The Perseus at 1500 guineas was of course long ago abandoned for the large Dante subject at 2000 guineas, and thus according to my view the joint commission would be 2900 guineas. Of course about the Dante there is no doubt, nor about his having repeatedly said and written that he was willing (if I preferred it) to take smaller pictures instead to the same amount.

The _Ghirlandata_, as you know, he refused; not only by refusing advances, which was in itself sufficient when I needed them, but by saying distinctly that a picture with 3 heads in it would not suit him.

I am not answering him today, but shall probably tomorrow, and shall put my views clearly though in the most friendly way,--shall also remind him of his original scheme--quite positivly expressed--of having 7 pictures from me for the drawing rooms in addition to my 2 already there. Of course if this scheme is at an end, and past advances have to be paid off on a small remaining commission, I cannot stick to his work alone and live by it.

> Ever yours,
> D.G.R.

Let me know your views and return his note.

[Line on p. 1:] You see if he rates his aggregate commission at 2300 guineas-- and the _Proserpine_ and _Roman Widow_ are paid 800 guineas each, _La Pia_ would be rated at 700 guineas only whereas his own coupling of it with the _Perseus_ shows 800 guineas.

[1] _Aspecta Medusa_ (Surtees 183), never completed.

309. CAH to DGR

Northend Grove, Northend, Fulham
11 October 1873

My dear Gabriel,

What a fool I am, of course the bill is wrong. Here is the other and many thanks to you. Xmas makes no difference to me. My accounts run all the year round and no bill is ever forgotten. Yesterday I arranged for your £120 so that you need not pay it, or you can pay part, or you can owe all. Let me know when it comes due. All right about "Old Clo."

Would it suit you to be paid for the large picture the same sum of 1500 guineas in four quarterly instalments of £393.15.0 handing me over the copyright and going thirds in all profit coming from the engraving you being exempt from all risk or loss? The engraver to be selected by you, and the work as it progresses to be looked over by you. As yet I have not mixed you up in the affair but let me know your views on this subject. Valpy is still away and does not know any more about it than he did at first. Engraving this picture ought to ensure your market for the future, and as far as I am concerned I am ready to risk a good deal.

Of course Leyland is sulky, he is always sulky now, and I begin to suspect that he is not quite right in his head. No one would dream of it, but I am sure that I am right, and the thing is a species of madness like any other.

In haste for post

> Ever your affectionate
> Charles A. Howell

310. DGR to CAH

Kelmscott
12 October 1873

My dear Howell,

Here is your bill.

Mine for 120£ (in two bills--100 and 20) is due 23rd of this month, or with the 3 days, grace, 26th. I shall pay it if feasible then and see the last of it, but if awkward at the moment, am much obliged for your forethought. Will keep you informed.

As to the engraving scheme, if we are to go thirds apiece in profits, I don't see that it is necessary for me to transfer my copyright unless I am paid for it. But above all, who is the third person? Now please let us be quite plain about matters and then I shall know what I think of them. If the third person objects to my knowing who he is, I decline to deal with him. Moreover if, after all said and done, I am only to have 1500 guineas for the picture and nothing for the copyright, it would seem we are unkind to Valpy who might reasonably pretend to a priority. I quite agree with you as to the advisability of engraving if we thoroughly see our way to it. However you know in Spring of 1872 Gambart (not his successors) raised the question of engraving this picture by Blanchard[1] and was ready to do it, as he had formerly expressed himself desirous to engrave other things of mine. At that time my enquiries seemed to

result on all hands in a certainty that Cousins[2] was the only Englishman in the least capable of doing such a thing, and he, as I was told, had retired from the profession. There is Blanchard and I dare say other Frenchmen; but living out here it might be difficult for me to overlook an engraving sufficiently; and the engraving could not be made from the large picture which is unmanageable; moreover I shall be making some changes for the better in the replica.

Please let me have your answer on this subject at once, and also to my yesterday's letter.

<div style="text-align:center">Ever yours,
D.G.R.</div>

P.S. I remember Wallis the painter,[3] when he saw my picture, recommended me strongly to publish a really fine photo of it which he felt sure would sell to more advantage than any engraving. What do you think of this?

I'm not certain that the proper picture to engrave might not be La Ghirlandata. It is a manageable size, and the lines of it, deprived of colour, would be richer and less severe than in the large picture. It is my most perfect work as yet, and I am provoked it did not go to your house to be seen.

[1]Thomas-Marie-Auguste Blanchard (1801-98), possibly best known for his engraving of Frith's Derby Day.
[2]Samuel Cousins (1801-87), mezzotint engraver.
[3]Henry Wallis (1830-1916), whose best known picture was his Death of Chatterton.

311. CAH to DGR[1] Northend Grove, Northend, Fulham, S.W.
(Fragment) 13 October 1873
My dear Gabriel,
This is a downright royal black Leyland sulk, and it will take a long time to get him out of it.

I know the man so well that I can almost always quote his answer on any subject a fortnight before it comes.

Hold your own in this matter but do it so gently and in such a friendly way that he may never suspect that you need him if he once gets the notion that you require him and will not remain at his mercy the game is up, as far as he is concerned. In this letter he is half frightened, and I look on it more as a feeler than any thing else, give away to him in a good natured way half way this will please him, and you will master him better than you can do unless you follow this course.

Close with his offer for Proserpine and Roman Widow, and at any cost decrease his debt by the £700. If the two future advances of £364 for Proserpine, and £490 for Roman Widow do not carry you through the two pictures I will see if I can get you some tin at 5 or 6%.

Leyland most distinctly refused the Ghirlandata. I remember every word he said on the subject by my bedside--viz "Damn this stay at Kelmscott one cannot see his work, and I am not going to buy pictures without first seeing them, he has already a large advance in hand, and now wants to paint this picture with three heads! I would not take it at any price for what I distinctly want are pictures with one head each. Three heads would throw out all my plans at once."

My impression also is a distinct one as to 900 guineas for La Pia and this commission I would claim, saying you have always intended to make this one of your important works and counted on its being seen in his collection.

You are right in your calculation, if Leyland only wishes to spend £2415, and takes Proserpine and R. Widow for £1680, of course he rates Pia at £735. I should point out to him simply that according to arrangement on completion of Pia he will have to hand to you the balance viz £490 in discharge of all claims and demands this sum making up the £2520 as the price of the three pictures supposing the Pia to be 800 guineas but £595 is the real balance owing to you rating Pia @ 900 guineas.

As to changing the Perseus[2] commission for the Dante subject at this round sum of 2000 guineas. I distinctly remember it being present at the time, to say nothing of Leyland having often mentioned and talked the matter over with me since. The moment you let him have say two more pictures the affair will blow over and you will be able to manage him better.

I am sorry I could not answer this by return, but I have only just received
both your letters on my return from Surrey since last Sunday where I have been
house hunting having to leave this crib in about three weeks.[3] By the way if I
am very pushed could you lend me a room at the top of the house where I could
keep all my china and best pictures? I cannot find a house and do not know what
the devil to do. Many thanks for the bill and all right about yours.

Respecting the engraving I do not know who the third person is, i.e. I have
no proposal from any one. My idea is to borrow

[The letter breaks off here.]

[1]About half of this letter appears in D-W, pp. 1225-26.
[2]See n. 1, Letter 308.
[3]This is the first of two moves forced upon CAH by extension of railway lines.

312. DGR to CAH [Kelmscott]
 16 October 1873
My dear Howell,
I enclose you a copy[1] of my answer to Leyland, which goes to him today. Please
return copy, which I ought to keep. If he behaves very badly--i.e. if he sticks
to the absurdity of pretending that the Perseus at 1500 guineas and not the
Dante at 2000 guineas is in question--I have made up my mind. I shall send him
the Proserpine and Blessed Damozel head for 1050£ debt, and paint no more for
him. But one must not suppose it possible he will behave so badly. Of course
such a wind-up would be most inconvenient to me, but I could not put up with
such conduct.

Do whatever you like at Cheyne Walk. I should think your most convenient plan
would be to remove the present contents of the old china room--to left of street
door--into one of the top rooms--either one of the servants' rooms which cannot
both be wanted now, or else the little room beyond my old bath-closet, which is
not used,--and so stow your own things in the said old china-room. I speak
supposing that this room now only contains old strainers &c which I think is
the case. Do, as I say, precisely what you like if the house can be of any use
to you. Your turn-out must be a most awkward affair for you. I had no idea it
was so imminent.

Dear old Graham is in raptures with his picture[2]--and my best it certainly is,--
and hints at a companion. I had thought of one, and may probably send him a pen
and ink sketch.

Your views about the large picture are most enterprising and deserve my thanks;
but pardon my asking,--Could you, with the best will in the world, be quite
certain of paying the instalments regularly for the picture? I judge that the
paymaster would be Eyre: then he would I suppose be the owner of the picture,
even if I made over copyright to you. Is Eyre thoroughly solvent? Do not doubt
that I am most willing--nay anxious--to do anything that might offer some
prospect of your being ultimately the gainer. You would deserve to be by such
a speculation; and I quite see the advantage to myself of a fine engraving being
issued. However I must tell you sincerely that I believe my gain of position by
the engraving would be a much more decided fact than any money profit arising
from it to any one; and you must remember that all the established firms would
be down on the enterprize and do their best to discredit it. My own belief is
that the Ghirlandata might be the safer picture to start with; but you must
judge of this, and take opinions worth having. Thus then:--
 I.--Could you absolutely secure me the payment by 3-monthly instalments during
 18 months?
 II. Should I be quite certain to run no risk of responsibility as to expenses?
 III. Is Eyre distinctly the person you have to look to for money, and is he
 solvent?
 IV. Should we have a deed of agreement, securing to me a third of profits of
 engraving, and absolute control in choice of engraver and carrying out of
 engraving up to the moment of publication which could not be before I was
 quite satisfied with the work?
One more question. It strikes me as possible that some hitch has occurred with
Valpy, and that you are manfully trying to supply his place by another plan,
without giving me so anxious a piece of news. But if this by chance is so, will
you frankly tell me so at once,· which would be in reality the more friendly

course, as one ought to know one's ground; much as I should appreciate your
friendliness in endeavoring to withhold unpleasant news.

Ever your affectionate
D.G.R.

P.S. Was any move made towards Armstrong or any one else about sale of picture
at a higher price? Or is this plan given up?
P.S. It strikes me that the picture, if sold for engraving, ought really to
bring me 2000£. I suppose I should certainly have to obtain the loan of the
smaller replica to engrave from, as that would contain some changes which must
be adopted in the engraving.

[1]Inserted at this point: Can't get copy made today but will send it tomorrow.
[2]La Ghirlandata.

313. DGR to CAH [Kelmscott]
 21 October 1873
Dear Howell,
Here is Leyland's answer, much as I expected. Please return it with your views.
 If he really thought himself neglected, and, but for that, would still wish
to "cover his walls" with my work, it might be worth while to explain his
mistake to him. But what do you think?
 You see, my working for him was deferred for some time by the hanging on of
the completion of Graham's large picture which had to get done. Then I painted
him the Veronica and devoted some 6 weeks to the sketch of his large Dante which
however did not satisfy me and proved lost time. Then illness followed, during
which I worked for no one; and shortly after I settled here, I began offering
him pictures again; but he substantially declined the first--the Ghirlandata--
and so forced me to be working for others again. He has shown affection towards
me at times, and I would not like to do anything abrupt if his feelings are hurt
in any degree by supposed neglect.
 Now that he mentions about the proposed copy of Palmifera (engaged for at
same time with La Pia but afterwards given up) I believe he is right about the
price of La Pia, as I think I compromised the matter and lumped the 2 pictures.
 But why he should consider himself engaged only to the long-ago abandoned
Perseus and not to the much more recently abandoned Dante is of course
unaccountable except on grounds of parsimony.
 What do you think of the matter altogether and what is your advice?
Ever yours,
D.G.R.

Of course (as you will remember) I mentioned his plan of 7 pictures in my
letter only as a past plan to which I referred for explanation merely.
 I must have spent at least 2 months on bettering old pictures for him, without
charge, which ought to show him that I do my best.

314. DGR to CAH [Kelmscott]
 Tuesday, 28 October [1873+]
My dear Howell,
I know you must be awfully busy with your change of house, and am sorry to add
to your bothers with my affairs; but have been expecting to hear again since
your last. I have not yet written to Leyland.
 Ought I not to be renewing that acceptance for £100? I write as supposing
that it was not presented and paid at my bank yesterday. If this were done,
there might have been just the money to meet it and barely that; but if so I
ought to know, as then several cheques I have given would be returned as
overdrawn. But I suppose you have stopped the presentation of the bill and that
I shall get it immediately for re-acceptance.
 About Leyland. Should you be surprised to hear that I have actually repainted
the Proserpine a 3rd time on a 3rd canvas[1]--at least I have done all the laying
in, and the glazing &c will only take me some 10 days or so when the laying in
is dry in a week from this. My reason for doing so was, that I found the man
who lined the canvas of the Proserpine I was offering to Leyland[2] had managed to
leave some rucks or ridges in the face, which, though only showing in one light,
are very injurious. This annoyed me so that I have done the thing right out

again and 20 times better than ever. Thus Leyland ought to be delighted when he gets it (if I settle on sending it him) and the other <u>Proserpine</u>[2]--the one you saw here--remains with me for sale elsewhere. I shall probably offer it to Rae at a moderate price, which I can afford in this way, and thus the 2 together will bring me a good sum.

Do let me hear from you.

<div align="center">
Ever yours,

D.G.R.
</div>

By the bye I am awfully hard up for the moment. Is tin getatable any how?

I write with this to Rae to say he will get the picture through you from London in a few days, and that it has had to go there on account of the frame needing amendments.

[1]<u>Proserpine VI</u> (Surtees numbering).
[2]<u>Proserpine V</u> (Surtees numbering).

315. CAH to DGR[1] Northend Grove, Northend, Fulham, S.W.
 30 October 1873

My dear Gabriel,

I am just home from Esher weary with house-hunting and so seedy I can scarcely keep up.

The hundred pound bill was of course <u>not</u> presented. The £20 one was and paid. Here is new one for the £100 at three months. I could not get it done under £5 as Eyre who arranges all these things for me is stumped and could not lend the coin himself. It is done through him with a butcher who finds us coin when we need it. Please send the new bill accepted to H. Eyre Esq., 3, Lower Grosvenor Place W. with a cheque for £5 as the butcher would not add the interest to the bill. In writing to Eyre write "Dear Mr. Eyre"--not formal as he is the best fellow in the world, we do a good business together (old masters) and he can often be of the greatest service to you, having as he has the greatest respect for your Lordship.

Write direct to him as I have to run down to Liverpool tomorrow and will not return till Monday. When there I shall see Leyland's humour again and will write to you.

For the present--I have thought the matter well over--close with Leyland for the three pictures and work away at them: He really fancies himself neglected, and is so surly on such occasions that nothing in the world will make him come round, every word makes things worse, but if you leave him alone, and paint the three pictures, you can be sure of further work when that is done. At present he is quite in the wrong, and if you will make him <u>feel</u> it, by sending the 3 pictures as soon as you can, he is sure to come round. As to bettering his old pictures for nothing, Leyland is a man that never counts a kindness done to himself when he is grumpy except as a sop and his due, and the more one tries to soothe him, the more he frowns and sulks. Depend on it I know him better than you do. I have put up with things from him, that have nearly choked me, and carried it all as if I thought he had never meant it, and twice <u>he has</u> "come round" like a dog with his tail between his legs, doing me some kindness of his own accord, and seeming glad to blow the affair over. I had a fearful row with him about La Gargantini, he had not been open or straight-forward in the matter, and I cleared every thing to his face before her, asking him in the end if one single statement of mine was distorted or untrue to contradict it there and then, he had to cave in, look foolish and small, and for <u>three months</u> he never looked me straight in the face. He is not bold and so bad tempered that the only thing is to let his temper waste itself.

Here is proof just come,[2] return it corrected at once, and send it here as it will be forwarded to me. I am astonished at the new <u>Proserpine</u>! How the devil <u>can</u> you do it? If Rae fails let me know, but try him first.

I will see what coin I <u>can</u> get you. How much do you want?

In haste.

<div align="center">
Your affectionate

Charles A. Howell
</div>

Graham was here this morning delighted with his <u>Ghirlandata</u>.

[1]Part of this letter appears in D-W, p. 1226.
[2]?Of a description of the large <u>Dante's Dream</u>. See following letter.

316. DGR to CAH [Kelmscott]
 2 November 1873

Dear Howell,
What do you think of the letter [of][1] Parsons enclosed? I forget if you saw his
letter of the 7th which is the first of these I send. I certainly had never
answered it--hence his ire--but I think I have kept my temper wonderfully in my
reply now. The fact is I bore in mind your views about his backer. It looks to
me as if they were working towards a lawsuit, and of course I couldn't be
bothered with such rubbish as that. Let me have the letters again as soon as
you can. What I enclose of mine is a copy. I have sent the replica to him.
 I think all you say about Leyland is quite sound, and am putting it cordially
(I hope) to him. As he limits his commission now and curtails the full commission
I expected (as from <u>Dante</u> picture) I really cannot be resuming the <u>Lucrezia</u>.
This I must tell him. The <u>Proserpine</u> has cost me quite infinite trouble, and
it is absurd to expect that I can cut a further 120 guineas off besides what
goes towards the debt. On reflection I find I have done absolutely nothing
since Graham's big picture which has not first been offered to Leyland, so he
has no cause to complain of neglect. Parsons's <u>Proserpine</u> was the only exception,
and of this I offered him the improved version--Leyland has been affectionate
to me, and that is what I never forget, and I could not bear him really to think
me neglectful. The new <u>Proserpine</u>[2] goes on swimmingly and will be done now very
soon. I have worked at it with a will.
 I do want tin badly, but perhaps Leyland may be in time with the <u>Proserpine</u>
if all goes well.
 I send the bill to Eyre with this, and £5 cheque. Proof enclosed. ~~There seems
no hurry if you are not offering the picture to different people to whom
description might have been useful~~. I dare say I could promise delivery
of the picture in a year if whole price could be had down thereby.
 [Line on side:] Certainly it might be useful in various ways.
 But Valpy rankles a little in my bosom. I can't help thinking he might be
safest card. But I suppose you keep everything in your weather eye.
 I am frightfully curious about your new house. Can't you send me photos of the
plans, or run down and show them me? Perhaps said picture might be made a start
with on same occasion.
 Ever yours,
 D.G.R.

[1]A word has been over written with another and is really illegible. DGR's
letter to Parsons is printed in D-W, pp. 1228-29.
[2]<u>Proserpine VI</u>.

317. DGR to CAH. Kelmscott, 13 November 1873. Irritated at not hearing from CAH
[who was busy negotiating with the railway and house-hunting]. Wants to have
back "the 2 letters and copy of one of my own which my last to you enclosed."

318. CAH to DGR Northend Grove, Northend, Fulham, S.W.
 14 November 1873

My dear Gabriel,
I am just home from various quarters of the globe, and am fairly out of my mind
with this cursed Railway. They pay me £4,000, but I must be out at once and God
knows where we shall go to.
 You can write now as I am home for good, and will answer by return. This
affair of Parsons is <u>too</u> bl--dy.[1] Your letter is admirable only <u>I</u> could not
have kept my temper so.
 This is the kind of treatment I have met with from a few friends and gentlemen,
and will give you a kind of taste of the sweet manners and ways, to say nothing
of common honesty of the majority of br___gs.
 Oh damn them all, they would suck anything for six pence.

On arrival at Liverpool I had to rush off again and could not see Leyland so that I do not know the frame of mind that cuss is in. Let me know his answer to you.

As soon as I have moved any where (Kitty may perhaps take a house today at Clapham rent £250 until I build mine) I will come down and bring you plans, and the Lamb if you like only she is not looking so well, chest and back and things out of order, and Marshall seeing to it.

The plans for my house are my own, put to measure all by Jeckyll.[2] Such a crib.

I have fought these Railway devils until they had no legs to stand on, and Ry. just at my door. Last night they agreed on the £4000, and they give me the house besides, i.e. all the fire places doors windows, _every thing_ except the bricks which I do not want.

Not bad for a Portuguese, is it?

In haste,

<div style="text-align: right">Ever your affectionate
C.A. Howell</div>

[1]DGR had objected to the incivility of Parsons' letter and wrote to him, "For the future I can answer no letters which contain such phrases as 'You must' and 'I cannot allow'" (D-W, p. 1229).
[2]Tom Jeckyll, a well-known architect.

319. DGR to CAH

<div style="text-align: right">Kelmscott
16 November 1873</div>

My dear Howell,

You must indeed be head over heels in the railway muddle. However you have made a haul out of them, and I hope it will go some way towards raising your tower even to the skies.

Meanwhile, in my small way and having no railway to pay my way for me, I am getting anxious to come to some clear understanding about the large picture. Dunn is here, just arrived with his revised outlines for the reduction, and there is every opportunity of its advancing rapidly. Marks said to him (Dunn) something about the engraving. Is this scheme still the most promising and what has M. to do with it? Or has anything been heard of Armstrong? Or how stands Valpy? Is he back from Germany? I suppose so of course ere this. I am much wanting some supplies of tin. Where can it come from?

I really hardly think we can manage discussion of this picture question so well by letter as by talking it over. I wish you could come down,--then the drawing might be done into the bargain. How soon can you come? Bring your plans with you.

I have heard no more from Leyland since writing him ~~I think about a fortnight ago~~, as enclosed. I don't know if you can make out the 2nd sheet. I thought it necessary to decline _Lucrezia_ in accepting his view of the sum in commission between us; but I dare say he is out of sorts about this.

No more as yet from Parsons. I expect to be soon sending you the picture for him--little girl with flowers[1]--which you know he agreed should be placed in your hands for sale. But how are you to manage this if you have not a roof over your head?

Please write me on all points--particularly as regards the tin question which gets pressing.

<div style="text-align: right">Ever yours,
D.G.R.</div>

[1]See n. 1, Letter 305.

320. DGR to CAH

<div style="text-align: right">[Kelmscott]
22 November [1873+]</div>

Dear Howell,

Leyland has at last answered quite satisfactorily. I enclose his letter and copy of my reply which please return if (as I hope) you are still alive.

It has occurred to me to ask you to call on Morrill, the picture liner, 3 Duck Lane, Wardour Street. He came here to look at the _Proserpine_ which had suffered (as I told you) when he lined it; and he has taken it back with him

to re-line it and remedy the defect if possible. He is skilful and careful and I do not now believe the evil was owing to any fault of his. You are also skilful and careful, and as 2 heads are better than one, it has struck me that I should like you to look at the picture and consult with him as to ways and means. You should put it first with light from left (i.e. your left) when no damage would be apparent,--then with light from right, when you would at once see the ridgy lines disfiguring the face. Only you should go at once, as he took it away on Wednesday and promised to return it in a week.[1] I write with this to him that you may possibly call. The picture is so good now that, if it can be set right, I should prefer sending it to Leyland instead of waiting till the last one is finished. In fact I could not be quite sure of making the new one as good as the one Morrill has, which now quite satisfies me but for the accident.

<div style="text-align:center">Ever yours,
D.G.R.</div>

[1]Refers to Proserpine V.

321. DGR to CAH

Kelmscott
Sunday, 7 December [1873+]

My dear Howell,
You are become to me even as the Banshee or hereditary spectre in royal houses, which is seen now and then by a casual old woman on a back staircase, but never enters an official appearance. What is the matter? You are not dead, for Morrill of Duck Lane has seen you twice. Have I offended you in some unwitting way? You really should let me know something of matters which to me are of importance, and you also should return the letters I asked for. I write again this once, but if you are dumb still you must remain so; only don't forget that there is that bill for £50 to meet at my bank before end of this month.

<div style="text-align:center">Ever yours,
D.G.R.</div>

322. CAH to DGR

Northend Grove, Northend, Fulham, S.W.
7 December 1873

My dear Gabriel,
I am not ashamed of not having written, I am only truly sorry that I have not been able to do so. You have no idea what a dance I have had, and how ill and tired I am. For weeks I have not had a moment to eat or sleep, and am far from well with it. I must now be fairly out by the 11th and the work before me is something fearful!

Have a little patience with me in my need, and as soon as every thing is smooth count on me for every thing as of old.

I am going to a fine old place "Chaldon House" close to Putney Bridge until I build my tower, and there you will find me when you come up. Meanwhile write here, as I shall hang on as long as I can. Of course Leyland was sure to come round. Go on, paint him the four pictures as soon as you can and count on him for fresh orders.

Though I have not written I have been most anxious about Proserpine and have of course seen to it as I should. The poor chap has done it twice, and you cannot be too liberal to him, for I never saw him so anxious about any thing in my life. He has worked for me for years and I know him well as an honest workman. All that can be done has been done, and I think it will now pass any where especially with a glass or when it is varnished. Varnish will do away with all trace of the lines.

I told him to send it to you at once, and no doubt you have it by the time you get this scrawl.

The picture in itself is simply wonderful, and it would be folly not to send it to Leyland.

On Friday evening I was with Graham, and I cannot describe to you his state of delight about his new picture. He wants a companion for it, and told me you had promised to send him a sketch but that nothing had come! "I wish Howell you would spur him on, and see to this. Let it be a fair beautiful woman, as like Botticelli as possible, for this one is exactly like Botticelli, and if

Rossetti will <u>only</u> paint me pictures of this class I will buy <u>nothing else but his</u>, and any old master you can get me."

I took his damned Watts on the spot and paid him £315 for it. Yes Valpy is back and collecting cash for the <u>Dante</u>. Let <u>me</u> have an hour to breathe and <u>you</u> will be all right.

Don't be angry with silence. I am ill and worn out and the Dr. comes every morning and sets me up, and if I do not turn my toes up, I will sit on every one's head before they know where they are.

<div align="center">
Your loving

C.A. Howell
</div>

I have resigned School Board and every thing else, I could not hold on any longer.

323. DGR to CAH Kelmscott
 9 December 1873
My dear Howell,
I confess your letter remains mysterious to me.
 I asked you 2 distinct questions about the big picture: viz:--
 I. In relation to your former offer of 1500 guineas <u>down</u> on the understanding that I should promise delivery of the picture in a year's time,--I asked you whether, <u>supposing</u> I were inclined to close with this offer, you would be ready to meet it at any moment.
 II. I asked you what is Marks's connection with any project relating to the picture.
 <u>All</u> that you say regarding this picture in your letter is that "Valpy is back and collecting cash for the <u>Dante</u>."[1]
Now your subsequent projects would seem to show that no engagement of a positive kind exists with Valpy. The picture is worth much more than 1500 guineas <u>intrinsically</u>, and at one moment you seemed bent on our getting more, even after the Valpy question. I have myself had no correspondence with Valpy, and the course of your suggestions and proposals is all I have to go on. I now find both Graham and Leyland buying freely, and have no wish to precipitate the sale of this important work, unless fresh circumstances or a specially tempting proposal should alter my views.

About letter writing, really, my dear Howell, I shall begin to doubt my own convictions as to your business gifts if you are unable to keep "au courant" of what is <u>necessary</u> in correspondence, which is not much. Promptness in this respect is just the first quality of a man of business. During a good many years when I dealt with Gambart, he never failed to answer letters promptly, though no man could well be busier. The number of Graham's letters must be legion, yet no one is a surer correspondent than he.

Thanks about the picture lining business. It has not yet reached me, owing I suppose to its being sent by Goods Train instead of Passenger Train.

I owe Graham some 100 guineas for an old chalk drawing transaction never realized. I am offering him that profile head of Miss Wilding which is in your hands for 50 guineas. Perhaps he may call to see it or send for it.[2]

<div align="center">
Ever yours,

D.G.R.
</div>

[1]For DGR's suspicion that CAH and Marks had entered into a plot to buy the <u>Dante's Dream</u> for 1500 guineas and sell it to Sir W. Armstrong for a huge profit, see D-W, pp. 1238. The suspicion was groundless. All that was contemplated was an engraving of the picture.
[2]On 17 December DGR sent CAH a postcard asking him to send the drawing to Graham or ask Foord & Dickinson to fetch it and deliver it to Graham.

324. DGR to CAH 56 Euston Square
 [24 December 1873+]
Dear Howell,
Will you look in at Cheyne Walk on Friday[1] and can you stay to dinner?--Potluck you know, as things are in a scrambling state rather. If this letter does not bring you to life at last, I must begin to suppose in good earnest that you mean

to be buried henceforward as far as I am concerned. So I'll hope to see you.

Ever yours,
D.G.R.

P.S. No doubt you bear in mind the £50 bill payable at my bank on the 28th.

[1]The day after Christmas.

325. DGR to CAH

[Kelmscott]
Friday, [9 January 1874+][1]

Dear Howell,
Enclosed received from Mr. Cudby who I suppose got my £50 cheque though he does not say so. He sends the £54 bill which I will accept when I hear from you. It lacks your own signature as yet.

I confess I cannot see the use of keeping up this running fire of £50 acceptances. Surely if unceasing, the balance equalizes itself whether you have the bills or no.

I have not yet got the profile drawing.

I trust to settle the £100 bill at the end of this month when due. It has cost quite enough already.

Thanks for the jewellery. I note what you say, but have not yet settled about it. Will return cameo shortly.

Ever yours,
D.G.R.

P.S. Perhaps I had better enclose bill for your signature.

[1]CAH wrote 1873 instead of 1874.

326. CAH to DGR

Northend Grove, Northend, Fulham
10 January 1874[1]

My dear Gabriel,
Did you receive the descriptions? And are they nice.

I would have written about this bill, only I have been so distressed that I have been unable to see to any thing. Northend is half pulled down, coin as yet not stumped up, and Chaldon House not to be had till March 25th. My things half ruined and a perfect hell all over the place.

Cudby is my Dunn, and does everything for me, and the reason he said nothing about the £50 is that I told him I would answer.

I do not understand what you mean by the balance equalizing itself. The fact is this, coin comes in to me irregularly but I am always sure of £50 or a hundred in three months, indeed before I ever draw or accept a bill I always have the money to come for it. Sometimes I have other business bills, and it is often of great use to me to pay a batch of bills instead of coin. In this case I have to pay £188 next Monday, I have a bill of Pinti's for £100, I have £35 cash and it struck me that if you would oblige me with another acceptance for £50, I pay my £188 without discounting or paying heavy interest. And in due course the cash will be at your Bank to meet it.

When you do oblige me like this it is always for a fresh affair, and it is lending me your signature instead of cash, said signature being quite as good as money.

In haste

Ever your affectionate
C.A. Howell

I send you the bill signed.

[1]CAH again wrote 1873 for 1874.

327. CAH to DGR Northend Grove, Northend, Fulham
 26 January 1874
My dear Gabriel,
"Stop a moment!" As yet I have never failed to write by return <u>since</u> Xmas. And
here goes by return now only it is now 7.30 too late for this mornings post.
 I have <u>four chances</u> for a picture by you, and it all depends on one of my
four chances caring for this work. Graham or Leyland I will not approach on the
subject. All you have to say is the least for which I can sell the picture, and
then I will try and get the most I can. Call it the <u>Bower Maiden</u>.[1]
 I would come down and see it but just now it is quite out of the question.
Northend is half pulled down, and on Wednesday we leave it, for (address)
 Norris's Hotel, Elsham Road, Kensington, W. It is a swell private Hotel where
I have taken swell private rooms till the 25 of March when Chaldon House
becomes mine and will be ready to receive us. As to Parsons I should not consult
him, he has behaved so badly that when the picture is sold I should simply send
him his money and five per cent and claim the <u>Proserpine,</u> i.e. give an order
for it to be delivered to me.
 Meanwhile it would be right to offer the <u>Bower Maiden</u> to Leyland, only I
would ask him 700 guineas and make it quite a separate purchase apart from old
commissions.
 Brayshay arrived here yesterday, and is now parted from Heaton doing business
for himself, lately he has sold me some fine costly water colours and now asks
me if I can give him a chance with a fine Rossetti, now it strikes me that
between us two we might plant one of the <u>Proserpines</u>--the least good--either in
London or Bradford. What say you to the try? Think of it and let me have one
for the lowest possible price and I will see how I can work it. Also send
<u>Lucretia</u> I may get you the £120 for it.
 Brayshay wishes me to tell you that his wife has been dying, and he very ill,
or he would have thanked you ere this and sent the little drawing to which you
promised to do something.
 By registered post I send a little necklace price £3.10.0 and I shall be
glad to get the cameo back, either as a cameo or £100 which I can receive for
it the moment it arrives.
 All pictures etc etc send to Norris's Hotel.
 Ever your affectionate
 Charles A. Howell
P.S. I have now returned the Life of G. the great Spaniard[2] to Dunn.

[1]Also called <u>Marigolds</u> (Surtees 235); it was sold to Graham in Feb. for 650
guineas.
[2]?Goya.

328. DGR to CAH [Kelmscott]
 31 January 1874
Dear Howell,
I am sending a letter to Leyland <u>today</u> of which I enclose you a copy to keep
you <u>au courant</u>.[1] Please return it. I don't suppose he'll buy without seeing.
In that case Graham might perhaps, or else we'd try your men.
 If you saw Leyland and he asked you about this picture, say you saw it in
the Spring forward but not finished, if you like, and that it was a ripper.
 As to the Cameo I'll see about it forthwith. Should like to keep it, it is
so fine--but can't afford though the terms you proposed about the drawings
seemed well enough. Where is the profile of Miss Wilding? Is it not coming from
Bradford?
 Thanks for the necklace which is jolly. Of the other lot I only keep the
belt-buckle. Will return them, but have mislaid the address. Shall I send them
to you?
 I'll think about <u>Proserpine</u> and <u>Lucrezia</u>, but am writing in great haste.
 Ever yours,
 D.G.R.

Don't encourage Leyland to come here just now should he propose it. The house
will be full in a day or two. He writes me he is coming to London on the 10th
February, and wants his <u>Proserpine</u> by then.

[1]An offer of the <u>Bower Maiden</u>, which Leyland refused.

329. DGR to CAH [Kelmscott]
 Thursday, 5 February 1874
My dear Howell,
Leyland declines the <u>Bower Maiden</u>. I am now offering it to Graham for <u>650</u> guineas
as I want to get it off my hands if possible without further trouble. Graham
has been pressing me for new work--and specially for <u>bright</u> work such as this
is--yet you'll see in all likelihood he won't buy,--such is the crooked luck in
all such cases. It would be no good I think making a pen and ink sketch to send
him,--the charm of the picture being so much involved with its colour.
 You will be sorry to hear that Graham has been seriously ill--is still, I fear.
He went to Glasgow and had an attack of illness,--is not now going in again for
Parliament. I am anxious about him. He wrote me (but by his daughter's hand) 2
days ago, again pressing for fresh work and still in ecstasies with his
<u>Ghirlandata</u>. So my offer of this picture comes to him as an answer to his request.
I have told him no one has set eyes on it yet except you who saw it begun. Of
course I did not mention Leyland in the matter.
 Now about pictures. Imprimis--<u>I want money</u>. Item, I will sell one of the 2
spare <u>Proserpines</u>, whichever preferred, and the <u>Lucrezia</u> (together) for £420.
But it must be cash. Who will buy? The <u>Proserpine</u> I send Leyland now is the one
you saw at Morrill's but vastly improved.[1] On getting it again I found it was
more luminous in colour than the one I had first sent to Leyland (and which
returned to me without going beyond the railway station at L'pool, owing to an
accident which smashed the frame and scratched the picture.) Thus this picture
(scratches now quite remedied) is one of the 2 <u>Proserpines</u> I offer for choice,
the other being Parsons's when it returns to me.
 As for accounts for sofa &c, I'll settle that by chalk drawings as proposed
before by you. The <u>Lucrezia</u> must bring me cash.
 Ever yours,
 D.G.R.

P.S. Little May Morris is here with the measles. Perhaps we may all be laid up
with it.

[1]<u>Proserpine V</u>, the rucks now repaired. I think Mrs. Surtees in error in saying
that the picture was lost in transit between Paddington and Lechlade and that
"nothing more was heard of it." In Letter 1441 (D-W, p. 1251) DGR wrote to F.M.
Brown that "the missing picture has been traced." This letter to CAH makes clear
that DGR was substituting the repaired <u>Proserpine V</u> for the damaged <u>Proserpine VI</u>.

330. CAH to DGR Norris's Hotel, Elsham Road, Kensington, W.
 6 February 1874
My dear Gabriel,
I have been away two days busy on election for Dilke. Notwithstanding table[1] has
gone off this morning very dear, but a nice one which I hope you will like. I am
truly sorry to hear of little May's illness, but none of you need fear any thing.
I have seen many children with it but never caught it myself.
 With your letter comes one from Graham and I shall go and sit an hour with him
this evening and will prime him up to buying the <u>Bower Maiden</u>. If he fails send
it to me and I will try my hand.

 Saturday
 2 a.m.

I thought it better to see Graham before writing further and therefore lost the
post. I found him very ill and broken down but cheerful and I rather think that
his having had no chance to get in again for Glasgow has had much to do with it.
The fact is I saw him two days before Gladstone dissolved and I am sure he had
the straight tip from him for he was off to Glasgow like a shot and seems to
have failed though he says that he sent his intimation that he would not stand
again it seems well known in political circles that he had no chance. We have got
Dilke in for here, i.e. Chelsea, at the head of the poll and I got him over 2000
votes. Graham asked me at once about the <u>Bower Maiden</u> and I cracked it up high,
he spoke about the big picture <u>and seemed fearful of</u> going on with new pictures

for fear you should not set about the Dante. This quite between us and for your guidance. As to cash of course I never do sell any thing of yours except for cash. Only I must have the things people will not buy without seeing. You have now had the Lucrezia[2] at Kelmscott for weeks doing nothing and yesterday I might have sold it to an American for our price and over however he has returned today to N.Y. and the chance is gone.

As to Proserpine and this water colour send them up at once I have a chance for Proserpine but I cannot buy myself. This money is not paid me yet though I have a good bond which I do not wish to discount, and there is much here and there owing to me now, and I cannot go further. All right about accounts any thing you please. Only I do wish you could some how fiddle up at least some of the Dante sketches now owing by me for such a long time that I have to refund the money with interest at 5% which is any thing but pleasant--and must now try to place them some where else. Patience.

As you please about pictures. I have a chance for one or two but I must have them, no one cares for descriptions, and how I made Watts' market was by having the things and not by talking about them.

<div align="right">

Ever yours affectionately,
Charles A. Howell

</div>

On receipt of the table drop me a line. If you send Bower Maiden to Graham and he refuses tell him to give it to me and I will send for my men and if they fail go off to Leeds Bradford etc etc with it.

Excuse half sheets I am hard up for paper.

[1]On 2 Feb. DGR had sent CAH a note, saying, "Pray do send me that card-table talked of a year ago...."
[2]This conflicts with Mrs. Surtees's statement (p. 77) that the picture, though DGR's property, continued to hang in Leyland's house until it was acquired by George Rae in June 1874.

331. CAH to DGR Norris's Hotel, Elsham Road, Kensington, W
 7 February 1874
My dear Gabriel,
One point I have always forgotten, to tell you all about the Miss Wilding head. Leyland refused it on the ground of "having determined to buy no more chalk drawings." Graham refused it on the same grounds, and valued it at £21. I then sent it to Salt who did want a drawing, and he refused it on the ground of my "unheard of price"!! (the fool) In all cases I have only asked your price viz £52.10.0. I have now offered it to Heaton for the same price. It is in Bradford in Brayshay's private house but Heaton has not seen it yet his wife having been at death's door with brain fever. The case with Heaton is this, a speculation in which he finds £200 and I £200 for chalk drawings by you profit to be divided. In this case I say "Here is one which you can have for £52.10.0 on account" if he says yes I take it at that price from you and gain nothing--if he refuses I will let you know.

<div align="right">

Yours affectionately,
Charles A. Howell

</div>

P.S. Let us know about little May.
What will you charge more for back ground if asked for?

332. DGR to CAH [Kelmscott]
 8 February 1874
Dear Howell,
The enclosed from Graham will show you that he has bought the picture[1] and seems ready for others if I can let him have such. Please return it me.

I heard from Parsons a few days ago--a line or two enquiring for the picture (mislaid by me apparently,)--and propose to answer him now as enclosed. Please let me know by return what you think of such answer, and also on the following points. Would you be willing to call on him, pay the money (for which I would send you cheque) and make him sign such a receipt as I here enclose?[2] At same time (and before the money is paid) I wish you to see the Proserpine and be sure that no damage has occurred either to picture or frame. You might then take it with you to your hotel, but I should not wish any one to see it at present--

particularly not Leyland. At the same visit to Parsons, if you have no objection, I would be obliged to you to resume possession of, and remove, all photographic negatives he has of mine, and to receive from him a proper account of sales of photographs of mine made within the last several years. For this purpose I would send to him and to you beforehand a list of such negatives to be delivered to you. Please let me know by return if you can do all this for me.

As to the Proserpine and Lucrezia, my proposal was in case any one chose to buy them for cash down as a speculation to sell again. If sold as my property they would have to fetch me at least 100 guineas more or probably over that. I don't want to be shooting more than one Proserpine (besides Leyland's) on the market at present, and had therefore better ask you, when you get Parsons's back, to send it at once to me, that I may see whether it or the one here would be most available to put forward now. The surface of Parsons's picture having now been long dry, I dare say I might work on it again to great advantage with little trouble before sending it to market again, and would also add accessories.

Thanks about table. I'll let you know when it comes. I didn't know you added electioneering to your other accomplishments. I should have given my vote to Dilke if I had been in town, but couldn't go up on purpose. I never before took the trouble to vote at all.

I must most certainly see about letting you have some chalks. Pardon delay, but you see evening work here is impracticable for want of light.

How go Sandys and Clive?

<div align="right">Ever yours,
D.G.R.</div>

You don't tell me how you liked Graham's Ghirlandata which I suppose you must now have seen for first time.

What stamp should such a receipt as I enclose have?

[1]The Bower Maiden.
[2]DGR was buying back from Parsons Proserpine IV, which had proved unsaleable.

333. DGR to CAH Kelmscott, Lechlade
 16 February 1874
My dear Howell,
I now hear from Parsons accepting my offer to repay the money. As he assures me he has paid 5 per cent interest, I will pay that also,--the whole amounting to 604£.

I write to him with this as enclosed, as you kindly consented to manage the matter for me. Please let me know by return that you are still in town and able to do so, and I will then at once forward you the cheque,--otherwise, if it chanced you were away, the cheque might go wandering after you.

You see your functions are
1st To return P's letters (which I forward you) and receive mine from him.
2nd To get him to sign enclosed receipt
2nd 3rd To look at the Proserpine and ascertain it is all right and then take possession of it. The best would be for you to write to F. & Dickinson to let their van meet you at Parsons's and afterwards convey the picture (in closed case) straight to 16 Cheyne Walk and deliver it to Dunn who would forward it to me here as soon as I need it.
3rd 4th To claim and receive the photographic negatives of which I send you a list similar to the one I now send Parsons.
4th 5th To pay him the cheque and get him to sign enclosed receipt. But not to do so unless all the above preliminaries are duly fulfilled.
You will observe by the draft of my letter to him, that he has to write you of his readiness for your visit, whereupon you are to fix the time.

Thanks for card-table duly to hand.
I am anxious about Graham from whom I do not hear since my last some days ago. I will write of other things soon, but am very tired tonight.

<div align="right">Ever yours,
D.G.R.</div>

P.S. I believe some sales of photos must have been effected by Parsons since I told him none should be sold at less than 2 guineas each. Thus there ought to

be some money due from him to me. I suppose the slide-boxes to hold the negatives ought not to cost much.

Of course you would take good care not to return his letters till all is concluded, as till then they are very important. There is a description I sent him of the Proserpine picture which must be returned to me with my letters.

334. DGR to CAH

[Kelmscott]
Thursday, 19 February [1874+]

Dear Howell,
I enclose cheque for Parsons.

I think the negatives had better be all sent to Cheyne Walk. I shall not want any more of them printed in all likelihood, and am writing to Mrs. Cowper (who has those done by her brother Thurston Thompson)[1] asking her to return them. Would you mind calling on her and receiving them whenever I hear from her that they are ready for delivery? Her address is The Residences, South Kensington Museum.

Thanks about everything. May is well, but I am still worrying lest her Mamma should catch it.

A pembroke table I use here is crippled. I'd have another if to be found.

Ever yours,
D.G.R.

[1] Official photographer at the South Kensington Museum.

335. CAH to DGR

Norris's Hotel, Elsham Road, Kensington
20 February 1874

My dear Gabriel,
Just a line to say that cheque for £604 [to order] of J. R. Parsons duly received. I now telegraph to him to be ready by six this evening, as I cannot be with him before. From his place I will again report progress.

Delighted to hear May is well again. Do not be anxious about any one, no one will catch it now.

There are three kinds of pembroke table. What sort is yours send me sketch and I will send you a new one.

Your affectionate
Charles A. Howell

336. CAH to DGR

Norris's Hotel, Elsham Road, Kensington,
20 February 1874

My dear Gabriel,
Here is receipt. Your letters go by this (book) post. Proserpine frame, and packing case all right.

Description of Proserpine I have kept in case I should have one of the pictures. Parsons thinks he has given me all your letters, I had no means of testing, but if you miss any I will make him hunt them up, he is not capable of keeping any back.

Negatives instead of your list these were about 100 all counted and all so beautifully done up that I dare not unpack them, they are all in sizes, with a paper between each and beautifully tied up, I have them and will not send them to Chelsea as I am afraid of slovenly ways and something being dropped on them and a batch ruined, which would be most fatal the pictures being gone. So if you see no objection I will take them tomorrow to Chaldon House lock them in one of my cabinets and send you the key if you wish it. I could not buy you the boxes. Parsons has only a few, and they are awfully dear. I saw Parsons's books and all the balance in your favour is 15/- this he gave me and tomorrow will send me written statement to forward to you. Proserpine I have screwed up and will take it tomorrow or Monday to Cheyne Walk, I had a cab and could not go to Chelsea tonight. All said and done I was more sorry than angry when I faced Parsons this evening, "Dear Sirs" and the rest came not from him and all I cannot understand is how one man sells body and soul to another and how the other buys. I saw letters from this fool of his backer with the signature cut off by which I see that Parsons is so much mud under his feet. It seems Parsons was quite ruined when this man took him up and since then not a farthing is his own.

The first letter "Dear Sir" to you he made Parsons write it to his dictation and then took it to the post himself! Who can the cad be? U [sic] When Parsons came to sign the receipt his eyes filled with tears, and he took about ten minutes to sign it saying "it is a sad finish with an old friend, and I wish to God I had had the money myself, and he certainly could never have had one word from me on the subject."

Now would you like to try and have your £420 next week? If so and I can sell this Proserpine send the Lucretia at once, I have a chance, and if I fail I will send both at once to Chelsea. Of course if I can get you £100 more and so on I will do so. I am anxious to serve you in this matter, I sold you the Proserpine to Parsons, and I am sore at its going back to you, nothing of yours through my hands having ever come back even to me. Send word by return and not a screw shall be removed from the case until I hear from you.

Your affectionate
Charles A. Howell

337. DGR to CAH [Kelmscott]
 Sunday, [22 February 1874+]
Dear Howell,
About the Proserpine, I do not think it judicious to offer it again for sale till I have done something to it. It can probably now be sent down here almost immediately when I would get Dunn to come down and copy into it the accessories which I have introduced in the other versions and which would greatly increase its attractiveness. I would then work over the whole myself in its now quite dry state, and no doubt greatly improve it.[1]

You know I have 2 Proserpines already here. One will immediately be going to Leyland,--is he yet in town? The other I wish to compare with Parsons's and see which of the 2 is most promising for sale. The Lucrezia I will send.

About a pembroke table, the only thing to be said is that it must not be of the horrid turnstile kind with a loose leg which brings all one's traps to the ground; but must have its one or two flaps lift on brackets. Also it must be on castors, and 2 drawers would be preferable to one.

As for the letters you returned me, I just pitched them into the fire unopened, and there an end.

As for the photos, are there more than 15 of Janey from nature?

Having wound up this matter, is it not time for me to think seriously about the big picture?[2] Brown told me--what I have certainly never heard--that the sale to Valpy was conditionally on a better sale not being effected in a year's time, when the work would revert to Valpy. This he says you told him, but it was new to me. Indeed I have been personally a stranger to the Valpy question having had no correspondence with him.

A better sale should certainly be made if possible, and I wish to sift the reports about Armstrong. As I told you, I have a way of approaching him myself, though of course I do not mean to appear personally in the matter. This is firstly through Scott, who is intimate with a special intimate of Armstrong's who could be got to ask questions. But this is somewhat roundabout; and as you tell me Marks was the origin of the Armstrong matter before, I shall probably now write a note to Marks myself asking for clear details; and then judge whether his intermediary or the other seems most feasible.

I shall be sending Graham his Bower Maiden almost immediately. But I had an accident with it--as usually now. It fell on its face in the frame, and the smashed glass left a minute glass-dust on all the sticky portions of the picture. Another glass is now come, and the picture having been put by and dried, the glass-dust brushed off in a minute. Graham is marrying his daughter Amy on the 26th but I fear this delay will prevent the picture reaching quite by then.

Ever yours,
D.G.R.

[1]All of this refers to Proserpine IV, bought back from Parsons.
[2]Dante's Dream (the original large picture).

338. CAH to DGR Norris's Hotel, Elsham Road, Kensington
 23 February 1874
My dear Gabriel,
Parsons has found another note which I enclose, I have since called and find it
is the only one he has.
 Tomorrow I send Proserpine direct to Kelmscott as on second consideration it
saves van hire from here to Chelsea and from Chelsea to the station to say
nothing of the risk of loading and unloading.
 Leyland and family are expected either today or tomorrow.
 I bought you a beautiful Pembroke table today at Welch's and being short of
money and not wishing to run up bills with these blokes I told him to send you
the account. The table he will forward to you tomorrow.
 I do not know how many negatives there are of Janey from nature, but Parsons
says there are more than 15. Shall I open the packets and see? Many are from
drawings of your wife's, and some for Christina's book,[1] trials for the
drawings etc etc.
 Now about the big picture, you have heard nothing from Brown that you did not
hear from me, as I told Brown the same thing I told and wrote to you long since,
viz that I had sold the picture to Valpy but that if in the mean time I could
get you more for it I would manage the thing for you. I send you two of your
letters on the subject which will freshen your memory and show that I am right.
Will you kindly return them to me as they are good for reference so that we may
always be d'accord. Very often I go through your letters in order to bear well
in mind all you wish. As you please about Armstrong but if my advice is worth
a rap do not move at all in the matter. Scott (intimate or not with an intimate
of Armstrong's) would do more harm than good. He is called in Newcastle "an old
fool," and when I have praised him to Newcastle men as one of the cleverest of
the day I have had to shut up seeing they thought me a fool for saying so.
Armstrong is like the Duke of Brunswick who would not look at a whore unless
she approached him veiled and on tiptoe, like a lady in disguise. He will not
buy a thing if it is for sale, of course I do not compare your picture to a
whore, but if he knew that it was in the market he would not buy it at all, any
pushing from any friend of Scott's would injure my plans. They may fail with
him, but they are certainly laid out as they should be. With Marks I have acted
with all caution. He is the intimate of Mr. Shaw[2] and Shaw Armstrong's right
hand. Through my hints Marks thinks that I can enable Armstrong to obtain the
picture, he at once fusses off to tell Shaw (this I knew he would do) that he
thinks he can get the picture through me, Shaw fusses in turn and so excites
Armstrong that he at once says, "do you think that as soon as I am well enough
Mr. Howell will let me see the picture?" Mr. Howell said "yes" and here for the
present the matter rests. Of course if you write to Marks he will at once think
that you require to sell the picture, and all will be ruined.
 Sorry about Bower Maiden. I saw Graham today but of course said nothing about
it. I knew of Amy's marriage and the opposition to it.
 Ever your affectionate
 C.A. Howell

Have you written to Jagus Shout? Do you keep the swell cameo? Let me know about
both.

[1]For Goblin Market.
[2]See n. 1, Letter 295.

339. DGR to CAH [Kelmscott]
(Postcard) Tuesday, [24 February 1874]
I am sending the 2 pictures to Queen's Gate and Grosvenor Place tomorrow--
Wednesday.[1] George takes charge of them to town to prevent accidents. Try and
persuade L. to hang the Proserpine with light from left (of spectator) as it
needs that light absolutely--much more than his two others. I don't hear from
you yet if he is in town. The pictures will reach both places about 6.
 [D.G.R.]

[1]I.e., to Leyland and Graham.

340. DGR to CAH [Kelmscott]
 25 February 1874
My dear Howell,
I wish you would kindly do as I ask in matters of detail. I did not wish that
picture to be coming here till I asked for it, and would willingly have paid
carriage to Chelsea. However, coming it is, and there an end. If no paper-strips
are pasted on the glass, it will probably arrive another wreck of broken glass
and scratched paint.
 The letters of mine you send me are right enough. What I said and say still is
that when you told me the picture was sold to Valpy, you said so simply,--never
that it was so conditionally on another sale not occurring within a year. Shortly
after you said V. was gone for a month to Germany and we would try meanwhile to
sell it better elsewhere. Then came proposals as to engraving &c--but no word
of the year's probation for the picture ever reached me. Of course this has no
remotest resemblance to impeding your conduct in any way. Only that omission
occurred accidentally and made some things seem rather unexplained till now. All
this could be proved by over-hauling letters, but it would take an hour or so to
rummage them.
 As for the Duke of Brunswick and his whore, I am perfectly agreeable to that
nobleman having her in his own way, though I believe his weakness was not for
her sex; but he who buys my picture had better set about it in a more or less
straight-forward way; if as you truly say "the matter rests," it seems to me
that rest it may if we get no further news about it. Is there any reasonable
supposition that Armstrong distinctly means to come and see it within any
reasonable time? If I am not to tackle Marks, had not you better do so? As for
Scott, he would have been in no way mixed in the matter except to mention it to
a third person whom I know to be judicious.
 The pictures are gone today to Graham and Leyland.
 Thanks about the pembroke table. I will return the cameo in a day or two and
with it the remaining jewellery if you will kindly let me, as I don't see much
good in sowing correspondence broadcast. I have now taken a gold bracelet as
well as the Indian buckle, and will send cheque for them when I know their value
or get a bill, as I have mislaid in some heap your letter containing prices.
 I didn't know of any opposition to Amy Graham's marriage. Whose, and why? Get
him to show you the Ghirlandata and Bower Maiden by daylight. I want you to see
them but they don't do at night.
 [unsigned]

341. DGR to CAH [Kelmscott]
(Postcard) [26 February 1874]
As to Queen's Gate, you say "Thursday next" but don't explain whether you mean
today or Thursday of next week. The picture must be there now. Can't you go and
hang it in proper light?
 I suppose the best thing would be to hang it and Lilith on the side where
Lilith now is, and Veronica and the Roman Widow (when done) on the other.
 [D.G.R.]

342. CAH to DGR Norris's Hotel, Elsham Road, Kensington, W.
 26 February 1874
My dear Gabriel,
Now then scold!! When I was thinking of sending the Proserpine I thought that
after all it might put you out and I determined not to send it until you wrote.
So it goes to Chelsea.
 No picture is ever sent by me without paper-strips all over the glass.
 The picture was not sold conditionally to Valpy. All I said was that I had so
arranged that in the meantime I could sell it for more if I could. Otherwise had
you not understood this how could you cancel your sale to Valpy after accepting
it and how could I accept the same without remonstrance? No overlooking of
letters would prove any thing beyond the facts as they are, though perhaps a
little confused. Did I say Brunswick?[1] I meant Queensbury. About buying the
picture I wish to god you would see these things in the same light that I do.
You say "he who buys my picture had better set about it in a more or less
straightforward way." Is this the way of looking on it? Has Armstrong or any

one else set about buying the picture. Do they know it is in the market? No!
Every one knows it belongs to Graham for he has talked of it all over the country,
and then damn fool like wants your finest work a third of the size, and this one
sold!

Let outside buyers know that Graham after having it hung up, exchanges it for
any thing else, or wishes it sold, and the sale (not the picture) is ruined. It
is not as if Graham was dead, or was selling his pictures, he goes on buying
and spends a £1000 a week in works of Art, and fools ask why part with this one?
The plea of no room is not listened to, any one with Graham's fortune builds
rooms, and makes places to enjoy his pictures. What I have told you about
Armstrong and every thing else is the truth and tomorrow I will see Marks on
the subject. Of course write to him by all means if you wish it.

Do not send me the remaining jewellery--send it direct to Shout, I do not wish
him to think that I have kept it all this time. Long since he said that as you
had not written he concluded you had kept it all, of this I informed you, and
George might have made up the packet of things refused and posted it to him.
Do do it now and I will explain the rest to him. I quite forget the cost my
letter was written at his place and left there to post but I will ask him.

The opposition to Amy's marriage[2] was the Father's, I do not quite know why
but think on the ground of coin, she however held out and he had to give in. I
am going to see both pictures[3] tomorrow.

In haste

<div align="right">

Ever your affectionate
Charles A. Howell

</div>

[1]See Letter 338.
[2]That of Amy Graham.
[3]La Ghirlandata and The Bower Maiden, bought by Graham.

343. DGR to CAH [Kelmscott]
 28 February 1874
My dear Howell,
Alas! Pray pardon, and send me Shout's address again. Everything here gets
buried in heaps the moment it arrives. Instantaneously on getting the address
this time I will forward remainder jewellery to S. and the cameo to you. S. has
been gainer by the delay, as it was only the other day I resolved on keeping
the bracelet for a birthday present.

About "Thursday next" I still maintain, that in dating Wednesday, the natural
thing would have been to say "tomorrow." So there!

I hear from Graham who seems I regret to say somewhat disappointed with the
Bower Maiden on the ground that it is not ideal! He wanted a "bright cheerful"
picture and I gave him one, but cannot make bright cheerful ideals. I hope if
you have seen him by this you have helped to make him like it. It is really good
work, but realistic. Who is it that has married his daughter? If he spends £1000
a week in pictures, what does he buy in heaven's name?

Thanks about Proserpine. I shall be glad to hear further as to the big picture.

I see Wynn Ellis is said to have lost all his modern pictures at the
Pantechnicon fire. I remember the late Pearse telling me that he had sold W.E.
an early picture of mine--the Annunciation,[1] perhaps the best I did just then.
Would there be any means of finding if this was among the burnt ones? I suppose
so and should be sorry.

<div align="right">

Ever yours,
D.G.R.

</div>

No word from Leyland. If he sulks at this picture, I shall sulk too. It is
my very best. L. told me to send it to 23 Queen's Gate.

[1]This is apparently Surtees 44, although I do not find the name of Wynn Ellis
connected with its history. See Letter 353.

344. CAH to DGR No. 1 [at top of letter][1]
 Norris's Hotel, Elsham Road, Kensingtc
 1 March 1874
My dear Gabriel,
That confounded silver fusee thing for George is not yet ready--I went about
it yesterday. They promise it soon. I send you however registered post the flint

silver box and flint a beautiful old silver one which I found and which is carried in the pocket not attached to the fusee. Also the silver dog whistle which George can afterwards slip into the fusee split ring.

Leyland is very much pleased with the Proserpine, and so am I. What a lovely thing it is! Ten times as lovely as Parsons though I would not say so to him.

Leyland would <u>have it</u> in the breakfast room, and <u>I saw it was no use trying</u> for the drawing room. It looks most beautiful where it is light from the left but there is not enough light.

He has now ceased to care for Queen's Gate having bought Lord Somers' house which he is going to do up swell. We have had long talks together and he is harder than ever, he told me you had offered him the <u>Bower Maiden but that he would not buy another single picture from you until you delivered his three viz R. Widow, Pia & another.</u> "As soon as he does that, we will start afresh, but <u>not before as it becomes too tedious</u> to wait all this time, I shall remain inexorable and unmoved until he does do it." Of course you will keep this secret, I only tell you for your guidance, and because I think it may be of all use to you to be a sort of spy in these business matters and let you know all just as if you heard it. Today he was with me all day, and spoke about old days, "The whole thing is broken up," he said. "You and Rossetti were the two that kept it up, some turned out a lot of scandle mongers like so many intriguing washerwomen, Rossetti insists in living away from us all, and now there are no evenings and no days."

His great grief seems to be your being away. Dunn comes to say that he is off on Wednesday to do something to Proserpine as you will know by this I stopped its departure. Shall I send it off by Dunn on Wednesday all the same?

Telegraph back.

<div align="right">Your affectionate
Charles A. Howell</div>

[1]But I find no No. 2.

345. DGR to CAH [Kelmscott]
3 March 1874

Dear Howell,

I'm glad you like the Proserpine. Leyland's acknowledgment is--well, moderate. I suspect he doesn't deserve to have the picture which is really my finest. I am writing to him with this to explain the story about the two pictures--the one he has and the other, so that there may be no future misunderstanding.

You don't say that you have yet seen Graham's 2 pictures.

I enclose a letter about the endless paper job.

You do not send the address of the eternal Shout.

Thanks for the silver whistle and flint-box. What is the exact use of the latter? Have not fusees quite superseded it? Of course no doubt you are getting the chain &c made. George is delighted with these "payments on account" of his birthday present and wants the rest bad.

The table is very pretty and answers well though a little small.

I am trying to get Leyland to go and see Legros' pictures. I hear L. has some fine ones, and he has had a sad stroke of ill luck lately through the death of one Benson from whom he had important commissions. So be a good fellow and don't try and prevent Leyland from buying but rather encourage him thereto.

You don't tell me if you have yet seen Marks and spoken to him.

Leyland wants his Roman Widow by June, when it will be <u>quite sure</u> to reach him I trust.

I am telegraphing and trust Dunn will bring the picture.[1] Surely I explained this in my last.

<div align="right">Ever yours,
D.G.R.</div>

P.S. In one of your last letters you said you thought you could pay me the 1500 guineas <u>down</u> if I engaged to deliver the large picture within a year from date of receipt. Could you do this <u>now</u> if I preferred such course? Dunn's outlines are very satisfactory, and the replica may thus be considered as already well advanced.

Please answer this by return if you can.

[1]The Proserpine bought back from Parsons.

346. DGR to CAH Kelmscott, Lechlade
 3 March 1874
My dear Howell,
I had just written an answer to your letter which reached me this morning, when
now by the afternoon's post I receive from Brayshay the news of your terrible
loss and deep sorrow. I feel for you with all my heart, believe me. Certainly
you have retained your father longer than I did mine; but he was a man not old
yet, and even younger than his years, and you had no shadow of reason to
anticipate this sudden blow.[1]
 I do not see any way in which I can lighten for you any of the calls on your
attention which must be so irksome at such a moment; but if there <u>were</u> any means
by which I could in the least serve you, Kitty would let me know.
 Love to you and to her.
 Your affectionate
 D.G. Rossetti

[1]CAH's father was critically ill but did not die at this time. Mrs. Angeli is
incorrect in stating that he lived until 1880. (See Letter 430.)

347. DGR to CAH. (Postcard.) Tuesday, [10 March 1874]. Is sending letter held
back on hearing news of illness of CAH's father. Is returning things to Shout,
cameo to CAH.

348. DGR to CAH [Kelmscott]
 10 March 1874
My dear Howell,
Your state of uncertainty on such a terrible subject must be all but unendurable.
I hope most heartily that you may soon learn something certain one way or the
other. Anything would be better than such suspense.[1]
 Since you tell me to write as usual, I will do so, and perhaps it is better
for you to occupy your mind in ordinary ways as far as you can.
 Dunn came here on Wednesday last with Miss Wilding. She has remained, but he
went back last Friday. He brought the <u>Proserpine</u> with him. It doesn't do at all
after Leyland's. I shall take some steps with it and the other which is here
when I have time to attend to the matter. I suppose L. didn't seem rusty at the
story of the vicissitudes of the various <u>Proserpines</u> which I told him--that is,
of the 2 sent to himself. I said nothing of Parsons's. He ought on the contrary
to be grateful for my zeal in his cause.
 I am glad you were pleased with the <u>Ghirlandata</u>. The <u>Roman Widow</u> progresses
well and will be fully its equal.
 You may remember I told you I had written to the sister of Thurston Thompson
about those negatives she retains of mine. After T. T.'s death, she wrote asking
if she should retain or return them. I said retain--and she has printed some
since for me--but now I write about them I get no answer. I believe she is
associated in the photographic business with her younger brother--another
Thompson. Her name is Mrs. Cowper and her address
 The Residences, South Kensington Museum
I forget the number. Could you call on her at your convenience and see why I
get no answer. The negatives in question are <u>Mary Magdalene Hesterna Rosa Borgia</u>
(children dancing) <u>How they met themselves Borgia</u> (washing hands). I can
remember no others. Mrs. C. seemed a nice person once when I saw her and I do
not understand her silence.
 I think I told you Graham seemed not to care for the <u>Bower Maiden</u> quite as
much as his others. He has since written very nicely about it, though still
preferring the others, in which of course he is right enough. What you tell me
of his endless purchases is bewildering. What <u>does</u> he want with all these things?
 I have received a sort of little predella picture--A <u>Resurrection</u>. Curious
and good--of the Angelico School--whence and wherefore I know not. Do you?[2]
 The jewellery went back to Shout, and George enclosed a request for the
account. What I keep are an Indian gold bracelet and an Indian buckle. There
is a broach--a crystal set in gold and surrounded with little moonstones. I
would buy this if a large moonstone or cat's eye--not too expensive--were
substituted for the crystal which is uninteresting.

Everyone in the house is playing at hide and seek which they are likely to
keep up till one in the morning! All day they been snowballing in the garden!
I begin to feel very old indeed.

<div align="right">Ever your affectionate

D.G.R.</div>

Has Leyland been to see Legros?

Janey expresses great concern at your sorrow, and writes "I should like to go
and see both him and Kitty sometimes, but should be made uncomfortable if I did
so."

P.S. If you know of any one who can do up furniture well, charge moderately,
and be tolerably quick over jobs, please send the address to William. He wants
some things done up against the wedding outfit for the rooms he is getting ready.

What has become of that brass covered box of mine? Is it going on in any way?

[1] A reference to the critical illness of CAH's father.
[2] Sent by CAH. DGR later attributed it to Pietro Laurati or Lorenzetti, 14th C.
painter.

349. CAH to DGR Norris's Hotel, Elsham Road, Kensington, W.
 15 March 1874

My dear Gabriel,

I was obliged to go away for two days, I wanted to be quiet and speak to no one,
I came back last night. As yet no news from home!

Cameo duly received, many thanks.

Paper and envelopes now in hand.

The flint is to strike a light when a man is fishing or hunting, or at sea or
in a gale of wind or any where where he finds himself without fire or fusees.
The tinder cord will be attached to the chain, and George shall have both as
soon as ready. Of course I should always be a good fellow in matters like the
Legros business. Legros is a coward, and the greatest canaille I ever met, he
is a cur as false as Judas, and quite incapable of doing any one any thing but
a bad turn. I know the man out and out, and there is not one redeeming point
about him, a cad and a sneak by nature he has made his Art the stepping stone
to beggary, and every picture of his sold from 5/- to £100--has attached to it
a beggars petition suggested by the noble artist, and put forward by Leighton,
or Watts, or Jones. Still I am not the man to stop any one from buying his or
any one elses pictures. About 3 weeks ago Marks came to ask if I would buy one,
no doubt put on by some Ionides or Legros himself and my answer was that I would
not buy all he ever painted if he offered them to me for 1/-. Leyland has not
spoken to me about it, but I think--nay I am sure--that he would not buy one,
he quite despises Legros, and seems to know all about him though I have never
said a word, in fact I never mention the man at all.

One thing I should say as your friend, and that for your guidance Legros is
no friend of yours, and as great a canaille to you as he was to me.

I hope to see Marks either tomorrow or Tuesday and will then put every thing
in straight working order for you. Leyland told me of the history of the
Proserpines as detailed by you, he only laughed and seemed quite pleased.

I will call on Mrs. Cowper tomorrow.

The Predella picture. Don't you remember it? It belonged to Pearce and you
once, before me, offered him a sketch for it, he used to ask £60 and call it
Giotto, well it fell into Pinti's hands, and somehow the other day it passed on
to Eyre's, and on seeing it there I bargained with him for it for a 20 guineas
sketch of yours in exchange, this he accepted and sent you down the picture. Be
wise and stick to it or if you do not care to do so I will myself pay the 20
guineas.

About Cat's eye I will see what can be done, but one that size would of course
cost dear.

Sorry not to see Janey, but I would not for worlds have her uncomfortable
through us. It must be uncomfortable enough to know that husband or his friends
can and would cripple her pleasure. Our love to her, and we are hers all the same.

As to furniture for William I have for a very long time refused every one every
service of the kind. You are the only exception. And I must not break my
resolution, besides which William has never even told me that he is going to
get married at all, so that I could not well intrude on the subject of chairs

and horsehair. Morris or Stennett would no doubt aid him in all such requirements.
You will pardon this, but as no one has ever thanked me for any thing, I have
determined to take care of myself, and people must do as I do, find out for
themselves, and be as independent of me as I am of them.[1]

Your box is now in a good mans hands in hopes that he may be able to do the
job.

<div align="right">
Your affectionate

C.A. Howell
</div>

[1]This paragraph appears in PRT, p. 104.

350. DGR to CAH

<div align="right">
Kelmscott, Lechlade

3 April [1874+]
</div>

My dear Howell,
Here is a letter from Mrs. Cowper of the photos. I got it only on my return
here last night.

Marks called one day on Dunn while I was in town, and two words with him
settled the question about Sir W. Armstrong who has said definitively that the
picture is too large for him. I judge you have not yet seen Marks. I find he
has bought from you my drawing of Siren.[1]

Please kindly note that a certain £54 bill is payable at my bankers, on 12th
April. I am very short of funds, and no doubt you will bear it in mind as
heretofore.

I was at William's wedding breakfast on Tuesday last.[2] He and bride cool as
cucumbers.

The cash question stares me out of countenance. Parsons having fallen through
I am still wanting a dealer ready to take and pay for whatever I could let him
have and dispose of it in his own way afterwards. I have ready or almost ready
for such a phoenix of a dealer several things--Proserpine, Lucrezia, Blessed
Damozel, &c.--for which I want cash at a moderate figure. Should you be in a
position to buy for cash? Please let me know.

How soon could you look me up here if feasible?

<div align="right">
Ever yours,

D.G.R.
</div>

[1]Ligeia Siren (Surtees 234). Mrs. Surtees lists the provenance as CAH and
Constantine Ionides without mention of Marks.
[2]William M. Rossetti married Lucy Brown in a civil ceremony on 31 Mar. DGR was
present at the small breakfast but refused to attend a large party on the
preceding evening (Doughty, p. 562).

351. CAH to DGR[1]

<div align="right">
Chaldon House, Fulham, S.W.

9 April 1874
</div>

My dear Gabriel,
Your letter and post card[2] only reached me today owing to their having been
sent to the Hotel. We are here now for good, so please note the address.
Yesterday I called on Fanny with £200 (Brayshay with me) as a further payment
towards the £500, this owing to Fanny having pressed for the money when last I
was at Cheyne Walk. She was out, but as the girl said she would be in soon I
went in and waited 20 minutes. Much to my surprise I found the portrait gone,
and a most lovely new one in its place! The girl said it had gone to Cheyne
Walk so I thought no more about it, and left word that I would call today. Today
to my most intense astonishment and I must say utter disgust, I find that Marks
some days since bought the missing drawing for £100 (as he says). This is really
unpardonable and has no excuse whatever. I behaved better to Fanny in this
matter of the drawings than I ever did to any one in my life. This for three
reasons, first because I was anxious (as I always am) to be all that I should
be to you, second because I was most anxious that she should have a little house
of her own and I wanted to help towards it as much as possible, and third
because when you were ill, I found her in a terrible state, and she declared
emphatically to me that both your brother and Brown had been harsh to her, had
proved they did not care for her, and that she considered she only had two
friends in this world who would do any thing for her viz yourself and myself!!

This God knows is quite true, for if you were to die tomorrow and leave nothing, as long as I had 1/- Fanny should never want it. Well there is something that makes it blacker than all, when I fancied that she grieved at losing her portrait, I said, "Well Fanny don't say any thing to Rossetti for he might insist on the contrary, but hold your tongue, I will bring you the remainder of the money as I can, and with all my heart I give you the portrait, only after this if you ever sell it again you must sell it to me." Marks also has behaved like Marks. He knew that I had bought the things, worried my life out to get the portrait for the £100, offered to give me the money for it, which of course I might have taken to Fanny, but I refused and evaded the question simply because I did not care to say what I was going to do about the portrait. All this hurts me more than I can say, and tells me plainly that I am a cursed fool I try and try and try my best, and in payment Fanny not only tries to chaff me before every one but slights me in a serious matter in which so help me God, I had nothing at heart but her comfort and peace of mind.

Her idea that every one is going to swindle her is a broad insult thrown out without the least meaning but which for her sake ought to be corrected. As to her chaff I care not two pins, indeed it has always been my task not to explain why she chaffs me, but to excuse her for doing so, and so do away with the bad impression against her which such a proceeding creates.

The fact of the 500£ question hanging thus long has nothing to do with it, Fanny wanted to have the money idle at the Bank and seeing this I always added that I would give her the same 3 per cent the Bank gave her, and that I would produce all the money in 24 hours the moment she found a house. I write to her today and send you copy of the letter. When today I told Marks quite plainly that I considered the whole thing a blackguard affair, especially on his part he said something about "2 years and money not forthcoming etc etc," which leads me to suppose that, besides the bad treatment, I have also been accused by Fanny of something or other in her way. No doubt I am wrong in all I have said and felt, but I am always wrong, only I wish enough all my friends were as right to me as I am to them.[3]

I will call for the negatives tomorrow. When I did call on Mrs. Cowper they never said she was out, they said she was away.

I had not seen Marks for two months and he had taken care not to tell me that Sir W. Armstrong found the picture too large, I fancy this was owing (through something he let fall) to the fact that he was trying to get it for £1,500 which he says you refused. I will take care of the £54 bill. How much do you require for the three pictures? and when will they be ready? Marks tells me that you offered him Proserpine and Lucretia, and any thing else you might have!!!! ? Which of us, Marks or myself? This is quite for you to decide. You may answer that I have done nothing. Quite true, but I have tried damned hard, and when I cannot, no one in this world can except Agnew if he likes, Parsons as you know is shut up, my best man is also shut up through your not sending me the particular Dante drawing. I had to pay up half the money to him in hard cash a week ago, and if you want the clear proof I will send you his receipt this with interest for 3 years which leaves me so hard pressed that I do not know which way to turn the compensation money being all (for the present laid out, and shut up) but don't worry yourself it is enough that I should be worried.

With a weeks notice I will come to you and rest and talk.

Your affectionate
C.A. Howell

I should have thanked you for that fiver, I will send it to you in a day or two.

[1]About half of this letter appears in PRT, pp. 102-03.
[2]I find no postcard.
[3]The point of all this is that CAH had "bought" the pictures from Fanny but had not paid for them. Mrs. Angeli's judgment (PRT, p. 102) is that "Fanny, whom [Howell] seems sincerely to have wished to help in money matters by selling her pictures for her, behaved badly towards him. This seems to have been true and is not difficult to believe."

352. DGR to CAH Kelmscott
 10 April 1874

My dear Howell,

Really this question about the Elephant[1] and her portrait is one into which I cannot enter. You may be sure that when £100 in solid coin is offered to the Elephant, she will not wait for other possibilities. Moreover I clearly remember your saying to myself (and writing too I think) that this drawing was less valuable than the others to you, as being too absolutely a portrait. Do not let us be setting up grievances about what really matters particularly to no one. I assure you I was <u>excessively</u> annoyed at finding that lame Knewstub water colour[2] in Graham's possession (whither I could myself have transferred it at any moment and got the profit, had I not most strongly, as I told you beforehand, objected to his having it); but even on this <u>very sore</u> point, having once mentioned it, I let grievances drop. I now have the thing here and shall have to repaint it. The only thing will be to take care there is no opportunity for the same thing to happen again. Do you the like, if you think it necessary, in the Elephantine question.

I am sorry you took Brayshay down to F.'s. I do not know him, and do not take every one there myself.

About Marks and my pictures, thus it stands. If the dialogue is to be as follows:--(Howell <u>loquitur</u>.) "I offer to buy such pictures as you have to offer at moderate prices out of hand, and to send them to seek other purchasers afterwards as my property." (Marks <u>loquitur</u>) To the same effect:--Then Gabriel will reply: "I accept the offer of Howell."

But if the dialogue is to turn thus:--

(Howell <u>loquitur</u>) "I do not find myself able to buy such pictures as you have to offer for cash out of hand, but will undertake to send them wandering after purchasers as your property with my best efforts to place them."

(Marks <u>loquitur</u>) "I will buy your pictures for cash out of hand, and will only send them wandering as <u>my</u> property."

Then Gabriel must reply:--"I accept the offer of Marks; seeing that I never did in my life send any picture wandering after a purchaser as my property, nor even consented to submit one for inspection beforehand at a distance to any recognized customer of mine, and that I cannot begin to do so now."

As to my having spoken to Marks on the subject when he called accidentally on Dunn in London (without knowing I was in town) it arose from my mentioning--what he knew already--the untoward break-up of the Parsons connection. The question then arose about the fresh destination of the picture Parsons had, and as I judged from what Marks said (and his possession of my <u>Siren</u> drawing and purchase of F.'s portrait) that he would be disposed to buy for <u>cash</u>, I sounded him on the subject. That I had no intention of breaking with you unless I found <u>cash</u> transactions unfeasible between us, my subsequent letter to you will show. I have been trying for some weeks or months past to come to a clear understanding with you on this <u>cash</u> question, but you have never positively replied. Will you tell me now clearly whether you view such a <u>permanent</u> arrangement as possible. In such case you would have my preference as <u>hertofore</u>: but if not possible, Marks is the next person whom I should have to consult as to <u>his</u> willingness and ability to take up the position of a purchasing dealer as regards my unengaged works.

Now about the Dante drawings owing to you. Some time back--about a month ago-- you told me, to my great regret, that you <u>had had</u> to refund the price of them to some one who had bought them of you. You now <u>tell</u> me that this repayment occurred only <u>last week</u>. If on the former occasion you had told me the repayment was not yet consummated, I would have done my utmost to forestall the difficulty by supplying you with any drawings I have by me which could meet the value. I will still do so when I see you here, as I hope to do ere long. At present Hüffer and Nolly Brown are here. In about a week from now I might probably be able to make an appointment.

Will you thank the Lamb[3] very much for a kind letter I received, and accompany my thanks with kindest remembrances.

 Ever yours,
 D.G.R.

You say you enclose me a copy of a letter of yours to F. but there is no such enclosure.

What I say of the Knewstub drawing must not lead you suppose that I set up a grievance to Graham. I said no word tending that way to him at all, but merely undertook to work on the thing.

[1]Fanny.
[2]Surtees 201 R.2, a water-color of the 1867 <u>Loving Cup</u>. (See Letter 355.)
[3]Kate Howell.

353. DGR to CAH

 [Kelmscott]
 Monday, [20 April 1874]

My dear Howell,

I find a picture of mine--<u>Annunciation</u>--is to be sold on Friday of this week at Christie's. I enclose a scrawl which represents the picture I suppose it to be-- the one I lately thought burnt. If it is this, I would like to buy it up to £300, and if you will undertake to bid for me, will send you cheque in time. It will probably go much under that I suppose, but one should try to prevent its going for less than £200.

If you will attend to this <u>pressing</u> matter for me, you perceive it is necessary I should hear from you by <u>return of post</u>. Otherwise it will be no use my writing again.

On the other hand, the picture being Heugh's, it strikes me it may not improbably be merely a water-colour thing of same subject (but quite different design) which used to belong to his partner Dunlop,--only the advertisement puts it among the oil pictures.[1]

 Ever yours,
 D.G.R.

[sketch]

[1]Mrs. Surtees (44) thinks this the original <u>Annunciation</u>, painted in 1850 and sold with the Heugh sale at Christie's, 25 April 1874. Graham acquired it from Agnew and returned it to DGR for revision (D-W, p. 1282).

354. CAH to DGR[1]

 Chaldon House, Fulham, S.W.
 14 June 1874

My dear Gabriel,

Having done you no harm, of which I am aware, I have been waiting patiently till you should complain and accuse me of any single act by which my old and most sincere love for you could be contradicted.[2] You do not do so, and too anxious to be sullen any longer I now ask for your reason for behaving so harshly to your old friend. Respecting that bill I was less to blame than you think, I was <u>unfortunate</u> about it and if ever I have counted on any one in misfortune I certainly have counted on you. The facts are the following I had £184 to pay, £130 was all I could muster at the time, and as a remedy to make up the whole sum I asked you to lend me the bill for £54 which you kindly did. I paid this with the remainder in cash and when the bill was coming due money being short I asked the holder to hold it over for 10 days for me, this he promised to do but broke faith with me and presented the bill. The Bankers answer "refer to acceptor" only means, "I have no instructions to pay" and certainly no discredit to you. Discredit from a Bank arises when they endorse a bill or cheque "not sufficient" or "no account." Thus far I have done you no harm. When Hake came up the second time the bill was paid, and I never knew that he was in town at all until the man himself told me that Mr. Hake had called in the morning. Hake it is true had called on me at two places and written two letters, but I had gone out early in the morning and only received these two letters after the bill was paid and I had the receipt to hand over to him. So far it is right that you should listen to this statement and for the rest I will not even plead my having been <u>distressed</u> for money at the time, but limit myself to begging your pardon most humbly for having been one hour too late in my <u>duty</u>, asking you not to forget that like yourself I have never been a second late in my friendship.

<u>Do</u> write me a line and if there is any thing besides say so. I was angry myself about the bill for it was <u>too hard</u> to think that you (by sending Hake up you seemed anxious) for a moment even thought me capable of allowing any bill or liability of my own to fall on your shoulders.

About your work you know that I have done my best, and that if I have not been able to buy at the time, and every time, it has never been my want of inclination but simply want of money. When I have been able to manage any thing in the way of business I have not been fortunate and if you will allow me to show you how far things have gone wrong with me I am sure you will admit that I have some reason for what I say.

Twice I have obtained money from Valpy for two distinct batches of drawings by you, you have always paid him well and given him good money value, but as you know I have gained nothing i.e. I never have bought them of you for £100 and sold to him for £200.

He has been kept years waiting and during that time his door has been shut against me for advances for every thing else.

Next I sell him the big picture with your consent and take a lot of his rubbish to facilitate the sale, you pay me for so doing it is true, but before two months expire you withdraw my contract and I find myself in a horrible position.

Next I arrange the Parsons affair two pictures are bought on easy terms i.e. without their being seen etc etc. The second you send Proserpine you declare to Parsons is your "best work," both he, his partner and buyers fail to see that you have done yourself justice and then comes the row. When you get the picture back you yourself write to me and say "This Proserpine is really bad and won't wash." Well whose fault was it?

The other day, i.e. when I went for the negatives Parsons showed me part of a letter from this confounded partner of his in which he said, "Howell was a fool in this matter, had he procured for us a good Rossetti he certainly might at any time have had from me £3000 or £4000 for works by him, but after this failure nothing more can be done."

The Dante drawings I borrowed the money at 15 per cent to pay you for them 4 years ago. I have sold them twice, and have had to refund the money twice and now no one believes that I have them or ever had them, and by the time you let me have them one way and another they will have cost me about £350.

Mary Magdalene with your knowledge I save it from Christie I take it from Clabburn with a B. Jones for hard cash and sell it for cash price £220 to Brayshay and he now falls on me saying that you write yourself saying that it is so bad that it is only fit to burn.[4] Now is this helping me, what position can I hold respecting your work when in my hands?

You say I sold the Siren to Marks!!! Such is not the case. Marks stuck to the Siren as security for £160 being the half of a transaction for which he advanced the money, and here I must tell you that it was not Marks or any one else that saved your pictures at Christie's,[5] it was myself and Agnew, notwithstanding your having given it to Marks, and his going straight off to ask my man to bid against him for it,(which by the way my man refused to do) I determined to do my duty by you, and saw Agnew (William) the day before the sale and settled the matter. And here I may tell you that both pictures were Agnew's long before they went to the sale room, that Graham knows this, and Marks does not--that a man like Marks never can help you, that the only one who can is myself and that I do not say so to bring you round. I do not wish to gain any thing by you, if you think Marks or any one can serve you better well and good but this believe that if you never write to me again, I shall always do my duty by you and by your work and that though my friendship is worth little, I am the most sincere friend you have in this world.

<div align="right">Your affectionate
Charles A. Howell</div>

I have Mrs. Cowper's negatives now quite safe here with the others.

[1]Excerpts from this letter appear in PRT, p. 103.
[2]On 10 June DGR wrote to F. M. Brown that he was expecting a visit from Leyland and asked FMB to come at the same time. "You see," he wrote, "I had thought of asking Howell to meet him, but have dropped that particular H. lately, and don't know whether I shall pick him up again..." (D-W, p. 1292).
[3]See following letter for DGR's comment on this point.
[4]This history differs from Mrs. Surtees' history of Mary Magdalene at the door of Simon the Pharisee (109 R.2), the only one which she connects with Clabburn, but she mentions "one, or possibly two, oil replicas [which] appear to have been begun in the early 1860s." See also Letters 356 and 359.

On 24 Apr. DGR had written to Marks authorizing him to bid on The Annunciation
and The Two Mothers at Christie's (D-W, pp. 1274-75). On 20 Apr. (Letter 353),
however, DGR had asked CAH to bid on The Annunciation for him. In Letter 356
CAH speaks of receiving a letter threatening to "withdraw the matter of the
pictures" which "drove [him] quite wild with rage." The context makes clear
that the reference is to the pictures at the Christie auction.

355. DGR to CAH [Kelmscott]
 16 June 1874
Dear Howell,
I will tell you exactly why I quite ceased writing.
 Firstly, for months before then you had almost ceased writing, and when I
wrote, no answer came to important questions either altogether or else for long
together. I choose to write to no one who will not take as much trouble with
the correspondence as I am willing to do.
 I was also irritated at your unmeaning fuss and violent language about those
things of Fanny's,--your absurd pretension to have given her the portrait
drawing long before your bargain for the mass of things was nearly concluded,--
and your equally absurd pretension that in any case whatever she had not a
perfect right to sell it to whom she pleased. Besides, to speak plainly,--who
is there--and above all what person such as F.--who would have placed the
least further reliance on your word after the utter neglect and contempt with
which you treated her in the paltry affair of Marks's £6 cheque?
 I was also greatly irritated and discouraged as to future transactions by
your direct contravention of our distinct engagement as to that Loving Cup daub
not being sold to Graham.[1] It is no use to say that such prohibitions ruin your
market,--you had no need to buy the thing in that case, as my stipulation was
made and agreed to most distinctly beforehand.
 It is no use beating about the bush relative to the trumpery bill question.
The facts are, that you knew perfectly well that I should be willing to renew
with you if you could not meet it, and you should have arranged this in time;
that when it came to the point you were out of the way on all occasions
(repeating all the time more than once that the thing was paid!) and that the
bailiffs were on the very point of being put into my house (as George
ascertained) when at last you were got to pay. The reckless trouble to which
you put me was beyond words; and had not George happened to be here to help, I
suppose I must have done it all myself. As it was I was from £5 to 10£ out of
pocket during George's 2 journeys by accessory expenses.
 About the Dante drawings I have said before and repeat now (and moreover you
know perfectly) that if at any moment you had really given me to understand
that you were in any serious difficulty about them, I should have met it, as I
do always in such cases, at the first possible--not at the last impossible--
moment--and taken care to be in time.
 I was about to write to Valpy to come to an understanding. Can you tell me
clearly how matters stand with him? As for the contract being "withdrawn" (as
you now say) this is the first word I hear or dream of in any such way. You
say too "withdrawn by you" (i.e. by me). Any break in the matter (which did not
in the least amount to withdrawal) was brought on solely by your proposal to
go and try to effect a better sale during V's absence in Germany. It is now
necessary I should understand clearly and without delay from Valpy himself or
from you how I am situated with respect to this matter. I have already long
ago paid to you on the sale what you admitted to be an extremely handsome
commission.
 You state with points of quotation that I wrote you relative to Parsons's
Proserpine, "This Proserpine is really bad." I never used any words of the sort,
nor would they be true from myself or any one else. You must know that I have
mines of memory and am always perfectly clear as to what words I have used on
all occasions. So far as the picture is a failure, it is so because I took too
much pains with it; and at the time I said it was my best I honestly thought so.
 As for talking of any one having "saved" my picture of the Annunciation at
Christie's that is all nonsense. I had taken care to be well assured that it
could not possibly come to grief. It is impossible Agnew could have had it for
long, or he would certainly have offered it to Graham.
 You see I have spoken quite plainly on these points. It is not because I have
taken to hating you in consequence of them, for I regard you just as I have

always done; but it is much better to speak plainly. I have no value whatever for friendships in the abstract, and am of opinion that the first duty of one friend to another is never to leave him in the lurch.

<div align="right">
Ever yours,

D.G. Rossetti
</div>

[1]See n. 2, Letter 352. (Mrs. Surtees quotes this paragraph.)

356. CAH to DGR[1] Chaldon House, Fulham, S.W.
 18 June 1874

My dear Gabriel,

Your letter comforts me so far that it brings me the assurance that you do not hate me, and regard me just as you have always done. It is quite true, the first duty of a friend is never to leave his friend in the lurch, and here I must ask you, when have I left you in the lurch? If I have ever lurched you it certainly never entered my head that I was either doing it or would ever do it. Every thing you have ever asked me to do I have done to the best of my ability and with such delight that I have never regarded trouble, or time or cabs or any other small expenses this I mention through your complaining that I put you to from £5 to £10 expenses in the matter of that cursed bill, every farthing of which I wish to pay and if George will kindly make out a little account and send me the total I will at once either send you the money or place it to your account, and here I must blame George and Dunn in this matter. The lawyer charged 10/6 for writing to you and to me for I got just the same two letters that you did, this I paid, and when in the evening I handed over to George the receipt for the whole thing the first thing I did was to press him on the subject of his own expenses, he said £2, this I gave him at once, and had he said £10 he would have had it just the same for I did not wish and do not wish you to be one farthing out of pocket. Then for friendship and partly because I did not wish to appear unmindful of any trouble he might take on my behalf I gave him the little Greek fragment which you did not want, and a little Millais drawing the two costing me over £20. I only mention this in proof of my anxiety to do my best. It was he who did me the favour in accepting them, but I hate to be considered shabby when I am no such thing either by nature, or idea of taking care of myself. Then it is careless on George's part to say that the bailiffs were on the very point of being put into your house for there is not a particle of foundation for the assertion. What the lawyer did tell him was that had he not called or the money been paid that day (which it was) he was going to issue a writ, the writ would have been against me I having disclosed that the bill was mine and not yours, and you would have received a copy of said writ. Now a writ is not bailiffs, it is simply an order to pay in twelve days or to show cause why you do not do so, you could show that the bill was mine and a favour bill, and having a house of my own and a good one, the bailiffs would come to me, and not to you, besides it takes 3 weeks for a bailiff to be put into any place after service of a writ and so far you were quite safe. Unfortunately I must claim to know much more about it than George or you, and if he is ignorant of the law he certainly had no right to lead you into a belief for which he had not the slightest ground to go on. It was all Dunn's fault George coming up the second time. Dunn received the second letter to you, and I received one also, he at once wrote to me (in the evening), saying "here is another letter, please answer what I am to do, or I must telegraph to Rossetti." Well I telegraphed back to him. "The money is here" or something to that effect, "don't telegraph to Rossetti," simply because I did not wish to cause you any further annoyance or trouble, but he knowing that his letter would only reach me at 8 in the morning by the first post, telegraphed to you at 7 - !! Showing as plain a piece of humbug as I ever saw.

Of course I knew that you would help me, and renew the bill and the proof that I did not wish to lurch you is that I did not ask you. I wanted to pay it and free you, knowing very well that a bill either mine or your own always worried you.

Again I am never out of the way in any money matter, the first time George came he found me in my yard cleaning tiles, and spent the day with me, the second I was out, and never knew he was in town until I went to pay the bill, and the lawyer said Mr. Hake had been there. On arriving at home after paying I

found enclosed letter from George, and another like it at another place I then took a cab and went straight to him at Cheyne Walk.

This letter I confess drove me quite wild with rage, the threat to withdraw the matter of the pictures was really without parallel. One would think on reading it that I was going to make thousands by the affair, instead of which I was only going to lose a day at Christie's and oblige you. Perhaps George meant to say, if you cannot meet the bill at least mind you go to Christie's and see to the picture.

Be this as it may, I had done all the night before. And here I will tell you all about it, trusting that all I do say on this, or any other subject remains with you. I know all--always--that is going on, and if I talk about it, I may get not to know, this would not benefit you and would certainly hurt me. So here goes.

Agnew certainly had the picture long before the sale. Perhaps he did offer it to Graham, and Graham refused it, perhaps Heugh offered it to Graham and Graham refused it, certain it is that Agnew never offered it to Graham just before the sale or after it until he had your letter asking him to keep it for Graham and thus enabling him to sell it for over three times what he originally gave for it.

Agnew bought all Heugh's Modern and English pictures direct from him for a sum on condition that Heugh would allow him to sell them at Christie's in his (Heugh's) name. To this Heugh agreed, and the whole thing was a plant to enable Agnew to dispose of such as obtained fair paying bids, and to buy himself all that did not, this on fictitious bids which would save his reputation respecting the prices at which he himself had sold most of them to Heugh.

After telegraphing to you I went in the evening to meet W. Agnew himself at Christie's and before Christie himself Agnew offered me the Annunciation for a covering bid of £250 no matter what price it fetched at the sale, as it could of course not be withdrawn. Seeing which way the wind blew, i.e. that Agnew was funky respecting the result, and would rather gamble it out there and then, I at once had my gamble too, and answered, "I should be only too glad to buy the picture at such a price, but could not do so having a letter from a friend commissioning me not to lose it at the sale under £350. Immediately after he led the conversation to Graham saying he heard that he was in Portugal. "Yes he is" I answered eagerly and from that moment it was a settled thing that I had orders from Graham to buy the picture.

I went to bed quite satisfied knowing that for once I had been equal to Mr. Agnew and that the picture was all right. I never went near the sale, but I had my two men there, the first bid for the two mothers[2] was mine, with orders to drop the picture the moment it was covered, and for the Annunciation I never bid at all, Marks never bid one shilling in fact no one did except Agnew and his man Johnson who for 10/- a month sells himself and every one else in the way of information and can always tell you every thing about every one except myself simply because I only pay him to know and not to do any thing for me. I also have mines of memory and I never said I had saved the Annunciation I only said I had done my duty by you in spite of every thing.[3]

The picture I said I "saved" from Christie's is the Magdalen, and that I have done twice. I know very well that you can assure your market in any sale room but you can only do it, by buying the picture yourself and paying for it in hard cash which may not always be desirable or convenient, and my idea has always been to get to do so without the cost of a farthing to you.

When I have to do a thing of this kind for you, do you suppose that I am such a fool as to go to any one and say Rossetti wants this done? No I say it does not suit me to let this picture go under so and so, and thus you remain free of the least suspicion of backing your own work.

What is the result of writing on any thing like this to Marks? He takes your letter straight to Brayshay and asks him to go and bid against him. Brayshay comes to me astonished, and I could almost tear my hair at the folly! Now mark you, not a word of this to Marks or to Brayshay, Brayshay has pledged me his word of honour that he will never mention it to any one and I have in turn pledged my word that Marks shall never hear it through me. So mind, and let us be careful in future. I have serious business often with Marks and it does not suit me to indispose myself with him for a thing that is past and gone and which really does not concern me since Marks has never opened his lips to me on the subject.

Graham I may also tell you for your guidance, has kicked like mad at the price charged him by Agnew and told me that it was "most preposterous," but that "his regard was for you, and not for Agnew and that had it been double he would have paid it simply because it concerned you." Of course he knows nothing respecting my ever having had any thing to do with the picture or Agnew all he does know, is about the contract between Heugh and Agnew and this of course he knew long before I did from Heugh.

It is quite right for you to say plainly all you have to say, there is nothing that discourages me more than to hear complaints (not that I have ever heard them from you) against me, without a word to me, or sign of any thing being amiss.

I will go on writing tonight as I am anxious to catch the post, and have to go to Valpy's. Every thing will be all right.

Your affectionate
C.A. Howell

[1] The first several sentences of this letter and the penultimate sentence appear in PRT, pp. 103-04.
[2] I.e. Two Mothers, an oil of 1852 (Surtees 53), listed by Mrs. Surtees as Lot 152 in the Heugh sale of 25 Apr. at Christie's [The Annunciation and The Two Mothers].
[3] It is a little difficult to unscramble the truth of all these assertions. In Letter 354 CAH did say that he had saved Mary Magdalene, "with your knowledge," from Christie. But he also wrote, apropos of DGR's accusation that he had sold the Ligeia Siren to Marks, "Marks stuck to the Siren as security for £160 being the half of the transaction for which he advanced the money, and here I must tell you that it was not Marks or any one else that saved your pictures at Christie's, it was myself and Agnew...." And in his conclusion to the letter he wrote, "...I shall always do my duty by you and your work...."

357. DGR to CAH [Kelmscott]
 Friday, [19 June 1874+]
My dear Howell,
It is no use going further over dead and buried matters. However, your statements about the sale are so strongly various that I will note a point or two. At the time the sale occurred you distinctly told me that the Annunciation belonged a month before to Wynn Ellis,--now you say Agnew had long had it. The picture was most certainly never early offered to Graham by Heugh or Agnew, for only shortly before the sale G. was expressing a wish to have seen it, I having reason to suppose it burnt, and he must have recognized it by what I said if he had ever seen it.

Lastly your statement that Marks never bid at all at the sale! Why say so? George and Dunn were there and saw him bid. And what ever should make Agnew go up to that price if there was no real bidder against him?

I judge by your last few words that I shall hear tomorrow as to the only point that I named worth further talking about--and that most necessary to talk about immediately,--viz: the Valpy matter.

A stupid muddle has been occurring about that little Lucrezia Borgia that I took back from Leyland. Seeing by an advertisement that Leyland was selling some pictures last Saturday (and didn't he just make a haul with that stupid Leighton of his! The frame did it!) I asked him to father this little L.B. as his and sell it with the others--it remaining in reality mine of course. By some inexplicable muddle (for I am sure it was sent in time, and Leyland himself wrote explicitly to Christie's, as well as George to Christie's when it left here), it never appeared in the sale.[1] Would you call at Christie's and try to find out what has become of it without delay, as I have reason to think they will be for sticking it into some other sale which might be very unadvisable, unless a promising and creditable one like Leyland's. Please do this and let me know at once. I write to Leyland with this, asking him to send me an order on Christie's withdrawing the picture, which I will send on to you the instant you let me know you think it desirable to do so. Of course my name has never been mentioned in the matter (unless Leyland did so in writing them without my knowledge). George simply sent the thing from here as Leyland's.

Ever yours,
D.G.R.

[At top of last page:] Please do not delay in seeing to this.

[1]Mrs. Surtees accepts Dr. Williamson's explanation (pp. 70-71) that the picture was sent to Christie's and that George Rae saw it in the sale room and purchased it at once, thus accounting for its not appearing in the auction. This account, however, is contradicted by DGR's letter to F. M. Brown (D-W, p. 1303, dated ?7th July 1874): after saying that CAH had spent "last Saturday to yesterday morning" [presumably 4-6 July] at Kelmscott, he continued, "I have written offering the Borgia drawing (which H. brought with him) to Rae." CAH's explanation in the following letter appears to be the true story.

358. CAH to DGR Chaldon House, Fulham
 20 June 1874
My dear Gabriel,
I write this at Christie's. Natalli says (he is the principal fellow under Christie) that Leyland sent the picture in as your property with a reserve of £100. They have included it into a rather mixed sale and I will post you the catalogue at once. Christie says you can if you like without the slightest ceremony withdraw the picture at once. Send me your instructions at once.
 I can go on sending you £50 every month or pay it regularly into your account on account of the large picture,[1] and on delivery of the picture Valpy will pay you up the balance of the fifteen hundred guineas--the £50 of course comes from Valpy.
 I am dead with tooth ache, can scarcely see and only come out to see to Lucretia. Tonight in bed I will finish my letter to you. If you want £100 at once instead of the first £50 you can have it.
 Your affectionate
 C.A. Howell

Natalli says Lucretia came too late for L's sale.

[1]Dante's Dream.

359. CAH to DGR Chaldon House, Fulham, S.W.
 21 June 1874
My dear Gabriel,
I have been suffering most horribly from neuralgia without sleep or rest of any kind. I wrote yesterday as I could, and only hope you understood my letter. I only go over dead and buried matters in justice to myself and in the hope that you will never bury any thing concerning myself under a wrong impression for to change any thing wilfully you are not capable. Agnew bought the pictures of Heugh four months ago and with them the Annunciation, as well as the "two mothers"[1] which really belonged to Dunlop he having bought it some six months ago.
 It is quite possible that Graham never saw the Annunciation at Heugh's for he lives at Tunbridge Wells and Graham never goes, he certainly never saw the "two mothers" before for he asked me what I thought of it. My authority for saying that Agnew offered the Annunciation to Graham before is Johnson who said "What a funny gentleman Mr. Graham is, when Mr. William offered him Mr. Rossetti's Annunciation he would not buy it, and the moment Mr. Rossetti writes to Mr. William he takes the picture for double the price!!"
 Even of this I spoke guardedly I only said perhaps Agnew did offer the picture to Graham?
 My impression nay certainty is that he did, and I feel sure Graham must have refused it on the ground of price, and having it now did not care to tell you about it.
 Now about Wyson Ellis, it was at Agnew's that I met him now some 3 months since, for it must be longer than that since the fire took place, I said "Oh Mr. Ellis I am so sorry to hear of your great loss, did you lose your little Rossetti that you had from Pearce?" To which he answered "Oh dear no, I only lost some rubbish, i.e. the forged pictures which went from the sale room to the Pantechnicon because I could not see them again, all my good things are safe thank God at Cadogan Place." Of course I wrote to you at once saying the picture was safe, and so it was, only Ellis never told me he had exchanged it,

and from his answer I concluded what you would have concluded, viz that it was safe with his "good things."

About Marks I did not go to the sale as I told you, and my authority for saying that Marks never bid at all is Marks himself, and my two men who watched him all the time as they do every one. I said to Marks on his observing what a "wonderful" price the picture had brought "How far did you bid?" to which he answered "I never bid at all I had no chance, I only bid for the "two mothers" and that was started at £40 over what I thought I should have got it for myself

Believe it or not just as you like the only thing that made Agnew bid up was my declaration that I had a commission to buy it for £350 and his thinking that it was for Graham, as to bidding Johnson is quite ready to tell you that "no one bid between him and Mr. William," and I believe Johnson in preference to Marks, besides Marks says he never did bid. Besides Agnew has often carried a picture which has stopped at a bid of £300 to 1000 guineas especially when the picture is his own, he only pays Christie 2% and of course it pays him, for at the worst he sticks it into some one "for what he paid at Christie's" and of course makes £700 more than he would by auction, do you think this foolish? I bought a Martin[2] at Gillott's sale for 45 guineas and a man in Bedford offered me £20 for it! "Good heavens" I said "Why, I paid 45 guineas for it at Christi at Gillott's sale!" he asked me for the catalogue which I sent him, and he sen me £60 for the picture!!

This Christie is the devil, I hear of several chances of things of yours coming to the hammer all through the Annunciation and if you wish to keep safe they must all be backed. Indeed it is a splendid game for you and worth every sacrifice, back up any thing that may come on for the season, and for years to come men who buy for investment will keep the things and buy more. In fact it will quite make your market.

Now about Valpy when I said you were off the bargain I quite believed it, an did not know which way to turn or how to face Valpy, my reason for so believir being that when I last dined with you you said "I shall not sell the picture f 1500 guineas it is worth £3000 and I will not let it go." At least so I understood it, and being only too happy at being with you I did not wish to sa any thing but left Cheyne Walk worried and not knowing which way to turn.

I had sold the picture to Valpy for 1500 guineas only on condition that you found yourself able to complete the replica in a twelve months. This I did to leave the door open to £2000 or £3000 and delay of replica in case I could get it. Valpy agreed to sell water colours and be ready at the end of the 12 month if needed with the 1500 guineas. Well you have taken the load off my shoulders and I have been to Valpy, and said "replica is going on like steam when can yo begin to pay?" "£50 a month and at once," answered Valpy. "Can you arrange wit Rossetti for such small instalments as an old friend, being poor, and only soaring above in consequence of dust and weariness, and the longing for peace and a rise, and the necessity of going up now that my poor mother is gone and the wife longs for that which before was a blank?" I was too bothered to be touched, but I said it was sad and no doubt you would be willing to fetch him up and comfort the family by taking any cash that might be available and here the matter rests.

I cannot write more I am in awful pain, in fact I cannot write at all.

> Your affectionate
> C.A. Howell

[1]See n. 2, Letter 356.
[2]Of the several Martins who were artists, I suppose this one to be John Martir (1789-1854), historical and landscape painter.

360. DGR to CAH [Kelmscott]
 Sunday, [21 June 1874][1]
My dear Howell,
I am writing rather hurriedly to Sandys asking if he could come down from as soon as possible to Friday next. After that I find I shall have a large family and Brown party filling the house, so am trying to get him meanwhile, as I war much to see him after a most friendly letter he wrote me about Proserpine, in which he expressed an intention of coming. Perhaps you would come with him-- What say you? We could then talk over several things and you could find yourse drawings.[2]

I am very sorry for your toothache and much obliged for your trouble on my account. I don't fancy this 29th sale at Christie's is at all promising, is it? If you think the thing really likely to go over the £100 put on it, I will leave it in--otherwise would ask you to withdraw it at once, as I think I might place it in a quarter which has occurred to me.³ Of course I never meant Leyland to mention my name in the matter, but distinctly asked him to send it as his and cannot guess why he did otherwise nor ever knew he did till now. No doubt it is most injurious to be known as sending one's own things to a sale room. Before sending it in, I worked again a good deal on it, and it is really now very good--should be worth a fair price.

Thanks about Valpy. You see I think (do not you?) that there should be a written agreement drawn up now between him and me for his purchase of the Dante's Dream at the price of 1575£. Besides this there is the question of the frame which cost Graham close on £100 if not quite that. I know G. will not like to pay a new frame for the replica. Would not the best plan be for the replica frame bill to be sent to Valpy by F. & D.? (it must be much less than the big one,) and for him to pay that?

I should be glad to commence monthly payments on the plan you indicate but hardly think it wise to do so without an agreement which seems necessary on both sides. Either V. or I might die. Moreover I want to know, when does V. expect delivery of the picture?

It is a strange fact that I am hard up, and that the £100 as opening payment from Valpy would be welcome when arrangements were ripe.

<div align="right">

Ever yours,
D.G.R.

</div>

Trains to Lechlade
Dep: Pad: arr: L.
 10:13 1:10
 2:15 5:30
 6:30 9:40

¹Erroneously dated 21 June 1875 by CAH.
²CAH's visit was delayed until 4-6 July.
³A reference to the Lucrezia Borgia.

361. DGR to CAH [Kelmscott]
 Monday, [22 June 1874+]
My dear Howell,
I may as well send you on Leyland's order on Christie's though (as you tell me) not needed in case you think it wisest to withdraw the little picture. Should you on the contrary leave it in, of course the greatest care must be taken that the reserve of £100 is placed on it as a first bid. I myself incline to suppose the sale unhopeful, and therefore to withdrawing it, but not if you think otherwise.

I am extremely vexed to hear again through George of your plaguing toothache. I know what it is from of old. I fear it is likely to prevent your coming down. From Sandys I have no news as yet.

One other matter necessary to consider with Valpy is this. When I am myself fully at work on the replica and making it my chief or only occupation, I shall need supplies in a much larger proportion than £50 a month. This should be thought of in arranging.

<div align="right">

Ever yours,
D.G.R.

</div>

362. DGR to CAH [Kelmscott]
 Tuesday, [23 June 1874+]
My dear Howell,
Two points are untouched in your letter. First, the Sandys matter (I enclose a note from him received this morning) and second the advisability or otherwise of withdrawing the little picture at Christie's. Perhaps I shall still see you tomorrow with Sandys. In haste

<div align="right">

Ever yours,
D.G.R.

</div>

363. DGR to CAH [Kelmscott]
 Thursday, [25 June 1874+]
My dear Howell,
By all means come on Saturday--perhaps the journey will drive out the last
remains of neuralgia. If the Lucretia is not sold before then, better bring it
with you perhaps, and I will see about sending it to Rae, as I fancy he would
buy. I can't very well afford to sell it for less than I paid Leyland.
 Watts the lawyer is likely to be here on Saturday and Sunday I believe, but
no doubt you know and like him.
 Trains from Paddington to Lechlade are 10:10 2:15 5:40. There are none on
Sunday to Lechlade, but there are to Faringdon. However your plan of coming
on Saturday is much best and needs no consideration of this point.
 Hoping to see you, as I have much to talk about.
 Ever yours,
 D.G.R.

As to Valpy, we could consult Watts when you come. But of course V. as a lawyer
would wish to draw up any agreement himself, and might not like to know that any
other lawyer was even spoken to.

364. DGR to CAH [Kelmscott]
 Saturday, [27 June 1874+]
My dear Howell,
I am extremely sorry for your continued illness. I believe now that Tuesday or
Wednesday next would suit me best for your coming here if feasible to you.
 As you wrote me on Tuesday last--i.e. 2 days before the pictures for that
sale were even on view--that you meant to withdraw the Lucretia, no doubt you
then did so; but if I could have had that fact in 3 plain words, it would have
enabled me to know how the matter stands.
 Ever yours,
 D.G.R.

P.S. If the thing is still by some oversight in the sale on Monday, at least
let us try and make sure it does not go for shillings.
 Love to Kitty.

365. CAH to DGR Chaldon House, Fulham, S.W.
 29 June 1874
My dear Gabriel,
You have no notion of the anguish and agony I have been going through, literally
crying with pain day and night, and so sore all over body and head that even if
I can come down it must be to lie down. These last few days I have got so thin
with suffering that my clothes quite hang on me. I expect Williams[1] every
moment--thought it better to send for him, and if he says I can go I will come
down on Wednesday if not I will telegraph to you and come with Leyland.
 As I told you I went at once and stopped the sale of Lucretia but as the
order for the picture was to Hake they required his endorsement for delivery.
I went on to Chelsea having heard that George would be in town that evening but
Dunn knew nothing about it. Get George to send a line to Christie's saying that
he has already sent them Leyland's order through me, and now writes to say they
can give me the picture. They require this for their file as a receipt.
 When I come down we will draw up something for Valpy.
 I think I can get you the £120 for the picture but if I cannot and you like I
will buy it for your reserve of £100 and pay you £25 a month, I cannot send you
all the money because I am so stumped with the workmen here.
 Your affectionate
 C.A. Howell

You are not to make ceremony about Lucretia if I fail for the £120 and my
arrangement does not suit you, say so. I will of course pay Arthur[2] he is doing
this house now.

[1]His medical man.
[2]A builder who had made the couch for which DGR received a bill.

366. DGR to CAH [Kelmscott]
 Tuesday, [30 June 1874+]
My dear Howell,
George is sending you with this a letter for Christie's. I hope the result will
not prove to be that, not getting such letter before, they left the thing in
the sale. We can see about further sale of the picture if once recovered.
 It seems to me there can be no need of your telegraphing if you do <u>not</u> come
tomorrow, but only if you find you <u>are</u> coming in a hurry. In that case a
telegram might be necessary. Brown and wife are here at this moment, but will
be leaving tomorrow evening. Their being here need not of course interfere with
your coming down, as there is plenty of room.
 The <u>Ghirlandata</u> drawing[1] is here (3 heads in it) and others we might see
about <u>if you like</u>.
 Ever yours,
 D.G.R.

[At top of p. 1:] It is most woful to hear of your suffering so horribly with
neuralgia.
[At side of p. 2:] If tomorrow does not suit for your coming, say what day
would, and <u>do</u> let me know when the picture is safe in hand again.

[1]Surtees 232A, a colored chalk of 1873.

367. CAH to DGR Chaldon House, Fulham, S.W.
 1 July 1874
My dear Gabriel,
I was out in the garden yesterday, and today am going out straight to Christie's.
The sale was of course stopped, the new order only regarded the delivery of the
picture. I will add a line to this note at Christie's saying if I have the
picture safe.
 Williams says I must not go down before next week but if it suits you I will
run down on Saturday (next) in the evening stay the Sunday and return on Monday
morning. What say you?
 Your affectionate
 Charles A. Howell

All pain is gone but I am as weak as a cat.
P.S. I have <u>Lucretia</u> safe and sound.[1] Will try and sell it tomorrow morning.

[1]If so, George Rae could not have seen the picture in the salesroom and bought
it immediately. (See n. 1, Letter 357.)

368. DGR to CAH Kelmscott
 Wednesday, [15 July 1874][1]
My dear Howell,
I am obliged to put off Sandys after all--being unexpectedly called to London.[2]
I shall try to see both him and you there if I stay at all. Don't tell people I
am coming, as I don't want to be besieged.
 Ever yours,
 D.G.R.

[1]Dated 14 July 1874 by CAH, but Wednesday was the 15th in 1874.
[2]By whom, for what? Was it to see Janey Morris before her departure, with
husband and family, for a tour of Belgium? Was it to escape Kelmscott--to which
he never returned--following an altercation with three or four anglers?
According to Doughty (p. 507) DGR's earlier "auditory hallucinations and
persecution mania of paranoia had returned. Strolling one day by the river with
George Hake, Rossetti passed a party of three or four anglers when, fancying
that they had called out some insult to him in passing, he suddenly turned and
attacked them with reproaches and abuse for the supposed outrage." The incident
was noised about, "and finding Kelmscott impossible Rossetti...returned to
Cheyne Walk."
 It has always seemed to me that the simplest explanation of this incident had
nothing to do with auditory hallucinations but that DGR probably did hear or

overhear some remark made about "that painter-feller living up at the Manor with his friend's wife." But this is conjecture. DGR's subsequent explanation, hardl to be taken at face value, appears in a letter of 20 Dec. 1874 to Dr. Hake (D-W p. 1324).

III. "Good-Hearted Fellow and D--d Bad Man of Business"

23 July 1874 to 11 October 1875 (Letters 369 to 431)

369. DGR to CAH 16 Cheyne Walk
 Thursday, [23 July 1874+]
Dear Howell,
I hope you can dine with me tomorrow (Friday) at 7 o'clock. Potluck--but I
suppose I go on Sunday.[1] Watts the lawyer is coming--no one else.
 Ever yours,
 D.G.R.

[1]It is clear that in leaving Kelmscott, DGR did not realize at the time that
it was forever.

370. DGR to CAH [16 Cheyne Walk]
 Saturday, [25 July 1874+]
Dear Howell,
Welch[1] again!
 If I am to continue receiving these bills from the different people whose
debts were included in the bargain for the drawings, we had better cancel the
engagement, as I had rather pay and have done with it.
 Ever yours,
 D.G.R.

 I believe Sandys is likely to be looking in on Monday about 3 to see the large
picture.[2]
 All tomorrow (Sunday) I expect to be busy till evening, but if you can look
in then (after 9 or so) do.

[1]A tradesman submitting a bill.
[2]Dante's Dream.

371. DGR to CAH [16 Cheyne Walk]
 2 a.m., [5 August 1874+]
My dear Howell,
I am désespéré to find your letter. I posted one late last night[1] to prevent
your visit, knowing I should be out; but you seem not to have got it. Now I
post another to say that tomorrow most unluckily I shall be quite taken up all
day and unable to see any one. I hope heartily this may reach you in time to
prevent a fruitless visit,--shall be most sorry if such occurs. Shall write
again to try and fix a time which may suit both of us, as I am wanting to see
you.
 Ever yours,
 D.G.R.

[1]A two-sentence letter saying that he would be "preoccupied" during the following
two days. Two days later DGR invited CAH for Monday (10 Aug.) to stay the
evening.

372. DGR to CAH. Friday, [7 August 1874+]. Inquiring whether frame for Watts's
head (Surtees 529) has been ordered and is coming.

373. DGR to CAH [16 Cheyne Walk]
 11 August [1874+]
My dear Howell,
You see these bills come in one after the other and continue to do so. Before
handing you the Ghirlandata drawing, I must beg you kindly to show me receipts
from Arthur, Welch, and the other tradesmen concerned in the account which we
proposed to cancel. If we cannot manage this, I had rather keep the drawing,
sell it and the others elsewhere, and settle the bills myself, as I hate these
endless applications.
 Yours ever,
 D.G.R.

 If you think of looking in, don't do so tomorrow (Wednesday) as I shall be busy
all day, but other days would probably suit all right.

374. DGR to CAH [16 Cheyne Walk]
 Friday, [14 August 1874+]
Dear Howell,
Would it suit you to dine here Sunday at 8?
 Ever yours,
 D.G.R.

 I haven't yet got that gilded picture[1] done, but shall do it in a few days.
P.S. You told me Valpy was prepared to make a first advance of £100 and then
continue at the rate of 50£ monthly. He may begin that game as soon as he likes.
The replica is already well advanced. Will you see about this or shall I write
him?

[1]A second version of The Blessed Damozel (Surtees 244C); entitled Sancta Lilias.

375. DGR to CAH. Wednesday, [19 August 1874+]. Is anxious about Valpy, wants to
hear about him.

376. DGR to CAH [16 Cheyne Walk]
 Thursday, [20 August 1874+]
My dear Howell,
I wrote yesterday about Valpy. I now write to say that the gilded picture is
finished--so stump up and it is yours.[1] Will you call on Saturday? Tomorrow I
shall be busy all day and evening.
 Ever yours,
 D.G.R.

Price £262-10/-

[1]CAH was obviously unable to come up with the £262/10, and DGR sold the picture
to the Cowper-Temples--see Letter 379--rather than gave it to them as stated by
Mrs. Surtees (244C).

377. DGR to CAH [16 Cheyne Walk]
 Wednesday, [26 August 1874+]
Dear Howell,
I want to know about Valpy and Brayshay. Please let me know,--I hear from and
of neither. If B. does not care to have the picture at this moment, I'll sell
it elsewhere. Perhaps the best plan will be for me to write direct to Valpy now.
 Ever yours,
 D.G.R.

 I'll expect an answer kindly by return.

378. DGR to CAH [16 Cheyne Walk]
 Saturday, 3 a.m., [29 August 1874+]
Dear Howell,
Brayshay may go to blazes.
 As for Valpy, I shall write to him immediately at Lincoln's Inn Fields and no
doubt the letter will reach him somehow.[1] The work is progressing too seriously
for further delays.
 The one result of these serious questions is Welch's bill, for which due
thanks.
 As for the old picture I don't know what sketch we fixed on. Eyre can have
the picture back if he likes.[2]
 I shall be at home all tomorrow and evening. I confess to being rather out of
sorts at all this dangling on of everything to no purpose.
 Ever yours,
 D.G.R.

[1]DGR did write, on 2 Sept. (See D-W, p. 1309.)
[2]A reference to the so-called Pietro Laurati picture. (See Letter 348 and n.2.)

379. DGR to CAH [16 Cheyne Walk]
 22 September [1874+]
My dear Howell,
I am very sorry the Blessed Damozel should not be yours after all: but you know
I never keep my pictures even a day, and not hearing from you for a week, I
sold it to Mr. Cowper Temple, who came in and fell in love with it, and by the
bye, my dear Howell, gave me more than I had asked you for it![1]
 I can now offer you the "Damsel of the Sancgrail"[2] (size 37½ x 24 inches) for
450 guineas, if you like to have it. My price to a private buyer would be 600
guineas. It is a half length figure with hands and with a good deal of costume
&c, and would I believe suit you well. The subject is taken from the Arthurian
romances.
 Ever yours,
 D.G. Rossetti

[1]This contradicts Mrs. Surtees's statement (p. 142) that DGR gave the picture
to the Cowper-Temples.
[2]A variant in oil of the 1857 water-color (Surtees 91 R. 1); acquired by George
Rae. The water-color is inscribed "Sanct Grael," but I follow DGR's spelling
in his letters.

380. DGR to CAH [16 Cheyne Walk]
 Thursday, [24 September 1874+]
My dear Howell,
I judge the enclosed is pretty much the thing, isn't it? The picture I fancy
would be done in about a week--10 days at outside.
 I shall be writing to Valpy now, accepting his terms (as in the letter you
read me) but suggesting that whenever I was really confining myself to the
replica work, it might be necessary for special supplies to be obtainable from
him. I shall also ask him what sum he proposes to pay in January, to last over
March.
 Connecting the cheque I changed with a passage in Brayshay's letter--was it
not sent by Valpy for the purchase of the picture already sold to Cowper Temple?
 I shall be in tomorrow between 2 and dinner, if you can look in any time.
 Ever yours,
 D.G.R.

381. DGR to CAH. Sunday, [27 September 1874+]. Inquiring about a green dinner
service spoken of by CAH. Picture likely to be done within week.

382. CAH to DGR Chaldon House, Fulham, S.W.
 29 September 1874
My dear Gabriel,
No one can be expected to keep a green dinner service for 27 months (as many
have run since you promised to send a sketch value £19 the price of said service)
waiting till the purchaser is reduced to half a plate. On your accepting the
exchange I informed the owner of the fact, and he began to wait, and waited
till he began to dun me for the sketch and then for the money. I paid the £19
and as I never dun any one, I said nothing to you. The other day Grant[1] offered
me 40 guineas for it, and fearing you might ask me to damn the owner and return
him the service, I took the coin and gained £23.
 If under the circumstances you would have done the same, well and good, if
not I am very sorry for it.
 Today I have received enclosed from Shout, after hearing the following from
him some 3 weeks since--"You asked me to send Rossetti some jewelery I did so
at yours and his request, and it was only many weeks after that he sent back
what he did not want without a word on the subject!!" Had this happened with
you on my behalf I should have seen George or Dunn at once and Scott [sic]
would have felt very much offended, as it is it is of course quite right, "damn
Shout, damn Howell and damn every body else concerned."[2]
 Shout's letter shows what a nice fellow he is and I want to pay him, and keep
my credit with him for any thing of any value that I may want (and can have)

out of his shop tomorrow so say if you wish me to send him the coin and I will
do so.

I have seen Brooks[3] and here is what he says. "Very well Howell, you wish me
to have a Rossetti, we will have a stunner, I will give you the money for as
many as you wish, I am now going to send you a fine Millais and you can show
it with your Rossetti, and do something. Tell Mr. Rossetti that I should like
to see his work, this picture and any thing else he may have and see if we
cannot go higher than 450 guineas."

It is now for you to decline or accept. Only please let me know by return.

Brooks says he neither wants Graham or Leyland. Graham has gone smelling
about the place for £20 Leonardo's and Brooks has shown him the cold shoulder,
if he comes after any picture we may buy from you I shall ask £1000 and he can
take it or drop it, more than this I cannot promise. I make say £2000 by old
Masters and it is just the difficulties with modern men that have led me to
work these instead of the old friends who through me might have made thousands
for themselves and for me.

<div align="right">
Your affectionate

C.A. Howell
</div>

Tomorrow I am out of town, but I shall be back early on Thursday.

[1]Presumably "Baron" Grant, né Albert Gottheimer, financier and banker; M.P.
1865-68, 1874-80. As President of a society for the improvement of the city of
Milan he completed and opened the Victor Emanuel Gallery, in gratitude for
which King Victor Emanuel conferred upon him the dignity of Baron (Men and
Women of the time). In 1874 he presented Leicester Square to the Metropolitan
Board of Works.
[2]The letter to this point appears in PRT, pp. 104-05.
[3]A dealer.

383. DGR to CAH [16 Cheyne Walk]
 Wednesday, [30 September 1874+]
My dear Howell,

Brooks sounds well, I admit,--the net result being again Shout's bill!! Now
that brought a damn, didn't it? Never mind, old chap, it's only chaff. I send
Shout his money with this, as there was no talk of its being paid by you.

The picture is nearly finished and quite transmogrified now that the dove
and the foliage are in.[1] Were Brooks to come, I should like to show it finished,
or it would show to disadvantage beside the others. Suppose you were to look in
tomorrow (Thursday) and we could talk matters over. I would see Brooks at a
fit moment if you think it desirable.

I am very sorry to have missed the dinner service, but damn nobody at all.
George has brought the chalk drawing in exchange for early picture,[2] and you
can have it when you like.

<div align="right">
Ever yours,

D.G.R.
</div>

[1]The Damsel of the Sancgrail.
[2]The so-called Pietro Laurati. (See Letter 348.)

384. DGR to CAH. Wednesday, [30 September 1874+]. Damsel of the Sancgrail to
be put by to dry. Must reconsider seeing Brooks.

385. CAH to DGR Chaldon House, Fulham, S.W.
 1 October 1874
My dear Gabriel,

You really must have a little more consideration for me, all this seems like
child's play, and I am kept dancing about from one to another like a fool or
a knave, first with one story then another till people think at last that I do
not know you at all, and that it is all humbug about my being able to get this
or that picture, and very often doubting the existence of the picture at all.
It is not fair to me and compromises and hurts me and you are the very last
man who should place me in such a position.

What <u>am</u> I to tell Brooks <u>now</u>? On receiving your letter I at once wrote to him, and <u>now</u> comes your second letter what the devil am I to say?

Brooks three days ago said "it is strange that Mr. Rossetti should never exhibit." Not [at] all I answered one of these days he is going to exhibit all his fine things together and that is very much better. "Well if he does, and you wish to serve him I will empty my gallery and lend it to you!!"

Damn in all, <u>what do</u> you want? I have tried my best and I must say you do not aid me. New buyers <u>will</u> not buy your pictures without seeing them and you cannot expect them to do so.[1]

Would you buy any thing without seeing it, especially if you saw that every obstacle was placed in the way of its being shown to you?

I do not wish Brooks to come to you, I wish to bring no one, I have never asked, but one thing I do know and that is had I been able to bring one or two men long since you would have had two or three <u>far better buyers</u> than either Leyland or Graham.

Do quite as you please only do not place me in these false positions.

<div align="right">Ever your affectionate
Charles A. Howell</div>

Of course I never said "damn" I never do about any thing you do but I do not see why you who find so much fault with me should not give me a better example in all that concerns you towards myself.

[1]Excerpts from the remainder of the letter appear in <u>PRT</u>, p. 105.

386. DGR to CAH. Wednesday, [14 October 1874+]. Picture finished, asks about arrangement for bringing Brooks to see it.

387. DGR to CAH [16 Cheyne Walk]
<div align="right">Monday night, [19 October 1874+]</div>

Dear Howell,

I wrote hurriedly tonight, but now again write, as I had better tell you plainly that I have asked Lady Ashburton to come here on <u>Wednesday</u> and promised her the Dante picture[1] by then. Thus <u>pray do perceive</u> that <u>it is</u> <u>absolutely necessary</u> she should then have it. Otherwise I shall be forced in my own defence to explain the circumstances to her exactly.

<div align="right">Ever yours,
D.G.R.</div>

[1]As in Letter 389 DGR refers to the picture as a "double drawing," this must be the replica of two panels executed for Lady Ashburton in 1863 (Surtees 116 R.1). I do not know why it should have been in CAH's hands; apparently DGR did not know either, as on 9 Nov. he wrote to CAH, "I never clearly realized why the picture had been removed from here at all." Presumably it must have been returned to DGR for retouching. For CAH's explanation see Letter 396.

388. DGR to CAH [16 Cheyne Walk]
<div align="right">Monday, [26 October 1874+]</div>

Dear Howell,

I have written Valpy, chiefly as I wrote in your presence but with some slight modification--saying however that his plan of engraving is <u>likely</u> to suit me if brought forward at the proper time, but that I cannot forego control in the matter.

He had now much better begin paying I think, as a definite plan on this head, to have been begun with £150 last September, has now been talked of among us for a long time.

How about Brooks? I don't want to plague you, but the picture[1] is eating its head off.

<div align="right">Ever yours,
D.G.R.</div>

[1]The Damsel of the Sancgrail.

389. DGR to CAH Saturday, [31 October 1874+]

My dear Howell,
I believe I have a customer for the <u>Damsel of the Sancgrail</u>. Do you think it
nevertheless still advisable to wait for Brooks's return. I do not wish <u>on any</u>
<u>account</u> to <u>throw you over</u> in the matter or put your plans out.
I hear nothing as yet from Valpy, and so judge that he probably expected an
answer to his letter before sending cheque, and shall write a brief one today.
Lady Ashburton has been enquiring about that double drawing of hers which is
in my hands.[1] Dunn says he will call on Monday and bring it away, as it
requires that I should complete some retouching which I began on it before it
returns to her.
Tomorrow I should be at home but I know Sunday is a bad day to bring you out.
All Monday I shall be very busy--other days free I believe.
 Ever yours,
 D.G.R.

[1]See n.1, Letter 387.

390. DGR to CAH [16 Cheyne Walk]
 Tuesday, [3 November 1874+]
My dear Howell,
I must really beg that Lady Ashburton's picture be at once returned. I have
been asked for it urgently and <u>must</u> give it to the owner <u>at once</u>, and before
doing so it is necessary to complete the retouching I commenced. I do not
understand its having been lent to a third person; but wherever it is, pray let
me have it now.
As Mr. Brooks is· now in town, an arrangement had better be made <u>at once</u> (had
it not?) for him to come here. If many days more elapse, I must accept the
other offer for the picture.
How about wine? There is not a glass of that fluid in this house. If we are
to have a regular engagement on this point, promptitude is necessary. George
proposes to look you up tomorrow (Wednesday) and try to get a few bottles at
any rate!!!
 Ever yours,
 D.G.R.

391. DGR to CAH [16 Cheyne Walk]
 Wednesday night, [4 November 1874+]
My dear Howell,
I shall be glad to have the Irish Harp for £8. Thanks.
I have been thinking that, with all these delays, perhaps the best plan would
be to place this Sancgrail picture elsewhere and let Brooks come when he can
and see the· other things here. However I will not sell it elsewhere till after
end of this week, in case you would prefer his having it. Friday Saturday or
Sunday would suit me for a visit from him, but not tomorrow (Thursday). However
I dare say you would let me know when to expect him.
I saw poor Brown tonight. Nolly[1] is not likely to last till tomorrow, poor
fellow--certainly not to get better.
 Ever yours,
 D.G.R.

[1]Oliver Madox Brown, FMB's son, who died on the following day.

392. DGR to CAH [16 Cheyne Walk]
 Thursday, [5 November 1874+]
My dear Howell,
Thanks, many thanks, for bringing me that sad news this evening.[1] I went down
but only saw Hüffer who thought it better I should not see Brown. He and the
rest were sinking into bed after their bitter exhaustion. There was no rally at
all with poor Nolly, who passed away quite unconsciously.
 Affectionately yours,
 D.G.R.

You and Kitty must try and dine with me as soon as you can.

[1]News of the death of "Nolly" Brown.

393. DGR to CAH [16 Cheyne Walk]
 Sunday, [8 November 1874+]
My dear Howell,
Tomorrow I shall be writing to Lady Ashburton, and must absolutely be able to
tell her when her picture will reach her--else she will think I have pawned it
or the devil knows what. Do help me in this at once and let me have her picture
instantly.
 I am still in correspondence with Valpy. What the precise result will be I
cannot even yet tell.
 Ever yours,
 D.G.R.

394. DGR to CAH [16 Cheyne Walk]
 Monday night, [9 November 1874][1]
My dear Howell,
I find Mr. Brooks called this evening after I was gone out.[2] Not having seen
him during the day, I had quite given him up of course, and one cannot well
show pictures by gaslight.
 I really must hope that Lady A's picture will reach me tomorrow without fail.
I have written to her and told it will come at once. If you do not meet this
necessity, I shall be put to the greatest inconvenience and shall not know how
to act in any respect. I never clearly realized why the picture had been removed
from here at all.
 Ever yours,
 D.G.R.

 All is now straight with Valpy who has acted in the most liberal and friendly
way.

[1]Dated 10 Nov. by CAH, but Monday was 9 Nov. in 1874.
[2]In a note of 2 December DGR wrote CAH that he had suddenly concluded that the
"Mr. Brooks" who called was really an Italian named Boschi, calling on a begging
errand, and that the maid had confused the names.

395. DGR to CAH [16 Cheyne Walk]
 Thursday night, [12 November 1874+]
My dear Howell,
I am quite at a loss to understand how you can continue to leave me in this
most awkward position towards Lady Ashburton. Yesterday evening I receive a
telegram from you saying that the "picture" and "drawing of Magdalene" are "on
their way"--yet George calls later on you and then only brings the drawing on--
whereas of the important thing--the picture there is still no sign whatever.
What am I to suppose it all to mean? Tomorrow Lady A. (who was prevented coming
yesterday) is coming by her own appointment. I shall have to say something to
her, and am certainly--not disposed to let her draw inevitable conclusions as
to myself.
 Ever yours,
 D.G.R.

396. CAH to DGR[1] Chaldon House, Fulham, S.W.
 30 November 1874
My dear Gabriel,
You may well ask what this "monstrous" statement can mean, and if you look at
it again it will appear more and more "monstrous." The fool not daring to tell
quite a lie, tells half a one and damns himself.
 He says I offered the excuse that the 200 had been lent to you, but that you
had not sent the drawings promised in return!!! Why should I expect drawings in
return for money lent?!

The facts are the following. Master Heaton very hard up borrowed my acceptance
for 739.9.0 at four months, out of kindness I lent it, and it was with difficult
he paid it, I having to lend him another for £300 not £200 as he mentions now.
I enclose the said bill for you to see, and also an infamous letter he wrote me
about you on the 11 January 1873[2] when I forwarded him your letter (which I also
enclose) requesting that he should send me the £15 at once as I had sent you a
cheque for it, a course on which we two you and I had both agreed.

From this date I never again received him in my house, and when I did him the
kindness to accept the bills I knew he was sinking and only thought of his wife
and children and thus did it at my risk. Read his letter well. How can I owe
£180 balance on a bill of £200 if I have paid £100?!! It is quite true that I
owed the £200 and for this I promised to send him the Dante drawings, saying I
had paid you up for them, so that there was nothing but for you to deliver them.
Well, you never did send them and so far I have been waiting, this you know.
On the 2 of March last they fell on me (Heaton & Brayshay) for "the drawings or
the £200." I at once paid £100 off because you failed me, and failed myself in
consequence in meeting that bill of yours of £54 for which you sent George up
twice! Brayshay thank God was here at the time and doubting the existence of
the drawings told George all about it and that I had paid him (just then) the
£100. Thank God all this has happened for it may prove to you once and for all
that I am what I am, and that for your sake I would put up with any thing, as
I have done, before I would worry you. I have always been a friend to you and
a gentleman, and I have suffered through being surrounded by a lot of cads and
blackguards. Do do me justice and let us see how this hound Heaton should be
written to. I must see you on the subject.

Lately you have not been just to me and I have felt it more than I can tell
you.

For instance the Ashburton drawing. You asked me to take care of it for you,
she Lady A. being absent and you also. I did so.

When Northend began to be pulled down one night the water poured in in
torrents, and the next morning I sent all my valuable drawings (and yours with
it not thinking about it) to Kitty's cousin Lady Otway. I enclose the portraits
of herself and Sir George as you do not seem to think they exist at all. When
you wanted the drawing I wrote twice for it, and then went to Otways (the night
I telegraphed to you) and said "for God's sake send the drawing at once as it
belongs to Lady Ashburton." George like an ass takes it to Bath house straight.
Then comes your fourth letter! Off we go to Bath House and the butler tells us
with a most stupid smile--"Oh that Lady Ashburton is not on terms here, and is
not received by his Lordship"--!! Off goes Otway to you with the drawing but
you never say you have it! In your letter you say Lady A. would think you had
pawned it. This was not like yourself. She might say I had pawned it, and then
it would be for you to answer that no pawnbroker would lend much on it, and
that besides that I had plenty to pawn of my own.

Name a time for me to see you respecting the hound Heaton.

Your affectionate
C.A. Howell

Please keep this letter of Heaton's. The beast is a Bankrupt and by God I am
going to make him pay dear for this.

[1]Portions of this letter appear in PRT, p. 88.
[2]With this, CAH enclosed the letter of 11 Jan. 1873 from Heaton to CAH in which
he said: "A more contemptible and ridiculous move (than Rossetti's) I never
came across in all my days.... If anything were wanting to prove a terrible
depreciation of character in D.G.R. here it is he takes 5 weeks to sell and
deliver a pencil drawing--actually being paltry enough midway to decline
delivery on the ground of 'the trouble of packing'...... . Disgusting. Why if the
man were really what he ought to be he wouldn't have time to write such
ridiculous letters" (Angeli Papers).

397. DGR to CAH [16 Cheyne Walk]
 Tuesday, [1 December 1874+]
My dear Howell,
I keep the documents till I see you.
 Could you look in tomorrow (Wednesday) daytime, staying to dinner if you can.
After dinner I should be going out. On seeing you, I will show you the draft
of a letter which I wish to send by <u>tomorrow's</u> post to this cur Heaton.[1] So
please come as early in the day as you can after 1 o'clock.
 We can talk all over when I see you, but at this moment I am very hurried.
 Ever yours,
 D.G.R.

[1]See n. 1, Letter 399.

398. DGR to CAH Wednesday night, [2 December 1874][1]

My dear Howell,
It has only this minute flashed on me that the supposed "Brooks" who called
that evening must have been an Italian named <u>Boschi</u>, who has been in the habit
of calling on begging errands. The names are sufficiently alike for my English
maid's ears, and she had not seen Boschi before. This, I have not the least
doubt, is the clue to the équivoque.
 Ever yours,
 D.G.R.

The description she gave would answer for Boschi.

[1]CAH has dated this letter 3 Dec. 1874, but Wednesday was 2 Dec. in 1874.

399. DGR to CAH [16 Cheyne Walk]
 5 o'clock Friday, [4 December 1874+]
My dear Howell,
Yesterday I was quite prevented by visitors up to post-time from copying and
forwarding the letter to Heaton. I have now just done so;[1] but I have found it
quite impossible to introduce into <u>such</u> a letter the explanation respecting
yourself. Nevertheless the explanation is quite due to you: therefore I make
it in a letter to <u>yourself</u> which I now enclose and which will answer just as
well if you forward it to Heaton.
 That fellow's name please let me not hear again in <u>any</u> form, whatever he may
write or do. I myself have shot him out as excrement for good: so let his name
be silence between us. I had thought him a friend for 13 years, and the whole
thing is sickness to my soul.
 Ever yours,
 D.G.R.

 You shall get the <u>Ghirlandata</u> drawing[2] very soon. I wish you would come again
and remove the Globe figure,[3] or come to any other arrangement which may suit
you better than that hasty one, but which may <u>finish off the matter for good</u>.
P.S. I have another letter from H. this morning (of the genial order) which I
can show you when we meet again. It refers to your affairs, but temperately,
and I find from it that you had written H. meanwhile.

[1]A draft of DGR's letter to Heaton, with many deletions, is preserved in the
Angeli Papers. In it DGR defended himself against the charge of "contemptible"
meanness and continued, "But even had my conduct been mean in any degree, the
fellow who could write in such a tone of me to Howell, and who could continue
till now writing in so widely different a tone to myself--with occasional
disparagement of Howell to me into the bargain--must be the poorest sneak
alive. It is sad to have to write this to a supposed friend of some 13 years
standing, proved at last to be doublefaced and unworthy." DGR concluded by
saying that his "secretary" would return unopened any letters addressed to him
by Heaton.
[2]The colored chalk of 1873 (Surtees 232A).
[3]<u>Madonna Pietra</u>, "design for a picture never executed. Half-length figure of a
female nude turned slightly to the right. She holds a crystal globe in her
right hand..." (Surtees 237). Sold by CAH to C.E. Fry.

400. DGR to CAH Chelsea
 4 December 1874
My dear Howell,
I had intended, in writing today to that fellow Heaton, to have included a
statement (in justice to you) relative to the transaction about the studies for
Dante's Dream, which I found, on our interview, to be in question in his former
letter. However what I was obliged to write to him proved of such a nature that
one could not combine it with business statements. Thus I had better just state
the facts to you in this note, which, if sent on to him, will equally serve your
turn as explanation.
Some time back you bought from me, and paid for up to a certain point, some
8 studies (I think) for the Dante's Dream. Some of these which were finished
were delivered; others unfinished stood over--a further sum having to be paid
on their delivery. These were the drawings you proposed to give Mr. Heaton for
his £200, but of that transaction (of course quite open to you to make) I knew
nothing till now, and of course neither knew of nor received Mr. H.'s money
which was no affair of mine: but the drawings were really due to you.
The matter between you and me is just now liquidated, as you know.
 Ever yours,
 D.G. Rossetti

401. CAH to DGR Chaldon House, Fulham, S.W.
 13 December 1874
My dear Rossetti,
Thanks for your letter respecting Mr. Heaton. I do not know that I shall use it.
He can remain under the impression created by your first letter, viz that I had
no drawings to expect from you and swindled him out of every thing. One more or
less makes no difference to me.[1] Thanks about the drawing which I shall be glad
to have on Tuesday closing the transaction as you wish.
Do you mind writing to Kelmscott for the frame you kindly gave me for it. It
will save me the time I shall have to wait for a new one.
I send you seven of the embroidered stomachers I spoke to you about. They are
beautiful either to paint or make two dresses for the Morris kids back and
front.
They cost 40/- each and the dark blue one 50/-
In haste.
 Ever your affectionate
 Charles A. Howell

[1]First three sentences in PRT, p. 106.

402. DGR to CAH. Monday, [14 December 1874+]. Ghirlandata drawing to be ready
by Monday. On DGR's seeing receipts for various bills and on receipt of
"outstanding sum," picture will be delivered.

403. DGR to CAH [16 Cheyne Walk]
 Monday, 21 December 1874
My dear Howell,
It is 3 days since you wrote me to expect Arthur's bill[1] receipted by next post.
If I do not receive it within 48 hours from this date, I shall consider the
transaction for the Ghirlandata drawing entirely cancelled and dispose of it in
a completely new quarter settling the other accounts in your list connected
with the drawing.
 As to the Girl and Globe,[2] you know there was £60 due on the former bargain,
and therefore also on this drawing before delivery. Otherwise I will collect and
deliver the Dante draperies &c as soon as you please.
 Ever yours,
 D.G.R.

[1]For a sofa sent to Kelmscott when DGR was there.
[2]See n. 3, Letter 399.

404. CAH to DGR Chaldon House, Fulham, S.W.
 22 December 1874
My dear Rossetti,
I say nothing. When people owe money they must expect to be asked for it, and
to pay it. One thing I do say, viz that I cannot understand how a friend of old
standing can place me in this position with Marks, or any one else. I certainly
would not do it to you were I to see the Union before me, as the sure prospect
in exchange for the deed.
I have given the cursed receipt to Marks and would have paid double its value
to avoid your letter.[1]
I have now found a memorandum of your account and there are many items that my
bad memory had cancelled for me, and which you could not remember, the balance
of obligation being always in your favour.
I shall now send you a proper statement which you can either burn or enter as
cash paid by me for you.
I am not writing at home or I would send it now.
There is a silver necklace which I mentioned before, for this I do not wish
to be paid, but I do for the remainder.
I find 30/- for a stand and dish for Mrs. Morris, repairs. A silver flint box
for Hake, a silver whistle for George, a dog whip for yourself, and a few more
things I cannot remember now.
There is no such balance as £60 due on the Dante drawings there is a balance
of £30 which I promised on your finishing them. This I will pay when the five
remaining are delivered, and I must ask you to fix the date for their delivery
yourself. I do not wish to have them in 48 hours, but I will suggest 48 days
from now, which with four years make a tidy time; space which neither you or
any one else ever gave me for any debt of mine. Another £30 I offered on my
Miss Kingdon drawing [?when][2] finished. This I will also pay when you finish it.
I cannot afford five drawings and £60 for the Girl with the Globe, I have to
pay my liabilities and do not see any chance at such a rate.
The exchange of the Globe girl arose from you, and I said at the time all that
a gentleman could say on the subject.
You have now given me a good lesson and I shall profit by it.
 Always the same
 Charles A. Howell

[1]The letter up to this point appears in PRT, p. 106.
[2]CAH wrote been.

405. DGR to CAH [16 Cheyne Walk]
 23 December 1874
My dear Howell,
I say something. And that is that there is not the least reason to complain of
anything in my conduct to you. I place you in no awkward position towards Marks
that I can see. Marks naturally wants the drawing he has bought from you, and
as I could not deliver it before seeing that receipt, I asked for the same after
giving you three days over the one on which you wrote that it was coming by
next post, and leaving 2 further days for you to get it in.
The old arrangement--i.e. for the Dante drawings--will suit me much better of
course than that for the Globe drawing. Only I know of only 4 outstanding since
the last 2 you had. If you can remember a fifth, take it by all means. I am
uncertain whether you took a Dante or not, with the 2 standing females. If you
did, I believe only 3 remain due:--viz: Standing female at foot of bed--Love
and Beatrice--and Love alone. What other is there? As for the money due on
delivery, I thought £200 had to be made up, and £140 was what I received. How
does this stand?
As for the Dinah drawing,[1] whenever you choose to bring it me, I will as soon
as possible fulfil any engagement I made about it.
As for anything owing (if so) of course you know I shall pay fast enough.
 Ever yours,
 D.G.R.

[1]This is a mystery to me. Under this title it is unknown to Marillier and
Surtees. Was Dinah the first name of Miss Kingdon? Or did DGR mean to write
Dante? His calligraphy is unmistakable.

406. CAH to DGR Chaldon House, Fulham, S.W.
 30 December 1874
My dear Gabriel,
I do not complain, I only complain to you and cannot help feeling that the old
days in which we used to help each other through thick and thin are quite gone
by, that with your excellent memory you forget much and that I forget nothing.
 Of course you did place me in an awkward position with Marks. After all Marks
is Marks and I am myself. I had to suffer two letters from him respecting this
cursed receipt--thus entering into yours and my private affairs all because you
allowed him to do so, and besides this the assertion when all was finished, that
you were in such a "violent rage" that he saw his bargain in danger!--
 Once for all let me say I have as much right to owe Arthur £25 as you had to
owe it to me and up to the present you have owed it. There was this, Arthur
owed me money more than the £25 long before the sofa was sent and I owed him
money after and he neglected to send the receipt and so far I am on the safe
side.
 The other night you were very pleasant and funny about the cost of this Marks
drawing and the other head and so far I took it as old play, now you must
forgive me if I ask you to state the full price for which you sold me these
drawings and on hearing from you I will send you a statement of account, and
any balance due to either will be paid. It is far better to have things clear
and then neither you or I can complain.
 All right about the old arrangement only please let me have the drawings now.
 You had to deliver 8 studies you have given me 3 and one you mentioned (that
came up from Kelmscott) as not good and which you would touch up makes 4. This
one is still at Cheyne Walk, so that you have to give me 5 and on giving them
I have to pay you £30.
 As to the £200 the facts are the following. I had £140 in notes in my pocket
and I offered you this for the batch. You took it, and after you had done so
you said "Well they are b----y cheap!"
 I then answered, when you deliver them if they are nicely done up I will give
you £30 more, and months after I said I would give you £30 to finish the Kingdon
drawing. Months after you took from me the Mrs. Morris with the dark hair all
I gained in your first Valpy transaction of £262.10 and said "I will either
give you another drawing, or if you like the £30 on the Dante drawings." To
which I answered all right. Well I ask for nothing. Now I ask you for the
drawings; you have always said a friend should make his wants felt, and repeated
that you would have delivered these drawings at once had you known I wanted them
Well I do want them most urgently and no price for which I may sell them will
ever cover the cost and worry I have been put to in having to refund twice the
money for which I sold them in all good faith, thinking I would be able to
deliver them in time.
 I wish you every happiness in the coming year, this from my heart as you will
find in time.

 Your affectionate
 Charles A. Howell

407. DGR to CAH [16 Cheyne Walk]
 31 December 1874
My dear Howell,
As regards our friendly relations, I have only to say that I consider you, after
some 9 or 10 years' intercourse, a very good-hearted fellow and a d--d bad man
of business. As for Marks, I had really no idea that he did not know all about
the sofa when I named it in your presence to him (or I think to you).
 The drawings received by you on our bargain in question were at the time as
follows:--
 2 Studies for Beatrice
 1 for head of Love
 1 for head at head of bed (Miss Spartali)
 1 for head at foot of bed (Miss Wilding)
and since then you had at Kelmscott
 2 figures at head of bed
 1 Study for Dante
 T o t a l 8 S t u d i e s

If you say the bargain was for 8, it would appear you have now had them. However I have considered 3 more all along as being due to you: viz:--
1 figure at foot of bed (now at Kelmscott)
1 Love
1 Love and Beatrice.
The 2 last are here and I have now nearly finished working them up at odd times since I saw you.
If you like to come here any time, we can talk over any thing you please. Tuesday and Wednesday next I expect to be preoccupied.
Ever yours,
D.G.R.

408. DGR to CAH [16 Cheyne Walk]
 Thursday, [28 January 1875+]
My dear Howell,
George brought back from Kelmscott yesterday 3 drawings marked as yours: viz:
 I. Female at foot of bed
 II. Another Love
 III. Another Dante drapery.
The last 2 are quite useless unless finished with heads, hands, &c. being at present mere draperies. The first of the 3 is pretty complete in black charcoal.
 I will finish these and the others which you saw if the 30£ is to be paid me on delivery. Otherwise I cannot possibly afford the time.
 Ever yours,
 D.G.R.

P.S. There are several items in your last bill which we shall have to look at together.

409. CAH to DGR 64A, New Bond Street, W.[1]
 29 January 1875
My dear Gabriel,
I shall be most happy to go over any and every item in your account.
 I shall also be happy to pay the £30 on the drawings. I am also most happy to find that I am right in both the cash arguments viz £3.15.0 to Welch instead of "£5.0.0" and three drawings at Kelmscott which make up the five claimed by me, this notwithstanding your last detailed written account of the drawings declaring that I was wrong. I now do want these drawings, and have waited long enough for them. In all justice I should have them, for you must remember that I gave up ten to Valpy--which were mine in discharge of your debt to him, simply because I could be dunned no longer.
 As a fact these eight studies stand me in £140.0.0 and when I pay you the extra £30.0.0 they will stand me in £170 paid you four years ago. "Quite enough too" you said the last time I saw you. Well, I never entered into the market value of the drawings but if really you can find any one that will give me my £130.0.0 back just now, I will send back the three I have, framed and all and the matter will rest for ever.
 You say I am a "damned bad business man" of course I am, or I could never place myself in this position.[2]
 Ever yours affectionately,
 Charles A. Howell

 I have a chance of getting 100 guineas [sic] or even 1200 guineas for the picture you are painting[3] but I could only enter into the matter quite from a business point of view picture being seen delivered in a fixed time etc etc.

[1]Printed address.
[2]Quoted in slightly different words by Mrs. Angeli (p. 15).
[3]Presumably La Bella Mano (Surtees 240), commissioned by Marks on 15 Feb. for £1050.

410. DGR to CAH [16 Cheyne Walk]
Tuesday, [2 February 1875+]

My dear Howell,
Valpy has named tomorrow (Wednesday) at 3 for coming here.
 As for the drawings, you shall have no reason to complain of me.
 As for the picture of <u>La Bella Mano</u>, £1050 is what <u>I</u> must pocket as its price.
If you can find any one who will give more than that, you are welcome to the
surplus. Otherwise we cannot deal.

 Ever yours,
 D.G.R.

411. DGR to CAH [16 Cheyne Walk]
Sunday, [14 February 1875+]

My dear Howell,
I overlooked what you said of the Fuseli Dante picture--when are you to have
it? I have got the sketches--My gracious! Fifteen and some tracings--none so
important as yours, but some as fine. Are you aware that close by you--at Col:
North's on Putney Hill, is <u>the</u> collection of Fuseli pictures, bought by the
Guilford family from him--whether really his best I cannot say, but they should
be worth trying to see.
 Tuesday and Wednesday I shall be quite preoccupied.

 Ever yours,
 D.G.R.

412. DGR to CAH [16 Cheyne Walk]
Thursday, 25 February [1875+]

My dear Howell,
As yesterday was fixed by you for the payment of the £20, I write one line.
Tomorrow Friday I shall be too busy to see any one.
 I expect to get the 5 Dante drawings[1] finished in course of next week, and
will deliver them on payment of £50, being the balance of their value and the
loan together. They had better not be delivered except all at once, as
otherwise things would get confused.

 Ever yours,
 D.G.R.

[1]On 16 May 1875 DGR sent CAH a postcard saying that "the 5 drawings are ready."

413. DGR to KH [16 Cheyne Walk]
Wednesday, 31 March 1875

My dear Kitty,
Pardon my troubling you with this note, but it is impossible to get any
attention from Charley. George Hake met him accidentally today, and learned
from him that my photographic negatives (for which I applied yesterday) are
still at Chaldon House. I am needing them at once, so George will call on you
at 11 a.m. tomorrow (Thursday) and fetch them away in a cab, as he told Charley
he would do, to which the answer was "All right." Thus I trust it will be
giving you no trouble. However Charley's oblivious habits make me write you
this line, to beg you will exercise your kind good will towards me by giving
your lord's memory a jog in the morning and ascertaining exactly where my
negatives are and the means of getting at them when George comes. For which,
my dear Kitty, best thanks beforehand from

 Yours ever sincerely,
 D.G. Rossetti

414. DGR to CAH [16 Cheyne Walk]
Monday, [12 April 1875+]

Dear Howell,
All right. I keep the harp, chàin and bracelets, and little cross. I return
the heart. The Fuseli is lovely and I should like to arrange with you for it.
The photos: I haven't yet examined. Shall be glad to see you when possible.

 Ever yours,
 R.

415. DGR to CAH [16 Cheyne Walk]
 Thursday, [22 April 1875][1]
Dear Howell,
Before I forget again--what became of that little trunk-shaped box with stamped
brass plates covering it and leather binding? Pardon my troubling you again
about it. I remember you told me the man could not make the proposed alterations,
but I much wish in that case to have it back as it was and would pay for any
trouble of his.
 I also want much that Venetian Steel-bound casket of mine which Lekeux[2] had,
but I suppose you never see him. I would pay for his completing it, though I
remember he proposed to charge high.
 Ever yours,
 D.G.R.

[1]Dated 23 April, a Friday in 1875, by CAH.
[2]John Henry LeKeux, an engraver.

416. DGR to CAH [16 Cheyne Walk]
 Friday, [14 May 1875+]
My dear Howell,
I will complete the 3 belonging to you, and if possible Toynbee's 2[1] also, by
Monday. Your 3 are
 I. Standing female figure
 II. Dante full length
 III. Love full length
These 3 I believe only need revising as with black chalk. The first is quite
completed and would lose by another touch, only you know we found it had had an
accident--hole knocked in it--thus would need mounting. The two others I will
see to, but they need no colour. Toynbee's 2 need more revision than these.
 Ever yours,
 D.G.R.

[1]One of these should be Surtees 81 R.2.E, a study for figures of Love and
Beatrice; the other may be Surtees 568, head of a young girl (possibly May
Morris).

417. DGR to CAH [16 Cheyne Walk]
 Tuesday, [18 May 1875+]
Dear Howell,
I forgot to say--Don't send those glass drawings to the factory, or they will
get dirty and unfit for the frame. Make tracings and Dunn will colour them for
you no doubt. He will be coming down tomorrow (Wednesday) morning for the
flowers.
 Don't bring strangers here--I can never see any one without appointment--
being always closely at work.
 Ever yours,
 D.G.R.

418. DGR to CAH (Postcard)
DGR to CAH. Monday, [14 June 1875]. Request for CAH to look in next day,
when head, wings, etc. of drawing will be added.

419. DGR to CAH [16 Cheyne Walk]
 Thursday, [17 June 1875+]
Dear Howell,
Thanks for the belt; I'll keep it, but must with your leave reconsider and
decline the cape,--it is too dear and not sure ever to serve me.
 I am sorry to go on to an unpleasant subject. You may judge that I am
extremely displeased (after what you assured me) to see the enclosed, brought
me by some one who saw the drawing today hanging at Christie's. The result will
be that the coachmaker will sue you for the surplus of his debt (after the
drawing has sold for a trifle in this accidental way) and my work will suffer
serious depreciation.
 Ever yours,
 D.G.R.

420. CAH to DGR Chaldon House, Fulham, S.W.
 22 June 1875
My dear Gabriel,
These two girdles finish my present account, or rather you owe me £2/- i.e.
taking the three drawings at your price viz. £70, £50 and £30.
 When do you think I can have them? As I have not "done" you in this
transaction you might get Dunn to throw a slight vail over the boys spout and
add a few lines to the towel in their hands.[1]
 Also if you like to look over what drawings you have in the lumber room, and
send for those at Kelmscott I do not mind taking a batch, provided you send me
none minus an eye or some important feature of that sort, for I am sure to sell
it saying the eye will be sent afterwards and from that day my life becomes a
curse with letters and telegrams asking me for certain missing features, and
it is only when I am on the verge of consumption that I succeed in convincing
the buyer that such and such a Dantesque character had no eye at all, and was
celebrated for it.
 I will pay part coin and part fine things, and will take the things as you
can let me have them. How does this smell.
 Let me have your views on the subject, and we can then see what is to be had.
 Your affectionate
 Charles A. Howell

Long letter from Burton,[2] thinks they are more Pinturicchio than any one else,
but very like a fragment of a predella attributed to Raphael where every thing
is exactly like this or rather these. Will show it to you when I come.

[1]The drawing referred to by DGR in Letter 1618 to Dunn (D-W, p. 1372).
[2]Later Sir Frederick Burton, who had become Director of the National Gallery in
1874.

421. DGR to CAH [16 Cheyne Walk]
 Wednesday, [23 June 1875+]
My dear Howell,
Your letter is very funny. About further drawings I'll see what can be done.
 My own impression was that the account stood somewhat to my advantage. As it
is otherwise, would you kindly send items that we may be agreed.
 The large belt should really not be more than £20, the price first named by
you in describing it accurately enough. The smaller belt I think on second
thoughts I will return, as it is of a decided late character of ornament and
would hardly come into my style of picture.
 Ever yours,
 D.G.R.

I believe £75 was my price for the Girl and Globe.

422. DGR to CAH [16 Cheyne Walk]
 Friday, [2 July 1875+]
My dear Howell,
On seeing the draperies by daylight, I am more than ever delighted with them.
There is only one which I think would not serve me much--i.e. the little girl's
brocade dress--it is a good deal faded and frittered. This I think with your
leave I will return. The large red piece is much finer by daylight and I begin
to wish for another opportunity of examining the lot of smaller pieces and
seeing how they might be joined to good purpose: but perhaps they are gone now.
 The sword is such a beauty I must try and keep it.
 There is a small edging of the Louis Seize set which I enclose in case of any
use.
 Ever yours,
 D.G.R.

423. DGR to CAH [16 Cheyne Walk]
 Friday, [9 July 1875+]
My dear Howell,
Something was said yesterday of that watercolour portrait head you are to have,
and the silver things &c brought lately as being towards its price. But I shall
have (as I said when the head was first spoken of) to get cash for it, being a
thing needing some work and costing me time and trouble. So the silver things &c
must go to some other bargain, only take or don't take the head for cash just
as you please.
 I shall be much pleased to receive Valpy's £127, being somewhat short.
 Yours ever,
 D.G.R.

424. DGR to CAH [16 Cheyne Walk]
 Saturday night, [31 July 1875+]
Dear Howell,
You lately named to me a large Dulcimer, but I didn't see my way to make it
useful.[1] I do now, if of the same sort on a large scale as a Japanese one which
I have here, which I think you said was the case. I should be very anxious in
that case to get it at once, as I see my way to a Leyland picture with that and
some of the draperies. Can you see about it for me without delay.
 Ever yours,
 D.G.R.

 I dare say I shall be hearing something from you at some time as to Valpy. I
should have mentioned that the frame of the Beatrice is ordered and will be
ready in 3 weeks but I expect to get the picture done before then.

[1]For the picture named A Sea-Spell (Surtees 248); bought by Leyland for £840.

425. DGR to CAH [16 Cheyne Walk]
 Wednesday, [18 August 1875+]
Dear Howell,
After you left, it occurred to me that I had never named in my letter to Fry the
necessary question of copyright.[1] Accordingly I sent him a second note which he
will get with the first and of which the enclosed is a copy. Please let me have
it again when I see you tomorrow evening. I was sorry to feel this necessary
but it seemed unavoidable, to prevent possible future misunderstandings, and I
hope will not change his views in any way.
 Ever yours,
 D.G.R.

[1]Clarence E. Fry had commissioned, through CAH, the picture Venus Astarte
(Surtees 249) for £2100. DGR remedied the oversight in the note mentioned in the
second sentence (D-W, p. 1345).

426. CAH to DGR Chaldon House, Fulham
 18 August 1875
My dear Gabriel,
Thanks for receipt in Valpy's favour for £127, and it is quite understood that
in case of Fry's death or any thing of the kind I at once refund the amount of
this receipt in cash.
 Yours affectionately,
 Charles A. Howell

427. DGR to CAH. Tuesday, [14 September 1875+]. Is anxious about saleableness
of Valpy drawings, "as funds will soon be absolutely needed."

428. DGR to CAH [16 Cheyne Walk]
 Friday, [24 September 1875+]
My dear Howell,
Thanks for your note. I was much grieved yesterday that your visit, undertaken
with the friendly view of helping me in a difficulty, should have had such an
untoward result for yourself. The accident was quite beyond my control, and I am
only glad to think that Clara[1] rates the whole matter at its true value--that
is, as an absurdity merely. Thanks to her for her kind message, and best
remembrances.

 Ever yours,
 D.G.R.

Leyland has sent the 200£.

[1]Is this the mysterious Clara Vaughan, whose affair with CAH was known to Rosa
Corder, as she says in a letter of 23 Mar. 1876 to DGR (PRT, p. 232)?

429. DGR to CAH [16 Cheyne Walk]
 Monday, [27 September 1875+]
My dear Howell,
As the Valpy picture is not yet finished, I fancy my best plan would be simply
to receive £300 now on account and leave £130 payable on delivery of the picture,
which would be a convenience to receive when I had to take it up for final work.
 I shall be out all tomorrow (Tuesday).

 Ever yours,
 D.G.R.

430. DGR to CAH 16 Cheyne Walk
 7 October 1875
My dear Howell,
I had been wondering at not seeing you from day to day, and was just thinking
of writing to you when I got your note this evening. It brings quite a shock
with it, as I thought you were lately again speaking of your father's coming to
England, and this had led to suppose that his health was favourable.[1]
 It is not at the moment of such a loss that one can reflect whether it belongs
or not to that class which reason must expect in due course and courage serve
to accept without despair. To mourn a father whose last hours have passed away
unknown to us and afar must for awhile banish all feeling except intensity of
grief. But you are not at least without the best comforter the world can afford
at such a time--a good loving wife; and in this you have the advantage over many
whose loss and whose sorrow equal yours.
 I need not say how glad I shall be to see you here whenever you again find it
possible; and remain meanwhile

 Affectionately yours,
 D.G. Rossetti

P.S. I shall probably be leaving town early next week.

[1]Though CAH was apparently expecting to hear of his father's death in Mar. 1875,
he seems to have lived on to this time (not 1880, as Mrs. Angeli says, PRT,
p. 29n).

431. DGR to CAH [16 Cheyne Walk]
 Monday, 11 October 1875
My dear Howell,
I enclose a letter from Valpy. In my answer I told him of the offer you
mentioned to me for the drawings, respecting which I suppose he will now write
when he thinks you can be troubled again with such correspondence. Pardon my
referring to the subject so soon after your last note, but I thought you ought
to be kept informed, I have told him it will not suit my purpose to rescind the
commission for Beatrice, but I would await the sale of the drawings in your hands.
 Ever yours,
 D.G.R.

IV. "In All Bitterness and Hard Work"
3 November 1875 to 26 March 1876 (Letters 432 to 463)

432. DGR to CAH Aldwick Lodge near Bognor, Sussex
 Wednesday, [3 November 1875+]
My dear Howell,
 I was glad to hear from you again after so long a lapse, and to know that you
are somewhat recovering from your heavy trouble.
 Fry did send £500. Did I not mention it? He seems a first rate fellow. I hope
to have the picture forward before long. Am also taking up Graham's Blessed
Damozel,[1] for which, as well as for the Venus Astarte,[2] I have all materials
here.
 This is a fine coast for bracing sea-air, only without downs. The house is
everything that is comfortable and extraordinarily sheltered from weather, so
that even a severe gale is imperceptible in the house.
 About the reference I am sure you will perceive that I could only do as I did--
i.e. send you the letter. I had no hint whatever from you as to how it should
be answered on one or two important points.
 I shall be glad to know that Valpy is all right as to his commission for the
Beatrice. It would not suit me to put the 200£ received to the account of the
Dante's Dream, and moreover (as I explained to him) the fact of the Beatrice
being his prevented (as you know) my adopting other plans with it.
 Ever yours,
 D.G.R.

[1]Surtees 244; commissioned by Graham in 1871, completed 1877.
[2]The picture commissioned by Fry; also called Astarte Syriaca (Surtees 249).

433. DGR to CAH Aldwick Lodge near Bognor
 Thursday, [4 November 1875+]
My dear Howell,
 What is the meaning of the enclosed about Levy and perjury?[1] It is part of a
letter from Edmund Hake (who is staying at Cheyne Walk) to George.
 I have answered Levy by a note of which I enclose a copy.
 Please explain.
 Ever yours,
 D.G.R.

P.S. Valpy writes again saying that he cannot hear a word from you.

[1]DGR's letter to Levy (below) and CAH's explanation in the following letter
hardly explain perjury. More is to be heard of the affair in later letters.

 To Mr. Levy Aldwick Lodge near Bognor, Sussex
 4 November 1875
Sir,
 I learn that you have called at my house 16 Cheyne Walk to enquire about 2
Turkish dresses.
 All I remember is, that I was told some time ago of a visit of yours on the
same subject, and that the 2 dresses were returned to you or some one by Mr.
Dunn at my house; but I never myself saw any one who called, nor do I remember
how long ago it occurred.
 Yours,
 &c &c

434. CAH to DGR Chaldon House, Fulham, S.W.
 5 November 1875
My dear Gabriel,
 I write from bed full of cold and very far from well. I know very little about
the Levy question, except that the said Levy has been having a law suit with
another dealer named Ferrario two points being in dispute--1st. that Ferrario
has sold things for higher prices than those named by Levy, said things being
given to him on commission, second that he has divided "lots," i.e. sold the
chairs and left the table etc etc.
 I have been applied to in the same way as yourself and have answered that I
myself delivered the two dresses to Mr. Levy though I had received them from

Ferrario but that I was not able to fix the date. I never saw this Levy but twice once at his house and once when I gave him the dresses from Cheyne Walk. It seems he keeps no books and wanted to fix the dates (some of them) from us. This Levy is a commune [sic] chap and they say queer--This is all I know--

Valpy as I said I would see this week very likely tomorrow. As regards hiring furniture I scarcely know what to say. It comes awfully dear and in the end as a rule there is a long bill for wear and tear so that things come dearer than buying them. The best would be to have the most comfortable from Kelmscott for the cheapest and nicest for you.

If to accomplish this Bailey[1] would be of any use to you I will lend him for the purpose and you can count on his doing every thing well.

I am glad to hear you are going to go on with the two pictures and most anxious to see them.

Did you finish Leyland's last? Let me know all you do.

Sandys is hard at work I am glad to say, he met Rosie[2] here and for a wonder of his own accord thought her the most remarkable girl he ever met "and a very fine nature." He has given her two lessons in drawing, i.e. had her to see him work and to teach her to be careful, he has been to her twice and given her capital lectures as to care and trouble on the ground that she must do every thing with all the pains in the world. He has only tackled her on drawing and outline--no colour or modes or any thing else of the kind. He says that if she is backed and helped for two years, she will be able to do any thing. She has worked very hard at your picture all the figure is in and she is at the background now.[3] She was delighted with your letter and was going to write to you yesterday.

When you can spare a minute to write her a line it is a feast to her which lasts for days.[4]

> Your affectionate
> C.A. Howell

[1] CAH's servant.
[2] Rosa Corder.
[3] The picture was a portrait of herself, as mentioned in Letter 1518 (D-W, p. 1308).
[4] "Sandys is hard at work....lasts for days" appears in PRT, p. 233.

435. DGR to CAH Aldwick Lodge near Bognor, Sussex
 [8 November 1875+]
My dear Howell,

I ought to have written you before, but indeed there was no special answer needed. Thanks for your offer of lending me Bailey to fetch things from Kelmscott but George would have to go in any case, and he can manage quite well by himself. However if at any time I did think of engaging Bailey permanently, how could this be done and at what expense? And could he come here if by any chance it became necessary? I ask because my cook suffers from a persistent injury to her back and it is doubtful whether I may not have to part with her and her husband, as she seems only half able to do the work. Will you answer me on this point.

I was extremely glad to learn from Miss Corder and from you that she is getting the advantage of Sandys's assistance with her work. She ought to make a jolly good painter in no long while.

With kindest remembrances to all.

> Ever yours,
> D.G.R.

P.S. There is a fine house and estate cheek by jowl with this--a property just purchased by Baron Grant. Didn't you once tell me you had some idea he wanted pictures of mine? Suppose he were to give me the place for a daub or two. He gave £5000 for it.

436. CAH to DGR Chaldon House, Fulham, S.W.
 14 November 1875
My dear Gabriel,

I do not mind entering into the Grant business, and can of course get you the £5000, but we must come to more regular and strict arrangements, I am sure you will pardon me for saying this, and your sense of justice will aid you in

finding that I am right and complain less than any one you know or have ever had to do with. It never seems to strike you that I need five pounds, and that when it is due for more than hard work, it should be paid with more pleasure than any demand that may come on you since I spare no pains to place you in the position of meeting those demands. Take for instance Fry. Fry buys of me, will now buy any thing I tell him to buy, and refuse any thing I tell him to refuse. I sell him your picture for £2100 you would have sold it for fifteen hundred guineas. I then agree to take 10%. I further agree to take it in work, to this you answer "all right" and there the matter ends for you make no effort to aid me. I could by being crooked have arranged every thing with Fry, bought your picture for fifteen hundred, paid you with his own money and pocketed 500 cash, or I could have sold him £2100 worth of things, had for myself the space your picture will deprive me of in his house and gained about 80% in the transaction.

The same applies to Grant name your pictures, I will fix the price (I am always just and liberal in that) and on such price you are to pay me 15% cash on every instalment that is paid you on account of the work.

Take Valpy for instance, his pictures stand at little or nothing the whole work falls on me, and the money paid you for them comes out of my hard earned gains and exertions and in the end I get nothing but worrying letters, unjust demands and hot pressure which I no longer intend to stand. I have a bad name, I do not deserve it and as others take care of themselves, I have come to the conclusion that I <u>must</u> take care of myself.

Just now Valpy <u>sells</u> me two chalk heads of yours for which he paid you £15 each for £70!!!! I take them in order to keep up your market, and to aid future transactions but how on earth <u>can</u> I afford it and where on earth will it lead me to unless you try to help <u>me</u> with the same good will with which I help you? Well now, you were to give me £210 cash as my profit on the Fry question. You did give me a receipt for £120 for and on account of L. R. V. Suppose you send me a further receipt for £90 the balance also for and on account of L. R. V. and thus enable me to pay this £70 for your two heads. I think it would be just considering that besides this you owe me about £500 worth of work cash paid out for you and for which I never worry you, but wait patiently taking at your price any thing you like to give me. Think well of all I have said and if you find it unjust say so plainly and if I can convince you I will.

I have just sold a picture for Sandys for one thousand,[1] but I made it a condition that I should have £200 paid me at once in cash. This I received at once and he finished Kitty's portrait for which I had paid him, and I find that being firm we remain much better friends than if I had followed the old way of saying "Oh never mind," and got nothing not even thanks.

Yes of course you can have Bailey when you like and any thing and every thing. Let me have an answer to this, and remember that if I was Fry or Graham or Leyland money might pour into you but certainly no word or request.[2]

<div align="right">From your affectionate
Charles A. Howell</div>

Note by WMR attached to the letter: "'The Grant business' was a project for securing Baron Grant, then a very rich man, as a purchaser of some work or works by Rossetti. The project never came to anything."

[1] In a letter of 16 March 1876 to DGR Fry says that CAH "prevailed upon [him] to advance" £1000 "to Sandys" (PRT, p. 111). This may explain CAH's statement.
[2] Mrs. Angeli (pp. 115-16) prints portions of this letter and portions of CAH's letter of 17 November as though her quotations all come from this letter.

437. DGR to CAH Aldwick Lodge near Bognor
 15 November 1875

My dear Howell,
Your letter is rather a startler, as I was not aware of being so much in the lurch.

You have often said (not perhaps very lately) that you owe everything to me as to your starting a position in England. I never expressed an adhesion to that sentiment, but neither did I ever deny it. As we have come to an argument involving mutual obligations, I will now say that I think your sentiment as

above stated was quite correct, however you may have since wantonly sacrificed many of the friends and advantages which accrued on my connexion.

To make a deliberate use of any services on your part in return, was of course what I never dreamt of doing; though had I done so, it might from a business point of view have been a not unusual course in this world.

I am glad you have now so good a position with so useful and capital a fellow as I believe Fry to be. It was no doubt consolidated entirely by your being able to do him as well as myself a service in introducing us to each other. The 10 percent which was to be paid you by me on the purchase of the <u>Astarte,</u> was, as I understood, to take the form of work as regarded the balance <u>still</u> due after my cession to you of the 120£ receipt. I am sorry to say it would not be convenient to me to give a further receipt for £90 and so reduce by that sum the remaining payments on so troublesome a piece of work as that Dante replica. But I certainly think you are unlucky in having taken 2 £15 drawings for £70, and should like to make all arrangements agreeable between us. At the same time I should be much relieved to know that Valpy recognizes my claim on him as to his commission for the <u>Beatrice,</u>[1] and still has a prospect of liquidating it by sale of drawings in your hands. How does this stand?

You speak of £500 owing from me to you--I judge for draperies &c--though I thought your last statement on the point did not at all reach this figure. However, when we come to an exact understanding on the point, I shall try and make sure that you are no loser, and that with as little delay as possible. Some little time ago you spoke of the <u>Blessed Damozel</u>[2] laid in her terra-verte as being a work of a "Speculative" character and suggesting commercial enterprize. I have now made a capital start here with the final picture for Graham, to be substituted for the laying-in in question: and the latter which is here also will soon be entirely at my disposal. What sum could you afford me in cash, over and above the cancelling of my entire debt to you, if I were to finish it in colour as your property--I mean making it of the size of Leyland's chalk drawing from which it was done by me at Kelmscott? You see it would need real work to make it satisfactory, though not a heavy job: and to prevent the need of hurry, I should require <u>some</u> cash as the result.

I do not know really that there <u>is</u> anything further that I can say on practical points before hearing from you again. As to the £90 you speak of, I should be most glad to help your position by any <u>feasible</u> plan. I shall probably be now getting down here all the drawings which remain at Kelmscott; and some one or two of these finished up, might prove valuable.

<div style="text-align:center">Ever yours,
D.G. Rossetti</div>

P.S. I have said that I do not see my way to diminishing the payments from Valpy which are to enable me to complete the Dante replica for Graham. There is however the second sum due from him on the <u>Beatrice</u>--(£430, the price being 600 guineas and 200£ already received); and this would be more feasibly mulcted by my giving you a receipt to L. R. V. for £90, if we could come to a clear understanding with Valpy as to the <u>Beatrice</u> and not the <u>D's Dream</u> being the picture so taxed.

As to the Grant question, it could not of course be treated as a <u>fact</u> in any way yet. What I wished to know was, whether you had any solid reason to think he wished for works of mine.

[1] I find no connection of <u>Beatrice</u> (Surtees 256) or <u>Beata Beatrix</u> (Surtees 168) with Valpy.

[2] The Blessed Damozel was an oil commissioned by Graham in 1871 but not completed until 1877. (See Surtees 244.) It was laid in from the drawing referred to here (Surtees 244A).

438. CAH to DGR Chaldon House, Fulham, S.W.
 17 November 1875

My dear Gabriel,

My letter was not meant as a "startler," nor is there any thing unjust in it. I have always thanked warmly, and my gratitude always endures, I have always said I owed you much, I say now I owe you much, but I counted it a higher debt than you seem to, and have therefore always tried to pay it, not in business considerations but in labours of real love and warm affection the only thing that counts at all with me. My position in England before I knew you was very

much better than it could ever be again, or has been since, but I preferred to go in for Art, and stumbled till I have been nearly dead. Ruskin I of course knew long before I knew any one. And as to Ned Jones I wish to God I had never known him at all.

He was my friend and worshipper as long as I rowed in with him and a most cowardly enemy the moment I struck, trying night and day to ruin me, and doing all that whores do.

Fry knows me through the men, the Quakers, his relatives who knew me as a boy and under whom I worked--no position I may have with him was consolidated by any thing, or any introduction. I knew him years ago and when he became rich he looked me up and said--"Howell I want you, I want good things, and I want you to get them for me." It seems that he likes me, besides liking the things, and in that respect he is a strange man. I never said a word about Jones, or Legros but some how he seems to know those gentlemen, and let them or any one on their behalf offer him their finest work for 1/- and the answer would amuse any one.

This is only in self defence, for what little I have, and what bread I have given to mine, I have earned in all bitterness and hard work, and owe it to no one but myself, the friends who I have so "wantonly sacrificed" have only tried to take it from mine and the mouths of those belonging to me. They have failed, damn the lot--and I only wish I had never known them for any good they have been to me--or to any one else that knows them--for the matter of that. However all this has nothing to do with you, it is only a let off, and the very best proof I can have of their being worthless is that you a much older friend of theirs, never see one, and for all use, enjoyment or pleasure they afford you, you might be in the same position that I am in.[1]

It is quite true, when you agreed to give the 10% on the Astarte, I suggested work, and would have been most glad to have it, but then my dear Gabriel where is it? and how can I go without? A little sketch when I need it, may be--and is-- worth any fine drawing three years hence, I mean of course as far as my needs are concerned. However, patience about the £90 though it would have been a great God send to me, being pushed and worried, and paying £50 a month for the draperies etc you had. You say, though, that you would be much relieved to know that Valpy recognizes your claim on him for the Beatrice! Of course he does, and quite counts on the two pictures. I saw him some days since, and said you asked me in one of your letters to be allowed to place the £200 paid by him on the Beatrice towards the Dante's Dream. "Of course was his answer, I am going to pay for the two pictures and it does not matter to which account Rossetti places the money." On the strength of this I took the two heads[2] feeling that we could jog on and that it would not matter to you to give me the receipt for the £90 on account of two big sums to come considering also that by the time and long before all the money was paid up no doubt you would have some drawing for which I would be able to give you £90 or £100 cash which would in the long run come to the same thing and serve me without hurting you.

I see in your P.S. you say you could give the receipt for the £90 on the Beatrice, well, do so and that will do, and as I say I will afterwards buy drawings for £90 and thus refund you.

I cannot write more, I am ill. I have been wet through helping the poor Fulham people with the inundations night and day and feel half silly.

I will write about Damozel tomorrow as it is important and I think should not be cut down.

<div align="right">
Your affectionate

Charles A. Howell
</div>

[1]Touché!
[2]I.e. the chalk heads that CAH bought from Valpy for £70. See Letter 436.

439. DGR to CAH [Aldwick Lodge]
 18 November [1875+]

Dear Howell,
What I know about Valpy's relation to the Beatrice is this. He wrote saying he could hear nothing from you as to sale of drawings and must give the picture up. I then wrote telling him I could not take this view but could wait his convenience as to sale of drawings. Since then he has written more than once but never referred to the Beatrice. Do you mind my writing him for a distinct

answer on the point before giving a receipt for £90 on account of the £430
owing on the Beatrice? I suppose what you say as to having told him I wished
the £200 paid on the B. to be transferred to account of the D's Dream must have
been for some reason I do not yet seize. The 200£ was my only hold on that
commission (the B.) and I should never have dreamt of wishing it transferred
to the other. I should wish to put the £200 back to account of the B.
 The Damozel will need no cutting down. It is now just the same size as
Leyland's drawing.
 As for affection as a currency between friends, I think highly of it, but do
not deal in sentiment verbally. You mention a friend of ours who formerly did
so towards you, and it has not answered in the long run.
 Ever yours,
 D.G.R.

P.S. After today's work I find I cannot get Valpy's drawing to him by the 20th
as I had forgotten today is already the 18th and the frame is not yet come.
But it will not be long after the 20th.

440. DGR to CAH Aldwick Lodge near Bognor
 Monday, [29 November 1875+]
My dear Howell,
I am sorry if you thought me neglectful in the matter of the 90£. But I had
said distinctly that I could not levy it on the price of the Dante, though I
would do so on that of the Beatrice as soon as I knew for certain that Valpy
admitted that commission. I have now virtually put the question to him more
than once, but he has abstained from answering at all on this point.
 I have not heard anything from you as to Grant. If you are unable to see to
it, please let me know, as (in such case only) I should take steps by another
means, as I wish to ascertain without delay how far such a thing as a purchase
or lease might be possible--whether exchange by pictures were practicable or
not. More likely there is not the least chance of success, but I wish to know.
 Ever yours,
 D.G.R.

Please write me a line on this.

441. DGR to CAH Aldwick Lodge near Bognor
 Tuesday, [7 December 1875+]
My dear Howell,
I wish you would, with as little trouble as possible to yourself, refresh my
memory as to the £70 mentioned by Valpy in enclosed note. I have now told him
(in answering) that the former £200 we spoke of should remain to account of the
Beatrice.
 That devil Levy keeps boring me with letters.[1] He now writes again and wants
me to say that you had sold me a dress previous to his bringing the 2 others.
 I have simply stated this fact in answer.
 I am in great haste for post.
 Ever yours,
 D.G.R.

I am getting on well with Fry's picture. Is he the buyer of Sandys's picture?
P.S. On second thoughts I enclose my answer to Levy to Watts[2] and ask his
advice as to whether or not to answer at all.

[1]See Letter 433.
[2]DGR's letter to Watts is printed in D-W, p. 1382, but not the answer to Levy.

442. DGR to CAH Aldwick Lodge near Bognor
 [10 December 1875+]
My dear Howell,
Some little time back I mentioned to you a house and estate next to this, which
have lately been bought by Baron Grant for, I believe, £5000. I had not then
seen it, but went over the place yesterday. The grounds are 27 acres, including
a private wood and all sorts of lovely matter--endless backgrounds for pictures.

The house is quite a wigwam--a sort of very slight Adams business, only suited as a kind of summer pavilion--at the same time curious and pretty. Any one who meant to live there would have to build either a new house altogether or else (in my own case) a solid block of studios to dwell in during the winter and let the house do summer service. The house is moreoever very dilapidated; and what is most serious--the sea is rapidly encroaching on this part of the coast and has already so undermined the sea-wall of the estate as to render at least £600 or 800£ necessary to lay out to make it safe again.

Now hereabouts there seems to be an impression that Grant (who has not yet been down to see the place himself) does not mean to live there but has only bought it as an investment. I wonder, would it be possible to approach him in any way on the subject--either as to buying it and paying either by pictures or gradual money payments; or else as to taking a good lease of it at whatever rental he may fix? I really should like much if it were possible to take some measures in the matter.

<div align="right">

Ever yours,
D.G. Rossetti
</div>

The place in question is called <u>Aldwick Place</u>.

443. CAH to DGR Chaldon House, Fulham, S.W.
 10 December 1875

My dear Gabriel,

My one but last letter explains all about the £70. Two £15 heads of yours which I took from him [Valpy] for £70 in order as I said before to encourage him and keep up your market. I asked you for the receipt for £90 to pay him with i.e. £70 for the two heads and £20 for one of the Dante sketches for which I gave you £25 and sold to Valpy for £15. Taking this last I would put an end to having to buy back your drawings for more than double what I have sold them to him for, as after this last study he has no more to <u>sell</u>. You said you would send me the receipt for £90 but left me in my trouble and have not sent it.

I will see Watts as to Levy. You have no dress of any sort or kind that was ever his.[1]

I have sold three more pictures for Sandys (portraits) at £1000 each.[1]

Glad you are getting on with Fry's picture, he has asked me to let him know how it is getting on as you write to me on the subject, as he does not wish to worry you with letters. We are going to arrange a room in his house for it, and he is most anxious to have it.

Did Marks do any thing with his picture?[2]

As to <u>Damozel</u> finish it and I will come and see it. You let me know how much you want and if I see my way I will give you the money.

Our agreement was that you should paint it jointly for our two selves for £500 i.e. £250 to be written off my account and two fifty to stand on your account, that when done I should sell it well and halve the money received for it with you.

We thought it would be a good chance of my having a work of yours ready to try and open a new source or field with.

As to Grant I will enter into it when you see your way quite clear to fresh business.

<div align="right">

Your affectionate
Charles A. Howell
</div>

[1] I am skeptical.
[2] <u>La Bello Mano</u> (Surtees 240).

444. DGR to CAH [Aldwick Lodge]
 Tuesday, [14 December 1875+]

My dear Howell,

As you consider all reference to pictures unfeasible in the matter with Grant (and I think your view correct as to best plan) it then seems better to transact simply through my solicitor, does it not? Watts would see to the matter for me as one of simple business, and I think, as such, it is certainly best placed in the hands of a lawyer. Indeed I should not have troubled you on the point had you not let me understand some time since that G. had expressed some wish for

pictures of mine. Please write me a further word on the point by return, as
delay is pernicious in such matters, and if Watts is to see about it, I should
wish to let him know at once.

Your letter really distresses me, as seeming to accuse me of habitual neglect
of your interests--a thing I am not at all conscious of. The debt I have
incurred to you was to be repaid in work; but you well know my numerous
engagements, and though you could feel certain that your due would come to you,
neither you nor I (as you knew) could be certain as to time. I would have
stretched a point and substituted cash for the remainder of your commission on
the Venus (though work was agreed) but you have so bedevilled the Beatrice
matter with Valpy, owing to your inconceivable blunder about transferring that
£200 to the Dante, that I no longer know how I stand with him and cannot give
a receipt for money which he may not be prepared to pay on the Beatrice. All
this is very distressing to be perpetually going over. If that Damozel were
ready, you should have it freely,--but Graham might complain of a second version
getting into the market before he sees his own well advanced; and moreover I
need the one in question as a guide in part of Graham's picture. Anything
possible to me I would gladly do; as it would be a relief to myself to cease
to hear these charges preferred against me by one who has certainly been the
means of widening my circle of purchasers to good purpose.

Those d--d Kelmscott drawings have never been brought here, as George found
so much else which must come that he left them behind.

Please let me have a line as to Grant and Watts by return.

> Ever yours,
> D.G.R.

445. CAH to DGR Chaldon House, Fulham, S.W.
 15 December 1875
My dear Gabriel,
Just a line in haste from a pot house to say I have your letter.

As you please, of course about Watts, but one thing I can answer for viz that
he will not be able to see Grant at all, and I very much question if he would
get an answer if the subject is treated by letter. Grant does not buy these
places as investments but for local influence and name, and cares no more for
£5000 than I do for a farthing. He should be sounded first privately and if he
goes in for it at all it will then be time to employ Watts which will be
necessary for the business part.

He does want some work of yours but he wants to see some, and then buy or
give a Commission.

If we have business with him it will be necessary to keep to our side of any
arrangement, as he would keep to his in any transaction with us, and have
every thing distinct. He has just given £9000 for Landseer's Otter hunt. Let
me have one more line on this subject, and I will either go on with it, or Watts
can take charge.

In haste

> Ever yours,
> Charles A. Howell

Yale.

446. DGR to CAH [Aldwick Lodge]
 Thursday, [16 December 1875+]
My dear Howell,
I think, as the difficulties in approaching Grant seem so insurmountable, that
we will say no more about the matter. Thus please let it drop.

I don't know what you mean by repeating continually that I should have to
fulfil my side of the contract. You know well that I am among the few who
invariably do so, and of whom no one ever had cause to complain on that score
eventually.

> Ever yours,
> D.G.R.

447. CAH to DGR. (Printed D-W, pp. 1390-91.) Clarendon Hotel, Watford, 16 December 1875. DGR not to worry about work for CAH, but he will be glad when it comes. What does DGR want for Lady Macbeth, when to be begun, when finished? Grant wants important picture, CAH wants description, price, size, date of completion. Wants details to give to Grant, but Fry's picture must be finished first. CAH has not broached subject of Aldwick Lodge but hears from G's secretary that G. intends to build on it.

448. DGR to CAH [Aldwick Lodge]
 Friday, [17 December 1875+]
My dear Howell,
I wrote in answer to your telegram by midday post: since then I got your letter from Watford.[1]
 If Grant is going to build on Aldwick Place, that matter seems at an end. If he wishes for pictures of mine, you know my plan, and I shall not certainly be hurried or worried by him more than by another. My view is, that he or any one is favored in getting a work of mine, because I never hurry it, but even fall back and recommence it if I am dissatisfied, and give my best in the end, and am sure to give it in good time, which means the time to make it good. If he likes to be on my list for commissions, I shall commence and finish the work at earliest possibility. Nothing can be done to time but what is more or less a potboiler. These I can do, and even make them good things; but important works are another question.
 I may write further on the commission question if there is no dictation of terms beyond what I think right for my work.
 Ever yours,
 D.G.R.

Of course to be tied to a size is a thing I could not entertain.
P.S. Of course you will understand that, unless Baron Grant were really anxious to get work of mine, and likely to treat for its acquisition in the only spirit I could entertain, I should not on my account wish that he should go to my studio, as that is not a favour of which I am lavish to every one. This is distinct. I presume he knows something of my work and desires it,--otherwise he should not enter my doors. I do not tout among strangers to see if they will buy, and should not be at all pleased to learn that he had kindly called to see the pictures but thought on the whole he preferred something else. I never in my life dealt with any one except those who were enthusiasts for my work.

[1]The telegram concerned the Grant business, as DGR wrote to Watts-Dunton, enclosing the letter which CAH posted from Watford. See following letter.

449. CAH to DGR Chaldon House, Fulham, S.W.
 21 December 1875
My dear Gabriel,
I was quite on my back yesterday and the day before with a sick fit or I would have written. We must always trust each other in the future for any thing either of us may say. For instance I did not in the least mean that you did not fulfil any side of any contract you made, it never crossed my mind, I only meant that we should keep the contracts distinct, i.e. Grant to grant the lease, put up wall etc. etc. and you to paint picture or pictures, each carrying out his agreement as to two separate transactions.
 Now about Grant. Your last P.S. throws me on my back, you either want to sell, and paint pictures at high rates, or you do not. If you do you must of course give me some aid, if you do not care about it, there's an end of the matter.
 Do you suppose Fry would have done what he has done respecting Astarte had he seen nothing? It is not reasonable to expect it. How often have I spoken to you about something for 30/- and how often have you said bring it, and if I like it I will buy it. This is quite natural, and more natural when a question of thousands is involved. What can you expect Grant to feel for you personally when he does not know you and only knows of you through me? He is a City man engaged in great financial affairs and Art is quite outside him, but being very rich now he wants fine things, and wants help in order to get them. He might become your fortune in money matters but in order to accomplish this one must help him.

All he does say is "I hear Mr. Rossetti paints the most beautiful pictures in the world, and I should like to have some." The question of going to the Studio came about like this.

Grant. "I never saw any thing of Mr. Rossetti's but a lovely little picture at Christies"--This was the Annunciation. "It was a religious picture and I should like something not touching on religion."

You must remember that he is a Jew and his wife a very strict one.

Grant. "I hear Mr. Rossetti is at present away, if you would kindly take me to see any thing he may have in the studio it might help me as to the kind of picture I would rather have." To this I answered "I will ask Rossetti to give me permission to do so."

Well I telegraphed as Grant thought he would be able to spare an hour each day for three days after. Tomorrow I see him again, and you may trust me for all good management in this and all other matters. As to touting he does not even know that you know he wants any thing of yours. It is funny of you to begin difficulties when I am trying my best, and when you yourself were the first to write and say "Would Grant like two daubs for £5000?"

I saw Valpy and told him of the £90. "Of course" he said, as he has always said "I am going to pay for, and have both pictures."[1]

> Ever your affectionate
> Charles A. Howell

[1]See following letter.

450. DGR to CAH

[Aldwick Lodge]
22 December 1875

My dear Howell,

Of course all you say about Grant is very true. I do want a new buyer and a good one, but nevertheless am not disposed to let into my house any one who is not sure to be a buyer, as you assured me Fry was, and so he proved. The house question is I fear evidently at an end. For this object, I would have stretched a point as to courting G.; but do not feel disposed to go so far for the mere sale of pictures, though most important if the result is certain.

I heard from Valpy and enclose receipt for 90£ as agreed between you and me, on account of the Beatrice, the commission for which he now recognizes. I write to him with this to say I have sent you such receipt.

My mind is rather foggy on the ins and outs of the question; but I believe I am thus completing your commission on the Astarte, which has therefore all been paid in cash instead of partly work as we agreed: moreover you will observe that I have paid your entire commission at a time when I have as yet only received something less than a quarter of the picture's price.

> Ever yours,
> D.G.R.

451. CAH to DGR

Chaldon House, Fulham, S.W.
Xmas Day [1875+]

My dear Gabriel,

Thanks for the receipt.[1] I have handed it to Valpy. Yes my commission on Fry is all quite paid up viz £210 by two receipts from you one for £120 levied on the large Dante, and this one for £90 on the Beatrice. So far we can call it cash though the truth is that I have handed these two receipts to Valpy in payment of chalk drawings by yourself which I have purchased from him, in order to please him, and keep up your market--for more than double the sums he has paid you for them, so that I calculate I have thus reduced my Fry commission from £210 say to about £135 which I have in work by you, this of course has nothing to do with you and I only explain all that you may know how things are going on. This does not inconvenience you, and of course you have the full balance from Fry to receive which must be some comfort to you. You leave Grant to me please. I have to see him again tomorrow. I shall either make a stunning sweep with him, and get you Aldwick Lodge into the bargain, or fail. If I fail I fail and not you, i.e. you are not in it at all and Grant never for a moment dreams of any step on your side.

Now for a very important thing. It seems some one is starting a paper called the "Artist," and this will contain portraits of the men of the day. Fry is most anxious to get the appointment, not for the sake of the money side, for for that he does not care but in order that all the engraved portraits may say "from a photograph by Mr. Fry." I send you his letter and have marked the men I can secure on his side. It strikes me that you might do a lot and so please Fry no end. You might write to Stephens and Colvin and thus get him the nomination he wants. I have been working it for him and have said nothing as to asking you-- in case you should not feel inclined to help.

As you know Fry never photographs any thing but special work, his work however is truly wonderful. He has photographed Kitty by Sandys, and also "Bradon Water" by Sandys, and they are wonders, just like the drawings, and printed on drawing paper in carbon so that they last for ever, you are going to have a proof of each and you will be as surprised as Sandys was when he saw them. Indeed Fry ought to photograph all your best things, and if you will send me an order to get the little drawings Mrs. Morris has I will get them done for you so that you will be quite astonished. In the case of the "Artist" you might perhaps write to Tadema,[2] and if a few men like him say "we wish to be photographed by Mr. Fry" the thing is done. Write to Watts R.A. etc. etc. No time is to be lost as Fry says if the whole thing is not pushed on at once, some Downing or any other nobody will get it.

Let me hear from you, and as to Grant I will go on and you can depend on me. Many happy years to you old chap and may every thing be bright.

Your affectionate
Charles A. Howell

P.S. It must have been the damp about the seal, as I posted the letter myself. Let Stephens send me at once clean copies of all his articles on your work.

[1]A note from DGR crossed this letter saying that he hoped CAH got the £90 receipt, asking for any further information about the Grant matter, and wishing CAH and his a merry Xmas.
Four sentences in the first paragraph of this letter are printed by Mrs. Angeli (PRT, p. 116).
[2](Sir) Lawrence Alma-Tadema (1836-1912), born Netherlands, naturalized English 1873.

452. DGR to CAH [Aldwick Lodge]
 27 December 1875
My dear Howell,
You will find a slight mistake as to Valpy's 2 receipts. The first was for £127-- thus the 2 amount to £7 over your commission on the Venus. That can go to our account in my favour.

About Grant. The best first step to take would be to see whether he fancies La Bella Mano and would buy it for 3000 guineas--after which (if he did so) I could deal with Marks. As for my taking commissions from Grant, I have so much on hand that the beginning of them would certainly involve delay,--so, if I accepted any commission from him, there must be no impatience on this head. You mentioned the Lady Macbeth[1] subject--I am quite uncertain about taking that up at present--what I shall take up soon is the subject called The Question[2] which is described at the end of Stephens's article, and for which I have made designs and studies, which however are not in a state to show as yet. The thing to try with is La Bella Mano at present.

As for Aldwick Place (not Lodge which is this house) I cannot understand your rather contradictory announcement. You told me last that G. had bought it specially for his own use--then is there any means of getting it? I have since heard the reason for which he is leaving Brighton, and no doubt he does need another seaside residence for himself. Please let me understand clearly what your prospects are on this head.

As to Fry and the "Artist," I will read the letter again (it is now close on post-time) and if I see anything I can do, will of course be delighted to do it, but am quite uncertain whether anything on my part is possible, so no word of this should be said to Fry at present. Of Colvin I have long lost ken--Watts R.A. I have worried so often with applications on behalf of friends that really I don't think I could tackle him again. What reason is there to suppose Stephens

would have any influence? To him again, as to the <u>Athenaeum</u> copies, I could not write anymore. He took the trouble to get the <u>last</u> one and send it to Chelsea, where Dunn now has it.

With all Xmas wishes.

Ever yours,
D.G.R.

[1]DGR executed several designs for a picture to be entitled <u>The Death of Lady Macbeth</u> but never painted the picture.
[2]DGR did a pencil drawing for this picture which he never painted.

453. DGR to CAH

[Aldwick Lodge]
Tuesday, [28 December 1875+]

My dear Howell,

On reading the list you sent me again I find Tadema is the only name within my reach, and <u>he</u> is quite out of reach, being at Rome. So I must give up the matter, and you had better say nothing about it. Of course if you can suggest further, I should be glad to serve if I saw my way.

Today I find it is positively asserted that Aldwick Place is again for sale; but on looking further into its belongings, I am obliged to acknowledge that desirable as its beauties make it--it is quite beyond my means. After the purchase money would come the necessity of building studios and thoroughly repairing the house--then keeping the grounds in order <u>must</u> cost 200£ a year; and further there is the repairing of the sea-wall which <u>must</u> cost something near 1000£. And even supposing all this could be compassed, the last and weightiest item concerns the "groins" or breakwaters between the sea-wall and the sea, on the public beach. I now find that these, along the whole frontage of the sea-wall, would have to be re-established and kept in order by the owner of Aldwick Place; and I learn that this onerous question was the cause why the Cabbells, the late and long hereditary owners, sold the place; the "groins" now needing thorough re-establishment, and after that calling for frequent probable repair in the future. This expense would be a crushing one, and one of which [sic] could never reckon the extent beforehand, as it depends on weather, and every gale may cost one hundreds of pounds. The Cabbells are people of large fortune, and if <u>they</u> funked the expense, where <u>should</u> poor I be? Thus it seems now pretty certain that the hope of possessing this lovely place must be quite resigned.

I will look to hear further from you as to whether or not it is desirable to attempt the sale of <u>La Bella Mano</u>--the only immediate transaction which now seems on the cards.

Ever yours,
D.G.R.

454. CAH to DGR[1]

Chaldon House, Fulham, S.W.
29 December 1875

My dear Gabriel,

"Just a line from a shit-house" in answer to your two last.

You are quite right about the £127. I found it out two days after I got your receipt for £90 and accordingly entered £7 to your credit in general account. It took place this way. The drawings I took from Valpy come to £120 but I owed him £7 besides hence the receipt for £127 which cleared me with him, and hence its dwelling on my mind--through the drawings as £120. However I gave you a receipt in due form and if we always do this nothing can fail to be straight. If you will send me back my receipt for £127 my letter respecting the Fry transaction etc etc. I will send you a proper receipt for the whole amount.

It only concerns myself and I am a curious person, but in the future I do not wish Dunn to know <u>any</u> details of any transaction between us, and I do not wish him to have access to any of my letters, or accounts with you. This as you say "is final."

I note all you say about Grant's place and you are quite right, but I had forseen all you say and was not going to let you into a hole. What I am trying for is to get you the place for £200 a year on a 21 years lease without repairs. Grant returns tonight and I am to be with him early tomorrow.

As to La Bella Mano, of course I will do any thing for you but it rather goes against my grain to work for Mr. Marks who is of course an ass--What in God's name does the man mean by having such a picture as that, and leaving it locked up at Cheyne Walk after it is paid for and finished?!! when dozens are dying to have something of yours. This seems to me the only insult ever offered you, unless the man has been quite frank and given you good reason for such conduct-- and I an old friend worth 50 Marks, wonder how it is that you pull me up so sharp about any thing, and stand all this from Marks!!

I am not going to risk any thing with Grant, and if I sell the picture for £3000 i.e. if I ask £3000 and Grant says he will have it you must understand distinctly that he is to have it, otherwise I cannot deal with that picture. Marks has tried Grant over and over again and seen the butler, and I do not see why I should do for him what he cannot do for himself. It would perhaps be better for you to write to Marks at once and ask him how much he wants from you for the picture saying you think you can sell it. He ought to be glad of £1500 for he will never sell it as long as he lives for more than he gave. If Marks accepts we will pay him out, and then you pocket £750 and £750 cash comes to me. I think this is quite fair, but fair or not such will be my terms.

If I have to treat for something quite your own and not Marks' then my terms are nothing and I remain very happy.

<div align="right">Ever your affectionate
C.A. Howell</div>

[1]This is the last letter from CAH to DGR that has been preserved. (Excerpts appear in PRT, p. 106.) It seems likely that DGR destroyed others that he received later, just as he customarily destroyed letters that did not concern business matters. We know that CAH wrote to DGR on 20 or 21 Jan., for example (D-W, p. 1402).

455. DGR to CAH [Aldwick Lodge]
 Thursday, [30 Decmeber 1875+]

My dear Howell,
As regards La Bella Mano, the terms you name could not suit me. You will perceive that no man who has not at any rate so much relation to the picture as to have paid for it ought not to make as much profit on it as I who painted it. You will answer that you do propose to pay for it beforehand to Marks: Yes, but then it is without risk: whereas I in any case run great risk by such a sale,-- viz: the risk of the picture getting again into the market and not maintaining so high a price. Indeed this is so serious a consideration that it is perhaps well for me that you dictate prohibitory terms.

The only thing which might have tempted me to such a sale (having my eyes quite open to the above serious risk) would have been the realizing now in the mass what ought to have been my own original gain on the picture--viz: 2000 guineas. To do this, I must now make 1000 guineas clear for myself.

I confess I had not contemplated your proposing more than 200 guineas commission for yourself; and on that plan, had in view the offering Marks 1800 guineas for the picture. Less I do not think he would take, as he would see clearly that a large further profit was to be alienated from him.

What you mean by insults on the part of Marks is dark to me. He gave me the price I asked for the picture, and his leaving it as yet in my hands has been valuable and beneficial to me.

As regards Aldwick Place, would it not really seem that if we are now reduced to this question alone it is solely a lawyer's matter, and that without a lawyer it could not be safely concluded?

Concerning Dunn,--it became necessary in the long run to let him know that Grant was the person who might possibly be expected at Cheyne Walk in your company. I do not know what you mean by his having access to your letters and accounts.

<div align="right">Ever yours,
D.G.R.</div>

456. DGR to CAH [Aldwick Lodge]
 Friday, [31 December 1875+]
My dear Howell,
I dare say my yesterday's letter led you to the conclusion that it was not
worth your while going on with any negotiations respecting La Bella Mano.
However, whether it did so or not, I think on further reflexion that it will
be necessary to drop all plans on the subject, as it now strikes me more
forcibly than before that it might place me in a false position with Marks who
has acted straight-forwardly towards me in our business relations.
 Ever yours,
 D.G.R.

457. DGR to CAH [Aldwick Lodge]
 4 January 1876
My dear Howell,
Much that you say is plausible but hardly exact. For instance, when I should
only get (eventually according to my plan) 2000 guineas for the picture, how
could your 10 percent on such sum amount to 300 guineas? With Marks's profit
of course I have nothing to do. What I originally projected projected [sic]
offering you was (as I said) 200 guineas the same percentage which you
proposed and accepted on the Venus Astarte, which price to me was also 2000
guineas.
 I quite admit that you have done me good service in my market, but utterly
deny that I have acted myself wrongly in any way.
 I enclose a note which might be sent to Marks if you think it advisable
supposing always the following to be the case: viz: that Grant is sure to buy
this particular picture and that you could raise the money to pay Marks for it
the moment he accepted the 1500 guineas and before Grant bought it. You would
then get 500 guineas and I 1000. For less than this I will not move a peg, and
you ought to be contented with 500. Of course there would be the possible plan
(as you suggest) of your dealing with Marks solely for the picture (if he would
do so which I doubt) and selling it after to Grant over my head; but this
would not be the act either of a gentleman or a friend, and I should certainly
not be patient of such dealing with a work which only my power to paint it can
make profitable to any one.
 I shall be glad to hear further about Aldwick Place; but I may tell you that,
from inquiries now made through a private channel of the auctioneer in Brighton
who has had to do with it I learn that he does not know of any intention on
Grant's part to relinquish use of the property.
 As for Dunn, he is a friend of mine introduced to me by you--perhaps as good
a service as you ever did me. If you were to invite me similarly to meet
Bailey at dinner, with a view to subsequent connections, I do not think I
should find the same advantage, and therefore cannot perceive the analogy
between the 2 persons.
 Ever yours,
 D.G.R.

 If the note to Marks is adopted, it will have to be returned to me that I may
post it from this place.

458. DGR to CAH [Aldwick Lodge]
 Wednesday, [12 January 1876+]
Dear Howell,
Hallo--o--o!! When am I to hear from you?
 I am engaged on 2 pictures out here--Fry's Astarte and Graham's Blessed
Damozel. Both are too serious to be hurried, and I propose to fill up spare
time with a picture I am now cartooning--a mere painter's picture of a girl
with a mandolin in that brocaded dress I had from you and with a lovely green
curtain--also yours--and I suppose some flowers somehow. The head will be
beautiful I am sure and the whole attractive. Size about the Veronica mark.[1]
Is there any outlet you know of for such a work? It is likely to get done soon,
and is not yet engaged.
 Ever yours,
 D.G.R.

In colour it will no doubt be unusually good.

If you see any outlet, tell me what the price should be to make the sale easy and what your commission.

P.S. I shall _immediately_ be much in want of that pearl hair-pin I lent you. Please do let Dunn have it at once that he may send it on with other things which he is sending _now_.

I send a slight sketch of action of potboiler--just a first scrawl. It will show _much_ more neck and arms in the picture.

[1]_Veronica Veronese_, an oil of 1872, 43 x 35 (Surtees 228). If the girl with a mandolin was painted, I cannot identify it. Mrs. Surtees suggests that it is probably her 247 or 248A.

459. DGR to CAH [Aldwick Lodge]
 Friday, [28 January 1876+]
My dear Howell,

After so prolonged a stay in the North of England, I could almost wish you had delayed writing to me for one day longer, as I think you might then have found yourself more serene; for there was no call to be otherwise. I must now however appreciate additionally the kindness which enabled me during your absence to receive two parcels from London addressed by yourself. It shows what tact and forethought can do, when heartily enlisted for a given object.

Though in the South of England, my letters are sent on to me, and I am thus able not to lose a post in returning the anonymous (or rather anonymized) letter you send me,[1] and not letting it get out of date for your reply. My advice to you is to accept the writer's offer as unreservedly as it is made. A third person proposing to buy a picture from Marks and put it in your hands for sale is initiating a transaction of course quite foreign to me--as much so as if Agnew instead of yourself were the person addressed by him.

Would you let me have back my draft of a letter to Marks. You seem to think I am in some correspondence with him. I have never written him a word for six months, nor heard from nor seen him, except once a line about some hot water plates. Nevertheless it is all nonsense to say I have any cause of complaint against him; such is not the case. As to yourself, it is so distinctly and so recently a fact that I have fully acknowledged your valuable cooperation in business matters, that it is no use dwelling again on the point, as your denying it shows simply that you wrote when out of temper.

Please let me have one line by return to say if you have dropped the negotiation about the house here, or not. I feel interested to come to some clear understanding.

Please also let me have back the sketch I sent you. Of course it in no way represents the picture which will be as "important" as the fiddle picture or any other of that kind: And of course I never thought of dealing about it as if it were a Venus Astarte.

One thing I must say about the proposed purchase of the picture from Marks on your behalf by the Anonymized One. If he carries out his offer, you will of course wish to have the picture in your own possession for further dealing, and I should not wish the writer of the letter or any one to be brought to my studio in connection with the matter. I shall be very glad if the transaction proves a good one for you. I assure you I take a great deal more interest in giving my best labour to new works than in the attempt to get more money out of old ones; nor would the latter question interest me at all save for the sake of the former and of the obligations towards others which are always upon me.

 Ever yours,
 D.G.R.

[1]As DGR wrote to Watts-Dunton on 23 Jan., CAH, in writing to DGR, had enclosed a letter from which signature and place had been erased and in which the anonymous writer wished to purchase La Bella Mano from Marks and place it in CAH's hands for sale (D-W, pp. 1402-03).

460. DGR to CAH[1] Aldwick Lodge near Bognor
 8 February 1876

My dear Howell,
I hear you rather coolly propose that I should pay the £40 due from you to
Mr. Levy! Why I?
 You knew perfectly well that such debt as there is from me to you was
contracted on the clear understanding that the draperies &c which it represents
should be paid for in work only, and you know perfectly that otherwise I should
not have dreamed of contracting so large a debt for such a purpose. What are
the items and what is the total? I will begin immediately putting such work as
I have at command against it.
 I lately paid you in cash much to my own inconvenience, a sum of £90 which
was due in work only on our clear understanding (it being the balance of your
£210 commission on Fry's picture, which was payable half in cash and half in
work); and now you want to wrest from me, who, as you know well, can ill afford
it, another £40 on the same transmuted plan of payment.
 Moreover I learn that Levy's real charge for the dress in question was £15.
You charged it to me at £35. What then am I to think of your statement in other
similar cases that your charge to me has been the same as you paid yourself?
Of course there is no earthly need that it should be so, nor any common sense
in such an arrangement; but why not state things as they are? I expect nothing,
as you know, but fair business relations.
 What I will do is this. I will send Watts £20 towards Levy's claim, being an
excess of £5 on Levy's charge for the dress; and you can continue if you like
to charge your still further £15 to my account; as I had agreed to pay £35 for the
dress in work. I must tell you that I disburse this sum at great inconvenience
to myself, being much pressed for money, as I always am now, owing to my
constantly increasing care with my work. To give more is out of the question.
Before I send Watts the £20, please hand him the pearl pin, as I need and
cannot be without it.
 Ever yours,
 D.G.R.

[1]This letter also appears in D-W, pp. 1407-08. The original letter is in the
HRC, Texas.

461. DGR to CAH Aldwick Lodge, Bognor
 22 March 1876

Dear Howell,
Mr. Fry has written one word of your proceedings in his regard for some time
past, and the impossibility of getting any word of answer or explanation from
you after the most unaccountable conduct.[1] I have had to explain whatever I
could, and found my position compromised with him at the time of his writing,
though of course not after my explanation of the real state of things. You know
I had your distinct promise that no chance sketches or studies of mine should
be offered to Mr. Fry, as I wished him to have my best work only; but I find
that not merely have you disregarded this promise, but have most unwarrantably
transferred to him, without my sanction or knowledge, some part (if not the
whole) of the transaction pending between you and me for work in exchange for
goods,--a matter which you had of course no business even to speak of to him
without my leave, as being quite private between you and me, and liable to
misconstruction if not clearly explained.
 To such among Mr. Fry's causes of complaint against you as do not in any way
concern myself, I need not refer.
 However, I do not write to make recriminations, as I know now how vain it is
to try to call you to account on fair grounds, and how utterly reckless you are
as to obligations incurred. What I now want is a clear understanding and final
wind-up of this question of the draperies and drawings. It would probably be
most to your advantage and to my comfort that I should let you have some one
creditable piece of work which you could dispose of to advantage, covering the
liability. But first I must know exactly what that liability is--the items and
the total. This I must beg you without fail to furnish to me at once in writing,
and I will at once see to meeting it.

The question of the pearl pin I lent you, it is no use reviving. You have evidently put it somewhere out of reach or you could not have let yourself be so endlessly asked for it without result, and given so many vain assurances about it. Thus I shall put my price on this and set it to the account, though very sorry to lose it. The silver necklace you sent me on approval got, as I told you, slightly damaged. It is now being well repaired and will reach you shortly.

You borrowed a set of drawings of St. George and Dragon to copy--for your own use only.[2] Please return them to Chelsea at once.

If this letter is met simply by your usual dogged silence, you will leave me no alternative but to put the matter without delay in the hands of a lawyer and get it settled. I am perfectly ready to wind up our bargain on the original terms; but I cannot have the matter hawked about and misunderstood without my being even cognizant how many persons are acquainted with it.

I feel your present position to be very serious and involved, and am far from wishing to aggravate it in any degree whatever. On the contrary, I hope such work as I shall furnish you with will prove a source of help to you. This letter will, I trust, meet with a clear and businesslike response from you, and then we shall be able to wind up the affair in a manner satisfactory to both.

Yours very truly,
D.G. Rossetti

[1]Mrs. Angeli thinks that CAH's dealings with Clarence E. Fry show "him at his worst, in his moment of blackest difficulties" (PRT, p. 113). DGR's correspondence with Fry appears in D-W, pp. 1411 and 1430-31; Fry's with DGR appears in PRT, pp. 110-113. A good deal of information is also provided by DGR's letters to Dunn and Watts-Dunton (D-W, pp. 1425-37).

The facts seem to be these: CAH sold to Fry two drawings by DGR--a Dante and Venus Verticordia, for which Fry gave a check but received only the Dante. Subsequently CAH obtained from Fry a check for £200 in exchange for a postdated check that was dishonored. CAH also represented to Fry that DGR owed him work in the amount of some hundreds of pounds and requested a loan from Fry of £250 in exchange for the non-existent work as security. Fry did so. On 6 Apr. 1876 Fry wrote to DGR about CAH and enclosed a letter from CAH, which states that in consideration of the "kind advance" of £250 "I hereby mortgage to you the sum of Five Hundred & Twenty Seven pounds of work by D.G. Rossetti, said work being fully paid up by me and at this moment due by D.G. Rossetti. As this said work is delivered you shall be at liberty to keep any one picture or pictures for yourself or failing this said picture or pictures to be sold by me and all profits to be divided between us the principal to be paid you back from the proceeds of the sale" (PRT, p. 113).

The Janet Camp Troxell Collection in Princeton Library contains a copy of an unaddressed note, signed by CAH, which reads as follows:

"My impression is that my debt to Mr. Fry is £400.0.0 but whatever it is, if Rossetti will pay it in drawings and Watts gets a proper receipt from Mr. Fry and my fine Sandys which has been strangled in Mr. Frys hands ever since as security for the lot I will discharge Rossetti of all debts to me. If Rossetti thinks this places him under any obligation to me and he does not like it I will accept any sketch he likes to send me as payment for the balance." This may refer to the statement by DGR in a letter to Watts-Dunton (23 Apr. 1876, D-W, p. 1432) that Fry "has come to some sort of agreement with Howell as to H. paying off scores and the Portuguese admits that he has been much to blame."

All that can be said of all this is that it is true that DGR owed CAH drawings that he had been unconscionably long in delivering, that the account between them went on into 1878, and indeed (by CAH's reckoning) till the settlement of DGR's estate after his death in 1882, but that none of this exonerates CAH in his relation with C.E. Fry. Let it be said on behalf of DGR, however, that however sternly he may have written to CAH on occasions, his letter of 21 Mar. 1876 to Fry is really a plea for mitigation of judgment of CAH (D-W, p. 1411).

[2]Five of the six drawings made for the Morris firm by DGR in 1861-62 remained in the hands of CAH at least until early 1878 (D-W, p. 1552).

462. DGR to CAH Aldwick Lodge
 23 March 1876
Dear Howell,
It has occurred to me today as a most necessary point in addition to what I
wrote yesterday, to say that, before transferring work of mine to you any
further I must have clear proof that the persons from whom you bought the
various goods I had from you are satisfied as to their claims on you, and that
there is no further danger of my being drawn into paying cash to avoid
inconvenience of subpoena or some other kind, as in the case of Levy.
 Before this proof is furnished to me I will do nothing; and if there is no
proof to be had, I will return all the goods just as I had them and have done
with it.
 Yours very truly,
 D.G. Rossetti

463. DGR to KH[1] Bognor
 26 March [1876]
Dear Mrs. Howell,
Let me express sincere regrets for the trouble you have been put to about that
celebrated hair-pin. A word of clear explanation on Howell's part would have
made all right. But any one might have been puzzled after so many months, when
such various accounts and assurances had been given on so trifling a subject.
 Sincerely yours,
 D.G.R.

[1]This letter, from a copy by DGR, appears in D-W, p. 1417, with the words
"pearl pin" in place of "hair-pin." In a letter dated "Saturday" (D-W, p. 1412)
DGR wrote to Dunn, asking him to look at the pin and see that it was all right:
"The story now (as told in an elaborate note by Mrs. H., which I shall not
answer) is that she broke it at a party and the jeweller who had to mend it
has kept it till now--some nine months."

Index

Numbers printed in italic refer to the introductory material; arabic numerals are letter numbers.

Meeting of Dante and Beatrice in Paradise, The, 387, 389, 390, 393, 394, 395, 396
Monna Primavera. See The Day Dream
Monna Vanna, 23n, 24, 34
Morris, Jane (portraits of), 64, 83, 91, 96, 104, 148, 212, 406
Morris, May (portraits of), 150, 153, 156, 159, 166, 167, 169, 170, 171, 172, 173, 174, 175, 178, 182, 187, 193, 212, 218, 221, 224, 226
My Lady Greensleeves, 166
Pandora, 146, 255
Passover in the Holy Family, The, 158, 162, 163
Pia de' Tolomei, La (drawings), 56n, ?57, 73, 74n, 76, 79, 89, ?104, ?113
Pia de' Tolomei, La (oil), ?257, 261, 265, 269, 282, 308, 311, ?312, 313, ?316, 344
Proserpine, 146, 148, 149, 150, 152, 154, 156, 159, 166, 167, 172, 185, 187n, 191, 193, 195, 196, 197, 225, 226, 236, 238, 239, 246, 247, 248, 250, 253, 255, 256, 257, 261, 265, 267, 269, 270, 273, 279, 280, 281, 282, 285, 287, 289, 296, 303, 304, 305, 308, 311, 312, 314, 315, 316, 319, 320, 322, 327, 328, 329, 330, 332, 333, 336, 337, 338, 339, 340, 341, 342, 343, 344, 345, 348, 349, 350, 351, 352, 354, 355, 360, 361
Perseus. See Aspecta Medusa
Question, The, 452
Regina Cordium, 162, 163
Return of Tibullus to Delia, The, 57, 61, 62
Roman Widow, The, 194, 265, 267, 269, 303, 304, 305, 308, 311, 341, 344, 345, 348
Rosa Triplex, 31, 54, 72
Rossetti, Elizabeth ("Lizzie") Siddal (drawings of), 160, 162, 163
Saint George and the Dragon, 163
Saint Luke Preaching, 163
Sancta Lilias. See The Blessed Damozel
Sea-Spell, A, 424
Sibylla Palmifera (drawing), 96, 147, 148, 224, 226, 227, 230, 233
Sibylla Palmifera (oil), 27n, 94, 264
Sibylla Palmifera (copy proposed, ?oil), 313
Silence, 104, 147, 148, 149, 150, 153, 154, 156, 174, 175, 178n, 235
Story of St. George and the Dragon, The (drawing), 31, 461
Story of St. George and the Princess Sabra, The, 53, 57, 58, 68, 98
Tibullus. See Return of Tibullus . . .
Tristram and Yseult, 44n, 183

Two Mothers, The, 354n, 356, 359
Vanna Primavera. See The Day Dream
Venus Astarte, 425n, 432, 437, 438, 441, 443, 444, 447, 449, 450, 452, 457, 458, 459, 460
Venus Verticordia (drawing), 31, 56, 58, 69, ?73, 79, 461n
Venus Verticordia (water-color), 56n, 58, ?72, 279n
Veronica Veronese, 185, 194, 197, 211, 255, 282, 313, 341, 458, 459
Washing Hands, 11, 12, 348
Watts, Theodore (crayon drawing of), 372
Wilding, Alexa (drawings of), 64, 74, 111, 185, 191, 197, 261, 271, 273, 274, 275, 280, 323, 328, 331
Woman with a Fan, 182, 186, 195, 351, 352
Rossetti family, 1
Rossetti, Gabriele (mother of DGR), 30, 34, 45, 85n, 122, 123, 124, 179, 265, 266, 269
Rossetti, "Lizzie" Siddal (wife of DGR), 4, *19*, 80n, 160, 163, 164, 338
Rossetti, Lucy Brown (wife of WMR), 5, *19*, 220, 222, 350
Rossetti, Maria, 45, 122, 123
Rossetti, William Michael, *vii*, *1*, *3*, *4*, *5*, *8*, *9*, *11*, *17*, *18*, *19*, *23*, 29, 7, 32, 33, 35n, 39, 54n, 71, 74n, 79, 80, 81, 84n, 85n, 88n, 91n, 92n, 96, 123, 126, 131n, 132, 135, 136n, 146, 147, 148, 150, 153, 156, 160n, 187, 215n, 228, 232n, 233, 235, 236, 273n, 279n, 294, 296, 297, 349, 350, 351, 436n. *See also* List of Letters
Rothschild (family of), 246
Ruskin, John, *vii*, *viii*, 2, *3*, 4, *5*, *6*, *7*, *8*, *12*, *15*, 22, 7, 11, 20, 21, 22, 23, 91, 92, 124, 158, 160, 162, 163, 230, 438
Russell, Rev. Mr., 188, 191, 193
Rutter, Messrs., 5, 7

Salt, Sir Titus, 131, 293, 331
Sandys, Frederick, *vii*, *1*, 8, *15–16*, *19*, 22, 23, 26, 44, 70, 99, 147n, 197, 214, 231, 246, 254, 256, 257, 258, 261, 265, 269, 270, 273n, 275, 276, 278, 279, 293, 295, 296, 332, 360, 361, 362, 370, 434, 435, 436, 441, 443, 451, 461n
Scott, W. Bell, *4*, *11*, *24*, 30, 47, 84, 85, 86, 87, 88, 105, 136n, 138, 231, 234, 337, 338, 340
Shaw, G. B., *17–18*
Shaw, Norman, 295, 338
Shelley, Percy B., 126
Shields, Frederic, 44
Shout, Jagus (jeweler), 338, 342, 343, 345, 347, 348, 382, 383

Table of Letters

Numbers of summarized letters appear in square brackets.

CAH to DGR: [126], 131, 147, 149, 153, 155, [157], 160, 161, 163, 171, 186, 202, 204, 207, 210, 214, 216, 218, 220, 224, 230, 233, 235, 242, 246, 250, 252, 254, 257, 261, 264, 278, 282, 283, 287, 288, 290, 292, 295, 299, 304, 306, 309, 311, 315, 318, 322, 326, 327, 330, 331, 335, 336, 338, 342, 344, 349, 351, 354, 356, 358, 359, 365, 367, 382, 385, 396, 401, 404, 406, 409, 420, 426, 434, 436, 438, 443, 445, [447], 449, 451, 454

DGR to CAH: [2], [3], [4], 5, [6], 7, [10], 11, [12], [13], [14], [15], [16], 17, 18, 19, 20, [21], 22, 23, 25, [26], 27, 28, [29], 30, 31, [32], [33], 35, [36], [38], 40, [43], 44, 48, 49, [50], 51, 52, 53, 54, 55, 56, 57, 58, 59, 61, 62, 63, 64, 65, 66, [67], [68], [69], 70, [71], 72, 73, 74, 75, [76], 77, [78], 79, 80, 81, [82], 83, 84, 85, 86, 87, 88, [89], 90, 91, 92, [93], [94], [95], 96, [98], 99, [100], [101], [102], [103], [104], [106], [107], [109], [110], 111, [112], [113], [114], [115], 116, 117, [118], 119, [120], [121], [125], 127, 129, [130], 132, 146, 148, 150, 154, 156, 158, 159, 162, 164, 165, 166, 167, 168, 169, 170, 172, 173, 174, 175, 176, 178, 179, 180, 181, 182, 183, 184, 185, 187, 188, 189, [190], 191, 192, 193, 194, 195, 196, 197, [198], 199, 200, [201], [203], 205, 206, 208, 209, 211, 212, 213, 215, 217, 219, 221, 222, 223, 225, 226, 227, [228], 229, 231, 232, 234, 236, 237, 238, 239, 240, 241, 243, [244], 245, 247, 248, 249, 251, 253, 255, 256, 258, 259, 260, [262], 263, 265, 267, 268, 269, 270, 271, 272, 273, [274], 275, 276, 277, 279, 280, 281, 284, 285, 286, 289, 291, 293, 294, 296, 297, 298, 300, 301, 303, 305, 307, 308, 310, 312, 313, 314, 316, [317], 319, 320, 321, 323, 324, 325, 328, 329, 332, 333, 334, 337, 339, 340, 341, 343, 345, 346, [347], 348, 350, 352, 353, 355, 357, 360, 361, 362, 363, 364, 366, 368, 369, 370, 371, [372], 373, 374, [375], 376, 377, 378, 379, 380, [381], 383, [384], [386], 387, 388, 389, 390, 391, 392, 393, 394, 395, 397, 398, 399, 400, [402], 403, 405, 407, 408, 410, 411, 412, 414, 415, 416, 417, [418], 419, 421, 422, 423, 424, 425, [427], 428, 429, 430, 431, 432, 433, 435, 437, 439, 440, 441, 442, 444, 446, 448, 450, 452, 453, 455, 456, 457, 458, 459, 460, 461, 462

CAH to WMR: [1], 97, [135], [137], [140], [143], [145], [152], 177

WMR to CAH: 128, [134], 136, 138, [139], 141, [142], [144], 151

WMR to KH: 41

CGR to CAH: 123, 124, [133]

CGR to KH: 42, 45, 122

DGR to KH: 8, 9, [24], 34, 37, 39, 46, 47, 60, 105, [108], 266, 302, 413, 463